ICONS OF AMERICAN ARCHITECTURE

ICONS OF AMERICAN ARCHITECTURE

From the Alamo to the World Trade Center

Volume Two

Donald Langmead

Greenwood Icons

GREENWOOD PRESS
Westport, Connecticut · London

Library of Congress Cataloging-in-Publication Data

Langmead, Donald.
 Icons of American architecture : from the Alamo to the World Trade Center / Donald Langmead.
 v. cm. — (Greenwood icons)
 Includes bibliographical references and index.
 ISBN 978-0-313-34207-3 (set : alk. paper) — ISBN 978-0-313-34209-7 (vol. 1 : alk. paper) — ISBN 978-0-313-34211-0 (vol. 2 : alk. paper)
 1. Architecture—United States. 2. Architecture and society—United States. I. Title.
 NA705.L35 2009
 720.973—dc22 2008040909

British Library Cataloguing in Publication Data is available.

Library of Congress Catalog Card Number: 2008040909
ISBN: 978-0-313-34207-3 (set)
 978-0-313-34209-7 (vol. 1)
 978-0-313-34211-0 (vol. 2)

First published in 2009

Greenwood Press, 88 Post Road West, Westport, CT 06881
An imprint of Greenwood Publishing Group, Inc.
www.greenwood.com

Printed in the United States of America

The paper used in this book complies with the Permanent Paper Standard issued by the National Information Standards Organization (Z39.48-1984).

10 9 8 7 6 5 4 3 2 1

This book is dedicated to Robert Scarborough, a true professional

Contents

Volume One

Volume Two

List of Photos

The Alamo, Texas (page 1). Ruins of the church of San Antonio de Bexar. Lithograph by C.B. Graham, from a drawing by Edward Everett, n.d. Courtesy Library of Congress.

Alcatraz Island, San Francisco Bay (page 25). The main prison building was designed by U.S. Army Major Reuben B. Turner, 1909–1912 and converted to a civilian penitentiary under the direction of Robert Burge, 1934. Photograph ca. 1934–1950. Courtesy Library of Congress.

Brooklyn Bridge, New York City, 1867–1873 (page 49). Engineers: John Augustus Roebling, Washington Roebling, and Emily Warren Roebling. Pedestrians on the promenade, ca. 1899. Photograph by Strohmeyer and Wyman. Courtesy Library of Congress.

Empire State Building (far left), New York City, 1930–1931 (page 71). Architects: Shreve, Lamb, and Harmon. 1937 photograph. Courtesy Library of Congress.

Edgar J. Kaufmann Sr. residence, "Fallingwater." Bear Run, Pennsylvania, 1936–1939 (page 93). Architect: Frank Lloyd Wright. General view from downstream. Courtesy Library of Congress.

Golden Gate Bridge, San Francisco, 1930–1937 (page 115). Chief engineer: Joseph Baermann Strauss; designer: Charles Alton Ellis; architects: Irving Foster Morrow and Gertrude Comfort Morrow. Aerial view across the Golden Gate toward Marin County during construction. 1934 photograph. Courtesy Library of Congress.

Graceland Mansion, Memphis, Tennessee, 1938–1939 (page 139). Original architects: Max Furbringer and Merrill G. Ehrman. Principal (east) front. There were extensive additions and interior alterations to the house after it was acquired by Elvis Presley in 1957. Photograph by Chris Walter. Courtesy Getty Images.

United States Capitol, Washington, D.C., 1783–1892 (page 421). Various architects. Dome over the central rotunda, seen from the National Mall; architect: Thomas Ustick Walter, 1854–1865. 1937 photograph. Courtesy Library of Congress.

U.S.S. *Arizona* Memorial, Pearl Harbor, Hawaii, 1958–1962 (page 447). Architect: Alfred Preis. The ship in the background is the decommissioned U.S.S. *Missouri*. Photograph by J. Scott Applewhite, 2003. Courtesy Associated Press.

Vietnam Veterans Memorial, National Mall, Washington, D.C.; "The Wall," 1980–1982. Architect: Maya Ying Lin (page 471). Photograph by J. Scott Applewhite, 1984. Courtesy Associated Press.

Washington Monument, National Mall, Washington, D.C., 1836–1885. Architect: Robert Mills (page 497). Aerial photograph, 1943. Courtesy Library of Congress.

The White House (Executive Mansion), Washington, D.C., 1792– (frequent rebuilding and alterations) (page 519). Original architect: James Hoban. North front; portico by Benjamin Latrobe, 1805–1817. 1941 photograph. Courtesy Library of Congress.

World Trade Center, New York City, 1962–1973 (page 541). Architect: Minoru Yamasaki and Associates; architects in association: Antonio Brittiochi and Emery Roth and Sons; engineers: Worthington, Skilling, Helle and Jackson. World Trade Center One (right) and World Trade Center Two (the "Twin Towers") were destroyed by terrorist attack on September 11, 2001; the remaining buildings in the complex, damaged by the collapse, had to be demolished.

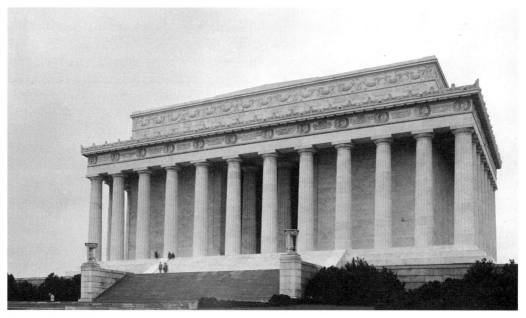

Courtesy Library of Congress

Lincoln Memorial, Washington, D.C.

"The salvation of the Union"

In March 1861, just a week after Abraham Lincoln was sworn in as the six-teenth president, seven southern states, having seceded from the Union, signed the constitution of the Confederate States of America. In effect, they formed another nation. Although Lincoln's stated opposition to slavery was a major issue, associated politico-economic reasons for the schism (beyond the scope of this essay) were complicated. In April, four more states seceded, and the North and the South descended into 4 years of tragic civil conflict. Half a million Americans died, and as many again were wounded before the Confederacy formally surrendered on April 9, 1865. The Union was saved. Six days later John Wilkes Booth, a young actor bent on avenging the South's defeat, crept into Lincoln's box at Ford's Theater and shot him in the back of the head. He wrote in his diary, "Our country owed all her troubles to [Lincoln], and God simply made me the instrument of his punishment." The president died the following morning. By year's end the thirteenth amendment to the U.S. Constitution, born of Lincoln's Emancipation Proclamation of January 1863, had been ratified by all the states. Slavery was abolished.

Inevitably, memorials to the martyred statesman multiplied, at least throughout the northern states. Between 1868 and 1900 several cities—Brooklyn, New York City, Philadelphia, and Chicago—would commission statues, some paid for by private citizens. His tomb in Oak Ridge Cemetery, Springfield, Illinois, mooted immediately after his death, was dedicated in October 1874.

Between 1868 and 1876 three statues would be set up in Washington, D.C. And as early as May 1865 the District of Columbia's "colored citizens" established the National Lincoln Monument Institute, "for the purpose of erecting a Colored People's National Monument to [Lincoln's] memory; said monument to be a seat of learning—a building of fine architectural design, to be dedicated to God, to Literature, to Science, and Art—to be held and appropriated for the education of the children of Freemen and Freedmen, and their descendants for ever."

But the nation's leaders had something grander and quite different in mind. At the first session of fortieth Congress in March 1867 the Lincoln Monument Association was allowed 4 years to raise $400,000 from private donations for a monument to be built on the grounds of the Capitol. The federal government promised to give the Association—once the fund reached $100,000—twelve decommissioned bronze cannon that could be melted down and used to cast statuary. In June 1868 they were handed over with no conditions attached. The self-taught New York sculptor Clark Mills proposed a monument with three levels of bronze figures—thirty-five in all—on a granite base. The lowest level was to have six equestrian statues of Union Army leaders (such figures seem to have been his forte); above it, there would be three groups of liberated slaves and low-relief tableaus of events of the Civil War; the 70-foot high composition would be crowned with a figure of Lincoln signing the Emancipation Proclamation. But by the time that Mills died in 1883 nothing had happened. For even such a noble cause, the subscription

fund seems to have been difficult to fill. So despite further empowering legislation and any number of ideas littering the next three decades, nothing substantial was achieved.

CHANGES TO THE CAPITAL: THE McMILLAN COMMISSION

Throughout the nineteenth century, profit-driven laissez-faire urban development had meant that Pierre Charles L'Enfant's original unified vision for the national capital (except for only the centrality of the Washington Monument) had been all but abandoned. By 1900, the city's centennial as the seat of government, the National Mall was randomly planted with trees and gardens and dotted with several public buildings—even some industrial ones. The Baltimore and Potomac Railroad station stood at the foot of Capitol Hill.

In 1898 President William McKinley convened a committee of state governors and federal politicians to begin planning social events to celebrate the centennial. Republican Senator James McMillan of Michigan, chairman of the Senate Committee on the District of Columbia, inclined toward a more permanent commemoration, suggested that the national capital be generally improved. Many influential organizations agreed in principle but not in detail, and throughout the centennial year alternative proposals provoked what one urban historian has called "the battle of the plans." On December 12 the American Institute of Architects (AIA) launched its annual convention in the capital, with the theme, "Improvement of the City of Washington." Speakers included nationally respected architects, landscape architects, and sculptors, and the subjects of the city's planning heritage and the development of The Mall as its focus were central to many of the papers. McMillan arranged to have them published as a government document. The subsequent complex political maneuverings between him and the AIA are beyond our present scope: in a nutshell, the AIA promised professional support for his bill to relocate Union Station in The Mall, if he would sponsor "a commission to . . . make recommendations for the future placement of government buildings and the development of Washington's park system."

Three months later, after being denied funding by the House of Representatives, McMillan secured a Senate resolution allowing him to set up the Park Improvement Commission of the District of Columbia that became known as simply the "McMillan Commission." Its four members, appointed by President Theodore Roosevelt, were all nationally—some cases, internationally—acclaimed designers: Chicago Beaux-Arts architect Daniel Burnham, who had overseen the design of the World's Columbian Exposition in 1893, was its recognized leader; New York architect Charles Follen McKim, also Beaux-Arts trained; young Massachusetts landscape architect Frederick Law Olmsted, Jr.; and the realist sculptor Augustus Saint-Gaudens, who also had studied at the Beaux-Arts. Their brief was to restore and develop L'Enfant's

plans for Washington and "fit them to the conditions of today." They began meeting in April 1901.

Travelling with McMillan's secretary Charles Moore, Burnham, McKim, and Olmsted undertook a 7-week study and design tour of Europe, visiting Paris, Versailles, Rome, Venice, Vienna, Budapest, London, and Oxford. They worked on proposals for Washington during their Atlantic crossings and separately developed the embryonic ideas when they returned home. The Commission set up three studios: one on the floor above McKim, Mead, and White's New York office; Olmsted in his own office in Brookline, Massachusetts, "where he assumed responsibility for the park plans"; and McMillan secured space for a drafting room in the Senate Press Gallery in Washington. Its 171-page report of January 15, 1902 was approved by McMillan's Senate Committee.

On the same day, organized by McKim, newly-elected president of the AIA, and its secretary Glenn Brown, an exhibition of more than 170 paintings, drawings, and photographs, as well as "before and after" models opened at the Corcoran Gallery of Art. Brown later recalled that Roosevelt "showed his keen appreciation of the value of the scheme in the development of the Capital City" and defended it during the remainder of his term in office.

Generally, the McMillan Commission's recommendations reflected ideas from the 1900 AIA convention. Affirming L'Enfant's scheme, it proposed a plan for all future development, predicated by the Renaissance ideals of convenience, order, and beauty. It included the relandscaping of the Capitol Grounds and The Mall (which was to be extended west and south of the Washington Monument), restructuring the city railways, clearing slums, providing a government office precinct, and—of course—improving the District's system of parks and recreation space. A key element was a memorial to Lincoln, to be built on land reclaimed from the Potomac marshes at the western end of the Mall.

The Commissioners' intention is best described in their own words:

> From the [Washington] Monument garden westward a canal three thousand six hundred feet long and two hundred feet wide, with central arms and bordered by stretches of green walled with trees, leads to a concourse raised to the height of the Monument platform. . . . At the head of the canal a great rond point, placed on the main axis of the Capitol and the Monument, becomes a gate of approach to the park system of the District of Columbia. . . .
>
> Crowning the rond point . . . should stand a Memorial erected to the memory of that one man in our history as a nation who is worthy to be named with George Washington—Abraham Lincoln.
>
> Whatever may be the exact form selected. . . , in type it should possess the quality of universality, and also it should have a character essentially distinct from that of any monument either [extant or future]. The type which the Commission has in mind is a great portico of Doric columns rising from an unbroken stylobate. This portico . . . has for its chief function to support a panel bearing

an inscription taken either from the Gettysburg speech or from some one of the immortal messages of the savior of the Union.

The portico contemplated in the plans, consisting of columns forty feet in height, occupies a space of two hundred and fifty feet in length and two hundred and twenty feet in width; it is approached by flights of stairs on the east and the west, is embellished with appropriate groups of sculpture, and is surmounted by a central crowning group of statuary. At the head of the canal, at the eastern approach to the Memorial, it is proposed to place a statue of Abraham Lincoln.[1]

STANDING ALONE, DISTINGUISHED, AND SERENE

The projected site, on swampy land reclaimed from the mosquito-infested Potomac shore, was a controversial choice. Joseph Gurney Cannon, then speaker of the House of Representatives, strongly disapproved of it, reportedly declaring, "I'll never let a memorial to Abraham Lincoln be erected in that Goddamned swamp." Some claim that his opposition delayed the memorial's completion by 10 years. Whether it did or not, the path to the building's official dedication on May 30, 1922, would be less than smooth.

Knowing the slow-grinding wheels of government, it was inevitable that still more commissions would be appointed. On January 18, 1909, lobbied by the AIA and responding to the administration's need for expert advice on artistic matters, Roosevelt established a thirty-member Council of Fine Arts, chaired by the provincial architect Cass Gilbert. At its only meeting, it endorsed the McMillan Commission's choice of site. The Council was disbanded when Congress declined to fund it on the grounds that it had been convened only by executive order. Roosevelt's successor, William Howard Taft, prompted Senator Elihu Root of New York and Representative Samuel McCall of Massachusetts to push the legislation, enacted on May 17, 1910, that created the Commission of Fine Arts "to advise generally upon questions of art" in the Federal District. Although its authority was at first limited to statues, fountains, and monuments, in October 1910 it was extended to include public buildings. In that same year two Illinois Republican senators sponsored a Lincoln Memorial bill. Signed by Taft on February 11, 1911, it created the Lincoln Memorial Commission, chaired by Senator George Peabody Wetmore of Rhode Island. Two million dollars—about two-thirds of the final cost—was set aside for the building. The Commission of Fine Arts authorized the Memorial 5 months later.

Given the recommendations and *imprimatur* of this succession of Commissions for the site and the form of the Lincoln Memorial, it seems surprising that debate continued. But continue it did and would do so even after construction began. It has been suggested, not without irony, that the Republican establishment that ruled when the Memorial was being planned and built wished to create "an American Empire"—a vision that may help to explain

the emergence of alternative proposals. For example, in 1911 Representative James McCleary of Minnesota proposed that Abraham Lincoln be remembered, not by a pseudo-temple but a "memorial road" from the White House to Gettysburg; the three states crossed, if they were so disposed, could erect their own monuments. Rejected in Washington, his idea would be taken up in 1913 by the Motor Car Dealers Association, the American Automobile Association, and other vested interests, to produce the Lincoln Highway, the first transcontinental road in the United States.

"THE QUALITY OF UNIVERSALITY"

On December 5, 1912, the Lincoln Memorial Commission not only unanimously approved the Potomac shore site for the building, but also "by a close vote" named Illinois-born New Yorker Henry Bacon as its architect; his design already had the endorsement of the Commission of Fine Arts. The report included appendices setting out Bacon's rationale of the preliminary, alternative, and final designs; similar statements by the only other short-listed architect, John Russell Pope (also of New York); and the Commission of Fine Arts assessment of the respective schemes.

In 1902 Burnham and McKim had produced drawings of a memorial approximating that described in their report to McMillan, *sans* the "appropriate groups of sculpture [and a] central crowning group of statuary." Although the project had remained in abeyance, other suggestions were forthcoming: some were sublime, like a triumphal arch to memorialize the fallen soldiers of the Civil War; others were ridiculous, like reconstructing in Washington, D.C., Abe Lincoln's log cabin at Sinking Spring Farm, Kentucky.

About a decade later, Burnham, Pope, and Bacon each submitted designs. Inexplicably, contradicting his original recommendations, Burnham proposed a semicircular colonnaded plaza on Delaware Avenue. The ten designs that Pope offered—some sources say there were only seven—included a circular open colonnade for the Potomac site surrounding a statue of Lincoln; his alternatives were located at Meridian Hill and the Soldiers' Home Grounds and included a meso-American pyramid, a ziggurat, and a funeral pyre. Bacon had submitted a single idea.

His successful design, which would be modified in the course of the 11 years it took to build, followed the McMillan Commission's principal recommendations: it was in the "correct style" and on the "correct" site. In 1911 Bacon wrote,

> We have at one end of the axis [of the National Mall] a beautiful building which is a monument to the United States Government. At the other end of the axis we have the *possibility* [emphasis added] of a Memorial to the man who saved that Government and between the two is a monument to its founder. All three of

these structures, stretching in one grand sweep from Capitol Hill to the Potomac river, will lend, one to the others, the associations and memories connected with each, and each will have its value increased by being on the one axis and having visual relation to the other.[2]

Certainly his original design, as the Lincoln Memorial Commissioners wanted, evoked "grandeur and republican simplicity." Gleaves Whitney believes that it was "no accident that Bacon's design reflected America's vacillating aspirations to be both the world's greatest democracy and the globe's strongest power," and comments that as built it looked like "an ancient Greek temple set in the Roman Empire."

> Indeed, a prominent inscription on the inside of the structure refers to the memorial as a "temple" dedicated to Lincoln and the ideas for which he stood. More accurately, perhaps, it is a temple to American ideals in the early twentieth century—union, freedom, democracy, and international power.[3]

Some writers have suggested that Bacon received the commission because he was born in Illinois—hardly a substantial reason. Others believe, perhaps more plausibly, that it was because he was one of Charles McKim's protégés. In *The Lincoln Memorial and American life*, Christopher Thomas asserts that "McKim trusted Bacon to use a visual vocabulary that would suggest the 'moral authority and fiscal sobriety of Republicanism.'" Regardless of how it has been used in more recent times, Thomas sees the memorial as a symbol of the "the Republican Party of Teddy Roosevelt's and William Howard Taft's era." In all, it was and is a confusing icon.

When he designed the Lincoln Memorial, Henry Bacon was widely regarded as one of the most adept interpreters of the Beaux-Arts fashion that permeated American architecture, and that would continue to do so well into the last century. The style had originated in the highly theoretical *Académie royale d'architecture* (Royal Academy of Architecture) created by Jean-Baptiste Colbert for Louis XIV in 1671. By the mid-nineteenth century, and following the bloody interruption of the French Revolution, its functions had been taken over by the *École des Beaux-Arts* in Paris. Beaux-Arts products were eclectic, hybridized from Greek and Roman antiquity and the Renaissance and Baroque. Many American architects trained in the school.

Before about 1420, Western architecture had been simply architecture. There was no thought of "style." Any variations of appearance, construction, and form simply expressed regional and historical differences in ways of building. But on many grounds what is now known as the Italian High Renaissance had turned architecture into a *retrospective* art, preferring ancient Roman models and theories to contemporary, vernacular forms. An analogy can be seen in the rejection of the contemporary Latin language, then still being used by scholars, in favor of archaic, classical Latin. Within fewer than 400 years, under complex constraints and despite attempts to theoretically defend its

"truth," that Renaissance architecture was reduced to just one more alternative in the stylistic supermarket, competing with its own sometimes deformed offspring, or revived Greek forms, or revived medieval architecture, or even with the exotic forms of India and China. Until the European Modern movement matured in the early twentieth century, architectural design was what Walter Gropius called "applied archeology"—a choice from a range of historical styles, of which there were abundant examples to copy. As recently as 1950, architectural students in the United States, Britain, and Australia were asked by the studio masters who looked over their shoulders at a developing design, "What is your precedent?"

Several ideas have been put forward to explain the popularity that Greek revival (or Neo-Classical) architecture enjoyed in the United States from the early nineteenth century. Among them was empathy with Greece, then fighting its own war of independence with the Ottoman Turks; there was also the romantic belief that ancient Greek democracy was the same as American democracy; that misconception may have influenced the choice for the Lincoln Memorial of a loose version of the Doric style that had reached its zenith in ancient Athens.

THE LINCOLN MEMORIAL

The Lincoln Memorial is at the center of a landscaped circle, defined by a roadway, in the 107-acre West Potomac Park. In front of it, the National Mall with its axial Reflecting Pool extends eastward past the Washington Monument to the Capitol Building, almost 2 miles away; behind it, the Arlington Memorial Bridge connects the Mall with the National Cemetery in Arlington, Virginia.

The 204-foot by 134-foot rectangular building is raised on a podium. It has ashlar walls of white Colorado Yule marble within a 44-foot high "not-quite-Doric" peristyle, whose columns are carved from Indiana limestone. The entrance to the Memorial chamber—simply an interruption in the wall, without doors—is approached from the direction of the Reflecting Pool along a formal pavement of Massachusetts granite and stones from the Potomac River; the path incorporates shallow flights of stairs as it rises to the memorial. Bacon designed the associated landscape elements in collaboration with Frederick Olmsted, Jr., who by then had been appointed to the Commission of Fine Arts. The final approach to the podium is flanked by wing walls, each supporting a 9-foot high tripod and censer carved from a single block of pink Tennessee marble. On the eastern face of each wing wall the *fasces*, symbol of authority in the ancient Roman republic, are carved in low relief. They are almost the same as those on Lincoln's chair within the building. Ironically, just 5 months after the Memorial was dedicated, the Italian dictator Benito Mussolini chose the ancient Roman device (and its name) to symbolize his

despotic political party and later Nazi ally, the *Fascisti*. The flight to the podium has thirteen steps, representing the number of States originally in the Union.

Standing on a classical stylobate (a platform of three high steps), the encircling colonnade, or peristyle, has thirty-six columns, one for each State of the Union at the time of Lincoln's death. In the frieze of its entablature, the triglyphs that normally were centred above the columns in the Greek model are replaced by linked double wreaths of pine and laurel branches; the spaces between them, which in a Doric building would have been filled with brightly painted low-relief sculptures, are inscribed with the names of the thirty-six States and the respective dates of their admission to the Union. A row of finely carved anthemion ornaments crowns the entablature. Within the peristyle, the wall of the Memorial rises in an attic story. It has a frieze of eagles with spreading wings, linked by garlands and ribbons; the wall beneath that band of subdued decoration is inscribed with the names of the forty-eight States of the Union at the time of the Memorial's dedication. The external masonry details are the work of 19-year-old Evelyn Beatrice Longman, already recognized as a sculptor in her own right and then working as an assistant to Daniel Chester French, who created the famous portrait of Lincoln in the Memorial, and English-born Ernest Cecil Bairstow, a decorative stone-carver based in Washington.

The Memorial chamber is entered through a full-height opening, three bays wide and divided by two Doric columns. The interior walls are lined with Indiana limestone; the floor and skirting are of pink Tennessee marble. The space is comparted into three chambers by two rows of four Ionic columns carrying a modified entablature (the classical model had three setbacks, whereas Bacon's has four). Perhaps he employed the more slender Ionic order inside the building, as the ancient Greeks sometimes did, because it took up less space. The profile of the entablature continues around the chamber's perimeter, rather like a cornice. The ceiling, beneath three separate gabled skylights, is framed in cast bronze, ornamented with laurel and oak leaves and supporting panels of Alabama marble, made translucent by saturating it in paraffin.

AESTHETIC CONFUSION: MISUNDERSTANDING HISTORY

Bacon's architectural style and his precedent—if indeed there was one—call for comment. Some populist sources claim that the Lincoln Memorial is based on the Athenian Parthenon; others more tentatively describe it as a "Doric temple." Such speculation is uninformed and the claims are inaccurate.

The whole *raison d'être* of the classical Greek orders was just that: order. The Hellenes believed that their architecture—indeed, all forms of their art—was bound by piety to reflect what they perceived to be the immanent mathematical

harmony of the universe. Their three systems of building, each with its distinctive proportions, form, and detail, were based on that belief, although the quite diverse outcomes were colored by regional cultural differences. Historians have classified the systems as the Doric, Ionic, and Corinthian "orders." But it is reiterated, to those who made them, they were simply architecture. The Doric, resulting from translation into stone of much earlier timber construction techniques, developed over centuries on the mainland peninsula of Greece and in the western colonies. It reached the pinnacle of its refinement—that is, a satisfactory conclusion about the cosmic order—in the Parthenon at the middle of the fifth century B.C., and thereafter continued with little change for about 300 years.

One can repudiate the assertion that the Lincoln Memorial was modeled on the Parthenon, simply by observing that it had a *thirty*-six (8 by 12) column peristyle compared to the *forty*-six (8 by 17), of the ancient temple. However, a couple of tenuous links can be noted. First, Bacon used an Ionic order *inside* his building, as architects Iktinos and Kallikrates did in a minor secondary space of the Parthenon. Second, Bacon tilted the outer columns of the peristyle inwards to overcome visual distortion of the form; that optical trick was among many employed with infinitely greater subtlety in the Parthenon.

And the Memorial was in no sense a Doric temple, much less a replica of the Parthenon. Even the approach to it was "un-Greek." Greek temples did not stand on a podium, because their stylobates served to level their usually uneven sites; their entrances were invariably on the shorter sides; they had gable roofs with ridges parallel to their longer sides, whose form was expressed at each end by a triangular pediment. And—as Bacon should have known, because many Beaux-Arts drawings depicted them so—although constructed of white marble, they were painted and patterned with the brightest colors, luminous in the Aegean sunshine.

Frank Lloyd Wright is accused of having said, "The Lincoln Memorial is related to the toga and the civilization that wore it." Indeed, the building's axial relationship to the Mall, the grand scale of the whole ensemble, the podium, the flanking walls that defined the approach—even the censers— were derived from *Roman*, not Greek sources. Each Doric temple stood in its *temenos* or sacred yard, and every detail of its design encouraged worshipers to walk *around* it, looking up at it; its essence was not really discernible from a distance, and it was never approached along an axis. If there was a geometry involved in its siting and its relationship with its neighbors, it was, as Constantinos Doxiadis demonstrated, much more mystical and subtle than the straight-lines-and-no-nonsense dogma of the Romans and the American planners of the Mall.[4]

Moreover, such formal urban design was not even of the Roman republic, but of the empire. The Forum Julian, the first of the Roman Forums, was commenced as part of Julius Caesar's planned redevelopment of the city in 46 B.C. Caesar's nephew Octavian, who became the first Roman Emperor and

took the modest name Augustus ("the illustrious one") famously declared, "I found Rome a city of brick and left it a city of marble."

It is therefore more satisfactory to conclude that Bacon, like any Beaux-Arts architect, scoured antiquity for architectural elements to combine with those of his own invention to create a betwixt-and-between style. Although his passion for antiquity may have been born in the office of McKim, Mead, and White and nurtured by his travels in southern Europe, there can be little doubt that it was also informed by literature, including such archeologically obsessive books as Stuart and Revett's *The Antiquities of Athens,* published 1762–1830 and Charles Normand's *A New Parallel of the Orders of Architecture,* translated into English in 1829, as well as any number of architectural picture books.

As a reward for his Lincoln Memorial, in 1923 he was awarded the AIA's Gold Medal at a theatrical ceremony in Washington. While Marine Band trumpeters played Walter von Stolzig's "prize song" from Wagner's *Der Meistersinger von Nürnberg,* Institute members, resplendent in colorful regalia and bearing banners, paraded alongside the Reflecting Pool, on which architecture students towed a barge bearing Bacon, enthroned beneath a gold-painted sculpture of a boy holding a laurel wreath. Taft, then chief justice of the Supreme Court, met the architect at the Lincoln Memorial steps and presented him to President Warren Harding, who conferred the Medal.

"GETTING TO KNOW MR. LINCOLN"

The lofty interior of the Memorial is dominated by Daniel Chester French's gigantic portrait of the seated Abraham Lincoln. It is probably the feature that visitors best remember. Its sheer size is impressive enough, but its enigmatic expression makes it even more compelling.

Its New Hampshire-born creator grew up in Concord, Massachusetts, where at the age of 18, he began to study art with Abigail May Alcott. After a short apprenticeship with sculptor John Quincy Adams Ward in New York City, he moved to Boston to attend art anatomy lectures by British-born William Rimmer and take drawing lessons with the painter William Morris Hunt. In 1874, sponsored by Ralph Waldo Emerson, he completed his first major commission, *The Minute Man,* that was unveiled in Concord in April 1875. French by then had moved to Italy, where for 2 years he learned from Thomas Ball in Florence. On returning to America he opened a studio in Washington, D.C., where he established himself as a leading realist sculptor.

In 1910 he and Bacon had collaborated on a monument in the Capitol grounds of Lincoln, Nebraska, that incorporated a bronze standing figure of Abraham Lincoln. Early in 1915, soon after the foundation stone of the Lincoln Memorial was laid, Bacon engaged the 65-year-old French to produce the portrait sculpture that would stand within. French immediately began

work on clay maquettes. His research was very thorough; he worked from Matthew B. Brady's portrait photographs, casts of the late president's hands, and a life mask made in 1860 by the Chicago sculptor Leonard Wells Volk. By the end of October French had produced a model with which he was satisfied. When that "sketch" was approved, he made a larger clay working model. Altogether, he made (with his studio assistants) four models, gradually increasing the scale as he changed and refined the detail. The incline of Lincoln's head; the drape of his coat; the position of his feet, his open and closed hands, the height of the chair, and the drapery that covered it all were carefully considered and reconsidered.

At first it had been proposed to place a 10-foot high statue in the memorial's central chamber, but a drawing of French's "working model" by Jules Guérin quickly demonstrated how even that larger-than-life figure was far too small in proportion to the vast interior. When seen in the still-unfinished space, an 8-foot-high model that French took to Washington was quite insignificant. So to discover what would be an appropriate size, he set up enormous photographs—14 to 18 feet high—on timber frames. It finally was decided that the seated figure of Lincoln would need to be 19 feet high (that would make the standing president 28 feet tall), raised on an austere base, 11 feet above the floor. The translation of the sculptor's model into white Georgia marble was entrusted to the skillful hands of the Piccirilli brothers, who since 1890 had produced all but two of French's stone sculptures.

In 1887 Giuseppe Piccirilli, himself a successful sculptor and stone carver from Carrara, Italy—it might be said, "the marble capital of Europe"—had emigrated to New York with his family. His six sons (Feirrucio, Attilio, Furio, Masaniello, Orazio, and Getulio) were also trained marble carvers, and each in succession studied at the famous centuries-old *Accademia di San Luca* (Academy of Saint Luke) in Rome. When they first arrived in America, Giuseppe and the older boys worked at Samuel Adler's Monument and Granite Works, but they soon opened their own studio. In 1890, shortly after meeting French, they moved to The Bronx, where until 1945 they carved for many sculptors and produced myriad architectural details. The Piccirillis used 150 tons of marble in the twenty-eight blocks that make up the Lincoln statue. Of course, the final touches to the 9-year project, completed on November 19, 1919, were left to French.

Visitors see different things in Lincoln's face and posture. Some see wistfulness, others strength, and still others both. But almost all see the terrible strain of the years of war. Sociologist James Loewen writes,

> The sculpture . . . offers more than the triumphalism of its hieratic scale. Huge it is, if erect, the President would stand 28 feet tall. Lincoln is not standing, however, nor astride a horse, nor is his pose or facial expression victorious. French has not forced viewers to see Lincoln in any one way. As historian Merrill Peterson puts it, "what some see as triumph, other observers see as resignation; what some see as toughness, others see as tenderness."[5]

Some writers have speculated on the detail of the hands, one closed, but not really clenched, the other open—one representing strength and determination and the other compassion. Whatever the meaning, they are the large, gnarled hardworking hands of the Kentucky rail-splitter. And there is a tradition, perhaps apocryphal, that French, whose daughter Margaret was hearing impaired, carved the hands to sign the letters "A" and "L" in American sign language. Lincoln's hands rest upon the supports of the seat, which are carved in relief with a modified version of the ancient *fasces*—a symbol that originally comprised an axe within a bundle of rods, tied with a thong. The axe represented power, and the rods the citizens of the state, bound together in common interest. Lincoln's *fasces* have no axe.

French was in Europe when the statue was assembled *in situ*. On seeing it, he wrote, "I was very much relieved to see that it was not too large for its surroundings. I got into rather a panic about this for it didn't seem that a statue that large could fit into any place without being too colossal." But in 1921, as the building neared completion, he became alarmed at the way his work was lit. Changes to the skylights and reflection from the marble steps had combined to make the face expressionless. Others failed to recognize the problem until 1925, and nothing was done for the next 4 years to correct it by interior electric lighting. The outside of the Memorial was floodlit in summer 1929.

The novelist Beverly Lowry recorded her response to French's statue, encountered during an evening walk, in a piece titled "Getting to Know Mr. Lincoln" in *The New York Times* on May 14, 1995:

> I switched off my Walkman and stood there gawking, saying, "Look. Look at that," out loud and to nobody at all. The lights inside the memorial had gone on. There's a moment when, after that happens, the sky suddenly gets dark enough that the statue of Lincoln . . . slowly makes a ghostly appearance from between the columns. From where I stood, I saw it happen. Like a picture coming into focus, gradually he was there, seated and in deep contemplation. With the sky on fire behind him, it was as if the whole thing had been staged, a drama of night and time, history and splendor.

THE WRITING ON THE WALLS

High on the west wall of the chamber, flanked by low-relief pilasters and Ionic entablatures (manneristically turned on their ends), is incised the simple inscription composed in April 1919 by Royal Cortissoz, art critic for *The New York Herald Tribune*:

> In this temple
> As in the hearts of the people
> For whom he saved the union
> The memory of Abraham Lincoln
> Is enshrined forever.

The succinct statement that emphasized the salvation of the Union was considered "exactly right" by its author. All associated with the Memorial, including Chief Justice Taft, then chairman of the Lincoln Memorial Commission, agreed. Well, not quite all. In April 1922, about only a month before the dedication was to take place, Charles Moore of the Commission of Fine Arts objected to the text because he thought that the Memorial should be graced by Lincoln's words only. An urgent flurry of correspondence followed and within days, assured that Taft had approved the inscription 3 years earlier, Moore backed down.

But more was to come. Shown the words, President Warren G. Harding wanted what seems to be a pedantic change: "In this temple, as in the hearts of the people of the Union which he saved, the memory of Abraham Lincoln is enshrined forever." Offended, Cortissoz objected for artistic reasons, and on May 1 he wrote formally to Bacon, withdrawing the text unless it appeared as he had written it. Bacon approached Taft, arguing for Cortissoz's inscription on aesthetic grounds. The next day Harding "agreed to disagree," and the stone carvers were able to complete the art critic's words by May 30.

There seems to have been no such dissension about the other words that have been immortalized in the stone of the Memorial. The text of Lincoln's dedication of the Soldiers' National Cemetery in Gettysburg, spoken on November 19, 1863—perhaps his most famous utterance—is incised in a classical cartouche on the south wall of building. The version is from the so-called Bliss copy and ends, "the great task remaining before us [is] that this nation, under God, shall have a new birth of freedom—and that government of the people, by the people, for the people, shall not perish from the earth." Beyond the north colonnade a similar, but necessarily larger architectural device, frames Lincoln's second Inaugural Address, made on March 4, 1865, one month before the end of the Civil War. It sets out his policy for reforging the Union.

The texts, like Cortissoz's inscription, were executed by Longman and Bairstow. The surrounding frames are in the form of a low-relief pedestal supporting flat, capital-less pilasters flanked at their bases by a stylized eagles with spreading wings; they rise to a narrow moulded entablature. The form has no precedent in classical architecture, but once again its parts are of Roman, not Greek, derivation. If these architectural details were designed by Henry Bacon, or even approved by him, their use underlines the fact, already remarked, that the style of the Lincoln Memorial is an eclectic melange of pieces pilfered from history.

THE MURALS

Over each text, 37 feet above the floor, is a 60 foot long, 12 foot high mural, painted in oils by Jules Vallée Guérin. As Thomas has remarked, they are so

placed that they easily become a parenthetical aside glossed over by most visitors, and on an overcast day, even unseen by some.

Guérin was born in St. Louis, Missouri. He enrolled at the School of the Art Institute of Chicago in 1880, when only age 14, and later studied with Benjamin Constant and Jean Paul Laurens in Paris. Returning home, he worked as a book illustrator before making a considerable transition of scale to mural painting. Early in the last century he exhibited in national and international expositions, and in 1907 Burnham and Edward H. Bennett commissioned him to paint renderings of their proposed Chicago Plan. After that he frequently collaborated with them and their firm's successors. He also painted maps on the ceilings in McKim, Mead, and White's Pennsylvania Station, New York, in 1911.

In that year Bacon engaged him to assist with presentation drawings of his proposal for the Lincoln Memorial, and in 1912, when the design had been selected, the architect asked him to paint the murals. Probably late in 1916 Guérin began work in a purpose-built two-story penthouse studio on East 23rd Street, New York City, painting his formal compositions on two continuous canvases. Therefore they were not *strictly* murals. In 1919 the completed works were rolled on wooden drums, taken to Washington and lifted into place so that the canvas could be gradually unrolled and stuck to the limestone walls of the chamber. Each is surrounded by a flattish moulded frame, supported by tiny widely-spaced guttae.

The mural above the Gettysburg Address, titled *Emancipation*, depicts at its center the Angel of Truth freeing slaves. The other is titled *Unification*, and shows the Angel, again centrally placed, joining the hands of figures that represent the North and the South. Other groups of figures—forty-eight in all—complete the vivid compositions. The detailed allegorical interpretation of those figures we leave to others, although probably it was never self-evident. The paintings are saturated with color and glowing with large areas of gold, but the style is hardly appropriate in a Neo-Classical building, because it is very much of its time. Indeed, similarities with Guérin's mural in the Louisiana State Capitol lobby, painted 15 years later, suggest that it was his one-size-fits-all style, redolent of the formal symmetry of Byzantine imperial art but touched by what became known as the Art Deco. That the style is incongruous is not to detract from the beauty of the paintings, but only to remark that with their static figures they owed nothing to the dynamic decoration seen in the narrative works that adorned antique architecture. Perhaps there was a slight nod toward the tripartite compositions of Greek pediments, but only perhaps.

Although all were deservedly respected in their fields, it is remarkable that, in a nation of 94 million people, the artists behind the Lincoln Memorial were already intimately connected. First, there was Henry Bacon's link with McMillan Commissioner McKim. Daniel Chester French, sculptor of the figure of Lincoln, had collaborated with Bacon on several projects, including his own

house. French's apprentice Evelyn Beatrice Longman was separately engaged to carve architectural details. Royal Cortissoz, composer of the inscription, had been an office boy in McKim's when Bacon was working there also. Frederick Law Olmsted, Jr., who worked on the landscape design with Bacon, also had been a McMillan Commissioner. The muralist Jules Guérin had worked closely with McKim and a third commissioner, Daniel Burnham (he had also made presentation drawings of Bacon's proposals). The remaining McMillan commissioner, Augustus Saint-Gaudens, died in 1907, before the project was launched.

ICONIC SIGNIFICANCE: *THEN*, THE SALVATION OF THE UNION

The Lincoln Memorial was built to symbolize the salvation of the Union. When news of the great president's death and rumors of a conspiracy to assassinate other leaders reached Philadelphia on April 15, 1865, three Union Army officers resolved to form a body to protect the Union. In May, the Military Order of the Loyal Legion of the United States—it remains active today—was established. President Harding asked the Order, then led by Lieutenant-General Nelson Miles, to coordinate the dedication of the Lincoln Memorial on May 30, 1922. The government declared a national holiday. Besides the thirty-five hundred invited guests, forty-six thousand others attended the ceremony on that clear and sunny Tuesday, and amplifiers and radio broadcasts carried the proceedings even further.

Frances Parkinson Keyes wrote to a friend:

> There was no military parade, no floral display. There were more than five thousand [*sic*] in the reserved section on the platform: the diplomatic corps; the Senate and House of Representatives; the diplomatic and congressional ladies. . . ; General Pershing with his aides; members of the Grand Army of the Republic, and the United Confederate Veterans. In the center of the stage stood Chief Justice Taft. . ., with the President and Mrs. Harding, the Vice President and Mrs. Coolidge, and Mrs. Taft on one side of him, and Robert Todd Lincoln, eldest and only living son of the great President, and Representative Cannon of Illinois . . . on the other; the speakers for the day, and the other members of the commission occupying positions of honor.[6]

The Marine Band played *America*, followed by a prayer by Rev. Wallace Radcliffe, formerly of New York Avenue Presbyterian, Lincoln's church. General Pilcher, commander in chief of the Grand Army of the Republic, ordered the presentation of the flag and accepted the Memorial in the Army's name. The dedicatory prayer was offered by the chaplain in chief.

But not *all* the speakers occupied positions of honor. The keynote address was by African American Dr. Robert Russa Moton, principal of the Tuskegee Institute. Until he rose to speak he was obliged to stand apart from the white

guests, in an area roped off for "colored only" invitees, across the road by the Reflecting Pool. One author notes that he "achieved some decree of symbolic honor . . . by taking his reverent time in crossing the street when his time on the program was at hand." Dr. Moton's speech, as he wrote it, did not fit the political purpose of the Memorial's builders. Adam Fairclough writes that because he saw the Memorial as a "moral symbol of the African-American fight against discrimination" he "intended to deliver a passionate plea for racial justice." Bureaucrats censored it to remove any references to the ongoing troubles of African Americans, or criticism of the government. Moton had written, "My fellow citizens, in the great name which we honor here today, I say unto you this Memorial which we erect in token of our veneration is but a hollow mockery, a symbol of hypocrisy, unless we together can make real in our national life, in every state and in every section, the things for which he died."[7] When he concluded, he was escorted to the segregated seating. One writer observes, "It was an ugly reflection of the temper of the times" and another that "the Lincoln Memorial was built . . . in the midst of what has been called the 'nadir of American race relations,' an unlikely time to remember the Great Emancipator."

Toward the end of the ceremony, Edwin Markham read his poem, *Lincoln, the Man of the People*, written in 1900; selected from over two hundred other tributes, it lauded Lincoln for preserving the Union. Then came Taft's address on behalf of the Lincoln Memorial Commission. It contained not a single mention of slavery but underlined the importance of the Union. Finally, Harding's acceptance speech contained much about Lincoln's work for reunification but little of his role as liberator of the slaves.

The emphasis at the ceremony confirmed the symbolism deliberately set in stone. Even the texts chosen for the chamber played down references to slavery, avoiding offending the southern States. Indeed, when challenged that his inscription also neglected the issue, Cortissoz replied, "By saying nothing about slavery you avoid the rubbing of old sores." An anonymous writer for the National Park Service remarks that it is hardly surprising that "the predominately white, classically minded and university educated, upper-middle class generation [who] built the Lincoln Memorial would stress the theme of National Unity over that of Social Justice." Although that writer attributes such a mind-set to a reaction to post-1917 world events, it is clear that most of the design decisions predate them. Thomas' view, already noted, is much more credible: the Memorial was intended to "suggest the 'moral authority and fiscal sobriety of Republicanism.' "

Yet a symbol is not symbolic if it needs to be explained. Much of the iconography of the Memorial was reserved for an erudite elite; some of it was confused and even misinformed. A few examples demonstrate the point. Who, without being told, would recognize that the thirteen steps up to the podium represent the original states of the Union? Who would count or calculate, because the building is usually approached from the east, that there

are thirty-six columns in the peristyle, much less that they stand for as many states, unless the names of those states were inscribed between them? Who would grasp the significance of the *fasces*? Who would understand that the Doric order—or Bacon's version of it—was intended to represent democracy, or that it had been developed in ancient Athens, where democracy was believed—albeit erroneously—to have been the political system?

As an aside, it needs to be understood that at almost the same moment as Doric architecture reached its epitome, the historian Thucydides said of Athens: "It was in theory a democracy but in fact it became the rule of the first Athenian," and Herodotus used *aristoi* to describe Perikles, who financed the Parthenon. American political historian Steven Kreis correctly asserts that only seventy years later what began in 500 B.C. as a democracy became an aristocracy under Perikles.

Unlike the nation for which Lincoln longed, his memorial was not at first "for the people and of the people." But that was to be changed.

ICONIC SIGNIFICANCE: *NOW*, EQUAL RIGHTS FOR ALL

Jeffrey Meyer of the University of North Carolina has convincingly pointed out that the Lincoln Memorial is an icon whose meaning has changed, almost in spite of the intention of its creators and that change from "an emblem of the stabilization of the Union to one of emancipation and racial equality has been impelled by the pilgrims to Washington." Especially, two specific events changed the memorial's iconic meaning: the Marian Anderson Easter concert in 1939 and the civil rights March on Washington of August 1963. Later "pilgrimage" marches have reinforced the popular image of the Lincoln Memorial as an icon of racial equality and of defiance of social oppression.

In January 1939 the African American contralto Marian Anderson, already widely feted throughout Europe, accepted an invitation to give a fund-raising concert for Howard University's School of Music in Washington, D.C. Her previous performances there had attracted growing unsegregated audiences, so when planning an Easter Sunday concert—4 months ahead—university administrators applied for the use of the largest venue available: the four-thousand-seat Constitution Hall owned by the Daughters of the American Revolution (DAR). The DAR turned down the request, on the grounds that the hall was already booked by the National Symphony Orchestra.

That well may have been so; nevertheless, a clause in the DAR's contracts limited use of the building to "a concert by white artists only, and for no other purpose." Fred E. Hand, the booking manager who seems to have been initiated the policy as early as 1931, rejected Howard University's appeal for an exception to be made for such an illustrious performance. The DAR's hierarchy "promptly and explicitly" supported his decision. One source claims that alternate choices were offered, but impresario Sol Hurok had booked

Anderson's season so tightly that she was unable to accept another date. Given subsequent events, especially the reaction of First Lady Eleanor Roosevelt, the assertion seems specious. Although commented upon in the press in January, the incident came to the nation's notice at the end of February, when Mrs. Roosevelt resigned from the DAR in protest, and explained her reasons to four million readers in her syndicated newspaper column, *My Day*.

Incensed that Anderson had been so treated because she was "a singer of color," her Washington aficionados, black and white alike, formed the Marian Anderson Citizens' Committee to lobby for a suitable venue. The situation was exacerbated when the District Board of Education, on grounds of color, refused permission for use of the auditorium at the whites-only Central High School. Protests from across the nation forced a back-down, but the Board's reluctant agreement was encumbered by impossible stipulations. Walter White, executive secretary of the National Association for the Advancement of Colored People (NAACP), urged Harold L. Ickes, the secretary of the interior, to offer the steps of the Lincoln Memorial as the stage for the concert. Government combined with civil rights groups to involve over three hundred cosponsors from Congress, the judiciary, and scores of national organizations.

On April 9, Marian Anderson stood before the statue of Abraham Lincoln to sing to an integrated crowd of over seventy-five thousand—the largest gathering ever seen in Washington, D.C. Wearing a fur coat against the cold at 5 o'clock on that Sunday afternoon, and accompanied by Kosti Vehanen, she began her half-hour recital with *America*, followed by a Donizetti aria and Schubert's *Ave Maria*; after intermission she sang three spirituals, *Gospel Train, Trampin'*, and *My Soul Is Anchored in the Lord*. Mrs. Roosevelt and Ickes arranged for the concert to reach an estimated audience of six million through NBC's radio network. On the single sheet program were printed Lincoln's memorable words from Gettysburg, "Four score and seven years ago our fathers brought forth on this continent, a new nation, conceived in Liberty, and dedicated to the proposition that all men are created equal."

Reviewing Allan Keiler's *Marian Anderson: A Singer's Journey*, Terry Teachout wrote, "At no time was Anderson anything but a reluctant political activist. Likewise, the events leading up to her legendary performance at the Lincoln Memorial were in no way her doing." The review continued,

> All the players in this drama had agendas of their own. Hurok knew that such a concert would be of incalculable publicity value. Ickes hoped that blacks, who then voted Republican *en bloc*, could be induced . . . to support the Roosevelt administration. Anderson . . . disingenuously claimed that she knew nothing of the controversy until Eleanor Roosevelt resigned from the DAR, but in fact she was fully aware of what her manager had in mind, and by all accounts was terrified by it.[8]

The concert is commemorated in Mitchell Jamieson's 1943 mural, *An Incident in Contemporary American Life*, in the Department of the Interior

building in Washington. In that year, invited by the DAR, Marian Anderson made her first appearance in Constitution Hall. Cultural historian Scott Sandage remarked, "In one bold stroke, the Easter concert swept away the [Lincoln Memorial's] official dedication to the 'savior of the union' and made it a stronghold of racial justice." That dramatic change in the meaning of the icon would be greatly reinforced by another amazing event, 24 years later.

From the late 1950s and through the 1960s the United States experienced a burgeoning politico-social struggle by African Americans for human rights. On Wednesday August 28, 1963, over two hundred fifty thousand demonstrators, fifty thousand of them white, assembled from across the nation for the March on Washington for Jobs and Freedom. The event was proposed late in 1962 by 73-year-old Asa Philip Randolph, a veteran civil rights activist; initially, and for their own reasons, other civil rights leaders gave him little support. But in just 2 months, working with two hundred volunteers, Bayard Rustin (who had planned earlier demonstrations with Randolph) brought them together for the largest peaceful demonstration in U.S. history. This demonstration was in spite of opposition, resistance, and criticism from some politicians, the press, and reactionary organizations, and attempted undermining by the FBI.

Rallying at the Washington Monument, the vast, orderly crowd marched along the Mall to the Lincoln Memorial. On its steps, Marian Anderson again sang—this time the national anthem—to launch a 3-hour program. Interspersed by songs from Mahalia Jackson and the Eva Jessye Choir, the crowd was addressed in turn by Randolph and representatives of several civil rights organizations: the NAACP, the National Urban League, the Conference of Racial Equality, the Student Nonviolent Coordinating Committee, the American Federation of Labor/Congress for Industrial Organization. Also participating were prominent members of various religious bodies: the Catholic archbishop of Washington; the executive director, National Catholic Conference for Interracial Justice; the Presbyterian vice chairman of the Commission on Race Relations of the National Council of Churches of Christ in America; the president of the Synagogue Council of America; and the president of the American Jewish Congress.

The final speaker spoke for four times as long as the program allowed him. Rev. Martin Luther King, Jr. of the Southern Christian Leadership Conference delivered his eloquent and now world-famous "I have a dream" speech, beginning with an allusion to Lincoln: "*Five score years ago*, a great American, in whose symbolic shadow we stand today, signed the Emancipation Proclamation." And he concluded with the stirring words that struck chords in the hearts of his immediate audience, across the nation and then around the globe, words that echo still:

> When we allow freedom to ring . . . from every village and every hamlet, from
> every state and every city, we will be able to speed up that day when all God's

children, black men and white men, Jews and Gentiles, Protestants and Catholics, will be able to join hands and sing in the words of the old Negro spiritual: "Free at last! Free at last! Thank God Almighty, we are free at last!"

On August 22, 2003, Coretta Scott King and Judge Craig Manson, assistant secretary of the Interior for Fish, Wildlife and Parks, unveiled a stone tablet set in the approach to the Memorial, marking the exact spot from which King spoke.

It is fitting to end with apposite words from Scott Sandage, written in 2004 in support of saving the National Mall:

> Public uses alter the intended meanings of all monuments, and the Lincoln Memorial is our greatest example of this. Making it our national soapbox enhanced its symbolism. . . . Americans of all view-points have used this monument's platform to address supporters crowded down the narrow, center lane of the Mall. Where else did both the Rev. Billy Graham and the American Nazi George Lincoln Rockwell preach? The site has hosted demonstrations for abortion rights and fetal rights, evangelical services and gay pride events, rallies by Mothers Against Drunk Driving and by the National Organization for the Reform of Marijuana Laws.[9]
>
> Every president since Jimmy Carter has held an inaugural gala there, basking in a glow of freedom created by more than a hundred protests at the site after 1926. America is better today than it was seventy-five years ago, not only because one generation marched against Hitler, but because several generations have marched down the Mall to the Lincoln Memorial.[10]

Henry Bacon

Born in Watseka, Illinois, in November 1866, Henry Bacon (known as Harry) was one of seven children of government civil engineer Henry Bacon and his wife Elizabeth. In 1875 the family moved to Wilmington, North Carolina, and in 1884 Harry began to study architecture and engineering at the University of Illinois. After only a year he went to work as a drafter in the Boston architectural practice of Chamberlin and Whidden, before moving 3 years later to McKim, Mead, and White's New York City office.

In 1889 he was awarded the recently established Rotch Traveling Scholarship that enabled young American architects and talented draftsmen to undertake the professional equivalent of the Grand Tour to study art and architecture in Europe. He spent 2 years in the northern Mediterranean, mostly in Greece and Turkey, studying the remains of Classical architecture. Returning to the United States, he was again employed in McKim's firm, where he worked on the designs of Rhode Island State House (1891–1903), the World's Columbian Exposition, Chicago (1893), the Brooklyn Museum (1893), and the J. P. Morgan

Library (built 1902–1906). In 1897 he established a successful partnership, Brite and Bacon, with James Brite, another former employee of the famous New York firm, who took care of the business side of the practice.

From 1902 he conducted a sole practice and by 1910 had made a name for himself. Among his important works before the Lincoln Memorial were the Free Public Library, Paterson, New Jersey (1905); the Union Square Savings Bank, New York City (1905–1907); and the Eclectic Society Building, Middletown, Connecticut (ca. 1908). Those completed after 1911 include the General Hospital, Waterbury, Connecticut (ca. 1911), the Whittemore Memorial Bridge, Naugatuck, Connecticut (1912); the Court of the Four Seasons at the Panama-Pacific Exposition in San Francisco (1915); and the master plan and several buildings for Wesleyan University, Middletown, Connecticut (ca. 1916). He died in New York in 1924.

NOTES

1. *Report of the Senate Committee on the District of Columbia on the Improvement of the Park System of the District of Columbia. U. S. Senate Committee on the District of Columbia. Senate Report No. 166, 57th Congress, 1st Session.* Washington, D.C.: Government Printing Office, 1902.

2. Thomas Christopher A., *The Lincoln Memorial and American Life*. Princeton, N.J.: Princeton University Press, 2002, 64.

3. Whitney, Gleaves, "Abraham Lincoln Memorial." www.gvsu.edu/hauenstein/index.cfm?

4. As K. Graham Pont points out (www.nexusjournal.com/conferences/N2006-Pont.html), "In his doctoral thesis (1937), translated as 'Architectural Space in Ancient Greece' (1972), . . . Doxiadis argued that the apparently haphazard layout of Greek temple sites could be explained by a system of planning by 'polar coordinates'. From a fixed pole, usually at the ritual entrance, the planner could locate any building by measuring the distance to that building and the size of the angle between . . . sightlines from the viewer to the outer edges of that building."

5. Loewen, James, "The Sociology of Selected Monuments in Washington, DC, or Stories Behind the Stones." www.asanet.org/footnotes/apr00/stones.html

6. The description of the dedication ceremony is found in Francis Parkinson Keyes, *Letters from a Senator's Wife*. New York: London: D. Appleton and Co., 1924, 223 ff.

7. Fairclough, Adam, "Civil Rights and the Lincoln Memorial: The Censored Speeches of Robert R. Moton (1922) and John Lewis (1963)," *Journal of Negro History*, 82 (Autumn, 1997), 408–416.

8. Teachout, Terry, "The Soul of Marian Anderson," *Commentary* (April 2000).

9. Sandage, Scott A., "A Marble House Divided: The Lincoln Memorial, the Civil Rights Movement, and the Politics of Memory, 1939–1963," *Journal of American History*, 80(June 1993), 147.

10. *Idem.* Sandage, "Dead End for the Freedom Trail" (October 2007). www .savethemall.org/chron/dead_end.html

FURTHER READING

Brown, Glenn. *The Development of Washington with Special Reference to the Lincoln Memorial. Address by Glenn Brown, Secretary American Institute of Architects, before the Washington Chamber of Commerce, December 13, 1910.* Washington, D.C.: Chamber of Commerce, 1911.

Concklin, Edward F. *The Lincoln Memorial: Washington.* Washington, D.C.: U.S. Government Printing Office, 1927.

Dedication of the Lincoln Memorial, Washington, D.C., Decoration Day, MCMXXII. Washington, D.C.: Lincoln Memorial Commission, 1922 [brochure].

Fairclough, Adam. "Civil Rights and the Lincoln Memorial: The Censored Speeches of Robert R. Moton (1922) and John Lewis (1963)." *Journal of Negro History*, 2(Autumn 1997), 408–416.

Goldstein, Ernest. *The Statue Abraham Lincoln: A Masterpiece by Daniel Chester French.* Minneapolis, MN: Lerner, 1997.

Loewen, James. *Lies Across America: What Our Historic Sites Get Wrong.* New York: Simon & Schuster, 2000.

Morgan, H. Wayne. "An Epitaph for Mr. Lincoln." *American Heritage* (February-March 1987), 59–63.

Richman, Michael. *Daniel Chester French: An American Sculptor.* New York: Metropolitan Museum of Art, 1976.

Sandage, Scott A. "A Marble House Divided: The Lincoln Memorial, the Civil Rights Movement, and the Politics of Memory, 1939–1963." *Journal of American History*, 80(June 1993), 135–167.

Thomas, Christopher A. *The Lincoln Memorial and American Life.* Princeton, N.J.: Princeton University Press, 2002.

INTERNET SOURCES

Official Lincoln Memorial website. www.nps.gov/linc/

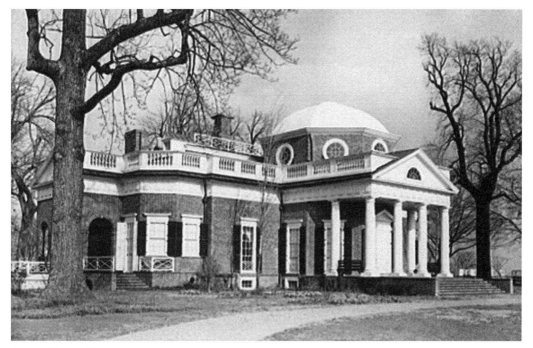

Monticello, Charlottesville, Virginia

Thomas Jefferson at home

On July 4, 1776, the Second Continental Congress adopted the Declaration of Independence, most of which was composed by Thomas Jefferson. Exactly 50 years later, shortly after noon Jefferson died in his bed at Monticello. He said in 1787, "I am happy no where else and in no other society, and all my wishes end, where I hope my days will end, at Monticello."

No American architectural icon is as self-evident as Monticello. That has been true for most of its existence. Following a visit in 1832, John H.B. Latrobe, son of the architect Benjamin Latrobe, wrote that although "the first thing that strikes you [at Monticello] is the utter ruin and desolation of everything . . . [when Jefferson's] spirit took its flight from it, there remained a halo lingering around it, which has made it a monument to his memory." He accurately prophesied, "As such it will be visited until the history of America shall cease to have an influence on the conduct of its people."[1] There were four hundred fifty thousand visitors to the house in 2006.

Like other buildings in this book, Monticello is an ambiguous icon. Semanticist Samuel Hayakawa's axiom, "Meanings are in people," applies also to nonverbal messages, including what places say to us. In 2003 African American Vesper Osborne wrote that though Monticello was "home—refuge—for Jefferson and the white family born of his flesh and blood," it was an invisible cage for the slave: "Monticello inspires and angers me, simultaneously. I am torn between the ideal of a free democracy and the reality of slavery. Monticello is majestic, elegant, but a symbol of the sweat and toil of my slave ancestors . . . Monticello you are magnificent. Monticello, you are a sorrow."[2]

Since 1938 an image of the house has been seen daily on five-cent coins—literally tens of billions of them—by all Americans, even children. In June 2002, when the U.S. Treasury proposed to celebrate the bicentennials of the Louisiana Purchase and the Lewis and Clark expedition with a new design for the nickel there was widespread complaint. Only 4 days after the Treasury announced its intention, Representative Eric Cantor, cosponsored by other Virginians, proposed "Keep Monticello on the Nickel" legislation, specifying that the coin must bear an image of Monticello; the draft also disallowed "the secretary of the Treasury's statutory discretion ever to change the design on the reverse of the coin." Cantor told the media, "The images of Thomas Jefferson and Monticello represent to America so much of what this nation is founded upon. I introduced the bill to make sure that our heritage as Americans and Virginians is accurately represented." Australian historian Jack Sexton suggests that the ultimate decision that Monticello would ultimately remain on the coin after a brief interruption—it was returned in 2006—indicates that Jefferson's former home remains one of America's "public places."

MORE THAN A RENAISSANCE MAN

Thomas Jefferson was born in April 1743 at Shadwell in Albemarle County, Virginia, the eldest son (and third of ten siblings) of Peter Jefferson, a surveyor,

cartographer, and planter and his wife Jane, who came from the powerful Virginian family, the Randolphs. Thomas Kindig writes,

> More than a mere renaissance man, Jefferson may actually have been a new kind of man. He was fluent in five languages and able to read two others. He wrote, over the course of his life, over sixteen thousand letters. He was acquainted with nearly every influential person in America, and a great many in Europe as well. He was a lawyer, agronomist, musician, scientist, philosopher, author, architect, inventor, and statesman. Though he never set foot outside of the American continent before adulthood, he acquired an education that rivaled the finest to be attained in Europe. He was clearly the foremost American son of the Enlightenment.[3]

Thomas Jefferson's earliest education—from the age of nine—was at a local school, where he was introduced to Greek, Latin, and French. After his father's death in 1757 he was sent to board at Reverend James Maury's School for Boys for 3 years; there, history and science were added to his classical studies. In March 1760 he enrolled at the College of William and Mary in Williamsburg and studied natural and moral philosophy. He is said to have been "a keen and diligent student [who] displayed an avid curiosity in all fields . . . and, according to family tradition, [who] frequently studied fifteen hours a day." There he was drawn into the erudite circle of Dr. William Small, who taught him mathematics and stimulated his interest in science. Through him, Jefferson, still in his teens, met George Wythe, a classical scholar and a "distinguished jurist," and following 2 years at the College, he studied law under Wythe for 5 years. One writer says that he claimed Wythe as "my earliest and best friend . . . [to whom] I am indebted for first impressions which have had the most salutary influence on the course of my life." In *Jefferson and his Time*, historian Dumas Malone identifies Jefferson's Williamsburg days as "the story of the . . . first flowering of an extraordinary mind."

In 1764 Jefferson inherited 2,750 acres of land from his father; 4 years later he started to level and clear the heavily wooded crest of a hillock (in Italian, *monticello*) 3 miles outside of Charlottesville in the foothills of Virginia's Blue Ridge Mountains, in order to build "the house of his dreams." Historian Marc Leepson writes, "Since childhood Jefferson had dreamed of building . . . on top of a nearby [860-foot] mountain—a radical idea at a time when most Virginia plantation homes were built in the low-lying, tobacco-growing Tidewater region." We shall return to the house later.

Passing his bar examinations in 1765, Jefferson practiced from 1767 until the Revolution led to the closure of the courts in 1774. For 6 years from 1769 he also represented Albemarle County in the Virginia House of Burgesses. On January 1, 1772, he married a young widow and heiress, Martha Wayles Skelton, of whom he once wrote, "In every scheme of happiness [she] is placed in the foreground of the picture as the principal figure. Take that away, and there is no picture for me." They were to have six children, only two of whom would survive childhood.

For several years Jefferson's attention was held by matters far weightier than architecture. In 1774 he drafted instructions (later published as *A Summary View of the Rights of British America*) for Virginia's delegates to the first Continental Congress in Philadelphia. The British regarded this attempt at reconciliation by the colonials' as nothing more than treason. The Revolution was looming. In March 1775 Jefferson was elected as a Virginian delegate to the second Congress, and a few months later he drafted "A Declaration of the Causes and Necessity for Taking Up Arms" and calculated the cost of going to war with Britain. Between October and December he served on several Congressional committees, then returned to Monticello. In June 1776 he led the committee of five that prepared the Declaration of Independence; he was its primary author. The committee (and subsequently the Congress) made several "stylistic and substantive" changes to it—Jefferson disagreed with many of them—before it was ordered to be printed on July 4. The first public reading of the Declaration took place in Philadelphia 4 days later.

In September 1776 Congress appointed Jefferson to represent the newly named United States abroad. Two weeks later he wrote to John Hancock, declining the post, mostly for family reasons: his wife and two of his children were very ill, he was homesick for Monticello, and he was anxious about the development of a new government for the State of Virginia. Returning there, he served for 3 years in its House of Delegates and in the face of vehement conservative resistance introduced bills to liberalize the state's laws. He campaigned for the abolition of laws of entail and primogeniture because he wanted to remove what he called the "aristocratic, feudal, and unnatural yoke of inherited distinctions." He prevailed and the archaic legislation was abolished in 1785. He proposed a bill for the General Diffusion of Knowledge that involved establishing a public school system, another for the expansion of suffrage, and another for reformation of the criminal code that finally became law in 1796. And most importantly, toward the end of his tenure he proposed legislation "that all men shall be free to profess, and by argument to maintain, their opinions on matters of religion, and that the same shall in no wise diminish, enlarge, or affect their civil capacities"; that provoked an ongoing dispute but eventually was enacted in January 1786.

In June 1779, Jefferson succeeded Patrick Henry as governor of Virginia for a one-year term; he was reelected in 1780. In January the treacherous Benedict Arnold led a British invasion of Virginia, putting Richmond to the torch and forcing the government to flee. Jefferson's political enemies accused him of inadequately protecting the city, and of "pusillanimous conduct," but a subsequent inquiry, at which he presented a 3-day defense, exonerated him and—on the contrary—unanimously commended his performance as governor. In June 1781 he retired from the governorship, just at the moment that a detachment from Cornwallis' army attacked Monticello. Thanks to the actions of one Captain Jack Jouett of the Virginia militia, Jefferson and his family escaped capture. Apart from stealing some wine, the British left the

property unharmed. Cornwallis continued to Yorktown, where in October George Washington trapped the British army and forced its surrender.

Martha Jefferson died at the age of 33 on September 6, 1782; the grief-stricken Jefferson refused to leave his room for 3 weeks, and it was several months before he "emerg[ed] from the stupor of mind which had rendered [him] as dead to the world as [she] was whose . . . loss occasioned it." He never remarried.

Toward the end of 1782 Congress appointed Jefferson to join John Adams, Benjamin Franklin, and Henry Laurens to negotiate for peace with Britain, and 2 days after Christmas he arrived in Philadelphia en route to France. But bad weather delayed the sailing, and he had second thoughts and declined the post. When Congress again offered him the appointment he accepted, but "the matter was so far resolved before he could sail" that his appointment was withdrawn in April 1783. Two months later he was elected as a Virginian delegate to Congress, where he made farsighted contributions. In April 1784 he submitted recommendations that led a few years later to the adoption of the dollar as U.S. currency. He also originated the Ordinance of 1784, the "first definitely formulated plan for the government of the western territories"; Congress adopted it except for its provision that after 1800 slavery should be excluded from the territories. In the event, the Land Ordinance of 1785 superseded his proposal before it had time to become effective.

Jefferson lived abroad from 1784 to 1789. Originally sent to Paris to help Adams and Franklin negotiate trade agreements, he succeeded Franklin as minister to France in May 1785. One writer notes that he took the opportunity to "avidly study European culture, sending home to Monticello, books, seeds and plants, statues and architectural drawings, scientific instruments, and information." Returning home in September 1789, he discovered that Congress had confirmed his appointment as secretary of state in George Washington's administration—a role that he reluctantly accepted at the President's insistence.

Jefferson was alarmed by the "regal forms and ceremonies" attached to the new presidency; his views are outlined in the essay on the White House, elsewhere in this book. Being pro-French and sympathizing with the French Revolution— he believed that its "excesses would end at some point, and a republic would rise out of the chaos"—Jefferson suspected that the pro-British Secretary of the Treasury Alexander Hamilton and other conservatives were conspiring to invest the new government with "monarchist characteristics." Two parties began to form and incipient political conflict developed. Gradually he assumed leadership of the Democratic-Republicans (not the same as modern Republicans), championing states' rights and opposing strong centralized government. As Washington was flattered by the Federalists and agreed with their views, Jefferson, marginalized within the cabinet, grew less comfortable in his position until, at the end of 1793, after twice being dissuaded, he finally resigned and retired to Monticello, devoting himself to his family and his farm.

Pleased that Washington did not offer himself for a third presidential term in 1796, Jefferson accepted the Democratic-Republican party nomination. Although he was narrowly defeated by the Federalist John Adams, because of a constitutional anomaly he became vice president. Four years later he defeated Adams to become the third president of the United States. Among the major achievements of his first term were the Louisiana Purchase of 1803 and the Lewis and Clark transcontinental expedition of the following year. There was no constitutional provision to do so, but Jefferson "suppressed his qualms in order to take over the vast new [Louisiana] territory"—an action met with "popular enthusiasm." The American people approved his other frugal policies: he reduced taxes, slashed military budgets, and reduced the national debt by one-third. He also declared the Alien and Sedition Acts—antique versions of the twenty-first century USA Patriot Act—to be unconstitutional, believing that they forced Americans to be "willing instruments in forging chains for themselves." He also sent naval vessels to join the Swedish and Danish fleets, effectively declaring war on the Barbary pirates, who preyed on American merchant shipping in the western Mediterranean from Tunis, Tripoli, Algiers, and Morocco.

Jefferson's second presidential term was checkered. In 1806 the disaffected former Vice President Aaron Burr, already a fugitive because he had mortally wounded Alexander Hamilton in a duel, conspired with a few others to create some form of independent southwestern empire (which of course he would lead), based on the division of the Union and even the conquest of Mexico. Exactly what his plans were and whether they were disloyal remains uncertain, but Jefferson had him arrested and tried for treason in August 1807; he was acquitted.

Jefferson was anxious to keep America out of the Napoleonic wars. Intended to secure "British and French recognition of American rights," his Embargo Acts (1806–1808) "[put] a halt to all trading with any country in the entire world [and served] as a retaliatory measure to the increasingly coercive trade policies of the British and the French." The U.S. economy suffered as a result, and of course there was an internal reaction, especially from the New England states. Jefferson signed the repealing legislation 3 days before the end of his presidency.

In March 1807, at Jefferson's request and reprising his Ordinance of 1784, Congress legislated against slave trading in any place under the United States' control, to come into effect on January 1, 1808. Although himself a slaveowner—he called them "servants"— Jefferson believed that slavery was an evil that should not be permitted to spread. He set only five of his own slaves at liberty, because toward the end of his life everything he owned, including most of his "servants," was mortgaged to his creditors, and they were not really his to free.

In 1809 he retired to Monticello, where he remained for the rest of his life. In those 17 years his major accomplishment was the founding in 1819 of the

University of Virginia at Charlottesville. He conceived it, planned it, secured its site, led the legislative campaign for its charter, designed its buildings, planned its curriculum, supervised its construction and the hiring of faculty, and served as the first rector. He wished to be remembered for just three things, and "not a word more"; so his epitaph reads, "Here was buried Thomas Jefferson Author of the Declaration of American Independence, of the Statute of Virginia for Religious Freedom and Father of the University of Virginia."

Although many writers have much more thoroughly and competently set out and analyzed Jefferson's worldview, it has been necessary to include here this simplistic overview, because his beliefs inevitably extended to his architectural philosophy, and especially to what he called his "essay in architecture," Monticello. As someone has said, "Jefferson's architecture is an integral part of his views of man, society, and the infinite possibilities offered by the new nation."[4]

BUILDING MONTICELLO: THOMAS JEFFERSON AS ARCHITECT

Jefferson noticed the buildings of Virginia (especially of Williamsburg) and formed opinions about them. In *Notes on the State of Virginia* (1782) he complained that "private buildings [were] very rarely constructed of stone or brick ... it is impossible to devise things more ugly, uncomfortable, and happily more perishable" and that their plans demonstrated little originality. He lamented, "The genius of architecture seems to have shed its maledictions over this land. ... The first principles of the art are unknown, and there exists scarcely a model among us sufficiently chaste to give an idea of them," he remarked that Williamsburg's only public buildings worth mentioning were "the Capitol, the Palace, the College, and the Hospital for Lunatics." Even then, although the Capitol was "tolerably just in its proportions and ornaments," he wrote,

> The [exterior of the] Palace is not handsome. ... The College and Hospital are rude, misshapen piles, which, but that they have roofs, would be taken for brickkilns. There are no other public buildings but churches and court-houses, in which no attempts are made at elegance.[5]

Architectural historian Fiske Kimball wrote that as an "inveterate reader, [Jefferson may be] supposed to have picked up from books some general smattering of artistic knowledge even before his attention was forcibly directed to architecture." He suggested that although Jefferson "was thoroughly familiar with Virginia and had been in 1776 to Annapolis, Philadelphia, and New York, we get no hint ... that it was the buildings he himself had seen that attracted his attention to architecture," and that he probably made no special study of the art until he thought about building at Monticello. Kimball added,

"There can be little question that he derived his first interest from the conversation of Dr. Small [and his circle] . . . while yet a student."[6]

Around 1762 Jefferson purchased his first book on architecture, most likely Giacomo Leoni's translation of Palladio's *I quattro libri dell' architettura* (*The Four Books of Architecture*). Seeing Palladio's work and reading his theories that were then enjoying revived fashionability in Britain introduced the young Jefferson—he was not yet 20—to an ordered architecture, based upon mathematical immutabilities. In the contemporary literature he discovered what he came to believe was the essence of architecture: the classical orders. What was the wellspring of this idea?

From the early seventeenth century the Italian architect Andrea di Pietro della Gondola, known as Palladio, had unparalleled influence on European architecture. Based upon his meticulous archeological observations of ancient Roman architecture and a study of two Latin treatises—Marcus Vitruvius Pollio's *De architectura* (*About Architecture*) of around 45 B.C. and Leon Battista Alberti's *De re aedificatoria* (*Of Things Relating to Building*), published in 1485—Palladio wrote a book of his own. In 1570 he published in Venice *I quattro libri,* enunciating his theories, giving practical advice to builders and (perhaps most importantly) including an abundance of woodcuts; the images included measured drawings of ancient buildings, as well as other illustrations that were (in effect) advertisements of his own works. *I quattro libri* was intended to demonstrate how principles of engineering, planning, construction, and decoration from classical antiquity could enhance public and private modern buildings. Moreover, the work was accessible at first to a wider Italian audience, as well as visitors to Italy, because it was written, not in classical Latin but in the vernacular. Soon translated into several languages in many editions, *I quattro libri* would dominate architectural studies until well into the nineteenth century.

Inigo Jones, originally a theatrical designer, has been credited with single-handedly introducing Palladian theories to the English-speaking world. As well as visiting many of Palladio's buildings, mostly near Venice, Jones acquired a copy of *I quattro libri* and made a serious study of it. His marginal annotations demonstrate an intellectual grasp of the theory of classical Roman architecture. In 1613 Jones, who had worked as a designer for Anne of Denmark, the wife of James I, was appointed surveyor of the King's Works. *Before* Jones, "the Italian style" had simply involved the ill-informed surface encrustation of English buildings with what was supposed to be renaissance detail—as a contemporary Italian proverb had it, "An Englishman Italianate is a devil incarnate." *After* Jones had elegantly interpreted Palladian theory in such buildings as the Queen's House, Greenwich (1616–1635), the Banqueting House at Whitehall (1619–1622), and the Queen's Chapel at St. James Palace (1623), the English way of building stood at the brink of change. But the new architecture was strangled at birth because of its political association with the Stuart dynasty.

After James I's successor Charles I was beheaded in 1649 (ironically, just outside the Banqueting House that Jones had built for the House of Stuart) England, following civil war, became a republican Commonwealth under the Lord Protector Oliver Cromwell. With the restoration of the monarchy in 1660, Charles II returned to London from France, overawed by his experience of baroque opulence of the court of France's young Sun King. The restrained order, clarity, and symmetry of Palladian architecture was not pretentious enough for Charles II's sycophantic nobility, who preferred the weighty grandeur of Wren, Vanbrugh, and Hawksmoor. So it was put in abeyance and remained unfashionable until well into the eighteenth century, when the politically ascendant Whigs, rejecting Restoration extravagance, returned to a more rational and less complicated architectural style.

In the 4 years from 1716 the architect Giacomo Leoni, newly arrived from Venice, published English translations of Palladio. In 1715 the Scots lawyer-turned-architect Colen Campbell—called by some "the first important practitioner of the new and more literal English Palladianism"—began to publish his influential, profusely illustrated *Vitruvius Britannicus*, which both established neo-Palladianism as the national style and (with typically British jingoism) anointed Inigo Jones as the "British Vitruvius"; two more volumes followed in 1717 and 1725.

From about 1710 many English architects produced Palladian buildings. Notable among them was the wealthy dilettante Richard Boyle, third Earl of Burlington, who designed Chiswick House (1725–1729) as a "reinterpretation" of Palladio's Villa Capra. Some writers connect it with Monticello. In 1730 Burlington published *Fabbriche Antiche disegnate da Andrea Palladio*, a collection of Palladio's measured drawings of ancient Roman buildings, which he had acquired while traveling in Italy a decade or so earlier. The following year the acerbic Alexander Pope had written a poem *An Epistle to the Right Honourable Richard, Earl of Burlington*, warning his friend that "the efforts of men of taste . . . are doomed to failure if the undiscriminating and vulgar are free to misinterpret and pervert the values they have to impart: Yet shall (my Lord), your just, your noble rules/ Fill half the land with imitating fools;/Who random drawings from your sheets shall take,/And of one beauty many blunders make. . . ."

The publication of drawings has been stressed in this discussion for good reason. Despite an abundance of theoretical volumes, mere Palladian copyists inevitably flourished. As has happened with many architectural movements down the centuries, most architects were interested in fashion, not philosophy, and were unwilling to explore the ideas that underlay Palladio's work, and even with the best of them, Palladianism "tended to become a sterile academic formula." Lesser architects and amateurs depended largely upon "pattern books"—collections of standard designs for all kinds of buildings; it is much easier to "read the pictures," so to speak, that to digest a theory and apply its principles. Through literature, England's Palladianism inevitably

extended to her colonies, as well as to France, Germany, and back to Italy—it even reached Russia, Sweden, and Poland.

Thomas Jefferson was not among the imitating fools. He owned two versions of Leoni's translation of Palladio, one with Jones' notes and one in English, French, and Italian. He also owned Roland Fréart de Chambray's French translation of 1650. He once referred to *The Four Books* as his "bible." By 1783 his library included, among many other seminal architectural treatises, James Gibbs' *Rules for Drawing the Several Parts of Architecture*, of 1732 and Claude Perrault's French translation of Vitruvius. Following a 1782 visit to the not-quite-completed house, the French soldier François Jean de Chastellux wrote that Monticello "resembles none of the other [houses] seen in this country," acknowledging that Jefferson was the first American who had "consulted the fine arts to know how he should shelter himself from the weather."

Kimball believed that even with the first version of Monticello, despite "direct inspiration from Palladian principles [Jefferson] made notable contributions to Virginian, and even to American, architecture." In so doing, he achieved more than

> any of his isolated predecessors, while at the same time his following of [Palladian] models was little more slavish than that of academic Europe generally, and involves no negation of his essential originality. . . . It was the academic correctness and superior convenience of Monticello . . . which drew the attention of foreign visitors to this house, and caused them to praise it above all others in America.

Kimball added that though contemporary American architects found their designs in the ordinary pattern books, "Jefferson had been drinking nearer the fountain head."[7]

MONTICELLO MARK I, 1768–1784

In the second half of 1768, Jefferson began leveling the hilltop at Monticello and building access paths on its slopes. On February 1, 1770, fire destroyed the Shadwell plantation house, his birthplace 2 miles away across the Rivanna River. A year later he wrote to his friend James Ogilvie that he had recently moved to Monticello, where he had begun building his house—only a single room that served the purpose of parlor, kitchen, hall, bedroom, and study. Although he intended to enlarge it in the following summer, for various reasons progress was slow. That original multipurpose room—the pavilion at the end of the south terrace—was incorporated in the final design. And it was to it, then still the only habitable part of the house, that he brought his bride at the end of January 1772.

Later that year the dining room was the first part of the main pavilion to be made liveable. The order of subsequent progress is now uncertain, but it seems that by 1774 (or at the latest, 1775) the first house was "primarily finished." The National Park Service (NPS) provides a peremptory description: "constructed of brick with cut-stone trim, it consisted of a central two-story unit, with pedimented gable roof running from front to rear and one-story gabled wings, set perpendicularly to the central block." To that may be added, that the portico design the employed grammatically correct superimposed orders: Doric at the first story supported Ionic above. The axially planned ground floor had a central parlor; to its north was the dining room and a room with an octagonal bow; to its south a bedroom and dressing room. On the second floor, the library above the parlor was flanked by two more bedrooms. No description, no matter how florid and detailed, much less one so pragmatic as this, can convey how Jefferson, with sketch after sketch and study after study, assiduously experimented with proportion, balance, and harmony to produce plans and elevations that aesthetically satisfied him. Those who have examined his finished delineations and preliminary sketches are convinced that "Jefferson resolved his problems on the drawing board. His uncanny draftsmanship provided him with the invaluable power to visualize and resolve the problems of spatial relationships."[8]

When Jefferson left to take up his diplomatic posting in Paris in summer 1784, it is likely that, except for porticos and interior finishes, the house was almost completed.

MONTICELLO MARK II, 1796–1809

Jefferson's time in France between 1784 and 1789 deeply affected his thinking about architecture. First, he had the chance to study French and Roman architecture at firsthand—without a Palladian filter, so to speak. Second, given impetus by a growing interest in classical archeology—Greek as well as Roman—France was then undergoing a change of ideas and taste that gave vogue to a new view of antiquity. Neo-Classicism, which pervaded the country's architecture until the Revolution, was attempting to reformulate classical artistic theories for contemporary application. Jefferson was "violently smitten" by Pierre Rousseau's Hôtel de Salm of 1784 in particular, and some historians suggest that it was the precedent for the west front of the second Monticello. Then, as William L. Beiswanger points out, Jefferson personally "experienced a new level of refinement in domestic architecture." The elegant Hôtel de Langeac on the Champs-Elysées, in which he lived for most his time in Paris, was planned, not as a formal exercise in proportion but as a house to be lived in, whose rooms were suited to their purpose, whether for entertaining or "private and intimate spaces that greatly enhanced comfort and convenience." The French idea of *appartements* certainly gave Jefferson pause for architectural thought.

Asserting that Paris was the "culmination of . . . Jefferson's education in architecture," Giordano explains that "his strict adherence to the allusion to ancient Rome and his knowledge of the classics," together with his European experiences, "provided the 'spark' that transformed him from the mere gentleman architect of his early years into a vigorous leader of the neo-classical movement in America. The Thomas Jefferson who sailed home in 1789 was a true architect."[9]

Jefferson began to envision changes to his hilltop house as early as 1784, and its transformation was commenced in 1796. Only the upper floors and northeast front of the original house were demolished; much of the ground floor brickwork on its southwest side was integrated into the new building. On completion, the remodelled Monticello was much larger—11,000 square feet—with thirty-three rooms, over three floors and a basement; there were four more rooms in the pavilions, six under the South Terrace, and a stable and carriage bays under the North Terrace. The following excerpts from the *World Heritage List Nomination* provide a pragmatic description of how the spaces in the house were disposed and used. But of course they totally fail to convey the elegance of Jefferson's mansion. Then, words must fail; Monticello is better conveyed by images, and best through personally experiencing it.

> The house is of red brick and white wood trim. . . . The northeast facade features the central main entrance portico, marked by a triangular pediment supported by four Doric columns. It is flanked by two bays of windows. At the first floor are long windows; at the second floor, are short windows at the floor level. The third floor rooms in the center of the building and are lighted with skylights. . . . The southwest façade is crowned with an irregular octagonal dome above a projecting portico with four Doric columns running across the front and two columns at the sides. A circular window is located on each side of the drum of the dome, except for a semi-circular window above the pediment. . . . For the major rooms, Jefferson selected designs for cornices and friezes derived from classical Roman buildings as published in architectural books. The upper floors are reached through two small stairways. On the second floor are five bedrooms. On the third floor are three additional bedrooms and a large dome room.
>
> The main floor was connected with the second and third floors by steep, narrow stairs. The bedrooms on the upper floors were tucked under the eaves, with windows at floor level. At the top of the house, above the principal room to the west, Jefferson placed the dome, the first to be built on any American house. . . . The entrance hall, located at the east end of the building served as a reception room and a museum. From the entrance hall, visitors most often moved toward the west, into the parlor, the most formal room in the house. The southern section of the main floor consisted of Jefferson's private rooms: the bedroom, study, library, and sitting room. The northern section contained the dining room, tea room, and two small bedrooms. The second floor contained five small bedrooms. Three additional bedrooms and the dome room were located on the third floor.

A unique aspect was Jefferson's incorporation of the "dependencies"—kitchen, pantries, laundry, slave quarters, stores, and stables—beneath L-shaped terraces extending from either side of the house and connected through the basement. At the end of each wing stood a square brick pavilion, with living space on the upper level and work space in the lower. As noted, the South Pavilion was the first structure completed on the mountaintop around 1769; the North Pavilion was built some 30 years later.

As much as possible of the *materiel* and labor was local. As was customary, the bricks were burnt on site. The nails for the house were made in the nail factory Jefferson had established to supplement his income from agriculture. Most of the structural timber came from his own land (only a fifth of which was under cultivation in 1796), as did the stone for the cellars and columns, and the limestone for mortar. Window glass was imported from Europe. Local white masons executed the brick- and stonework, while local carpenters, assisted by Monticello slaves, were responsible for the structural framing. But Jefferson imported highly skilled joiners to finish the interiors. John Neilson of Philadelphia worked there from 1805 to 1809, and James Dinsmore, also from Philadelphia, was on site from 1798, creating decorative wall moldings, floors, and some window sashes; others of imported mahogany were made in Philadelphia. Dinsmore trained an assistant, Monticello slave John Hemmings, who completed the work with other obviously very competent black artisans when the Irishman left in 1809 to build Montpelier, the home of then-President James Madison.

The exiled Duc de la Rochefoucauld-Liancourt, who visited Jefferson just as remodelling began, wrote that Monticello, "according to its first plan, was infinitely superior to all other houses in America in point of taste and convenience." He was even more enthusiastic about the proposed revisions, then, of course, they *were* French-inspired: "[Mr. Jefferson's] travels in Europe have supplied him with models; he has appropriated them to his design; and his new plan . . . will certainly deserve to be ranked with the most pleasant mansions in France and England."

By 1809, the house was completed; apart from maintenance works, which over the years moved further and further beyond his budget, no more changes would be made in Jefferson's lifetime. He had worked on altering, enlarging, and refining Monticello for over 40 years, reflecting (as someone has said) the pleasure he found in "putting up and pulling down." Beiswanger writes,

What Jefferson created . . . was unlike any other house in the United States, and not just because it was the first house in this country to have a dome. It was unusual in both plan and elevation. Jefferson himself acknowledged that it ranked "among the curiosities of the neighborhood. . . . " It is true that Monticello lacks the purity and geometric simplicity of Jefferson's other buildings. By contrast, [it] showed all the signs of a modified and evolving plan.[10]

The house's final form was born from Jefferson's studies of architecture in Europe and his inventive "adaptation of this knowledge to the requirements of living." As he wrote to Benjamin Latrobe in October 1809, "My essay in Architecture has been so much subordinated to the law of convenience, and affected also by the circumstance of change in the original design, that it is liable to some unfavorable and just criticisms."[11] Indeed, 30 years later an editorial in the *Niles National Register* denigrated Monticello as "a monument of ingenious extravagance . . . without unity or uniformity, upon which architecture seem [s] to have exerted, if not exhausted, the versatility of her genius," and accused Jefferson of having "no distinct conception of any design when he commenced building, but enlarged, added and modified as his ingenuity contrived, until this incomprehensible pile reached this acme of its destiny in which it stands at present, still indeed unfinished." So Jefferson had been right to expect criticism; whether such gratuitous comment was justified is another question.

Certainly, few since have agreed with it. Historian Howard Adams wrote, "As the work of a romantic, even radical idealist, Jefferson's . . . Monticello, can best be understood within the framework of [the] social and political ambitions that shaped [his] hopes and dreams for the new nation. . . . In its design, history, symbolism, and metaphor, Monticello is the quintessential example of the autobiographical house." Monticello was placed on UNESCO's World Heritage List in 1987 in response to an application that read in part:

> [Jefferson's] architectural works were an integral part of the neoclassical movement, but adapted to the convenience, ideals, and requirements of the new nation. [His] use of Roman classical forms initially was inspired by a love of classical language, philosophy and arts gained through books. [Desiring] to raise American architecture to a level comparable to European architecture, [he] joined in the Neoclassical spirit as no other American did before him. . . . Monticello was not a typical residence of the period. It was unique because it represented a reconciliation of classical orders and forms, on the one hand, and the informal way in which Jefferson chose to live, on the other.[12]

Jefferson also showed a "scrupulous" interest in agriculture, horticulture, garden design, and landscaping, developing the property at the center of a 5,000-acre plantation of corn, tobacco, wheat, and other crops between 1807 and 1815. In 1806 he set aside 18 acres on the northwestern side of Monticello as the "grove," an ornamental forest "of the largest trees trimmed very high" to give it the appearance of open ground cleared of undergrowth and "broken by clumps of thicket, as the open grounds of the English are broken by clumps of trees." Reflecting Lancelot "Capability," Brown's carefully devised romantic English landscapes of 50 years earlier, it also included a planting of ornamental trees in an open area next to the West Lawn.

The house was encircled by a series of roads or "roundabouts." Shade, flowering, and ornamental trees were planted between the inner and outer

roundabouts. Close to the house on the west, Jefferson planned an "extensive scheme" of flower beds, where at least 105 species were grown; in fact, as well as plants from other sources; each year he imported up to seven hundred varieties of seeds from the *Jardin des Plantes* in Paris. Beyond the flowers there was a *ferme ornée* (literally, "ornamented farm"), another nod toward English bucolic romanticism. A 1,000-foot-long street known as Mulberry Row (because of the trees that defined it) was set out to the south of the house; it was lined with log dwellings for slaves, a stone house that originally had been provided for building craftsmen, joinery and ironworking shops, a nail factory, a smokehouse, a dairy, a wash house, storehouses, and a stable.

Jefferson wrote in 1819, "I have lived temperately, eating little animal food, and that as a condiment for the vegetables which constitute my principal diet." Beginning in 1770 his kitchen gardens evolved on a slope below Mulberry Row. For years the crops were grown along the contours, but in 1806 the hillside was modified into a 1,000-foot-long, 80-foot-wide terrace, retained by a stone wall that stood over 12 feet at its highest point. Economic gardening reached its peak by 1812, with two hundred fifty varieties of over seventy species of vegetables. Below the retaining wall, some time before 1814 Jefferson planted more than one thousand fruit trees in the South Orchard that formed three sides of a berry square as well as two vineyards. Together, they yielded one hundred fifty varieties of thirty-one fruit species. To exclude foraging animals, the gardens and orchards were surrounded by a 10-foot high fence of wooden palings. Monticello became America's first National Horticultural Landmark in 1998.

FROM "ESSAY IN ARCHITECTURE" TO NATIONAL SHRINE

When Jefferson died Monticello was inherited by his eldest daughter, Martha Jefferson Randolph, the only of his six children to survive him. But even then, the house had sunk into disrepair. The cash-strapped Jefferson had not been able to find money for repairs or even carry out routine preventive maintenance. Left with debts of more than $107,000, in January 1827 Martha and her son Thomas began to sell off her father's chattels—everything except the house and land, including furniture and furnishings, livestock, supplies, and agricultural equipment and, of course, his slaves. Part of his art collection was given to relatives; part was sent to Boston in July 1828 to be sold. In summer 1828 the Jefferson family left Monticello and the property, too, was put on the market.

But it was not until November 1831 that James Turner Barclay, a "learned, if eccentric, many-faceted" apothecary of Staunton, Virginia, paid $7,000 for the house and 522 acres. Martha Randolph described him a "madman," responsible for Monticello's despoliation, although some writers insist that the portrayal of Barclay "as a Jefferson-hating eccentric who bargained

ruthlessly with the land-rich, cash-poor Randolphs" may not be accurate. It has been said that at Monticello he launched a "crackpot scheme to grow silkworms" and replaced Jefferson's careful landscaping with mulberry trees to provide fodder for his tiny livestock. Depending on their loyalties, writers have presented him in quite different lights; the debate is beyond our present scope. Whatever the reasons—one source suggests that hordes of uninvited pilgrims to Monticello made it impossible for Barclay to live there—the projected silk business failed, and unable to pay for even minimal repairs to the already decaying property, in 1833 he offered it for sale.

It is uncertain exactly when the "colorful, brash [and] controversial" U.S. Navy Lieutenant Uriah Phillips Levy acquired Monticello. Jewish, he deeply admired Jefferson, largely because of his "determined stand on the side of religious liberty." In Paris in 1832 Levy engaged the sculptor Pierre-Jean David d'Angers to make the statue of Jefferson that now stands in the rotunda of the U.S. Capitol. He also met the aging Marquis de Lafayette, a friend of Jefferson who had visited Monticello; in response to de Lafayette's inquiry, Levy promised that on returning to America he would discover what had happened to the property. Levy found that the house was abandoned, with broken windows and sagging shutters; the lawns were overgrown and Jefferson's carefully planned flowerbeds gone to seed. Through weathering, neglect, and vandalism the roof had caved in, the once-graceful columns had weakened, and the terraces had collapsed. Nevertheless, in spite of local rumors "fueled either by anti-Semitism or a distaste for Yankees," early in April 1834 Levy bought Monticello from Barclay. Together with "an indeterminate amount of acreage," it cost him $2,700; the legalities of the deal were not finalized until May 1836.

Levy immediately hired a local resident, Joel Wheeler, to supervise repairs to the house and the restoration of the gardens. He employed local craftsmen to carry out repairs and bought a dozen or more slaves to take care of the grounds. He also increased the land holdings and set about recovering some of Monticello's contents that had been sold nearly a decade earlier. Over the next 15 years he was to spend tens of thousands of dollars on the property.

In spring 1837 Rachel Levy, Uriah's widowed mother, took up residence at Monticello and remained until her death in 1839. Levy himself lived there only intermittently, mostly in the summers. In 1853, when he was age 61, he forsook bachelorhood and—in accordance with a Jewish tradition described in the book of *Ruth*—he married his 18-year-old niece, Virginia Lopez; they spent several summers at Monticello. In 1861, a year before Uriah's death, the Confederacy seized the plantation as "alien enemy" property and in November 1864 sold it at auction to one Benjamin Franklin Ficklin of Albemarle County, for 80,500 Confederate dollars—worth only $4,000 in U.S. currency. By then it was again in decline; one visitor wrote, "The place was once very pretty, but it has gone to ruin now. . . . The ballroom . . . has a thousand

names scratched over the walls. There are some roses in the yard that have turned wild, and those are the only flowers." When the Civil War ended all confiscated property was returned to its previous owners.

In a complicated will of 1858 Uriah Levy had bequeathed Monticello and the income from his estate to establish "an Agricultural School for . . . educating as practical farmers children of the warrant office of the United States Navy whose Fathers are dead." If Congress declined his offer, Monticello was to go to the state of Virginia; and if Virginia also refused it, to a number of Portuguese Hebrew congregations were to use it as an agricultural school for orphans. When Congress turned down the bequest, Levy's widow and his family challenged the legality of the will. Years of rancorous bickering followed (in 1876 there were nearly fifty claimants), until in March 1879 Uriah's nephew, the New York lawyer and businessman Jefferson Monroe Levy—by some accounts an "eccentric, high-living, deal-making egoist"—purchased the house and 218 surrounding acres at auction for $10,500. An unresolved lawsuit prevented him from obtaining title until May 1882.

When Jefferson Levy took possession Monticello was in appalling shape, the dilapidation largely the result of Joel Wheeler's neglect. He had remained there unpaid through the Civil War; since Uriah's death he had enjoyed unsupervised control while the Levys brawled over the estate. By 1879 the caretaker, now senile, "believed he owned Monticello [and] seems not to have done anything. . . . The gutters fell away, the roof rotted, rainwater flooded the basement, and the elements took their toll on every part of the great house." One historian, noting that Wheeler became "more cantankerous . . . as the years unfolded," explains, "during the war [he] started charging groups to use the . . . house and grounds for parties, picnics, and other activities, while doing little to discourage souvenir hunters. [He] also . . . planted vegetables on the West Lawn, allowed pigs to roam the property, stabled cattle in the basement, and stored and milled grain in the parlor." Jefferson Levy eventually needed an eviction order to rid himself of the troublesome caretaker.[13]

He then set about repairing the house and restoring the grounds, where "the orchards, terraced gardens, flower borders, walkways, and roads had 'all but disappeared.'" In 1889, after a succession of six unsuitable caretakers, he employed the "highly competent and dedicated" engineer Thomas L. Rhodes as superintendent. Rhodes' professional ability and Levy's wealth gradually "brought Monticello back to life." The house was repaired and renovated, and the grounds again landscaped according to Thomas Jefferson's original plans.

For many years Jefferson Levy used Monticello as his "bachelor's hall and summer estate." He spent a great deal—he would later claim that it was as much as a million dollars—improving Monticello. He installed running water, toilets, and a coal-burning furnace, and acquired another 500 acres of land. He also retained a European agent "for the purpose of purchasing furniture and works of art" for the house. It seems that his aesthetic taste was more

eclectic (and less informed) than that of his namesake; he combined Georgian and late Victorian pieces, so that the interiors (according to one critic) "took on the over-stuffed appearance of a Parisian banker's country house during Napoleon III's Second Empire"—what might be termed "nouveau-riche kitsch" style. His acquisitions included elaborate chandeliers, mirrors, sideboards, and a "spectacularly [designed] bed à la Madame du Barry."

He greatly admired Jefferson, and he welcomed to the house President Theodore Roosevelt, congressmen, ambassadors, and other officials and dignitaries who came out of esteem and admiration for Monticello's architect and builder. Indeed, from early in his ownership Levy received an "almost unbroken stream" of visitors from the general public; by 1900 there were probably twenty thousand a year and within a decade, as the property became better known and more accessible, that number more than doubled. Each paid a small fee, which Levy donated to local charities.

The last decade of the nineteenth century saw a revival of interest in Jefferson and all the Founding Fathers, due in part to growing nativism (read, jingoism) in the United States—a reaction to the influx of Europe's "huddled masses yearning to breathe free." Books and newspaper articles about Jefferson and his prophetic ideas proliferated, and it soon became clear to some that the time was ripe to make Monticello a national shrine. In April 1897 the Democrat politician William Jennings Bryan suggested to Levy that he give Monticello to the government. Levy declined.

The dark side of "nativism" was a concomitant increase in anti-Semitism—many immigrants were Jewish—and the rich and successful Jefferson Levy was targeted. In August 1902 one Amos Cummings in a *New York Sun* article criticized the twenty-five-cent admission charge leveled on "patriotic Americans" to see Monticello and complained that Levy valued the house at $100,000. In the April 1914 issue of *Good Housekeeping*, the journalist Dorothy Dix (Elizabeth Gilmer) referred to Uriah Levy—a fifth-generation American—as an alien, rekindled a rumor that he had acquired Monticello through chicanery, and "used dialogue in which [he] spoke in a thick, new-immigrant accent."

In 1911 Maud Littleton, the wife of a Brooklyn congressman, launched a campaign to have Monticello taken from the Levys and made into a public shrine. In 1899 she had effused over Jefferson Levy's good care of the house in *Munsey's Magazine*, but on July 24, 1912, she claimed in a statement before the House Rules Committee:

> [When I was there] I did not get the feeling of being in the house Thomas Jefferson loved and built and made sacred, and of paying tribute to him. I did not seem to feel his spirit hovering over around those portraits. My heart sunk. My dream was spoiled. Jefferson seemed detached from Monticello. . . . Somebody else was taking his place [there]—a [rank] outsider. . . . It seemed to me that the people of the United States should own Monticello; that it should be public property.

She petitioned Congress to buy the estate, supporting her emotional arguments with references to Uriah Levy's will of a half-century earlier. Littleton garnered support from politicians and the press—the Hearst papers celebrated her as the "Lady of Monticello"— and a resolution was introduced in Congress that would have forced Levy to sell to the federal government. Contentious hearings and impassioned debates raged in the House and Senate. Jefferson Levy's response was, "When the White House is for sale, then I will consider an offer for Monticello." A bill was defeated in the House of Representatives in 1912, and the following year Littleton intensified her campaign and hundreds of thousands of people were persuaded to petition their congressmen. Littleton accused Levy of "standing in the way of the American people, of being selfish, of not caring for anything except his own comfort, and . . . of being a poor caretaker of the estate, who guarded it like an 'Oriental potentate' refusing admission to those who would worship at the site." All Levy could do in the face of her tirades was to

> object to the slanders, and point out that he had poured large amounts of money into preserving Monticello, that visitors were always welcome, that the house was very well maintained, and that he had kept Monticello not out of the "selfish and sordid purposes" that Mrs. Littleton ascribed to him, but by an "unceasing flow of the fountain of a heart filled with love for Thomas Jefferson."[14]

In September 1914, in response to a second approach from Bryan, who by then had become secretary of state, Levy conceded, "I must put aside my feelings and yield to the national demand." He was prepared to sell Monticello for $500,000 (which he claimed was half its value) and agreed to Bryan's proposal to convert into a presidential summer retreat. It never happened. Congress failed to pass the legislation, the shouting and the tumult died, and the whole distasteful matter ended. When America entered the Great War in 1917 the question of who should own Monticello suddenly seemed much less important.

In the postwar depression Jefferson Levy's "personal fortunes sank [and] he wanted to sell the house both to get the purchase price [and] to rid himself of the burden of maintaining it." He put Monticello and 600 acres on the market in 1919 and sold it for $500,000 to the recently chartered non-profit Thomas Jefferson Memorial Foundation in December 1923. The Foundation was established to "preserve and maintain Monticello as a national memorial to the genius and patriotism of 'the apostle of human freedom.'" Theodore Fred Kuper, its first director, recalled that when Levy conveyed Monticello ". . . he burst out crying. He said that he never dreamt that he would ever part with the property." Levy died fewer than 3 months later. The Levy family had owned Monticello for 89 years—far longer than the Jefferson family owned it. Uriah Levy and Jefferson had taken over the house when it was in parlous physical state and had saved it.

Once the mortgage was discharged in 1937, the restoration and refurbishment of Monticello began. Fiske Kimball, an authority on Jefferson, and the Charlottesville restoration architect Milton L. Grigg guided the execution of the work over the next 18 years. Between 1939 and 1941 the Garden Club of Virginia revived and restored the flower gardens at the east and west fronts, which had all but disappeared after Jefferson's death. Kimball acquired many of the original furnishings held by Jefferson's descendants, negotiated the purchase in Europe of complementary pieces, and was involved in the "recreation of curtains, draperies, and bedspreads for Monticello, as well as the reupholstering of chairs and sofas, all in the manner he felt was most historically accurate."

Monticello is administered as a national memorial, museum, and educational institution to keep alive the name and memory of Thomas Jefferson. It is the only home in the United States that has been designated a World Heritage Site. The application for listing stated,

> Jefferson's first architectural designs were for his own house, Monticello, a project that occupied his attention from the late 1760s up to his death in 1826. [His] greatest intellectual energies and original talents were devoted to architecture and his two greatest architectural works, Monticello and the University of Virginia. Both properties were visited and admired because they were associated with Jefferson; they were in themselves outstanding works of architecture; they represented unique adaptations of eighteenth century neoclassical forms, and, they are symbolic of man's universal aspirations for freedom, self-determination, and self-fulfillment.

NOTES

1. Semmes, J. E., *John H.B. Latrobe and His Times, 1803–1891*. Baltimore: The Norman, Remington Co., 1917, 250.

2. See the full essay, Vesper Osborne, "Monticello," *Callaloo*, 26(Summer 2003), 590–592.

3. Kindig, Thomas, "Signers of the Declaration of Independence." www.ushistory.org/Declaration/signers/jefferson.htm

4. World Heritage List nomination. . . . www.nps.gov/history/worldheritage/us-jef.htm

5. Jefferson's notes are published in Washington, Henry Augustine, ed., *The Writings of Thomas Jefferson. . .*, Washington, DC: Taylor and Maury, 1853–1854, 391 ff.

6. Kimball, Sidney Fiske, *Thomas Jefferson Architect*, Boston: Privately Printed, Riverside Press, 1916. Reprinted New York: Da Capo, 1968. /www2.iath.virginia.edu/wilson/TJA/tja.body2.html

7. Kimball.

8. Giordano, Ralph, "Thomas Jefferson: Education of an Architect," *Early America Review* (Summer/Fall 2001). www.earlyamerica.com/review/2001_summer_fall/architect.html

9. Giordano.

10. Beiswanger, William L., "Thomas Jefferson and the Art of Living Out of Doors," *Magazine Antiques* (April 2000), 594–605.

11. Beiswanger.

12. Adams, William Howard, *Jefferson's Monticello*. New York: Abbeville, 1983, cited World Heritage List nomination. . . www.nps.gov/history/worldheritage/us-jef.htm

13. See "Caretaker Contributed to Monticello's Decline," *Monticello Newsletter*, 17(Winter 2006), 1–2.

14. The whole sordid story is told in Melvin I. Urofsky, *The Levy Family and Monticello, 1834–1923: Saving Thomas Jefferson's House*. Monticello, VA: Thomas Jefferson Memorial Foundation, 2001.

FURTHER READING

Adams, William Howard. *Jefferson's Monticello*. New York: Abbeville, 1983.

Beiswanger, William L. "Thomas Jefferson and the Art of Living Out of Doors." *Magazine Antiques* (April 2000), 594–605.

Beiswanger, William L., et al. *Monticello in Measured Drawings / Drawings by the Historic American Buildings Survey/Historic American Engineering Record, National Park Service*. Charlottesville, Virginia: Thomas Jefferson Memorial Foundation (TJMF), 1998.

Bernstein, Richard B. *Thomas Jefferson*. New York: Oxford University Press, 2003.

Giordano, Ralph. "Thomas Jefferson: Education of an Architect." *The Early America Review* (Summer 2001).

Girouard, Mark. "Monticello, Virginia, the Home of Thomas Jefferson from 1771 to 1826." *Country Life*, 133(January 17, 1963), 106–110.

Howard, Hugh. *Dr. Kimball and Mr. Jefferson: A Journey into America's Architectural Past*. New York: Bloomsbury, 2006.

Howard, Hugh and Roger Straus III. *Thomas Jefferson, Architect: The Built Legacy of Our Third President*. New York: Rizzoli, 2003.

Kimball, Sidney Fiske. *Thomas Jefferson Architect*. Boston: Privately Printed, Riverside Press, 1916. Reprinted New York: Da Capo, 1968.

Leepson, Marc. *Saving Monticello: The Levy Family's Epic Quest to Rescue the House that Jefferson Built*. New York: Free Press, 2001.

Madden, W.C. *Monticello*. Chicago: Arcadia, 2007.

Malone, Dumas. *Jefferson and His Time*. Charlottesville: University of Virginia Press, 2005 (six volumes.) Originally published Boston: Little, Brown, 1948–1981.

McLaughlin, Jack. *Jefferson and Monticello: The Biography of a Builder*. New York: Henry Holt, 1988.

Nichols, Frederick Doveton. *Thomas Jefferson's Architectural Drawings*. Boston: Massachusetts Historical Society; Charlottesville: TJMF and University Press of Virginia, 1961.

Nichols, Frederick Doveton, and James A. Bear, Jr. *Monticello*. Monticello, VA: TJMF, 1982.

Nichols, Frederick Doveton, and Ralph E. Griswold. *Thomas Jefferson Landscape Architect*. Charlottesville: University Press of Virginia, 1978.

Peterson, Merrill D., ed. *Visitors to Monticello*. Charlottesville: University Press of Virginia, 1989.

Stein, Susan R. *The Worlds of Thomas Jefferson at Monticello*. New York: Abrams, 1993.

Urofsky, Melvin I. *The Levy Family and Monticello, 1834-1923: Saving Thomas Jefferson's House*. Monticello, VA: TJMF, 2001.

INTERNET RESOURCES

Official Monticello website. www.monticello.org

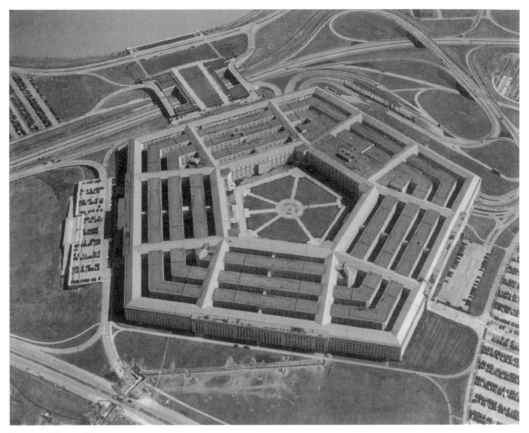

Courtesy Library of Congress

Pentagon, Arlington, Virginia

"This concrete behemoth"

Begun on September 11, 1941, the Pentagon was completed in just 16 months. It is the world's largest office building, with a floor area of 6.54 million square feet—perhaps meaningless as a number, that is equivalent to 114 football fields. A recent editorial in *The Economist* noted that in World War II this military headquarters was four times the size of the British War Office in Whitehall, the German *Kriegsministerium* in Berlin, and the Japanese general staff headquarters building in Tokyo combined. The vast building is "virtually a city within itself" that now houses the offices of the secretary of defense, the Joint Chiefs of Staff, the secretaries of the three military departments, and a workforce of about twenty-three thousand and three thousand support personnel. As many as thirty-three thousand people worked in it at the peak of World War II.

The architectural historian Witold Rybczynski writes, "The Pentagon is not generally considered a significant work of architecture, but perhaps it should be." He reasons that at a time when "every new art museum and luxury condo tower is touted as 'iconic,' the Pentagon is the real thing: a globally recognized symbol. This concrete behemoth . . . is also the product of considerable human ingenuity and resourcefulness."[1] Others have gone further. *The Economist* named the Pentagon among the "greatest engineering feats of the twentieth century," while the Virginia Section of the American Society of Civil Engineers holds it out as "a gigantic and lasting monument to the American spirit; unity in defense and war; the ingenuity of its architects and engineers; and the force and leadership of its builders." And other writers assert that the building stands with the White House, the Vatican, and a handful of others as symbols recognized around the world. To some extent, all those claims are justified.

But the irony is that the Pentagon is most recognizable from the air. Despite its almost inconceivable size, its almost featureless appearance from anywhere on the ground offers little clue to its distinctive, even unique, layout—but more of that later. Moreover, much of its status as an icon of American architecture lies in its associations: just as the terms *the White House* and *the Vatican* now universally conjure the U.S. administration and the Roman Catholic Church, respectively, more readily than the buildings that house them, so "The Pentagon" signifies (to most people) America's enormous military might.

The Pentagon was built for the Department of War, which since 1789 had operated the U.S. land (and later air) forces: Department of War—plain words. In 1945, attempting to minimize the interservice rivalry that they blamed for "limited military success" in World War II, the Army, Navy, and the Joint Chiefs of Staff proposed a unified Department of National Defense. The change was temporarily stalled in Congress, but following revisions introduced by President Truman in February 1947 the National Security Act was passed in July. Two months later the National Military Establishment was created. Perhaps because of the unfortunate acronym "NME" (try reading it aloud), in August 1949 it was renamed the Department of Defense. Replacing the

secretary of war, the secretary of defense presided over the former War Department and Navy Department; the Department of the Air Force was created as a new separate service.

Claiming that the name change was "the single most effective and far-reaching piece of doublespeak in the twentieth century," the American linguist William Lutz explained that it altered the "whole nature of the argument. Just think if you had to run for Congress and you wanted to stand up and say, 'I don't think $300 billion a year is a big enough war budget. We need to spend more on war.' "[2] The London-based critic Jason Oddy wrote in *The Independent on Sunday*, "While ostensibly designed to coordinate the impending [Second World War] effort, the Pentagon's construction also signaled a new ambition in US foreign policy." Before the Pentagon was built, there were those in Washington who feared that it would become a postwar white elephant, unless America was to "look forward to a permanent military establishment vastly greater than [it had] hitherto maintained." Oddy commented, "the Cold War provided the perfect excuse for this unprecedented surge in militarism, and the Pentagon came to symbolize the increasingly martial outlook of a nation that was about to become the most powerful country on earth."[3]

After the new Department of Defense took over the Pentagon, the building became the headquarters of a rapidly growing bureaucracy. It also assumed its own personality; in much the same way as *the White House* was synonymous with the current administration, *the Pentagon* became synonymous with the military-industrial order and might of a nuclear superpower. So though the Pentagon is an undoubtedly an icon, it does not signify defense and security to everyone. In *Armies of the Night*, the book that he styled his "nonfiction novel," Norman Mailer chronicled the October 1967 anti-Vietnam War march on the building. He characterized the Pentagon as "the symbol, the embodiment, no, call it the true and high church of the military-industrial complex, the Pentagon, blind five-sided eye of a subtle oppression which had come to Americans out of the very air of the century."

THE SOUND OF DISTANT DRUMS

The outbreak of war in Europe in 1939 had military implications for the United States. Signed on August 23, the Ribbentrop-Molotov Pact provided that Nazi Germany and the Soviet Union, despite their polarized ideologies, would not attack each other. It included a protocol that gave the Baltic States and eastern Poland to the Soviets if they kept out of Germany's probable conflict with the rest of Europe; that safeguarded the Germans against a war on two fronts. When Hitler's armies invaded Poland on September 1 the Soviets did not intervene. Two days later the French and British declared war on Germany, and World War II had begun.

After overrunning Denmark and Norway in April 1940, the Germans launched a *blitzkrieg* on The Netherlands, Belgium, and Luxembourg on May 10. Two days later Hitler ordered the invasion of France, and in about a week the allied armies were driven back to Dunkirk on the coast; by June 4, 338,000 allied survivors withdrew across the Channel to Britain, all their heavy equipment abandoned in France. Thirty thousand died, and 1.2 million had been taken prisoner. The Germans marched into Paris on June 14. A month later Hitler proposed Operation Sea Lion, the invasion of Britain; the plan was cancelled on September 17.

Japan, insisting upon its divine right to subjugate and unify Asia under Emperor Hirohito, had long been on the march on the Pacific Rim. It had invaded mainland China in July 1937, and 4 years later established a puppet government in Nanjing. In September 1940 it entered a Tripartite Pact with Germany and Italy and then invaded French Indochina (now Vietnam), which it occupied in July 1941.

The Roosevelt administration was "consumed by war anxiety." From the beginning of 1941 the United States had intercepted diplomatic messages between Tokyo and the Japanese ambassador in Washington, as Japan spread its tentacles toward the Pacific. In March the president signed the Lend Lease Act, which allowed America to provide its allies with "defense articles" (read, weapons) and other aid against German and Japanese aggression and to impose trade restrictions on Japan (a 30-year-old commercial treaty with Japan had been terminated in July 1939). Responding to the "swift and devastating" Nazi onslaught in Europe, Roosevelt declared a national emergency on May 27. Less than a month later Hitler breached the Nazi-Soviet Non-Aggression Pact and launched a surprise attack on the Soviet Union. Early in August, aboard a ship off Newfoundland, Roosevelt and Winston Churchill, prime minister of Britain, together with "high-ranking military officers of both governments" devised the Atlantic Charter—"a set of common principles that repudiated territorial aggression by 'the Hitlerite Government of Germany and other Governments associated therewith' and supported the right of self-determination."

Through the second half of the 1930s, in response to upheavals in Europe and Asia that pointed to imminent war, recognizing the widespread growth of isolationist—some call it noninterventionist—sentiment, Congress had passed a series of Neutrality Acts that "following its costly involvement in World War I, sought to ensure that the US would not become entangled again in foreign conflicts, especially in Europe." The Act of 1939, passed the day after the British declared war on Germany, was the final amendment, in "recognition of the imminent Nazi threat to western Europe's democracies." Unable to see that their country was inexorably hurtling toward war and needed to be ready for it, many prominent Americans resisted the Lend Lease Act and any war preparation on the part of their government; they advocated neutrality in what they regarded as a European war. Hundreds of thousands joined groups

like the America First Committee, established in September 1940. The anti-war feeling dissolved after the Japanese attack on Pearl Harbor on December 7, 1941.

General George C. Marshall became the U.S. army chief of staff in July 1939. For the next 2½ years, he oversaw the preparations for a possible war, and by December 1941 the nation had a well-trained Army of over 1.4 million, far larger than "the paltry forces" that had existed in 1939. Marshall's preparations included the creation of office space for headquarters staff.

In July 1941, twenty-four thousand Army personnel were working in seventeen separate buildings in the Federal District—the Social Security and Railroad Retirement buildings, as well as leased apartment blocks, warehouses, private houses, and even garages—with a total space of 2.8 million square feet and an annual rent bill of $3 million. Other staff was accommodated in Fort Myer and Alexandria, Virginia. Staff numbers were expected to reach thirty thousand by the beginning of 1942, and the existing 650,000 square feet of records storage space needed to be increased by 50 percent. One account says that "a typical high-ranking officer testified before the Congress that his business normally took him to several different offices daily and he wasted many hours in travel." The Army constructed a $9 million edifice in Foggy Bottom. But Henry Stimson, the secretary of war, despised the building and refused to occupy it; he thought that it was too small and that the façade looked like "the entrance to a rural opera house." The Department of State eventually used it.

"DYNAMITE IN A TIFFANY BOX"

Although Marshall believed that several temporary buildings on a single site would solve his space problems, the president was convinced, not without cause, that "temporary" buildings erected by governments often became permanent. During World War I, Roosevelt, when he was assistant secretary of the navy, had authorized the construction of barracks-like "tempos" all over Washington, D.C., and they were still there 20 years later. Roosevelt himself—perhaps a little harshly—called it a "crime for which he should be excluded from Heaven," and he was unwilling to repeat his mistake. But his reluctance to agree with Marshall had to do with location, and on July 14 he asked Congress to give the Public Buildings Administration $6.5 million to build "temporary structures in or near Washington, DC [for the] War Department and other agencies engaged in the national defense effort"—"temporary" because (it was assumed) that it would be hard to find use for three million square feet of office space after the war. He need not have worried.

Brigadier General Brehon Burke Somervell, head of the Construction Division of the Quartermaster Corps, was more than anyone else responsible for the Pentagon. He informally approached General Moore, deputy chief of

staff, and Representative Clifton A. Woodrum of Virginia, chairman of the House Subcommittee on Appropriations, with the unique notion that the entire War Department—as many as forty thousand workers—could be accommodated under one roof. Somervell has been variously described as smart, ambitious, hard-driving, "a tough administrator" and a "smooth but ruthless operator"; one associate characterized him as "dynamite in a Tiffany box."

On Thursday, July 17, Somervell addressed the subcommittee. Woodrum, having been suitably primed, suggested to Somervell and Lieutenant General Eugene Reybold, then acting chief of the Corps of Engineers, that the War Department should find an overall, rather than a piecemeal solution to its space problems. That same evening Somervell verbally ordered Major Hugh J. "Pat" Casey, chief of the Design and Engineering Section in the Quartermaster General's Construction Division, to make—by 9 A.M. the following Monday—preliminary designs for an office building on the site of the former Washington-Hoover airport on the Virginia bank of the Potomac River. Years later Casey recalled,

> [Somervell] said, "Pat, we're going to build a new War Department Building and we're not going to build it in Washington. It's going to be built over in Virginia. . . . It's to be for 40,000 people with parking for 10,000 cars, 4 million square feet of area . . . —not over four stories high and no elevators, solely ramps, and on Monday morning I want a general layout and design plan and perspective and so on for that structure. The structure is not to be air conditioned, and we want 500,000 square feet ready in six months and the whole thing ready in a year."[4]

TIME IS OF THE ESSENCE

The prescribed building and car park would need a site of at least 105 acres. The location Somervell had chosen was the former 134-acre Washington-Hoover Airport at the foot of the 14th Street Bridge in Arlington County, Virginia, abandoned in June 1941 when a new National Airport was opened. The land was periodically flooded; *Time Magazine* described it as "trapped and trammeled" and "hemmed in by a landscape as disheveled as a Congressman's collar." Casey immediately recognized that the swampy site presented engineering and cost problems, and Somervell was convinced to change the proposed location to a 67-acre tract of Arlington Farms, part of a former experimental station of the Department of Agriculture. The new site was almost rectangular, with one corner cut off by a diagonal road. The location having been finalized—or so it was thought—Casey gathered some of his designers to make tentative layouts. The key members of his team were the Los Angeles architects George Edwin Bergstrom and David Julius Witmer and Frederick H. Fowler, national president of the American Society of Civil Engineers.

It seems that Somervell was keen to appoint such eminent civilian consultants to his organization.

George Bergstrom had studied at Yale and MIT before beginning to practice architecture in New York City in 1899. He moved to Los Angeles in 1903 and 2 years later formed a 10-year partnership with John Parkinson, designing several commercial buildings. In 1916 he served as president of the Los Angeles Housing Commission, after which little can be discovered of his career until 1921, when he became vice president of the Los Angeles Allied Architect Association—a cooperative of thirty-three prominent architects committed to designing civic buildings at the lowest possible cost. The fourth shell for the Hollywood Bowl (1929) is among its works. Through the 1920s the firm of Bergstrom, Bennett, and Haskell produced several Southern Californian buildings including the County Hospital, the Hall of Justice, and the Museum of History, Science, and Art (all in Los Angeles) and the Pasadena Civic Auditorium in 1932. In the national arena, Bergstrom served as treasurer the American Institute of Architects from 1926 to 1938; he became its president in 1939 and 1940.

He was appointed chief consulting architect to the War Department in 1941. It seems that the pragmatic Bergstrom, who (according to *Time*) "scoffed at highfaluting notions," would do as he was asked. He believed architecture to be

> a collaborative profession; a coordination of efforts to create a work of art to fulfill a definite need within a definite cost. The mind of the architect must interpret the need from another mind, apply it to his imagination, translate the concept to other minds and direct still other hands to give it form and substance and make it fulfill the need for which, and satisfy him for whom it was created.[5]

After completing his architectural studies at Harvard, David Witmer returned to Los Angeles in 1912. In 1919 he formed a partnership with Loyall F. Watson, and through the 1920s they won several awards for their domestic work. The firm remained active for nearly 40 years. Commissions were scarce in the Depression years, and in 1934–1938 Witmer was architectural supervisor for the Southern California District of the Federal Housing Authority. One source suggests that this government connection eventually led him to the Pentagon design team; anyway, he served as "co-chief architect" with Bergstrom in 1941 and 1942 and as chief architect until 1943.

Bergstrom started work late on July 18. A tall building, the most obvious solution, was precluded. But a low building would need to have (to use a term that was not current in 1940) a very large "footprint"; besides, anything so spread out would be taxing on its occupants. Bergstrom probably deserved greatest credit for the pentagonal design although Casey, Fowler, and some of the others who were working with him on different geometries finally reached consensus. In its earliest form, the layout was an asymmetrical pentagon—a drawing by the gifted Socrates T. Stathes shows a square with a corner cut off. His aerial perspective indicated landscaping but no car parks; indeed, there

was little spare room on the site—certainly nowhere near three times the area of the building's footprint that ten thousand vehicles demanded. The building plan is succinctly described by Steve Vogel:

> It was really two buildings, a five-sided ring surrounding a smaller one of the same shape. The interior of the outer ring was lined with 49 barracks-like wings, sticking in like the teeth of a comb. The smaller ring had 34 exterior wings, all pointing toward the outer ring. The wings were 50 feet wide and 160 feet long, separated from each other by 30-foot-wide open-air "light courts." Corridors connected the two rings on the ground and third floors.[6]

Noting the problems of the irregular design—"the pattern was awkward, and the routes between wings . . . were circuitous. Lacking symmetry . . . the building was frankly quite ugly"—he reports Stathes' comment about the plan's "one overriding virtue," made more than 60 years later: it fit the site. But, as will be seen from the following discussion, the War Department's new headquarters was not destined for Arlington Farms.

During the subsequent, often antagonistic debate about location, the architects immovably retained (but refined) the pentagonal shape dictated by the original location. There were several reasons: the building already was designed, and there a degree of urgency about its completion; Army officers liked it because it echoed the star design of such buildings as Fort Pickens in Florida (1829–1934), Fort McHenry in Baltimore (after 1794) and of course Fort Sumter (begun in 1829), as well as older European models; and any plan form close to circular would provide "the greatest amount of office area within the shortest walking distance." Vogel adds, not altogether logically, "Seen from above, the concentric rings of pentagons, if not beautiful, were at least pleasing to the eye."

Although purveyors of conspiracy crackpottery point out that the pentagram has mystical meaning for Freemasons, it seems clear enough that even when a change of site meant that the pentagonal shape was no longer constrained by existing roads, the rushed schedule of the project meant that the architects did not change the design. Despite Bergstrom's late post-facto arguments about allusions to Napoleonic-era fortress architecture, the raison d'être for the form was as simple as that.

A BUILDING IN SEARCH OF A SITE

On the morning of Monday July 21, 1941, Somervell received what he'd asked for. As Casey remarked, it had been "a busy weekend." The same day, Marshall and Under Secretary of War Robert P. Patterson approved the proposal, and on Tuesday Somervell, Reybold, and Bergstrom presented it to Stimson. Somervell assured him that the building could be started in 2 weeks and completed in a year.

At first things moved quickly. On Tuesday afternoon Somervell told the reconvened Subcommittee on Appropriations that the building, respecting its environment, would now be three stories high, not four. Excluding the car park, it would cost $35 million. The Subcommittee unanimously approved funding. Two days later the building was included in the First Supplemental National Defense Appropriation Bill for 1942 presented to the full House. Of course, some Congressmen challenged it. Roosevelt gave his preliminary approval at the end of the week. On Monday, July 28, the House approved the bill and sent it to the Senate.

But the issues of size, shape, and site were far from resolved. Casey later put it rather blandly: "There was some opposition that way." Certainly, several political and bureaucratic noses had been put out of joint by Somervell's proposal. On July 30 Roosevelt's uncle, Frederic Delano, chairman of the National Capital Park Planning Commission (NCPPC) and Harold D. Smith, director of the Bureau of the Budget warned the President that forty thousand people commuting to Virginia would generate "terrific" traffic problems. In response, on August 3 Roosevelt sent a letter (that had been drafted by Smith) to the Senate Appropriations Subcommittee, conveying that concern and advising that, though he had no objection to the Arlington Farms site, he wanted a building that would house only twenty thousand employees.

Somervell, perhaps unwisely, had considered it unnecessary to consult the NCPPC about the project. Insisting that his building would spoil the "dignity and character" of the Arlington Cemetery and the Lincoln Memorial, the Commission also condemned his "flagrant disregard" for symbolic context. In the 1920s Washington had symbolized national reconciliation by establishing an axis from Robert E. Lee's Arlington mansion, across Memorial Bridge to the Lincoln Memorial and then along the Mall to the Capitol. Setting the War Department building on that axis (they insisted) would undermine that symbolism. Other institutional objectors, including the local AIA chapter and the National Association of Building Owners and Managers, protested about the building.

Somervell also had bypassed the D.C. Commission on Fine Arts (CFA), irking its chairman Gilmore D. Clarke, who irritably complained: "It is inconceivable that this outrage could be perpetrated in this period of the history of the development of [Washington], that is held in the highest esteem by every citizen who visits it." He deplored the construction of such a gargantuan building "at the very portals of the Arlington National Cemetery, thus resulting in the introduction of 35 acres of ugly, flat roofs into the very foreground of the most majestic view of the National Capital." He demanded that it be relocated about a mile to the south.

Recognizing that much of the ostensibly objective resistance may have sprung from other motives, Casey later said, "I think the principal reasons in opposition were mainly the idea of having the War Department building not in the District [of Columbia] but over in Virginia." He was probably right.

The Congressional hearings were heated, many politicians waxing indignant at what they saw as "the casual abandonment" of the District. Vogel records that one declared that siting the building in Arlington would leave the District "a ghost town," and alternative sites within D.C. were suggested. The press had joined the fray, tastelessly describing the proposal as a *blitzkrieg* on Congress and Washington. Somervell argued—speciously, as it turned out—that rejecting the Arlington Farms site would mean setting aside existing plans, thus causing a month's delay and adding to the cost.

But the Senate Appropriations Subcommittee endorsed the site—after all, President Roosevelt had approved it—and the bill went to the Senate, where robust debate continued. Senator Robert Taft unsuccessfully proposed an amendment to halve the appropriation. The act that passed on August 14 did not mention the size or design of the building or specify exactly where on the Arlington Farm site it would stand.

Three days later Roosevelt returned from his secret meeting with Churchill to face a salvo of complaints. Secretary of the Interior Harold Ickes was bewailing the "rape of Washington." A letter from the President's uncle implored him to have Congress revisit issues surrounding the Army headquarters building. The Senate having turned down his recommendation to halve its size, he was demurring about building it on the Arlington Farm site. Three days later, to the delight of the newspapers and the assorted commissioners, he announced that only a small part of the structure, revised to house twenty thousand employees, would intrude on Arlington Farm; most of it would be on a swampy land to the south. Called Hell's Bottom, that site has been described as an "unsightly former airfield and railroad yard littered with abandoned tin hangars and rusted-out boxcars." It was far from an ideal location for the Pentagon Building. . . . At that time the quartermaster depot was under construction at the present site of the Pentagon.

On August 25—2 weeks *after* the construction contract was awarded—Roosevelt approved the appropriations bill. Somervell was resigned to the new site, but (without telling the president) he refused to reduce the building's size and in fact pushed its population up to thirty-five thousand, and "with the help of Virginia congressmen, he protected the appropriations needed to make the construction permanent."

Somervell and Bergstrom received a decidedly cool reception at a special CFA hearing on September 2 to review the design. That was perhaps predictable, because their principal inquisitors were architects who may have coveted the project for themselves. Commissioner William H. Lamb, designer of the Empire State Building, believed that "great confusion [was] apt to result in the circulation of [a pentagonal] building." Beaux-Arts architect Paul Philippe Cret agreed. They advised Bergstrom to "do away with the monotonous appearance" of the façade. He agreed to make revisions—since he was designing "on the run," so to speak, they were inevitable anyway—but insisted on retaining the pentagonal plan. Cret—a favorite of Roosevelt's—decided to

take the CFA's case to the president, but Somervell preempted him. At 12:15 that afternoon "the general . . . strolled into the Oval Office, accompanied by Bergstrom. . . . Roosevelt . . . reviewed the plans carefully. He asked questions and directed a few changes, then approved the design." Two hours later Clarke, Lamb, and Cret called on the president. They argued for a rectangular plan because a pentagon "would make the biggest bombing target in the world." Revisiting the issue of what we now call "environmental impact," they also contended that the Department would be best housed in several buildings rather than a "single great mass." But Roosevelt replied that he liked the pentagonal shape because "nothing like it has ever been done that way before."

Yet it should be noted that Roosevelt, who seriously (and without justification) fancied himself an architect, made his own attempt at designing the building. He excitedly suggested a solid building, 1,000 feet square. Because it would be air-conditioned—clearly, a detail that had changed since Somervell first briefed his architects—there would be no need for courtyards, light wells, or even windows, except perhaps on the external walls. And the building could be reassigned as an archives store after the war. Whatever the disagreements among themselves, Clarke, Somervell, and Bergstrom and Henry Stimson successfully combined to dissuade the president from pursuing his own solution. Construction work commenced on September 11; after it had progressed for a month, Somervell presented the final plans to Roosevelt; faced with a *fait accompli*, the president approved the larger building. What else could he do?

AN APPROPRIATE AESTHETIC

It seems that Somervell enlisted his civilian collaborators not on merit but on prestige. Bergstrom was not a particularly good architect, an eclectic designer who had developed no particular personal style—but for a couple of years he had been national president of the AIA. Since around 1920 American architects had been made aware through professional journals of European Modernism. Their attention had been caught by the 1925 Paris *Exposition Internationale des Arts Décoratifs et Industriels Modernes*, and although generally only skin deep, the Art Deco style influenced much commercial architecture. But by 1940 many, if not most, architects continued to work in anachronistic styles. Washington's showcase, the National Mall, had been developed in accordance with the 1902 recommendations of the Park Improvement Commission—the "McMillan Commission"—and public buildings were in the Neo-Classical idiom. Examples include Hornblower and Marshall's National Museum of Natural History (1911), Henry Bacon's Lincoln Memorial (1911–1922), and Charles A. Platt's Freer Gallery of Art (1923). Contemporary with the Pentagon were the West Building of the National Gallery of Art and the Jefferson Memorial, both by John Russell Pope.

Only 2 or 3 years before the Pentagon project was initiated three of Europe's greatest architects, fleeing Nazi Germany, had been invited to important teaching posts at Harvard (Walter Gropius and Marcel Breuer) and Illinois Institute of Technology (Ludwig Mies van der Rohe). But it is hardly likely that Somervell would have commissioned them—they were Modernists, foreigners, *and* socialists.

But the architectural style of the Pentagon was neither Neo-Classical nor Modern. The application to include it on the National Register of Historic Places stated that the architectural mode employed is known as "Stripped Classicism," commonly employed for public buildings in the United States and other industrialized nations during the 1930s and 1940s. Indeed, it was popular with democracies and dictatorships alike. Noting that it was the last Stripped Classical public building near Washington's Monumental Core, the document explained that in the style,

> elements of the classical tradition (e.g. columns, moldings) were retained, but were presented in an austere and simple manner in buildings which were designed in the modern functional style. Facades became simplified, their classical ornaments turning angular and disappearing into the masonry, their walls becoming planar and their window openings shallow and anonymous. Symmetry remained an important element of design, as did the classical exterior layering of decorative elements from top to bottom. The proportioning of composition included closures at the ends and a focal point at the center of the building's facades. Another characteristic was the utilization of new materials for building construction, reflecting advances in construction engineering. . . .

Shortly before the Pentagon was built, in Europe Mussolini, Hitler, and Stalin were using monumental Stripped Classical architecture to "oppressive and soul-destroying ends." In 1935 Benito Mussolini commissioned the *Esposizione Universale Roma*, a huge complex of office buildings and apartment blocks that he planned to open in 1942 in celebration of 20 years of Italian fascism. *New York Times* journalist Alessandra Stanley, observing that architecture was Mussolini's "favorite mode of propaganda," pointed out that "Fascist architects . . . sought to blend the classicism of ancient Rome with twentieth-century functionalism and rationalism."[7]

Albert Speer wrote in *Adolf Hitler. Bilder aus dem Leben des Führers* (*Adolf Hitler. Pictures from the Life of the Führer*) in 1936 that fate introduced Hitler to Paul Ludwig Troost, who had preceded Speer in the role of the Nazi leader's architect. He noted that Troost had an architectural impact on Hitler, who was himself a failed architect obsessed with the idea of building Germania, a modern-day Rome for his Third Reich. Troost's *Haus der Deutschen Kunst* (House of German Art) in Munich, designed in 1933, was one of Hitler's first projects in the Stripped Classical style. Speer observed, "One can already see here the characteristics of the buildings that followed after the seizure of power: austere and plain, but never monotonous. It was simple and

clear, with no false decoration. Decorations were few, but each was in its proper place. The material, form, and lines were elegant."

As to Stalin, a recent Ukrainian journal editorializes, "Like all dictators, [he] considered himself a leading thinker in a number of fields including architecture." He imposed "his megalomania on the Soviet people through the . . . erection of dominating architecture designed to inspire awe among the masses. Dubbed 'Stalinist architecture,' this phenomenon has become a world-renowned calling card of imperial ideology and propaganda, and typically features monumentality together with eclectic touches of [historic] styles."

So, in the light of what was happening in European architecture in the 1930s, questions must be asked about the style chosen for the Pentagon. Was it constrained by its Neo-Classical environment, or by the urgency of the project and the austerity of incipient wartime? Was it limited by the skills of its principal designers? Or was there always the intention that, after a war of unpredictable length, it would not become an extravagant records repository, but the tangible focus of a military-industrial complex—to use Washington Headquarters Service's own words—"associated with events that have made a significant contribution to the geo-political role of the United States as a superpower during the period from World War II to the present?"

BUILDING THE PENTAGON

A cost-plus-fixed-fee construction contract was awarded to three companies: the Philadelphia firm of John McShain Inc., that had been building in the Federal District since 1934, and secondary contractors Doyle and Russell, and the Wise Contracting Co., both of Richmond, Virginia, chosen when Somervell rejected two New York tenderers. At least 500,000 square feet of offices had to be ready for occupation before May 1, 1942. The mechanical services contract was awarded on September 3, 1941, and that for site works 3 weeks later.

Oversight of the massive project was put in the hands of Colonel Leslie Richard Groves, deputy chief of Construction in the Quartermaster General's Office. He enjoyed a reputation for "high intelligence, tremendous drive and energy"; also, it is said, he was ruthless, arrogant, and self-confident—traits that served him well in slashing the red tape that often delays government projects. Groves guided the earliest stages of the Pentagon; in summer 1942 he was recognized as the fittest person to administer the embryonic Manhattan Project to build the atomic bomb. Meanwhile, he and Somervell selected Captain Clarence Renshaw of the Corps of Engineers as district engineer in charge—Casey called him a "very conscientious person."

By itself, the disused airport was not big enough for the building and parking area. It was augmented by 57 acres from the southern end of Arlington Farms and 80 from an Army depot site. In addition, more than 160 parcels of

land, many of them in private ownership, were compulsorily acquired to build roads. Of course, Casey's misgivings about building on marshland were justified. The site had to be cleared, graded, and levelled with 5.5 million of tons of earth fill, which would never support the building. The Raymond Concrete Pile Company drove more than forty-one thousand steel-cased, concrete-filled piles 50 feet into the underlying clay.

Some historians have recognized that the Pentagon also had another foundation—one of "lies, secrecy and cost overruns." Those responsible for the new War Department repeatedly lied about money. Much of the budget blowout was incurred because Somervell increased the number of floors, a decision he hid from Congress. As originally approved, the inner and outer rings of the building had five floors; the intermediate rings had four. Although a doublespeak press release described "a three-story building with basement," that "basement" was in fact *above* ground; the planned below-ground levels—a sub-basement (euphemistically called a "mezzanine") and sub-sub-basement—were not mentioned. Then, when work was 40 percent complete, Somervell instructed the contractors to remove the roofs from the intermediate rings and add another floor; other doublespeak submission to Congress called it a "fourth floor—intermediate." That gave the Pentagon a uniform height: five stories and seven levels.

In September 1941 Somervell's estimate of the cost was $31 million. In February 1944—about a year after the building was finished — the Army Department reported that $63.5 million had been spent. That comprised nearly $50 million for the main building and $13.5 million for access roads, parking lots, drainage and site works, and the power and heating plant (in a separate structure). The access road system—28 miles of it, at a million dollars a mile—included twenty-one overpasses and bridges and three cloverleaf interchanges, among the earliest constructed in America. In general, landscaping was pragmatic rather than aesthetic—just enough to prevent soil erosion and protect structures. Grading was the minimum required to achieve safe road shoulders. A contemporary report says that the work was done by "squads of Negro women, who all [wore] straw hats, cotton blouses and blue dungaree trousers, giving the countryside something of a plantation aspect." Later, the austerity of the Pentagon's parking lot-flanked site would be alleviated by expansive, formally landscaped—well, grassed at least—ceremonial terraces in front of the Mall and River Entrances.

It had been decided at some stage to extend water supply and sewerage beyond what was needed for the Pentagon, to serve other federal buildings in the area. Somervell tried to disguise all the extra work as a separate contract and approached the appropriations committees for more funds. Later sources put the final cost at $83 million. Congress kept on handing Somervell money. Nevertheless, the end, no matter how noble or necessary, does not justify dubious means. His duplicity cannot be excused, but perhaps it can be explained. To quote the English lexicographer Samuel Johnson, "Among the

calamities of war may be jointly numbered the diminution of the love of truth, by the falsehoods which interest dictates and credulity encourages"; the axiom was (supposedly) abridged in 1918 by Republican Senator Hiram W. Johnson as "the first casualty when war comes is truth."

Begun in the looming shadow of conflict, when "national security directed every effort towards provisions for war at the greatest possible speed," about 3 months after groundbreaking work on the building was made much more urgent by the Japanese attack on Pearl Harbor. Consequently, many behind-schedule military projects were re-energized. An *Engineering News-Record* editorial declared, "Building for defense is a thing of the past. The construction industry's new standard must be emblazoned 'Building for Battle.' There is a difference. Time was short. Now there is no more time." The redtapery that earlier had entangled approval processes could no longer be tolerated; national indignation about Pearl Harbor gave *carte blanche* to build an even larger headquarters without the pettifogging interference of city planners, the CFA, or even Congress.

The budget was greatly exceeded for other reasons. The extra cost of pile foundations resulting from the change of site has been mentioned already. To that may be added the increased cost of providing for the mooted postwar use as records storage—that demanded that the reinforced concrete frame had to carry about 2½ times the live loads imposed by normal office traffic.

Moreover, "Haste makes waste." Preliminary design and documentation took about 5 weeks—but it was *only* preliminary. One source says that Bergstrom's office staff of 327 architects and engineers generated a weekly output of between twelve thousand and thirty thousand blueprints, containing directions that were supervised on-site by 117 inspectors. Another enthusiastic journalist put the number of construction professionals at one thousand! Whatever the case, ensuring that the contractors received consistent instructions must have been a nightmare; doubtless much of the documentation was contradictory or at best repetitive. Army Corps of Engineers historian Janet McDonnell writes, "Sometimes construction actually outpaced planning." Revised contract documents (often printed the previous night) were given to builders only hours before the work was to be executed. Other *ad hoc* design decisions were made by the builders themselves, and architects and engineers renovating the Pentagon (over 50 years later) found large sections of the building for which there was no documentation; in cases where there were drawings, they bore little relation to what had been actually built. Such "design on the run" inevitably led to costly inefficiencies.

Other increases were due in part to hurried design development, leading to waste space. Despite the repeated boasts that a "[prime objective], rapid communications with coordinated action, was a design so effective that . . . any one point may be reached from another within the building by a walk of not more than six minutes," only 40 percent of the Pentagon's floor area is usable office space. If ancillary rooms are included, the plan efficiency increases to a

mere 56 percent. Present-day design criteria for offices set the figure at a minimum of 75 percent.

Then there was the extra financial cost—quite apart from the social one—of racial segregation. One of Groves' last decisions was to provide separate dining and toilet facilities for whites and "colored people." When Roosevelt, visiting the nearly finished building, queried the provision of more than two hundred lavatories he was told that the Army was abiding by Virginia's racial laws. Roosevelt immediately overrode Groves' instructions and had the "whites only" signs removed. For a long time the Pentagon would be the only place in Virginia where segregation was forbidden.

The diversion of raw materials for war production constrained the major design decision. The choice of a reinforced concrete, rather than a steel structural frame—saving an estimated 43,000 tons of steel—satisfied the Office of Production Management, which had been formed in January 1941 to manage national resources for defense. In the course of construction, nearly 700,000 tons of sand and gravel were dredged from the Potomac, feeding an on-site mixing plant that produced 3,000 cubic yards of concrete a day to be trucked to the pour sites. The building was constructed as a slab, beam, and girder system supported on mostly square spirally reinforced columns; floor spans were 10-foot centers on lower floors and 20-foot centers on fifth floor. The primary structure of the Pentagon is thus a veritable forest of 42,420 concrete columns—a system that does not lend itself to efficient use of interior space.

There were other savings. The Corps of Engineers' official history notes that to reduce steel requirements concrete ramps were substituted for passenger elevators. Concrete drainpipes were used. There were no bronze doors, copper ornaments, or metal toilet partitions, "no unnecessary ornamentation, no fountains, no 'marble constructing the Pentagon halls.'" Except for some 6-inch bases and just ten pieces of stringer facing, no marble was used in the building; indeed, Roosevelt personally had forbidden it. Vogel remarks that the designers even spent extra to *remove* marble "so as to give [the building] an appearance of frugality." Yet while the builders of the Pentagon strained at gnats they swallowed camels. Certainly they legitimately "minimized or avoided using critical war materials," but the impression of thrift they attempted to convey by minor details was overwhelmingly contradicted by the grossly wasteful overall design.

There were human costs as well. The urgency contributed to an inordinate number of industrial accidents—four times the average for Army construction projects. Generally, they were also of a more serious nature than normal. It has been commented that "speed seemed more important than safety." There were even several rumors that workmen were accidentally buried in the foundations.

As noted, building the Pentagon started as a rush job that became more urgent after the bombing of Pearl Harbor. Separate construction crews were assigned to each of the five "wedges." As a wedge was finished, Army personnel

moved in. By the end of April 1941, the first 600,000 square feet were handed over to the Ordnance Department, and the entire building was completed in just 16 months, by January 15, 1943. Normally, a structure of that size took 4 years to finish. The earlier construction phases were disrupted by (among other things) the decision to add an extra floor, late delivery of reinforcing steel, and strikes by ironworkers and plumbers. Besides that, as Yonatan Lupu writes,

> Various members of Congress attempted to curry favor with voters by persuading Somervell to construct the building using materials . . . from their home districts. The Commission of Fine Arts hoped to turn the courtyard in the center of the Pentagon into a "training ground for aspiring muralists and sculptors," a proposition that today seems quaint and quixotic.[8]

Stanley Nance Allan, a tradesman employed on the site, recalled 60 years later:

> We carpenters and several thousand other workmen, comprised the basic construction team—surveyors, drilling rig operators, laborers, water boys, iron workers, cement finishers, stone masons, plasterers, painters, roofers and special technicians. Electricians, plumbers and steamfitters were hard to find. By [1 December 1941] 4,000 men were working three shifts. . . . [Following Pearl Harbor] the number . . . increased to a peak of approximately 15,000. . . .
>
> Workers of all ages, with various useful skills and experience, poured in from all over the region. Well paying construction jobs were just beginning to become readily available after the long years of the Depression. . . . Drinking [and] gambling . . . during lunch breaks or after work on the job-site was forbidden. The on-site union shop stewards for all trades saw to it that everyone was paying their monthly dues. We worked 40 hours each week [for] the union wage of $1.625 an hour. There was occasional overtime to get ready for a large concrete pour early the next morning.[9]

THE PENTAGON INSIDE AND OUT

With the largest ground area of any office building in the world, the Pentagon covered 34 acres. It had three times the floor area of the Empire State Building and 17.5 miles of corridors. The building consists of five concentric pentagonal ranges, five stories high, around a 5-acre central courtyard. Each of its almost featureless 80-foot high outer walls is over 920 feet long, pierced (except at the top story) with rectangular windows. They are built of reinforced concrete (although nonloadbearing), faced with Indiana limestone and backed with brick. The ranges, separated by interior courts that serve as light wells, are connected by ten radial corridors. The external walls of the inner ranges (also nonstructural) are in-situ, off-the-form concrete; Groves thought that brick would expedite construction, but Bergstrom's "insistence" on concrete

added $650,000 to the cost—a bagatelle, given the total outlay. Originally each floor was painted a different color: the first was earthen brown, the second green, and the top three were red, grey, and blue, respectively. The sloped roofs of the innermost and outermost ranges were covered with mottled green Vermont slates, for camouflage purposes; the intermediate ranges had built-up roofing on flat concrete slabs. Ramps and escalators as well as stairs provided access between floors; a dozen elevators were reserved for freight and high-ranking officers.

The huge building housed staff numbers equivalent to over two-thirds the then-population of Arlington County that was almost incomprehensible. One war-time employee recalled, "There was a restaurant, several cafeterias, a beauty parlor, barber shop and many of the conveniences of a small village. There was even a hospital and doctors in residence."

> Three hundred policemen doubled as firefighters. There were 4,000 clocks and 17.1 acres of window glass. Four women were assigned to change the 6,000 light bulbs that burned out daily. [The Pentagon] contained 68,000 miles of telephone wires, and the switchboard could accommodate a city of 125,000 people. A pneumatic tube system rapidly transmitted messages around the building. Each of the five radial intersections on each floor contained a beverage bar. At these, the lunch counters, and cafeterias, 7,000 people could eat and drink at the same time. Fifty-five thousand meals were served daily. During good weather, secretaries could eat their lunches in the . . . center courtyard.[10]

During the Cold War there was an apocryphal story about that courtyard. Through satellite surveillance the Russians reportedly saw U.S. military personnel coming and going from the 1980s hotdog stand at its center and thought it led to an underground bunker. It was rumored that a Soviet nuclear ICBM was aimed at the stand, earning it the nickname "Café Ground Zero." Allegedly, it was painted with a huge bull's-eye—a grim joke that became tasteless after the events of September 11, 2001. The café was replaced in 2007.

Some employees arrived at the Pentagon by taxicab or in their own cars; the parking lots, though not as large as Somervell wanted, provided for 8,000 vehicles. But most commuted by bus across the Potomac to a "multi-lane main concourse that allowed twenty-eight buses to unload at one time." Their work schedules were staggered to ease traffic congestion. Lee writes that at first they resented the journey and, together with much of the population of Washington, hated the building:

> Washingtonians, accustomed to thinking in terms of gargantuan, were talking in awe of the largest air-conditioned structure and biggest office building in the world. The new design was confusing to [them]. Early in its construction, Pentagonians claimed the designer went mad after its completion; others argued that he was insane before he designed it. [They] called the complex Pantygon

(because you walked your pants off), and Washingtonians referred to it as Hellangon, because it seemed so remote from the rest of [the capital.][11]

Richard Halloran wrote in *The New York Times* in 1982, "Physically and politically, the Pentagon is the butt of endless jokes" and ungrammatically described it as "a low-lying block of concrete that could easily win a booby prize for architecture and has a reputation . . . for being dreary." Epithets had been attached to it for 40 years; even after it became officially known as The Pentagon, many dubbed it "Somervell's Folly," and soon after its completion *The New York Times* labeled it as a "great, concrete doughnut of a building [and] a maze of corridors, courts, ramps and roads."

The complexity of getting around within the Pentagon is underscored by the following verbatim extract from the *Pentagon Information Kit*, written by one Colonel Tom Moore, and issued by the Office of the U.S. Army Deputy Chief of Staff to its new employees:

> Here's a physical description of the Pentagon: it's a five sided, five story (plus two basements. . . that we know of . . .) building containing a large central courtyard and five concentric (five sided) rings of offices.
>
> *Floors:* numbered 1 through 5, except for the basements, which are labeled M (for Mezzanine) and B (for Basement . . .). Note that most people would think of the second floor of the Pentagon as its "main" floor.
>
> *Concentric rings:* labeled A through E (except in the basement, where there are also ring segments labeled F and G).
>
> *Office numbers:* starting with 100 and ending with 1099 as one proceeds in a clockwise direction around one of the concentric rings.
>
> *Radial corridors:* numbered 1 through 10, starting with the radial corridor off the south end of the concourse.
>
> Thus office number 3E210 is on the third floor, in the E Ring, about two tenths of the way around the E Ring in the clockwise direction, starting from the middle of the concourse. The radial corridors go between the concentric rings (and thus radiate outward from the central courtyard) are found where two adjacent sides of the building come together. Oddly enough, the radial corridor numbering and the room numbering are connected. For instance, if you walk down corridor 7 to its intersection with the D Ring, you will find that offices on the D Ring to your left are numbered in the seven hundreds and that offices on the D Ring to your right are numbered in the seven hundreds. Here is your first quiz: find Room BG634A in the Pentagon and report back here. You have ten minutes. (Hint: to make sure you can find your way back to turn in your paper, use a ball of string.)

So "maze" was an appropriate word for *The New York Times* to use. One war-time employee remembered, "People were always getting lost in The Building" (many Pentagon workers still refer to it simply as "The Building").

He explained, "Since [it] is built in the form of concentric rings, one loses all sense of direction inside of it. Many people had difficulty finding their offices." Anecdotes about the confusing complexity of the layout abounded. It is said that messengers and delivery boys made their rounds on roller skates or even bicycles. There is also a myth about a Western Union boy who, after being lost in the corridors for 3 days, finally surfaced as a lieutenant colonel. Another tells of a pregnant woman who asked a Pentagon guard to get her to a maternity hospital urgently. "Lady," he said, "you shouldn't have come into this building in that condition," only to be answered, "I *didn't know* I was in this condition when I came in!"

PENREN: The Pentagon Renovation Program

The Pentagon Renovation Program (PENREN) was prompted not only by terrorist attacks on U.S. government buildings at home and abroad, but also by necessity because the facility was "woefully dysfunctional," with leaking pipes, asbestos ductwork, a basement floor that in places had subsided by a foot, and electrical and communications systems that had been "incrementally jerry-rigged to bring them up from 1940s standards." To satisfy modern fire and occupational health and safety codes and to provide up-to-date electrical, air conditioning, and ventilating services, renovations were needed. In 1991 the administrator of General Services transferred ownership of The Building to the Secretary of Defense.

The Defense Department's stated goal was to achieve by 2014 (later revised to 2010) "a completed project that has uniform and compatible materials and systems that are economic to maintain." It was estimated that the complex PENREN—the project of its kind in the United States—would cost $1.8 billion. In combination, the building's size and the complexity of its services, the need to temporarily relocate personnel, and not least the issues of national security called for careful logistical planning that would include temporary offices for about 20 percent of the building's occupants at any one time; master planning, budgeting, and replacement of all supporting utility lines into the building; some new facilities on the exterior of the building; relocation of some facilities and the renovation of the entire building—all while keeping it in operation.

A concept plan was approved in 1990: the Pentagon would be renovated in five stages, each dealing with a one million square-foot "wedge": the basement would be fixed separately. Although exterior walls and windows would be upgraded "to provide a measure of resistance to extreme lateral pressures" (read, bombing), the otherwise ubiquitous renovation would not affect the basic structure, including the stairwells. The most significant work would include the total replacement of all partitions to create flexible open-plan offices—a big call, given the extremely tight column grid at the lower levels—and new

ceilings and floor finishes. The complete gutting of The Pentagon was dictated by the "wide-spread presence of asbestos"; there was an estimated 58,000 tons of asbestos-contaminated material throughout the building. The replacement of the plumbing was prompted by the "high probability of catastrophic failure." The renovation program expansively promised to provide

> new mechanical, electrical, and plumbing systems, sprinkler systems, vertical transportation, cable management systems, improvements in fire and life safety systems, and flexible ceiling, lighting, and partition systems. [It] will also provide accessibility throughout for persons with disabilities and will include the addition of over fifty elevators. It will preserve historic elements, upgrade food service facilities, construct co-located operation centers, install modern telecommunications support features, comply with energy conservation and environmental requirements, reorganize materials handling, and provide safety improvements in vehicular and pedestrian traffic.

When the Pentagon's obsolete heating and refrigeration plant, located in a separate building, ceased to be serviceable in 1989, the owners had rented temporary replacements. As the first phase of renovation, new plant was installed in 1998. Renovation of part of the basement on the main building, started in October 1994, was completed in 1999; design of the remaining basement reconstruction began in 1997.

Transformation and Tragedy

The design of Wedge One renovations began in January 1994, and construction started 4 years later. The journal *Program Manager* succinctly reported in January 2002, "Wedge 1 is the chevron-shaped space accessed by Corridors 3 and 4, encompassing all five floors of the Pentagon. . . . Structural demolition and the abatement of hazardous materials began in 1998, followed by the installation of new utilities and the build-out of tenant areas. A phased move-in of tenants began in February 2001." In September 2001 a new team of architects, engineers, and builders had begun construction work on Wedge Two. What happened next was, of course, unforeseen.

A little after 9:30 A.M. on September 11, 2001, terrorists intentionally crashed a hijacked American Airlines Boeing 757 into Wedge One at 500 mph. In one sense, that point of impact was fortuitous, but in every other, tragic. Sixty-four people on board the airliner and 125 Pentagon employees were killed; 110 other people were seriously injured. The jet hit at the ground floor of the external range and penetrated to the central range; together with the explosion and consequent fire, it demolished all five stories and created a 100-foot wide hole. But "the collapse, fatalities, and damage were mitigated by the Pentagon's

resilient structural system. Very few upgraded windows installed during the renovation broke during the impact and deflagration of aircraft fuel." *Civil Engineering* magazine reported that the steel framing that had been added to concrete walls of the Pentagon's held them up for approximately half an hour before they collapsed allowing many staff on the floors directly above the impact to escape the building unharmed. Two-inch-thick blast-resistant windows limited flying glass; and Kevlar-type cloth that had been applied between steel beams to the insides of the external walls arrested fragments that imploded.

Most of the work in the Wedge One phase, completed at a cost of $258 million, was utterly destroyed. Within a week the PENREN awarded a contract for the "Phoenix Project"—reconstruction of the damaged building. Offices that were only slightly damaged were reoccupied within about 3 weeks, and the unsalvageable areas were demolished by November 19. Symbolically, the reconstruction was completed on schedule on September 11, 2002; it cost $526 million, around $200 million under budget. In March 2003 the tenants returned to Wedge One offices. Another $758-million contract was let for the design and construction of Wedges Two through Five; the nature and extent of the work was the same, and the schedule was revised. Despite the setback, PENREN managers were confident that they would achieve their "overall schedule for completion of the Pentagon in December 2012."

NOTES

1. Rybczynski, Witold, "The Office," *New York Times Sunday Book Review* (June 10, 2007), 1.

2. "The Language of War" broadcast on "America's Defense Monitor." www .cdi.org/adm/Transcripts/345/

3. Oddy, Jason, "Shock and Awe Central," *Independent on Sunday* (March 30, 2003).

4. www.washingtonpost.com/wp-srv/local/2000/pentagon0426.htm

5. "Architects Scolded," *Time* (February 11, 1929).

6. Vogel, Steve, "How the Pentagon Got Its Shape," *Washington Post* (May 26, 2007).

7. Stanley, Alessandra, "Italy's Fascist Buildings in Style, and for Sale," *New York Times* (July 12, 2000).

8. Lupu, Yonatan, "Building the Pentagon—In a Hurry and Over Budget," *San Francisco Chronicle* (June 10, 2007).

9. Allan, Stanley Nance, "Building the Pentagon." www.chilit.org/Papers%20 by%20author/Allan%20-%20Pentagon.HTM

10. Lee, R. Alton, "Building the Pentagon," *USA Today*, 121(January 1993).

11. Lee

FURTHER READING

"Access to the World's Largest Building: The War Dept.'s Pentagon, Washington." *Engineering News-Record* (March 25, 1943), 68–72.

Alexander, David. *The Building: A Biography of the Pentagon*. St. Paul, MN: MBI Publishing; Zenith Press, 2007.

Carroll, James. *House of War: The Pentagon and the Disastrous Rise of American Power*. Boston: Houghton Mifflin, 2006.

Fine, Lenore and Jesse A. Remington. *U.S. Army in World War II. The Technical Services the Corps of Engineers: Construction in the U.S.* Washington, DC: Office of the Chief of Military History, U.S. Army, 1972.

Goldberg, Alfred. *The Pentagon: The First Fifty Years*. Washington, DC: Historical Office, Office of the Secretary of Defense, 1992.

"Government Office Building at Arlington, Virginia, for War Department: The 'Pentagon Building'." *American City* (March 1943), 44–45. See also *Architectural Forum* (January 1943), 36–52 and *Architectural Record* (January 1943), 63–70.

Hunkele, Lester M., Julian Sabbatini and Gary Helminski. "The Pentagon Project." *Civil Engineering*, 71(June 2001), 38–45.

McDonnell, Janet A. "Constructing the Pentagon." In Barry W. Fowle, ed., *Builders and Fighters: U.S. Army Engineers in World War II*. Washington, DC: Office of History, U.S. Army Corps of Engineers, 1992.

Ross, F.E. "Architectural Concrete Work on Pentagon Building (War Department), Washington." *Architectural Concrete*, 9(no. 1, 1943), 17–21.

Vogel, Steve. *The Pentagon: A History: The Untold Story of the Wartime Race to Build the Pentagon—and to Restore It Sixty Years Later*. New York: Random House, 2007.

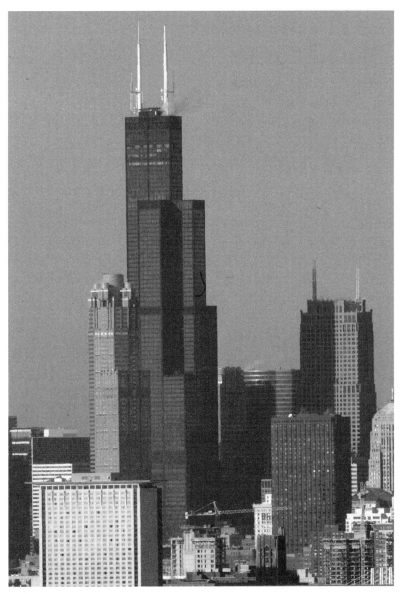

Courtesy Associated Press

Sears Tower, Chicago, Illinois

"One more mountain"

The Chicago area is an architect magnet. To begin with, as will be shown, the city is rightly regarded as the home of the skyscraper. It is the location of the best work of the "father on modernism"—Louis Sullivan—especially the Auditorium Building (now Roosevelt University). More than 80 years after the event the international design competition for the *Chicago Tribune* building still provides fodder for architectural scholars. And many projects by the German-American arch-Modernist, Ludwig Mies van der Rohe, including his highly influential steel-and-glass high-rise apartment blocks and the Illinois Institute of Technology campus, are in the "Windy City." The list of great architects and architecture goes on. Not least, in Oak Park and River Forest—now nearby suburbs—stand the early seminal works of the incomparable Frank Lloyd Wright. The region is replete with icons for architects. But, has been pointed out elsewhere in these essays, the meanings of icons are in people.

The Sears Tower, for many years the tallest building in the world, is presented to the wider public as an icon of Chicago. Asserting that the building's unusual shape immediately gave it a place alongside John Hancock Center and Marina City as the Chicago skyscrapers most frequently illustrated on souvenirs, the *Chicago Tribune*'s architecture critic Paul Gapp asked, "Is this a bizarre index for archaeologists of the distant future?"—whatever he meant by that. Although architectural historian Dale Allen Gyure sees the "large and impressive" Sears Tower as an "unmistakable symbol of the city's pride in its heritage as the birthplace of a uniquely American concept, the modern skyscraper," he observes that it did not quite capture the hearts of Chicago's citizens in the way that the John Hancock Center did. But he *does* allow that it "epitomizes the bustling prairie metropolis that Carl Sandburg called the 'City of Big Shoulders.'" Indeed. As the building's designer put it: "Tall buildings are man-made. Towers have historically been not only the pride of their temporary owners, but of their cities as well. So the Sears Tower, one more mountain, was created for this city on the plains." And who should know better than its architect?

Besides, each year about 1.3 million tourists take the 45-second elevator ride to the Sears Tower Skydeck. On the 103rd story it is the highest observatory in Chicago. From 1,353 feet above the city streets, on a clear day those visitors can see, not quite forever, but for 50 miles across Michigan to Indiana, Illinois, and Wisconsin. Those who care for such an adventure can experience how the building sways 6 inches from the center on a windy day. A second Skydeck, four floors lower, is used when it is closed; access to the Skydecks is through a separate tourist entrance, added in 1985.

DOES BIGGER MEAN BETTER?

The "race for the sky" began a very long time ago in the Tigris-Euphrates Valley. The book of Genesis recounts, "As people moved toward the east, they

found a plain in Babylonia and settled there. They said to one another, 'Let's make bricks and bake them thoroughly.' They used bricks as stones and pitch as mortar. Then they said, 'Let's build a city for ourselves and a tower with its top in the sky.' " Early in the twentieth century there was in America (really only in New York City) intense rivalry for the tallest building status. At first the race was between the 927-foot Bank of Manhattan Trust Company on Wall Street, completed in April 1929, and the 1,048-foot Chrysler Building on 42nd and Lexington Avenue, whose architect, 6 months later, held a last-minute surprise in store, when he added (in just an hour and a half) the distinctive prefabricated spire that made it not only New York's, nor America's, but the world's tallest building. But both towers were surpassed in May 1931 by the 1,472-foot Empire State Building, which held the record for 42 years. It was succeeded by New York's World Trade Center 1 (tragically destroyed on September 11, 2001). The Sears Tower, opened in 1974, was 3 feet higher again. And it wasn't in New York.

When the twin Petronas Towers in Kuala Lumpur, Malaysia, were completed in 1998, their spires extended 30 feet higher than the Sears Tower roof. This led to an international argument over which building was taller. The U.S.-based Council on Tall Buildings and Urban Habitat (CTBUH), whose mission is to "study and report on all aspects of the planning, design, and construction of tall buildings," controversially relegated the Sears Tower to not second tallest, but third (presumably because there were *two* Petronas Towers, albeit joined by a skybridge at the forty-first floor), and pronounced Petronas as world's tallest. Consequently (as though it really matters), CTBUH devised four categories of "tallness" for "habitable buildings"—defined as framed structures with floors and walls throughout.

Thus in 1999 the Sears Tower held first place in the "highest occupied floor" and "height to the top of the roof" categories; Petronas held "height to the structural or architectural top (including spires and pinnacles, but not antennas, masts or flagpoles)"; and the World Trade Center held "height to the top of antenna"—a distinction that was lost in 2000 when the Sears Tower added a new broadcast antenna.

Completed in April 2004, Taiwan's Taipei 101 immediately toppled all the records except that held by the Sears Tower. Everything is expected to change again with *Burj Dubai* (Dubai Tower); due to be opened in 2009, it will reach 2,684 feet at the top of its spires. Other Middle Eastern buildings presently in course of construction will go even higher. Jealous competition between developers means that their projects are shrouded in secrecy. *Al Burj*, also in Dubai, may extend to 3,937 feet high; another is the proposed 3,284-foot *Burj Mubarak al-Kabir* in Kuwait, part of a vast 25-year development, *Madinat al-Hareer*, and the proposed Murjan Tower in Manama, Bahrain, will be 3,353 feet high.

It is worth commenting that this race to the sky puts Frank Lloyd Wright's unrealized 1956 design for the mile-high "Illinois" skyscraper in a different

light from when it was first exhibited. Wright, America's greatest architect and then almost 90 years old, hated skyscrapers; he had called New York an "incongruous mantrap of monstrous dimensions!" Wright's own extensive, generally ground-hugging *opus* included only three tall buildings, each innovative in its way. Two were built: the fifteen-story Johnson Wax laboratory tower in Racine, Wisconsin (1944–1950) and the nineteen-story H.C. Price Company Tower in Bartlesville, Oklahoma (1952–1956). The third—the mile-high tower—was visionary.

Wright intended the skyscraper to be the focal point of his theoretical Broadacre City that he had begun planning in the 1920s. As its name implied, Broadacre was essentially a spreading horizontal project, but Wright later decided that even it would benefit from a tall building as a cultural and social nucleus. The foundation of the mile-high tower was massive, a deep rooted inverted-tripod column; it supported a tapering tower with cantilevered floors (all ideas Wright had used before). To reach the upper floors, Wright proposed atomic-powered elevators that could carry one hundred people. The 528-story building, designed for Broadacre City but intended for Chicago, would have housed one hundred thousand people. Had it been realized, it would have been the tallest building in the world. In 1956 it was neither technologically nor economically feasible. But now?

"THE MOST DISTINCTIVELY AMERICAN THING IN THE WORLD"

Only seldom, whether for ideological, political, or pragmatic reasons, has a society produced a new building type that was the product of invention, rather than convention. Even the earliest Christian basilicas had precedents in pagan society. William Starrett, the contractor who built (among many other skyscrapers) the Empire State, called the building type "the most distinctively American thing in the world." The term first had been used in an *American Architect and Building News* article 45 years earlier, referring to structures whose form expressed "that peculiar refined, independent, self-contained, daring, bold, heaven-reaching, erratic, piratic, Quixotic, American thought." The skyscraper was an invention in which those qualities were recognized, not least by deeply interested Europeans.

A network of necessities gave birth to the tall commercial building. By about 1870 America was becoming an urban industrial nation, and Chicago, then the country's fourth largest city, was a major focus of that change. Historian Carl Smith writes that since the Civil War Chicago had been the greatest railroad city in the world.

> The level landscape that surrounded it for miles may have lacked stunning beauty, but it helped make Chicago the ultimate railroad nexus. . . . [The] trains carried not only people, but also massive amounts of grain, meat, lumber and

other commodities, as well as a rapidly expanding volume of manufactured goods, establishing Chicago as the country's great inland mercantile and industrial metropolis.[1]

Most of Chicago's buildings were wooden, so fires were a constant problem; in fact, there were over six hundred in 1870. But the devastating conflagration that started on October 8, 1871, swept through 73 miles of streets in just 30 hours, killing about three hundred people, leaving one hundred thousand homeless and many more jobless. It destroyed eighteen thousand buildings, causing $200 million in property damage—one-third of Chicago's total value—and many fortunes were lost. The Great Fire was catalytic—but only catalytic—in combining existing theoretical and structural innovations to form a new architecture. The style that historians have dubbed "Chicago School" was born of the will of pragmatic clients with eyes on the bottom line. Constrained by commercial factors, not least the soaring land prices (a 600 percent increase from 1880 to 1890), their architects created a new building type and, as someone has said, within a couple of decades of the Great Fire downtown Chicago became "the wonder city of the Western world, its famous Loop the laboratory in which to study innovative commercial architecture."

Designed by Daniel Burnham and John Wellborn Root, the ten-story Montauk Block (1882) for Brooks Brothers of Boston—who insisted that it must be "for use and not for ornament"—was the first building to be called a "skyscraper." Like the same architects' twelve-story Rookery (1885–1886) and their sixteen-story Monadnock Building (1889–1891), it employed load-bearing brick construction. The fact that the Monadnock's ground-level external walls were 6 feet thick, wasting the most valuable floor space, demonstrated that traditional technology was unsuited to the tall building. The economic imperative of real estate value was met by the technological potential of "metallurgical architecture." What would soon develop was a tall office building with a metal frame—first of iron and later of steel—entirely covering its site; the large windows made possible by nonstructural walls provided ventilation and daylight that penetrated well into the interior. The electric elevator—a wonder of the age—gave efficient, time-saving access to upper floors.

Chicagoan William Le Baron Jenney pioneered the technique. His evolving ideas may be seen in the "simple, glass-enclosed cage" of his first Leiter Building (1879) followed by his nine-story Home Insurance Building (1884–1885), the first in which an iron frame replaced self-supporting external walls. The latter demonstrated the potential of skeleton construction. Iron had long been used for ornament and architectural hardware, but not for structure. And engineers, free of the aesthetic formalism that hobbled architects, had applied cast- and wrought-iron to bridges and utilitarian buildings. If architects *did* use iron framing, it was out of sight or in such frivolities as John Nash's Royal Pavilion at Brighton (1818–1821). Henri Labrouste's National Library in

Paris (1862–1868) showed how the metal column offered structural flexibility and a new proportion, and Eiffel and Boileau's Bon Marché department store in Paris (1867) showed how iron and glass lent themselves to commercial spaces. As early as 1848 the New Yorker James Bogardus had been experimenting with iron construction, and low-rise commercial buildings with cast-iron fronts and even cast-iron frames proliferated in American cities between 1850 and 1880.

Iron had two great disadvantages: in fires, it failed at relatively low temperatures; and it had little tensile strength. The first issue was easily addressed: building frames could be encased in fire resistant material. Steel, readily available in large quantities of predictable strength after 1875 (though also needing fire protection), would overcome the second problem. Burnham and Root's entirely steel-framed Rand McNally Building (1889–1890) freed the skyscraper from masonry and created "the plan and structure of the [modern] urban office block." The firm followed it with the fourteen-story Reliance Building (1890–1894). Its first four-story stage, designed by architect Charles B. Atwood and engineer E.C. Shankland, has claim to being the first example of the comprehensive system known as "Chicago construction:" a riveted steel frame with plaster fire-proofing, carrying hollow-tile flooring on steel joists. The projecting windows—"Chicago windows"—had a fixed central pane with opening side lights above terracotta spandrels. The other technological invention that literally underpinned the skyscraper was the development of a foundation design method to provide for the concentrated loads imposed upon the earth.

As noted, a safe, efficient mechanical vertical transportation system was also imperative. Steam-powered traction elevators had been used in Britain since 1835. In America, Elisha Graves Otis installed the first steam-powered passenger elevator in 1857, and by 1873 over two thousand commercial buildings throughout the country had Otis systems. The German Werner von Siemens applied an electric motor to a rack-and-pinion elevator in 1880. Motor technology and safe control methods evolved rapidly, and 7 years later an elevator was built in Baltimore that moved the cage by means of a cable wound on a drum. Otis' direct-connected geared electric elevator was first used in New York City in 1889.

The technology of the skyscraper had been established. But what of an appropriate aesthetic for a new building type? Although tall buildings were nothing new, in an age when architects looked to precedents, the skyscraper had none. As noted, it was distinctly American. In the Old World, most nineteenth-century architects were slow to reflect the significant social changes that sprang from the Industrial Revolution and continued to poach historical styles. The French theorist Eugène Emmanuel Viollet-le-Duc (1814–1879) was not among them; he insisted that new materials must be used in accordance with their properties and honestly expressed in the form of the building. His widely published and translated ideas had an impact in Chicago just

when America was beginning to recognize that it was different from the Old World. Whitman, Emerson, and Greenough had called for a home-grown architecture. Some sources cite Henry Hobson Richardson's Marshall Field Wholesale Store (1885–1887) as the stylistic model for the Chicago School. Jenney, though a structural innovator, had less success in expressing the framed building; he began to address the issue in three Chicago projects, the second Leiter, Fair Store, and Manhattan buildings, all completed by 1891. But better answers were provided by others.

David van Zanten hails Louis Sullivan as the "master of the skyscraper." The Borden Block (1879–1880) by Sullivan and Dankmar Adler had been among the first tall buildings to repudiate solid wall or heavy pier construction. But their first work that exclusively used metal framing, the Wainwright Building (1890–1891) in St. Louis, Missouri, is probably the best prototype of the skyscraper aesthetic. Van Zanten writes,

> It was a ten-story box, as all rental "skyscrapers" were at the time, but it showed its bones as no office building had before. Sullivan's tour de force was to make the exterior transparent of the interior functions. He wrote about this innovation in an 1896 article "The tall office building artistically considered," in which he gave modern architecture its famous dictum: "Form ever follows function."
>
> The first floor was intended to house shops, which required wide openings on the street. The second floor would have public offices . . . with direct access to the first floor by stairs. Above the second floor would soar a stack of floors with identical windows. Sullivan called each office "a cell in a honeycomb . . . nothing more." A closed floor screening the water tanks and the building's machinery would crown the top.
>
> And finally, the Wainwright Building is supported by a thin steel skeleton . . . whose even grid pattern is evident in the equally spaced piers marking the broad window fields of the exterior. The column-like piers stretch vertically, closely spaced to draw the eye upward. This communicates what Sullivan considered the final distinguishing characteristic of a building: its verticality. He once declared, "It must be in every inch a proud and soaring thing."[2]

Sullivan insisted that the façade should include a base (public floors), a shaft (any number of identical upper floors) and a capital (a pronounced cornice crowning the composition). Although he denied that this articulation reflected the column of classical antiquity, the connection is inescapable. All our endeavors, in whatever field, are built upon what we already have.

THE GERMAN CONNECTION: THE SECOND CHICAGO SCHOOL

In 1919 the German architect Walter Gropius, having been appointed director of the Academy of Fine Art and the Academy of Arts and Crafts in Weimar,

amalgamated them to create the National Bauhaus with a focus on improving applied and industrial design. His initiative was influential, probably beyond his expectations; for example, 3 years later the Association of Arts and Industries was established in Chicago "to further the application of good design in industry" and to facilitate keener competition with European products.

In 1924 the social-democratic government of the Weimar Republic was replaced by a conservative party who slashed the Bauhaus' funding and revoked its teachers' contracts. The school moved to Dessau. When Gropius resigned the directorship 4 years later the communist Swiss architect Hannes Meyer succeeded him and introduced architecture into the curriculum. In 1930 a German, Ludwig Mies van der Rohe (Mies), one of the pioneers of Europe Modernist architecture, replaced Meyer. At the end of 1932 the National Socialist (Nazi) government moved the greatly reduced Bauhaus to Berlin-Steiglitz. The Nazi's persistent intimidation compelled Mies to announce its closure in August 1933. The current and former staff—most were on the political left and many were Jewish—fled Germany.

In 1937 the Chicago Association of Arts and Industries invited Gropius to establish a school in Chicago to continue the work of the Bauhaus. But he had already accepted an appointment at Harvard, so he recommended the Hungarian *Bauhausler* László Moholy-Nagy to head the "New Bauhaus: American School of Design." Classes began in October; sadly, financial and other problems led to its closure in a year but in another form it became the Institute of Design, subsumed in 1949 by the Illinois Institute of Technology (IIT). But that is another story. In 1938 Mies arrived in Chicago to assume the role of director of Architecture, Armour Institute of Technology (later IIT) and commenced a private architectural practice. The Art Institute of Chicago exhibited his work, December 1838 to January 1939. These three significant Bauhaus teachers—two of them in Chicago—soon gathered former colleagues around them; their presence changed the approach to architecture and design in their new homeland—and indeed, much further abroad.

According to Mies' biographer Franz Schulze, "the origins of the Second Chicago School are traceable to two powerfully interactive factors: the advent of modernist architecture as a whole in America and Mies' arrival." Mies undertook the extensive redevelopment of the IIT campus, construction of which began toward the close of World War II. In the late 1940s the developer Herbert Greenwald commissioned him to design several high-rise apartment blocks, and Mies "came to regard structure in the abstract as the most important objective of the building art" more than the plan or elevational treatment.

Schulze points out that Mies' dual influences—as a teacher and as an architect to be copied—made themselves "felt most in Chicago" and

> by the late 1950s . . . the first works suggesting the presence of a Miesian school had been realized. Nonetheless, as the fifties passed into the sixties, the term "Miesian" seemed too personal to accommodate a growing body of Chicago

architecture indebted to him but not directly imitative of him, and the notion of a *Chicago* school gained currency. . . . In some quarters an effort was made to show a kinship with what had come to be regarded as a *first* Chicago school, centering on the metal cage and undecorated (or nearly undecorated) frame of the building. Nevertheless, there are as many differences of expressive intent as similarities between the two groups.[3]

Mies' own second Chicago School buildings include the definitive glass-and-steel apartment towers at 860-880 Lake Shore Drive (1951), the Federal Center (1964–1971), and the IBM Building (1971). Other firms associated with the school include C. F. Murphy Associates, who in the 1960s and 1970s designed most of the buildings at O'Hare International Airport; Loebl, Schlossman, & Bennett, architects (with others) of the Richard J. Daley Center (1965); and Harry Weese—it has been said that no tall building in the city has a façade more typical of the Chicago frame than his Time-Life Building of 1969.

But probably the first large firm to put up the high-rise glass-and-steel buildings that demonstrate the main features of the second Chicago School was Skidmore, Owings, & Merrill (SOM). Now an international architectural and engineering megafirm, SOM was established in Chicago in 1936 by architects Louis Skidmore and Nathaniel Owings; 3 years later they were joined by architect/engineer John Merrill. The following year they opened a second office in New York, where in 1952 they completed their first "international style" skyscraper, Lever House. The practice has designed many of the world's tallest buildings including the 1,400-foot Jin Mao Tower in Shanghai (1998) and the *Burj Dubai*, already mentioned, scheduled for occupancy in September 2009.

They also built the Sears Tower. The partners responsible for the project were architect Bruce J. Graham and structural engineer Fazlur Rahman Khan, assisted by Srinivasa (Hal) Iyengar. Graham believes that his professional collaborations with Khan "grew not only because of sympathetic aesthetic preoccupations or the mutual respect with which [they] regarded each other, but also out of [a] vision of the city, of the city beautiful, the purpose of cities and of the pride of human existence."

BRUCE GRAHAM (1925–): "SIMPLE STATEMENTS OF THE TRUTH"

Graham was born to a Canadian father and Peruvian mother in La Cumbre, Colombia. His early education was gained in San Juan, Puerto Rico, after which, with a scholarship at the University of Dayton in Ohio, he studied civil engineering for 2 years. He joined the U.S. Navy in 1942 and returned to study after World War II, receiving a bachelor's degree in architecture from the University of Pennsylvania in 1948. Graham then worked in the Chicago architectural firm of Holabird, Root, and Burgee from 1949 until 1951, when

he joined SOM's Chicago office. He was made a partner in charge of design in 1960 and over the next 30 years specialized in high-rise commercial buildings in Chicago. The first was the Inland Steel Building (1958), a "second Chicago School" skyscraper. Oral historian Betty J. Blum writes,

> Graham's contribution has profoundly shaped and irrevocably changed the character of [Chicago]. Set squarely in the [city's] tradition of structural innovation, Bruce sees his work as a straight-line development that pushes the existing boundaries and clarifies and refines the structural components of architecture. . . . In his own words, [he] describes the cultural framework and personal driving force by which his design production has been guided, as "clear, free of fashion, and simple statements of the truth."[4]

Over thirty of Graham's designs at home and abroad won awards. Among the Chicago projects were the Hartford Building (1959), the Brunswick Building (1965; now the Cook County Administration Building), the John Hancock Center (1970; see sidebar), the Sears Tower—of course—and Holy Angels Parish Church (1990). Elsewhere in the United States he was honored for (among others) the First Wisconsin Center Bank, Milwaukee (1974); Sixty State Street, Boston (1977); and Citicorp Plaza, Los Angeles (1985). In England, where he was awarded honorary membership of the Royal Institute of British Architects, he designed the Boots Company Headquarters in Nottingham (1968), W.D and W.O. Wills Corporation building in Bristol (1974), and London's Canary Wharf Master Plan (1988). He produced the Banco de Occidente in Guatemala City (1977).

Retiring from SOM in 1989, Graham moved with his wife Jane to Hobe Sound, Florida, where they established an architectural practice. He was elected a fellow of the American Institute of Architects (AIA) in 1966 and named an honorary member of the Royal Architects Institute of Canada and the Institute of Urbanism and Planning of Peru.

FAZLUR RAHMAN KHAN (1929–1982): "EINSTEIN OF STRUCTURAL ENGINEERING"

Receiving his early education in Calcutta, India, Khan obtained a first-class degree from Shibpur Engineering College in 1950. After working as an assistant engineer in the India Highway Department and as a teacher at Ahsanullah Engineering College in Dacca, East Pakistan (now Dhaka, Bangladesh), in 1952 he won Ford Foundation and Fulbright scholarships. He enrolled at the University of Illinois at Urbana-Champaign, where in 3 years he earned two master's degrees (in theoretical and applied mechanics and structural engineering) and a doctorate in structural engineering. Briefly back in Pakistan, he was appointed executive engineer of the Karachi Development Authority but "frustrated by administrative demands that kept him from design work," he

returned to America in 1955 and joined SOM's Chicago office. In 1961, he was made a participating associate; in 1966 he became an associate partner and a general partner 4 years later. In 1967 he became a naturalized U.S. citizen.

One of his biographers, Richard Weingardt, claims that during the second half of the twentieth century Khan ushered in a renaissance in skyscraper construction and characterized him as "a pragmatic visionary" who

> epitomized both structural engineering achievement and creative collaborative effort between architect and engineer. Only when architectural design is grounded in structural realities, he believed—thus celebrating architecture's nature as a constructive art, rooted in the earth—can "the resulting aesthetics . . . have a transcendental value and quality." . . . Fazlur Khan was always clear about the purpose of architecture: . . . [He believed that] "the technical man must not be lost in his own technology. He must be able to appreciate life; and life is art, drama, music, and most importantly, people."[5]

Another critic asserts that "[Khan's] contributions and innovative approach to tall building design and attention to aesthetic details . . . have been so significant that he has been called 'the Einstein of structural engineering' and 'the father of modern skyscraper.'" Among his works for SOM were the DeWitt-Chestnut Apartments (1964), the Brunswick Building, the John Hancock Center, the One Magnificent Mile building (completed 1983, after his death), and the Onterie Center (completed 1986)—all in Chicago, as well as One Shell Plaza, in Houston (1971). Outside the United States, his best known projects include the Haj Terminal of the King Abdul Aziz International Airport (1976–1981) and King Abdul Aziz University (1977–1978), both in Jiddah, Saudi Arabia. Khan had other claims to fame—he was a philosopher, writer, and educator and during Bangladesh's 1971 War of Liberation "made laudable contributions in creating public opinion and amassing an emergency fund for the misery stricken people of [what was then East Pakistan]." He died from heart failure in March 1982.

Between 1965 and 1979 Khan was cited five times among those who "served the best interests of the construction industry." During his life he was regaled with many other honors, too numerous to list here: honorary doctoral degrees, awards and medals from professional engineering and architectural organizations in America and abroad, and the Aga Khan Award for Architecture in 1973. The same year he was elected to the U.S. National Academy of Engineering. The Government of Bangladesh posthumously awarded him its Independence Day Medal in 1999 and issued a commemorative postage stamp. In 2005 The Bangladeshi-American Foundation named him the twentieth century's most famous Bangladeshi-American.

When in May 1998 the city of Chicago named the street intersection at the base of the Sears Tower "Fazlur R. Khan Way," President Clinton declared, "Drawing on the richness of his Bengali background and the vigor and energy

of American culture, Fazlur Khan pushed the boundaries of modern architecture and dramatically changed the physical landscape of the great city of Chicago."

"SHOP AT SEARS AND SAVE"

The Sears Tower may be iconic because of its superlative height, but it enjoys that status because it is—or was, when it was built—the *Sears* Tower.

The firm of Sears, Roebuck, and Company, now superseded by Sears Holdings, remains an American icon; its fame is international, spread throughout the English-speaking world through references in pervasive—dare one say invasive—American culture. And on the U.S. domestic stage, as Boris Emmet and John E. Jeuck expansively write, the company has "intrenched itself in the American mind, idiom, humor, and folklore to an extent unequaled since Paul Bunyan and probably unsurpassed in the commercial history of the nation." Fellow historians Tom Mahoney and Leonard Sloane agreed that "no other company is as close to the heart of suburban and rural America."

The compelling rags-to-riches story of Richard Warren Sears (1863–1913), one America's great entrepreneurial geniuses, has been told many times—often with generous embellishment.[6] At the age of 16 he became his family's breadwinner; by 1886 he was working as a station agent for the Minnesota and St. Louis Railroad in Redwood Falls, Minnesota. When a local retailer, Edward Stegerson, refused to accept a speculative consignment of cheaply made watches from a Chicago manufacturer, Sears negotiated a private deal to sell them, making $2 on each watch; within 6 months the young opportunist had made $5,000 profit.

Moving to Minneapolis, he rented space in the Globe Building and established the R.W. Sears Watch Company, a mail-order business with a potential clientele in isolated rural communities. He began by writing letters to prospective buyers, but to expand his market he soon starting advertising in farm publications and mailing out brochures. In March 1887 he moved his operation to a building on Dearborn Street in Chicago, and a month later he hired self-taught watch repairman Alvah Curtis Roebuck (1864–1948) to fix the many defective watches returned by dissatisfied customers.

The following year he began publishing a catalogue, promoting mostly watches, jewelry, and silverware. But more of that later. Then in 1889 Sears abruptly decided to sell the business for $100,000, turning a $72,000 profit. He briefly tried a career in banking in rural Iowa; but soon losing interest, he renewed his association with Roebuck. Two years later, having made "a small fortune" at the age of 28, the mercurial Sears again retired from business; but after only a week he approached Roebuck about again reviving their partnership. In 1892 A.C. Roebuck Inc. was established; it was reorganized and formally incorporated as Sears, Roebuck, and Company a year later. They opened

an office on West Van Buren Street, Chicago, in 1892 and soon after moved into a five-story building on West Adams Street. When they quickly outgrew that building, they again moved in 1896, this time to the Enterprise Building at the corners of Fulton, Des Plaines, and Wayman Streets. By then, Roebuck had left the partnership. The astronomical growth of business over the next 6 years made successive extensions necessary; in addition to its headquarters, the company also rented buildings throughout Chicago to house its merchandise. That was obviously an unsatisfactory arrangement.

"THE NATION'S WISH BOOK"

Of course, the key to Sears and Roebuck's success was the catalogue, carefully, persuasively, and not always truthfully written by Sears himself. It has been claimed that at the turn of the century it had become one of the two books read in rural America. For the "working poor and the geographically isolated" the products it described were the stuff of dreams. The 1891 R.W. Sears Watch Company catalogue had presented a meager thirty-two pages of watches with an eight-page insert of jewelry and sewing machines. The 1892 edition added several pages of testimonials from many contented customers; the next edition had 196 pages. By 1895 the restructured firm was distributing a 532-page book—popularly known as "The Farmer's Bible" and "The Nation's Wish Book"—which included many other items: to name a few, "shoes, women's garments and millinery, wagons, fishing tackle, stoves, furniture, china, musical instruments, saddles, firearms, buggies, bicycles, baby carriages and glassware." Groceries and patent medicines were added in 1896. At its peak in 1915, the general merchandise catalog contained one hundred thousand items in twelve hundred pages and weighed four pounds. Its grateful audience was still rural America, millions of consumers who otherwise had access only to their local general store, which offered a narrow range of goods marked up to outrageous prices for their captive clientele. In many towns, children were converted to bounty hunters, promised a free movie ticket for every Sears catalog they brought into the local store to be destroyed.

During the 1890s the durable, long-lasting catalogue items, such as bicycles, cream separators, and sewing machines were the most popular, so to keep merchandise prices low Sears, Roebuck relied on high turnover of less durable, lower unit-price lines. Customers were offered the opportunity to purchase C.O.D., but all orders initially required a one-dollar "good faith" deposit. There was also a money-back guarantee, an idea copied from the older rival mail order firm, Montgomery Ward. In 1893 Sears, Roebuck's sales passed $400,000; 2 years later the figure had grown beyond $750,000.

With impeccably bad timing (but because of ill health) in 1895 Roebuck sold his interest to Sears for $25,000. At his partner's request, for the next 4

years he managed, as a salaried employee, the watches and jewelry side of the business, and later the Home Entertainment Department. Meanwhile, he "pursued other interests," serving as president of the Emerson Typewriter Company and establishing a manufacturing company and a motion picture equipment company, which he sold in 1924. He semiretired to Florida, where he invested in real estate. But following his losses in the crash of 1929 he returned to Chicago to rejoin Sears, Roebuck—again as an nonexecutive employee—where he devoted his time to promotion and compiling a history of the firm's early days. He died in June 1948.

Following Roebuck's departure in 1895, Sears offered a half-partnership to Aaron Nusbaum, the owner of a pneumatic-tube company. Nusbaum in turn interested his brother-in-law, Julius Rosenwald, a successful Chicago men's clothing manufacturer. In 1896 Rosenwald, who "brought a rational management philosophy to the firm," became a vice president, and in 1901, treasurer. When Sears took on his new partners the company's annual turnover, as noted, was $750,000; 5 years later, sales reached $11 million. In 1900 about eight hundred fifty-three thousand catalogues were distributed to Midwestern and Western households. "The success of the company was helped by fortuitous timing; railroads were expanding across the United States . . . and the Rural Free Delivery Act, which went into effect in 1896, guaranteed the catalogs would be delivered to every single American home, no matter how remote." However, there was friction among the partners. Nusbaum's indecisiveness was a major problem, and at Sears' insistence, Rosenwald and he bought out Nusbaum in 1901.

Constrained by unchecked growth, 3 years later Sears, Roebuck purchased about 42 acres in North Lawndale on Chicago's west side and commissioned architects Nimmons and Fellows to design a complex of buildings "so large that they were compelled to ask the City Council of Chicago to close streets so that they might build over them." Beginning in late January 1905 Rosenwald oversaw the construction of the complex, that included a five-story Administration Building (1905–1914) and a nine-story Mail Order Plant—the world's largest commercial building at the time—with almost 70 acres of floor space. It adjoined the 225-foot, fourteen-story Sears Merchandising Building Tower (1906), the "tallest office building in the U.S. west of Chicago's downtown." There was also a six-story Merchandise Development and Laboratory Building (1906), where the catalogues were printed; and the largest private power plant in Chicago. By 1906 Sears, Roebuck was the largest mail-order business in the world; with annual sales approaching $50 million, it was capitalized at $40 million and had about nine thousand employees. In that same year, needing to raise additional capital, Sears and Rosenwald for the first time sold stock on the open market.

Alarmed by an economic depression in 1907 that caused a 4 percent drop in sales, Sears wanted to spend more on advertising. He and Rosenwald fell

out over the matter, and as a result, "opposed not only by his partner but by men he had personally trained" in 1908 he resigned as president. Appointed chairman of the board, he attended only one meeting before retiring to his farm north of Chicago. He later sold his shares to the Wall Street investment bankers Goldman, Sachs for $10 million. When he died in Waukesha, Wisconsin, in September 1914, he left an estate estimated at $25 million.

"THE GENERAL'S GENERAL STORE"

On Sears' resignation, Rosenwald was named president. He continued in that role until 1924, when he became chairman of the board, a position he held until his death in 1932. Marketing expert Robert Blattberg observes that "Rosenwald created a structure that allowed Sears to be successful," noting that while "Sears was a great marketer, but he didn't really have the internal structure to turn Sears into what it became. Julius Rosenwald . . . was the genius behind the company." According to the corporation's official history, Rosenwald resolved that the company's "primary goal must be responsibility to the customer. He established the 'satisfaction guaranteed or your money back' pledge and conducted his business dealings by the creed 'Sell honest merchandise for less money and more people will buy.'"

Sears, Roebuck had opened branches in Dallas, Texas, and Seattle, Washington, but, although annual sales reached $235 million by 1920, the growth of the mail-order industry was slowing. After the Great War the company faced financial problems. "Rosenwald pledged some $21 million of his personal fortune to rescue the company [and] by 1922, Sears had regained financial stability." The next important player in the firm's history was the former acting Quartermaster General Robert Elkington Wood (1879–1969).

In 1919 Wood had joined Sears' rival Montgomery Ward as its general merchandise manager, later becoming a vice president. In 1924, after disagreeing with the older executives, he left Ward's to become vice president of Sears. Wood recognized the retailing trend that would lead to the modern regional shopping mall and successfully expanded Sears' business into regional stores that were easily accessible to the automobile. The company opened its first such store in 1924; 5 years later there were over three hundred across America. Wood was made president in 1928 and maintained the company's growth through the Great Depression. In 1931 Sears, Roebuck established the Allstate Insurance Co., an automobile insurance business that soon became "one of its parent company's fastest growing and most profitable divisions." It later added life insurance to its portfolio. In 1939, Wood became chairman of the board at Sears, and within two years annual sales reached almost $1 billion. He remained at the helm during World War II, adding success to success. Following the war, *Time* magazine reported,

Six years ago [while] other merchandisers pulled in their horns in fear of the "inevitable" post-war recession, Wood launched the greatest expansion in merchandising history [spending $300 million] to open 92 new Sears stores in the U.S. and Latin America, and enlarged and shifted the locations of 212 more. . . . Wood's faith in the expanding American economy—aided by the backlog of demand for goods built up during World War II—was more than justified. Last year Sears sold [$2.78 billion] worth of goods. . . . Its estimated net profit was $113 million. Sears is now the sixth biggest corporation . . . in the U.S. Besides its mail-order business, which is run from eleven plants, Sears has 691 stores in 47 states, Hawaii and four foreign countries.[7]

Sears' 1952 spring and summer catalogue, sent to 7.2 million customers, had thirteen hundred pages offering one hundred thousand different items. By the time Wood retired in 1954, annual sales had passed $3 billion and Sears was America's leading retailer.

A NEW HOME

In 1969 Sears, Roebuck had become *the world's* largest retailer, with almost $9 billion in annual sales and about three hundred fifty thousand employees. The directors decided to consolidate their thirteen thousand Merchandise Group employees, then scattered in offices throughout the Chicago area, into one building at 233 South Wacker Drive on the western edge of the Loop. The company's immediate office space needs of three million square feet, "efficiently designed to house the small army," would be provided on sixty floors. According to a 1973 *Time* article, "Sears recently retired chairman, Gordon Metcalf [said]: 'Being the largest retailer in the world, we thought we should have the largest headquarters in the world.'"

But the genesis of the Sears Tower is more complicated than that. When the company decided to leave its sprawling old headquarters on Chicago's deteriorating West Side, height was the furthest thing from the executives' minds. They had bought a two-block plot on the western edge of Chicago's Loop and approached the problem of building the headquarters in exactly the same way as they planned any of Sears' stores throughout the world—from the inside out.

The company began by studying its space needs, down to the number of desks for personnel. Then it projected its office requirements to the year 2003. Next, Sears hired the New York design firm of Environetics to recheck the projections, draw floor plans, and figure out where every department should be located in relation to every other department. The result was . . . "a building profile"—a jagged shape that looks like a child's random construction with wooden blocks of varying sizes. When this interior scheme was shown to the building's architect, Bruce Graham . . . , he gasped: "How do you expect me to design around that!"[8]

Graham recalled that Metcalf "wanted to build downtown." It was not so much to occupy a monument—in fact the building that they had in mind was only sixty stories high, but with a massive floor area. Graham convinced his client that with such a plan the building would be difficult to sell if Sears should ever move out. Sears' projected expansion demanded more space, which could be let to small businesses until the company took it up; but to be marketable, that leased space could not occupy "super-floors," and the building needed a higher window to floor space ratio and access to services.

In the event, Sears' growth projections were overoptimistic. By the 1970s, although annual sales had reached $10 billion, and Sears was about to move into its new headquarters, it was facing increasing market competition from its traditional rivals and even more challenges from discount retail chains such as Kohl's, Kmart, and Wal-Mart. Within 30 years Sears' Chicago area workforce would shrink by thousands. Neither was there demand for rental space in Sears Tower, competing as it had to with other 1980s developments in Chicago. After unsuccessful attempts to sell the building, in 1989 Sears resorted to other means to offload its "white elephant." In November Stanley Ziemba wrote in the *Chicago Tribune*:

> Having removed the "For Sale" sign . . . Sears, Roebuck & Co. now faces a problem it had hoped to avoid—finding a new anchor tenant. When Sears' 6,000-member Merchandise Group moves [in 1992], the company will have to find one or more firms to lease the 1.8 million square feet of office space in the 110-story skyscraper that the retailing division will be vacating.
>
> Sears could have avoided the problem had it sold the building outright, leaving a new owner stuck with the task. Sears tried to sell the Tower. In fact, a sale to Toronto-based developer Olympia & York Developments Ltd. for $1.04 billion appeared imminent last summer, but fell through in the fall. Sears could find no other takers. The firm now is said to be seeking an $850 million convertible mortgage—in other words, taking its equity out of the building while retaining at least partial ownership.[9]

He pointed out that Sears would be vacating 1.8 million square feet of space—equivalent to two major office towers—and noted that its configuration limited its market appeal to "large insurance companies, banks, engineering firms and maybe . . . accounting or architectural firms." He added, "Most other office users, such as law firms, [need] lots of private offices with windows. Not too many people can be next to or near a window on a 50,000-square-foot floor." According to one source, the ownership of Sears Tower has changed several times since 1992, although the company has retained the naming rights for the building, which is now occupied by many different companies, including "major law firms, insurance companies and financial services firms."

In 1992 Sears retreated to the northwest suburbs. Now, Sears Holdings, occupying a state-subsidized low-rise corporate headquarters "campus" in

Hoffman Estates, Illinois, is America's sixth-largest retailer, managed by an eight-person board of directors chaired by Edward S. Lampert. It was formed in March 2005 by the merger of Sears Roebuck and Co. and Kmart. The combined companies operate more than thirty-eight hundred stores. In 2006 Sears Holdings reported revenues of $53 billion and net income of $1.49 billion.

But what of the architecture?

Sears' architectural brief was extended to 4.5 million square feet of office space. Graham later recalled, "[Gordon Metcalf] said that he didn't want any of those damn diagonal things like the Hancock building. So by this time, I was working with Fazlur Khan on a lot of tube buildings. . . . It's very efficient." The concept of a tube-framed skyscraper—a structure in which a rigid screen of perimeter columns braces the building and allows open floor plans—was first applied at SOM's The Plaza on Dewitt (1966). At about the same time, SOM—that is to say, Graham and Khan—developed the double-tube in the Brunswick Building. It employed a tube-within-a-tube structural system in which the core and perimeter are hollow, rigid tubes that brace the building and allow column-free interiors. Khan took the principle further in the John Hancock Center and, of course, the Sears Tower.

The Sears Tower is in fact a *bundle* of steel tubes. It has been explained by what might be called the "cigarette analogy." Many claims have been made to its authorship, but the uncertainty makes it no less apposite. One source says that "Bruce Graham . . . told the story that when he was trying to think of a design for the . . . Sears Tower in Chicago, he was playing with a bunch of cigarettes at his desk. Soon, he realized that if you bundle up the cigarettes, they made a stronger tower than a single cigarette." According to Graham himself, "We had built so many single tubes that I took out my cigarettes and I said to Faz, 'Why don't we build a whole bunch of little tubes that stop at different heights?'" But *Time* magazine gave Khan the credit: "Fazlur Khan, illustrates the concept by grasping a bundle of nine upright cigarettes." In 1998 Graham disclosed that "originally there were more tubes, it wasn't just nine. The original design had six more tubes, so it was fifteen, a series of tubes going up and down."

Whatever the case, each cigarette represented a separate 75-foot square building, the nine inherently strong, rigid square "tubes" form the Sears Tower's basic structure. By combining all nine tubes the building needs less structural steel than a conventional tower. In fact the first fifty floors are nine interdependent tubes, followed by floors made of seven tubes, then five tubes in cruciform format; the top ten floors consist of just two tubes. This gives the Sears Tower its form that one critic called "a driftwood carving by some giant." Graham's and Kahn's ingenious building—then the world's tallest—met Sears's needs. Graham explained,

The stepback geometry of the 110-story tower was developed in response to the interior space requirements of Sears, Roebuck and Company. The configuration incorporates the unusually large office floors necessary to Sears' operation along with a variety of smaller floors. The building plan consists of nine 75 x 75 foot column-free squares at the base. Floor sizes are then reduced by eliminating 75 x 75 foot increments at varying levels as the tower rises. A system of double-deck express elevators provides effective vertical transportation, carrying passengers to either of two skylobbies where transfer to single local elevators serving individual floors occurs.[10]

The client and the City of Chicago approved the design, and on July 27, 1970, the retailer "trumpeted its plans for the world's tallest building." Construction commenced almost immediately; the first steel was placed in April 1971 and the structure was completed in May 1973. The tower cost in the order of $150 million, equivalent to about $1 billion today.

For those who need more detail, the project has been analyzed by Michael W. Su of Princeton University School of Architecture:

[The foundation] begins about 100 feet below grade with a concrete mat foundation . . . supported by 200 rock caissons bored to reach the bedrock another 100 feet below. [The bundle of nine "framed tubes" is] bound together by, individually, deeply-sectioned spandrel girders, and collectively, one- and two-story tall belt trusses. . . . The tubes fall away with height—rather like a rocket shedding booster stages . . . only two reach [the full height.] Although framed tube structures are materially very efficient, their fabrication is more complicated. For the Sears Tower, steel sections of . . . about three horizontal bays and two stories high were especially prefabricated in the controlled environment of a shop. . . . These column-girder trees . . . were then hoisted into place and simply bolted to each other. Construction was also accelerated by the use of an innovative flooring system of [eighty-foot span trusses, about three feet deep, bolted to preformed concrete slabs.][11]

The completed tower received a mixed critical reception. In 1974 Paul Gapp wrote, "What we have here is a building whose exterior profiles are a bold, vital, and exciting departure from orthodox mediocrity; in sum, a finely engineered piece of sculpture, even if its interior is largely nondescript."[12] But 11 years later he was singing a different tune: "Even the shape became a bit of a bore after the novelty wore off, and the building's setbacks (which do not begin until the 50th story) never yielded the dramatic tapering quality of older skyscrapers. . . . But while the design was visually unsatisfying *from the start*, it fell short in other respects, too" (emphasis added).[13]

As to the "largely nondescript" interior, Graham still later recalled that when the architectural critic Ada Louise Huxtable visited the Sears Tower "before they made the changes on it—because the remodeling that has been done is anti my ideas—she said it was the only democratic high-rise building she ever saw.

And it was. It was very simple, there were no big stainless steel interiors. There were white plastic elevators. And the building was very simple."

In 1983 Sears, Roebuck and Company commissioned SOM to design $25 million in renovations to the lower-level, public spaces of the building. Gapp described them:

> The most striking change [is] the creation of a large new glassed-in entrance on the Wacker side—a vaulted transparent structure that is 135 feet wide, 60 feet deep and 58 feet tall. It replaces a skimpy little marquee and an exposed out-door staircase of 21 steps—which was a ridiculous entrance to a tower 1454 feet tall. . . . The other most obvious, costly and complicated change was made on the Franklin Street side of Sears Tower, where floors were pierced to create a large atrium [designed by Bruce Graham.] The five-floor atrium not only makes good marketing sense, but relieves the formerly cramped feeling just inside the Franklin entrance. From outside, however, the entrance still looks like a back door of little consequence. . . . [14]

But he still complained: "Sears Tower is simply too big. Its height is excessive. Its worker population and 4 million square feet of floor space on a single city block impose densities that in my judgment are unacceptable." However, if we may paraphrase George Bernard Shaw, "Those who can, do; those who can't, criticize."

When Sears, Roebuck, having failed to sell the building, moved to Hoffman Estates in 1992, it engaged Chicago developer John Buck to manage the tower. He commissioned architects James De Stefano and John Albright to renovate the lobbies and public spaces level yet again—"to warm up the base of Sears without tarting it up." New canopies were added to the Wacker and Franklin Street entrances, and major changes were made to "humanize" the plaza. Inside, elevator lobbies were moved to a sunken level and the main lobby was enlarged and heightened by relocating most of the shops to the basement, removing the low ceilings and hanging steel "chandeliers" from new 50-foot ceilings. Stanley Ziemba gratuitously offered his opinion. Noting that because of Mies' influence, "it is hardly coincidental that Sears' exterior is black and essentially boxy, like Mies' epoch-defining apartment towers," and that "it was not for nothing that critics referred to the world's tallest office building as 110 stories of soaring nonchalance," he wrote that "the old Sears was one of the most cold and fortress-like towers ever constructed—from some vantage points, a soaring presence on the skyline; from all sides, a dud at street level" and that the mid-1980s changes to the atrium at the Wacker entrance "flopped miserably in its attempt to transform Sears into a pedestrian-friendly office building."[15]

But the last word on the Sears Tower should be left to its creator, Bruce Graham: "The Sears Tower itself is much like the idea behind San Gimignano [della Belle Torre (of the beautiful towers), in Italy], but unlike most tall buildings in New York, it is a tower of the people, not the palace of a bank."

John Hancock Center, Chicago

In 1989 the architecture critic Paul Goldberger wrote in *The New York Times*, "It is no accident that tiny metal and plastic models of the Hancock Center fly out of the souvenir shops: along with its slightly taller cousin, the Sears Tower, the building is the icon of modern Chicago." Others agree that the one-hundred-story John Hancock Center at 875 North Michigan Avenue, known locally as "Big John" is "probably the Chicagoans' favorite sky-scraper." When completed in 1969, it was the tallest building in the world outside New York City (including its TV antennas, it stands at 1,500 feet); surpassed in 1973 by Edward Durell Stone's bland Standard Oil Building (now the Aon Tower), "Big John" remains the the fifth-tallest skyscraper in the United States. According to Blair Kamin, the "muscular, structurally ex-pressive" building is a "brooding, X-braced giant that is the city's Eiffel Tower."

Although it is not *solely* a commercial building, the Hancock Center is on the "magnificent mile" in the heart of Chicago's commercial district. When it was built, it was advertised as the only building in the world where people lived above the sixtieth floor; in fact, the forty-eight residential floors start at the forty-fourth. About seven hundred high-status condominiums are served by a heated swimming pool, workout rooms, saunas, "hospitality rooms, receiving room, valet service, mail room, a full-line grocer" and a restaurant on the ninety-fifth floor. From the street upwards: the lowest five levels house com-mercial tenants; the next seven, parking; and the next thirty-one, offices. The level above the apartments accommodates an observatory; the remainder are occupied by radio and TV broadcasters and mechanical services. According to one critic, "Controversial from the start for its enormous hulk and dark metal cladding, this mixed-use project . . . broke all the rules of its genteel, mostly low-rise Michigan Avenue neighborhood."

The architects Skidmore, Owings, and Merrill (SOM) offered their client, John Hancock Mutual Life Insurance Co., two options: a seventy-story apart-ment building and a forty-five-story office block located at the northeast and southwest corners of the site, or one very tall tower. Project architect Bruce Graham wrote that the design "was influenced by its unique site."

> [The client] insisted on producing a tall building with residences above, offices and commercial uses below. The search for a new kind of struc-ture which would accommodate multiple uses and also express the scale and grandeur of a one-hundred-story tower, lead Dr. [Fazlur] Kahn and me to the diagonal tube. It was as essential to us to expose the structure of this mammoth as it is to perceive the structure of the Eiffel Tower. For Chicago, honesty of structure has become a tradition.

The architect-engineer Kahn developed the structural system employed earlier in 1969 by SOM in San Francisco's Alcoa Building. Paul Clerkin describes "Big John" as "a super-tall steel tube," in which "steel columns and beams are concentrated in the skyscraper's perimeter, and five enormous diagonal braces on the exterior walls . . . give it extra strength in the wind." The structure, with a central service core, needed no interior columns. That had two advantages: it allowed more flexible use of floor space, and it used between 50 and 60 percent less steel than a conventionally framed building. Honestly expressing that system, as Graham said, gave the building its visual distinctiveness. The tower tapers toward the top on all sides, providing additional stability against wind forces. It narrows by a total of 105 feet on the east and west and 65 on the north and south, "in order to accommodate the different floor space requirements [from 40,000 square feet at the base to 18,000 square feet at the top] of a variety of uses. . . . " Graham explained, "The tapered form provides structural as well as space efficiency. The exterior columns and spandrel beams, together with the diagonal members and structural floors, create the steel tube. The diagonals, spandrels and columns are clearly articulated to depict the primary elements of this tube." The black anodized aluminum façade begins at the second floor. The walls at street level were originally clad with white travertine, but this was later replaced with dark granite.

The building stands on only half the lot; an elliptical-shaped pedestrian plaza on Michigan Avenue and formal landscaping occupies the rest. The plaza and the interior were remodeled in 1995. Further modifications were made around 2003. The John Hancock Center has received several honors: the 1970 Office Buildings Distinguished Building Award of the American Institute of Architects (AIA) Chicago Chapter (1970); the 1971 Architectural Award of Excellence, American Institute of Steel Construction; and in 1999 the AIA, Chicago Chapter's 25-Year Award and the AIA's National 25-Year Award.

NOTES

1. Smith, Carl, "Where All the Trains Ran: Chicago," *Commonplace*, 3(July 2003), 1.

2. Zanten, David van, "Master of the Skyscraper," www.neh.gov/news/humanities/2002-03/skyscraper.html. Adapted from *Sullivan's City*, New York: W. W. Norton, 2000.

3. Schulze, Franz, "Architecture: The Second Chicago School," in *The Electronic Encyclopedia of Chicago* (2005), www.encyclopedia.chicagohistory.org/pages/64.html

4. Blum, Betty J., *Oral History of Bruce John Graham*. Chicago: Art Institute, 1998, iv.

5. Weingardt, Richard, " Fazlur R. Khan," in *Great American Civil Engineers, 32 Profiles of Inspiration and Achievement.* Reston, VA: American Society of Civil Engineers, 2005, 78.

6. "R. W. Sears Biography." www.bgsu.edu/departments/acs/1890s/sears/sears2.html

7. "The General's General Store," *Time* (February 25, 1952), cover story.

8. "The Tallest Skyscraper," *Time* (June 11, 1973).

9. Ziemba, Stanley, "Sears Faces Tough Sell Leasing Tower Office Space," *Chicago Tribune* (November 5, 1989).

10. Graham, Bruce, *Bruce Graham of SOM.* New York: Rizzoli; Milan: Electa, 1989, 56.

11. Su, Michael W., "Sears Tower. In-Depth Analysis." www.allaboutskyscrapers.com/sp.sears_tower.htm

12. Gapp, Paul, "The Sears Tower," *Chicago Tribune* (February 9, 1974).

13. Gapp, "Architectural Giantism," *Chicago Tribune* (November 17, 1985).

14. Gapp, "Architectural Giantism."

15. Ziemba, Stanley, "Towering Changes," *Chicago Tribune* (October 10, 1993).

FURTHER READING

Ali, Mir M. *Art of the Skyscraper: The Genius of Fazlur Khan.* New York: Rizzoli, 2001.

Ascoli, Peter M. *Julius Rosenwald: The Man Who Built Sears, Roebuck and Advanced the Cause of Black Education in the American South.* Bloomington: Indiana University Press, 2006.

Asher, Frederick. *Richard Warren Sears: Icon of Inspiration: Fable and Fact about the Founder and Spiritual Genius of Sears, Roebuck & Company.* New York: Vantage Press, 1997.

"Bigger May be Better: Chicago's Sears Tower Is Nine Skyscrapers in One." *Architecture Plus,* 1(1973), 56–59.

Condit, Carl W. *The Chicago School of Architecture.* Chicago: University of Chicago Press, 1964.

Danz, Ernst. *Architecture of Skidmore, Owings & Merrill, 1950–1962.* New York: Praeger, 1963. See also Axel Menges, *Architecture of Skidmore, Owings & Merrill, 1963–1973.* New York: Architectural Book Publishing Company, 1974, and Albert Bush-Brown, *Skidmore, Owings and Merrill: Architecture and Urbanism, 1973–1983.* New York: Van Nostrand Reinhold, 1984.

Dixon, John Morris. "The Tall One." *Architectural Forum,* 133(July-August 1970), 36–45.

Emmet, Boris, and John E. Jeuck. *Catalogues and Counters: A History of Sears, Roebuck and Company.* Chicago: University of Chicago Press, 1950.

Graham, Bruce. *Bruce Graham of SOM.* New York: Rizzoli; Milan: Electa, 1989.

Huxtable, Ada Louise. *The Tall Building Artistically Reconsidered: The Search for a Skyscraper Style.* Berkeley: University of California Press, 1992.

Ingersoll, Richard, et al. "The John Hancock Center, Chicago, Illinois." *Design book review: DBR* (1988), 15–34.

Jaquet, G. Jake. "The Remapping of an Icon." *Inland Architect*, 36(July 1992), 59–62.

Khan, Fazlur. "The Future of Highrise Structures." *Progressive Architecture*, 53(October 1972), 78–85.

Khan, Yasmin Sabina. *Engineering Architecture: The Vision of Fazlur R. Khan.* New York: Norton, 2004.

Lindgren, Hugo. "Sears Tower." *Metropolis*, 14(November 1994), 25–30.

Marlin, William. "Sears Tower: The Mail-Order Approach to Urban Form. . . . " *Architectural Forum*, 140(January-February 1974), 24–31.

Mertins, Detlef. "Interview with Bruce Graham." *SOM Journal*, 2(2003), 152–165.

Mills, Raymond A. *The Sears Tower: A Spectator's View.* Tucson, AZ: Wheatmark, 2007.

Oharenko, John. *Historic Sears, Roebuck and Co. Catalog Plant.* Charleston, WVA: Arcadia, 2005.

Pridmore, Jay. *Sears Tower.* San Francisco: Pomegranate, 2002.

Stoller, Ezra, and Yasmin Sabina Khan. *The John Hancock Center.* New York: Princeton Architectural Press, 2000.

Weil, Gordon L. *Sears, Roebuck, U.S.A.: The Great American Catalog Store and How It Grew.* Briarcliff Manor, NY: Stein and Day, 1977.

Winter, John. "John Hancock Center, Chicago; Architects: Skidmore Owings & Merrill." *Architectural Review* (April 1972), 202–210.

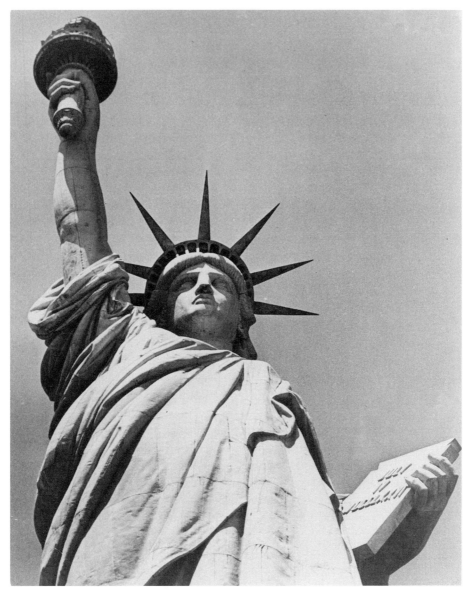

Courtesy Library of Congress

Statue of Liberty, New York City

"A changing icon"

The huge copper-clad statue of "Liberty enlightening the world" (in French, "*La liberté éclairant le monde*") stands on Liberty Island in New York Harbor. Lady Liberty, as she is popularly known, is draped in a voluminous classical *stola* and tunic; her pre-Raphaelite head is crowned with a seven-spiked diadem. Her fully upstretched right hand lifts a flaming torch; her left hand, hanging at her side, carries a tablet emblazoned with "4th July 1776" in Roman numerals; broken chains lie useless at her sandaled feet. The figure is over 152 feet high; including its broadly detailed granite pedestal, it rises to 303 feet. The Statue of Liberty National Monument was listed on the National Register of Historic Places on October 15, 1966. In 1984, it was added to UNESCO's World Heritage List because it represents "a masterpiece of human creative genius" and is "directly or tangibly associated with events or living traditions, with ideas, or with beliefs, with artistic and literary works of outstanding universal significance."

The statue's *raisons d'êtres* were political, complex, and not altogether American. The *intended* meaning of the Statue was unequivocal. Its French proponents wanted to send a message to European peoples (especially their own) about enlightened republican government, as exemplified in the United States. In 1875 its major sponsor, historian Édouard René Lefèvre de Laboulaye, called it a "monument of independence." That objective was confirmed by its sculptor, Frédéric Auguste Bartholdi, who in a U.S. patent application of January 1876 described the figure as "a commemorative monument of the independence of the United States," reinforcing the point by drawing attention to the tablet inscribed with the date of the Declaration.

In a twenty-five cent pamphlet published as a souvenir of the Inauguration of the Statue of Liberty—although half of it was advertisements for everything from sewing requisites to an amazing range of snake oil cures and even Buffalo Bill's Wild West Show—Bartholdi wrote floridly of his (literally) *magnum opus*,

> May God be pleased to bless my efforts and my work, and to crown it with the success, the duration and the moral influence which it ought to have. I shall be happy to have been able to consecrate the best years of my life to being the interpreter of the hopes of the noble hearts whose realization was the monument to the French-American Union.[1]

But though it was conceived in those terms, "a simple accident of location" (to use historian Elizabeth Koed's words) would very quickly transmute it into an icon of America's welcome to Europe's displaced masses. David Glassberg asserts that "in an era of global mass communication . . . it is a symbol representing abstract ideals of freedom and liberty to peoples around the world." He suggests that each successive *political* meaning, assigned by others than its original sponsors, supplanted the preceding one: it has been, in turn, an icon of the abolition of slavery; of national unity; of economic opportunity;

of global political freedom; and (since the September 11 attacks) of the resilience of the people of New York City.[2]

THE LAMP BESIDE THE GOLDEN DOOR

Often the wider public spontaneously identifies a significance that displaces the one contrived by an object's designers. With just 105 words the poet Emma Lazarus forever enshrined the statue as an icon of welcome, economic opportunity and political freedom for Europeans fleeing crushing poverty, religious or political persecution, or war. In the first half of the nineteenth century five million of them came to America. By 1905, the *annual* number had passed one million.

In 1883 the New York Republican politician William Maxwell Evarts, chairman of the American Committee of the Statue of Liberty—more will be said of that body later—invited Lazarus to write a piece for a fund-raising event, the awkwardly named "Art Loan Fund Exhibition in Aid of the Bartholdi Pedestal Fund for the Statue of Liberty." At first she declined but, thanks to the persuasiveness of her friend Constance Cary Harrison, her sonnet, "The new Colossus," appeared in the catalogue. Even for someone far removed from the project in time, space and experience, it is deeply stirring. The meaning of a "welcoming mother, a symbol of hope to the outcasts and downtrodden of the world" was attached to the statue only in the twentieth century. According to the Jewish Women's Archive,

> The famous sonnet echoes many of the conflicting identities and ideals Lazarus dealt with in her own life. As an American author, she felt that ancient lands could keep their old traditions and "storied pomp." At the same time, Lazarus invoked her ancient Greek ideals by transforming the "brazen giant" into a "Mother of Exiles" who retains Greek majesty, beauty and defiance as a *new* Colossus. The compassion of the lines "huddled masses yearning to breathe free" welcomes the tired immigrants, but the following image of the "wretched refuse of your teeming shore" hints at the condescension these refugees were to suffer. And while this Mother of Exiles' eyes command, and she stands alone beacon to all the world, she is still an ambiguous figure of power, speaking only with "*silent* lips."
>
> Struggling beneath the poem's surface, these tensions—between ancient and modern, Jew and American, voice and silence, freedom and oppression—give Emma Lazarus' work meaning and power. As James Russell Lowell wrote her, "your sonnet gives its subject a raison d'etre."[3]

Emma Lazarus died of cancer in 1887, at the age of 38. Apart from occasional republication in New York newspapers, her poem was largely forgotten for about 20 years. In May 1903 her friends, philanthropist Georgina Schuyler and editor Richard Watson Gilder, having waded for 2 years through

bureaucratic obfuscation, successfully lobbied to have a bronze plaque bearing the text of "The new Colossus" displayed on a second floor landing within the great statue's pedestal—not necessarily because of the sentiment it expressed—in fact, Schuyler had never read it—but in memory of its author. The plaque remained virtually ignored for more than a generation. But as the Great Depression and then Nazism and Fascism drove many Europeans from their homelands, the sonnet was revived, recited in radio broadcasts across the United States, and even set to music by Irving Berlin. "It ultimately melded with the statue itself as a source of patriotism and pride," reaching a climax during World War II. Thus, although the Statue of Liberty had not been conceived as a symbol of immigration, its association with Lazarus' sonnet rewrote its role to become the greeter of immigrants because it expressed what the statue itself had wordlessly communicated to the world's oppressed people for six decades. In 1986 the "New Colossus" plaque was moved to an introductory exhibit inside the pedestal.

A TANGLED SKEIN

The origins of the Statue of Liberty lie in a tangled skein of history, myth, and romantic vision. The simplistic version, accurate enough, is that the generous people, not the government, of France presented the monument as a gift to the people, not the government, of the United States as a gesture of enduring friendship, in celebration of the centenary of America's independence from Britain, and to honor her "cherished [republican] ideals of freedom and opportunity for all." But the motivation was far more complicated and included, perhaps even as a priority, a deliberate statement of a republican ideology in France.

There is an oft-repeated tradition that the gift was first discussed in summer 1865 by a small gathering of French politicians literati and artists and at a dinner party in Édouard de Laboulaye's home at Glavingny near Versailles. It must be noted that the single source of that claim is a fund-raising pamphlet written by Bartholdi; other historians believe that the plan was conceived in 1870 or 1871. Through the 1860s de Laboulaye, the so-called ideological father of the statue, and his circle, opposed to Emperor Napoléon III's authoritarian rule, sought to establish a liberal democratic republic. The Emperor was deposed in September 1870 during the Franco-Prussian War. But monarchist sentiment lingered—as it seems to do in ex-monarchies—and many people expected, even desired, the rebirth of constitutional authoritarianism, at least in some form. De Laboulaye was elected to the *Assemblée Nationale* and sponsored the creation of the Third Republic. So the Statue of Liberty was conceived because he and other French Republicans wanted to present their "sister" republic as a tangible focus of republican virtues. Marvin Trachtenberg asks, "What better way to cement their image of France . . . than with a

truly grandiose monument linking the history and destiny of France with the great modern republican state, the America that had not only triumphed over its internal enemies but was ascendant in every sphere, already marked to be one of the great world powers?"[4]

Several Freemasons were among the initiators of "*La liberté éclairant le monde*": Edmond and Oscar de Lafayette (grandsons of Washington's comrade-in-arms), the Marquis de Noailles, the Marquis de Rochambeau, historian Henri Martin, and others. Taken with the ideas he probably had shared with them, de Laboulaye and his peers turned to Bartholdi to create what they believed would be a powerful political machine for shaping French government and society. There is evidence that the sculptor himself embraced republican ideals, but it is likely that he was more attracted by the opportunity afforded his personal artistic aspirations. To find meaning in the Statue of Liberty, those aspirations and their sources must be understood.

LIBERTY AND IMMENSITY

Frédéric Bartholdi was born in the Alsatian city of Colmar in 1834, the younger son of a civil servant and wealthy landowner Jean-Charles Bartholdi and his wife Augusta Charlotte. When Jean-Charles died 2 years later, his "stern and possessive" widow moved to Paris. During Frédéric's childhood they often visited Alsace, and he developed a deep affection for the region; he studied drawing with Martin Rossbach in Colmar. In Paris he studied architecture with the rationalists Henri Labrouste and Eugène-Emmanuel Viollet-le-Duc, both pioneers in the use of iron-framed structures. And an ever-widening interest in art led him to take painting lessons with the classical portraitist Ary Scheffer; he learned to sculpt in the ateliers of Jean-François Soitoux and Antoine Etex, creator of the huge "Peace" and "Resistance" groups on the *Arc de Triomphe*. Thus, well-trained, well-connected, and well-heeled, Bartholdi fit almost anywhere into the elite world of art. When he was only 18 years old he secured his first public commission: his 12-foot tall bronze portrait of Colmar's Napoleonic hero, Lieutenant-General Count Jean Rapp, was completed in 1856.

In that same year, on an extended vacation with the orientalist painters Léon Belly, Narcisse Berchere, and Jean-Léon Gérôme, Bartholdi navigated the Nile in a rented boat, visiting the Pyramids and the Sphinx at Giza, the expansive temple complex at Thebes, and the colossal statues of Ramses II at Abu Simbel. The experience elevated his artistic aspiration from the larger-than-life, as in the Rapp portrait, to the gigantic as he sketched, photographed, and made notes about the ancient works that so excited him. About 30 years later, when he had revisited Egypt, he wrote in rapturous terms of the profound emotions that he felt "in the presence of these colossal witnesses, centuries old, of a past that to us is almost infinite, at whose feet so many generations,

so many million existences, so many human glories, have rolled in the dust. These granite beings, in their imperturbable majesty, seem to be still listening to the most remote antiquity."

Although "academic scruples" prevented Bartholdi from simply copying Egyptian art, its colossal grandeur overwhelmed him, and he began to dream of emulating it in his own work. On returning to France, his reputation established by the Rapp statue, for the next decade Bartholdi received no commission that called for such monumentality. But his career as a sculptor of patriotic monuments—on a decidedly smaller scale—was launched. Many of his projects were in Colmar: a statuette of Martin Rossbach (1856); a memorial fountain to Admiral Armand-Joseph Bruat (1856–1864); and a portrait of the fifteenth-century German painter and engraver Martin Schongauer (1861–1863).

One anonymous assessment of this phase of Bartholdi's career identifies him as "a proficient lobbyist for his own artistic ambitions." Certainly as early as 1867 he demonstrated his entrepreneurial adroitness in a proposal made to the Ottoman Khedive of Egypt, Ismail Pasha. Conceived 8 years earlier by the former French Consul in Cairo, Ferdinand de Lesseps, the Suez Canal was completed during Ismail's administration; it would be opened to shipping in November 1869. The Khedive boasted, "We are now part of Europe. It is therefore natural for us to abandon our former ways and to adopt a new system adapted to our social conditions," and when he visited the Paris *Exposition Universelle* of 1867, Bartholdi laid before him a scheme for a colossal statue-cum-lighthouse at the Canal's southern end, which the sculptor tentatively had named "Progress" or "Egypt Carrying the Light to Asia." Such a monument would draw attention to Ismail's efforts to modernize his nation.

Descriptions and sketches of Bartholdi's proposal vary widely. It has been claimed that his ideas were a synthesis of the Egyptian colossae he admired so much and other ancient models, notably the so-called wonders of antiquity, the Rhodes Colossus and the Pharos at Alexandria, which were also beacons. A friend of the sculptor recalled seeing a drawing of "a beautiful woman clothed in the ancient style, with a headdress [*nemes*] in the style of the Egyptian sphinx. . . . The right arm carried the lamp of a lighthouse, the left arm fell along the side of the body." Sketches and maquettes proliferated; some showed the torch raised by the *left* arm; others showed the beacon in the headgear, rather than in the flambeau.

For the next 2 years, certainly not discouraged by the Khedive, Bartholdi experimented with the pose of the figure. Late in 1869 he attended the extravagant opening ceremonies of the Suez Canal as a member of the French delegation. He showed his developing design to de Lesseps, who offered "polite encouragement" but warned him that Ismail, enthusiastic as he may have been about the statue, could not afford it. Indeed, Ismail continued to lead Bartholdi on but never offered a commission. When the project was shelved the sculptor, disappointed, returned to France.

During the Franco-Prussian War of 1870–1871, Bartholdi served in the *Garde Nationale*, as commander at Autun and as a major in the defense of Colmar. The Prussian annexation of Alsace deeply affected him, and he frequently revisited the theme of French heroism in his subsequent works. Remarkable among them was the "Lion of Belfort," finished in 1880 and honoring the 103-day stand taken by only seventeen thousand valiant men, mostly civilians, against forty thousand German soldiers. Doubtless drawing upon the ancient sphinx at Giza, the 75-foot long, 40-foot high stylized animal was carved from blocks of local sandstone on a ledge in the cliff below Belfort Castle. Bartholdi intended that it should look defiantly toward Prussia, but for political reasons that was changed. Bartholdi began his work on the Statue of Liberty while still creating the Lion.

Believing that the centennial of the Declaration of Independence would be the most fitting time to commemorate the France–U.S. friendship, de Laboulaye sponsored a visit to America by Bartholdi, during which the sculptor could canvass the proposal and find a site for the monument. On June 8, 1871, Bartholdi, accompanied by an artist friend and bearing letters of introduction from the Glavingny republican group, sailed aboard the French mail steamer *Pereire*. He later recalled—or reinvented—his patron's words of encouragement:

> "Go to America, study it, bring back your impressions. Propose to our friends over there to make with us a monument, a common work, in remembrance of the ancient friendship of France and the United States. We will take up a subscription in France. If you find a happy idea, a plan that will excite public enthusiasm, we are convinced that it will be successful on both continents, and we will do a work that will have a far-reaching moral effect."[5]

Even before he disembarked in New York Bartholdi identified the perfect location for the statue, "an admirable spot where people get their first view of the New World . . . it is Bedloe's Island, in the middle of the bay." The site, Bartholdi later rationalized, was ideal for a couple of reasons: the island, owned by the federal government was on "national territory, belonging to all the states, just opposite the Narrows, which are . . . the gateway to America." Of course, he could have known none of that as he stood on the deck of the *Pereire*. What he *did* know was that should his statue be erected on Bedloe's Island, it would be the first structure seen by European immigrants and visitors coming to America.

The islet (officially renamed Liberty Island in 1956) had passed from private hands to the City of New York in the mid-eighteenth century, and later to New York state. In 1800 it was ceded to the federal government, and 10 years later Fort Wood, an eleven-point star-shaped artillery battery was built to defend New York Harbor. The fort subsequently served at various times as a garrison, an ammunition dump, a prisoner of war infirmary, a recruiting station, and sometimes as a quarantine station.

In 1885 Bartholdi would claim that he "formed some conceptions of a plan of a monument" during his trans-Atlantic crossing but "at the view of the harbor of New York the definite plan was first clear to [his] eyes." The romantic claim perpetuated by many that the artist did not have even a rough drawing of the proposed monument until the moment he first entered Lower New York Bay, then in a flash of inspiration quickly grabbed a brush and paper and made his first notional watercolor sketch of the Statue of Liberty is nonsense. But more of that later. . . .

Acting on de Laboulaye's advice, for 5 months the "intelligent, warm, persuasive and charming" Bartholdi traveled through the United States, on what he called an "artistic journey through the cities and wild regions as well," visiting, besides New York, Philadelphia, Washington, D.C., Chicago, St. Louis, Salt Lake City, San Francisco, Niagara Falls—probably to sightsee—and other locations, familiarizing himself with the republic and (of course) promoting his great statue.

He enthusiastically shared his watercolors and a model of his proposal with President Ulysses S. Grant (who responded with indifference); scientist Louis Agassiz; industrialist Peter Cooper, founder of the Cooper Union; John W. Forney, European commissioner for the Philadelphia International Exhibition, that was already in the planning stage; newspaper publisher Horace Greeley; the landscape designer Frederick Law Olmsted; Henry Wadsworth Longfellow; General Philip Sheridan and Brigham Young, founder of Mormonism, as well as other influential figures. Although most seemed receptive, none beside Massachusetts Republican Senator Charles Sumner was willing to make a commitment to the project. Bartholdi returned to France.

WHEN "PROGRESS" BECAME "LIBERTY"

Historian June Hargrove believes that "The Statue of Liberty secured Bartholdi a fame perhaps disproportionate to his artistic talent, but commensurate with his ambition, drive, and showmanship in the promotion of great artistic undertakings." She adds that though he "aspired to create 'monuments of great moral value,' [his true genius was in] exploiting his organizational flair and enthusiasm for technology. His work was well received by his contemporaries, but only Liberty brought him the international recognition he sought."[6]

So we should read his own account of his achievements in that light. Although his choice of words about how his design for the Statue of Liberty was born, "the *definite* plan was *first* clear," was careful, the weight of evidence—historical and physical—points to the fact that his design was already well-developed before he arrived in America. Certainly, he had discussed the monument's general form and scale with the de Laboulaye enclave, and even its detail had begun to firm in his mind and theirs in the second half of 1869.

Even a cursory comparison of the respective preliminary drawings and models demonstrates clearly that "Liberty enlightening the world" is a variation of the abandoned Suez Canal colossus; it might be said, "an attempt to snatch victory from the jaws of defeat" and to redeem what otherwise may be considered to have been wasted effort. So many elements of the works were common: two huge, torch-bearing robed female figures, two lighthouses placed at strategic locations in major sea-routes; two symbolic nineteenth century values, Liberty and Progress, linking two continents.

And in each design the lighthouse was not planned for the torch, which was purely symbolic, but for the figure's forehead. But Bartholdi strenuously protested—some would say, too much—in a newspaper interview, "The only resemblance . . . is that both held a light aloft. Now . . . how is a sculptor to make a statue which is to serve the purpose of a lighthouse without making it hold the light in the air?" He also denied having executing "anything for the Khedive, except the features of a female *fellah*." In fact he had produced several maquettes of the Suez monument over a 2-year period.

About 30 years ago, an Australian professor of art history, doubtless courting controversy, dared to suggest that true art must be *only* serendipitous; the implication was, of course, that neither Rembrandt's "Night watch" nor Picasso's "Guernica" is art, but art is—wait, the esteemed professor could give not a single example to make his point. The book of *Exodus* tells how Aaron, during the temporary absence of his brother Moses, fashioned a golden calf for the Israelis to worship. On his return to the camp Moses, furious at the orgiastic goings-on that accompanied their idolatry, demanded an explanation. Aaron's lame excuse? He had acceded to the people's request for a tangible deity, "So I said, 'Who has gold?' And they took off their jewelry and gave it to me. I threw it in the fire and out came this calf." Out came this calf? Works of art are not serendipitous; they evolve through a process of concept, choice, assessment, and adjustment. That's how it was with the Statue of Liberty.

Beginning in 1869 or 1870 Bartholdi, in consultation with his patron, developed the form of the statue through several clay study models that were essentially a rehash of "Progress." He arrived at the approved version toward the end of 1875; in it, he retained the upraised right arm bearing a torch, but of course the Egyptian clothing had to go.

A possible major inspiration for the modifications was a figure on a medallion conceived by Benjamin Franklin in 1782, to promote Franco-American goodwill. "Libertas Americana" bore a woman's head with flowing hair and the Phrygian cap that symbolized freedom. Libertas, the Roman goddess of liberty, "usually pictured as a matron in flowing classical dress . . . began emerging in America during the colonial era as part of the American quest for political independence from Britain." Eschewing the humble cap, even in its earliest versions Bartholdi's Liberty wore a spiked diadem or aureole, like that seen in classical images of Helios, the Greek sun god; otherwise, her costume

evokes images from Roman antiquity. He seems to have been undecided about what she should carry in her left hand; in the earliest models it was a shattered vase which he next he changed for a broken shackle before (at de Laboulaye's prompting) deciding upon a tablet emblazoned in low relief with "July IV, MDCCLXXVI." Paradoxically, the blocky lettering was not Roman but *sans serif*. In the completed statue the shackle lies near her right foot and its broken chain disappears under the hem of her *stola*. For practical reasons further, less noticeable changes would need to be made.

THE FACE IS FAMILIAR . . .

Although his design was already approved, important details were unresolved when Bartholdi applied for a U.S. patent in January 1876. A drawing apparently lodged with the application shows a very early version of the statue. Intriguingly, it accompanied a bronze cast of the study model in which Liberty's face differed greatly from the final version. Because of lack of documentation the question of whose face it is has never been conclusively answered, but there has been much speculation.

One source insists that Bartholdi's model was Isabella Eugenie Boyer, the beautiful widow of the sewing machine magnate Isaac Merritt Singer. Others believe that the "classical, yet severe and calm, features" belonged to the sculptor's mother. The only evidence is anecdotal and Bartholdi never denied nor explained the resemblance (although that means little enough). Still others claim that Augusta Bartholdi tired quickly when posing because she was about 70 years old, so Bartholdi posed his mistress, Jeanne-Emilie Baheux de Puysieux, for the torso and arms. He met her in Newport, Rhode Island, during his first U.S. visit, and they married in December 1876. Other intriguing but unsubstantiated suggestions as to who was the model include the madam of a Paris brothel and an anonymous glove shop proprietor from Nancy, France.

In 1998 there was a widespread flurry of conjecture, apparently springing from earlier and insupportable claims made by Leonard Jeffries of New York City College, that Lady Liberty's primary purpose was to commemorate the African Americans who fought in the Civil War. In that connection, it was rumored that a black woman was the model for the face. An extensive investigation of the statue's early history, led by National Park Service (NPS) anthropologist Rebecca M. Joseph, cagily pronounced that though it was impossible to say whether Bartholdi's design evolved from his earlier sketches of Egyptian women, there was no evidence of any intention to make special reference to the abolition of slavery. The report commented that Bartholdi, acting in character, "cast the project in the broadest terms, hoping to encourage additional commissions." Then, he always had an eye to the main chance.

REALIZATION

The next phases of the project were, of course, interdependent: the transformation of a four-foot maquette into an immense reality, and raising the money to do it. De Laboulaye was elected chairman of the *Union Franco-Américaine*, a group composed of what were claimed to be the "most notable names in France." "*La liberté éclairant le monde*" was to be a jointly achieved: the French people would build the statue, and transport and erect it; the American people would build the pedestal. The *Union* formally asked President Grant to set aside a site on Bedloe's Island. On November 6, 1875, the *Union* hosted a banquet at the Hotel du Louvre for about two hundred wealthy and influential French and American guests; launching the fundraising campaign, the event raised 40,000 francs. The initial budget was fifteen times that amount, and the final cost of the statue and its transportation to the United States would be 2.25 million francs. The success of the *Union*'s first public appeal for funds allowed Bartholdi to start work.

Of course, for such a gigantic piece, casting was out of the question, especially because it needed to be safely shipped across the Atlantic. So Liberty would be of dual construction, with a structural wrought-iron armature carrying a 1/10-inch thick skin of copper, the material that would best resist corrosion in the marine atmosphere of New York Harbor. To permit expansion and contraction, each sheet would be independently supported on a secondary framework of iron bars and straps; the sheets would be riveted together. The structure was designed by the architect Viollet-le-Duc, who once had been Bartholdi's mentor. To improve its stability, Lady Liberty's pose was slightly changed, and increasing the folds in her *stola* made the structure more rigid.

When Viollet-le-Duc died in 1879 he was succeeded as structural designer by the bridge engineer Alexandre Gustave Eiffel (who later would build the famous tower in Paris), "assisted" by Maurice Koechlin, the real unsung hero of the project. They revised the structure, creating a 98-foot high, 120-ton iron column composed of four trussed pylons, and extended to support the right arm. The French industrialist Pierre-Eugène Secrétan donated over 6,000 square feet of sheet copper. There is a tradition that the metal was mined at the Visnes copper mines on Karmoy Island near Stavanger, Norway. Others have suggested Nizhniy Tagil in Russia. Because of Secrétan's business connections, Spain or North or South America are also possible sources.

Construction began in the Paris foundry of Monduit et Béchet (later Monduit, Gaget, Gauthier et Cie) around the turn of 1876. Bartholdi's model went through three enlargements. The final detail was developed on the second, 36-foot version; then the figure was divided into three hundred sections, each of which was scaled up to four times larger, and cast in plaster. From the casts, craftsmen made "negative" laminated wooden molds, which served as forms for hammer dressing the copper sheets, a traditional technique known as

repoussé, much more commonly used by silversmiths and jewelers at a much smaller scale. When the statue was assembled, each of the copper sections was stiffened by wrought iron bands and rods. The components were feather-edged and fixed together with 1/5-inch flush-headed copper rivets.

In France, various means—different entertainments, the sale of two hundred signed and numbered terra cotta copies of the "study model" and even a government-sanctioned lottery—were used to raise money, allowing work on the statue to proceed. The *Union Franco-Américaine* had hoped that the colossus would be completed in time for the Centennial International Exhibition in Philadelphia. In the event, only the right forearm, hand, and torch were displayed. In June 1878, the completed head and shoulders were exhibited in the gardens of the Champ de Mars, at the Paris *Exposition Universelle*. Hundreds of visitors queued every day to ascend forty at a time into the head of the Statue of Liberty, from which they could overlook the exposition grounds.

By June 1880 the statue fund was fully subscribed, without assistance from the French government. Donations had been received from cities, towns, and chambers of commerce but mostly from individuals—literally, from the people of France.

"Liberty enlightening the world" first stood, *sans* pedestal, outside the rue de Chazelles workshops in suburban Paris, where she was made. The American minister to France, Levi Parsons Morton, placed the first rivet at a ceremony in October 1881; by January 1884 the finished form, then dark copper, loomed above the narrow streets. During the statue's fabrication and assembly and until it was taken down for shipping to America, three hundred thousand people visited the workshops—it was more popular than any other monument in the French capital. The completion was celebrated at a dinner given to Bartholdi on May 21; about a month later he invited his Masonic Lodge at Alsace-Lorraine to review it. Appropriately on July 4 and again with due ceremony, Ferdinand de Lesseps, the new president of the *Union Franco-Américaine* (sadly, de Laboulaye died in 1883, never to see his vision realized), formally presented the statue to Morton, who received it on behalf of the United States.

MEANWHILE, ACROSS THE ATLANTIC . . .

Beginning in August 1876 the completed right forearm, with its hand and the torch, was displayed at the Centennial International Exhibition in Philadelphia, which had a daily average of about sixty thousand visitors. When the exhibition closed early in November, the massive fragment was moved to Madison Square Park in New York City, where it remained before being returned to France in 1882.

In January 1877 the American Committee of the Statue of Liberty was formed at New York's Century Club. Its early membership of 114 would

grow to include over 400 "prominent gentlemen" throughout the nation; efficient communication would have been hardly possible. Prompted by President Rutherford Hayes, a joint resolution of the U.S. Congress accepted the French gift on February 22 and committed to the future maintenance of the statue as a beacon. Hayes authorized General William T. Sherman to select the location. Working strictly to the script, and urged by the American Committee to confirm Bartholdi's preference, the retired soldier named Bedloe's Island, and the decommissioned Fort Wood was designated as the base of the pedestal. Retired Major General Charles Pomeroy Stone was appointed engineer-in-chief, and when work eventually started, the New York contractor David H. King Jr. "had general charge from the laying of the first stone of the pedestal to the driving of the last rivet." King worked *pro bono publico* and in fact sustained financial loss in completing the project.

A design competition, offering a $1,000 premium, was held for the pedestal. The winner was the internationally acclaimed Richard Morris Hunt, the first American architect trained at *L'École des Beaux-Arts* in Paris; he donated the prize toward reassembling the statue. Hunt presented the American Committee with alternative schemes, some domical, some pyramidal (a possibility entertained earlier by Bartholdi), some towers, and others in pre-Columbian styles. By the end of July 1884 a short list of three was compiled.

The president of the New York Beaux-Arts Alliance, David Garrard Lowe, describes the selected design as "deftly embellished with classical elements" and "appropriate in scale." Although the second point was probably correct (given Lady Liberty's size), there is little deftness and even less classicism in Hunt's 89-foot high centrally planned bastion. The pedestal is unlike anything else in his largely domestic oeuvre. Its ponderous elements, as could be expected of any Beaux-Arts product, seem to be of his own invention: heavily rusticated battered walls of Connecticut granite, quasi-loggias framed by stocky square columns of an indeterminate order, broad moldings, and heavy string courses—none finds a precedent in classical antiquity. The lowest tier is surrounded with circular "shields" intended for the coats of arms of the (then) forty states. Although the states were approached to supply details, the heraldic devices were never executed, probably for reasons of economy. Lowe noted that it received "universal acclaim." Admitting that the architect's other work has met with everything from "crests of approval to troughs of condemnation," he asserted, "The base of the Statue of Liberty has never been questioned." However, he cited no contemporary adverse criticisms, but only a recent extravagant accolade by the New York Metropolitan Museum's Lewis Sharp: "The height and mass of the pedestal—the major architectural considerations—are perfect." But perfect architecture is impossible to define, much less to attain.

News came from Paris in 1882 that the French subscription fund was filled and that Liberty would be complete within a year. Demolition of buildings within the ramparts of Fort Wood began in October 1883, followed by

construction of the pedestal's foundation. The American Committee had $125,000 in hand, most of it collected in New York. Despite delays and increased costs (both caused by the need to fill a network of unmapped tunnels and corridors), the 53-foot deep foundation of mass lime concrete was completed by mid-May 1884.

The Masonic Grand Lodge of the State of New York was invited to conduct an "appropriate" cornerstone ceremony. While some anti-Freemasonry conspiracy theories are dubious—one claims that the Statue of Liberty was simply a gift from French to American Masons—it is true that the Brotherhood has figured significantly in events in American history. That includes the statue; for example, Bartholdi, Eiffel, and Hunt all were Masons. Anyway, on the afternoon of August 5, 1884, about a hundred Grand Lodge members, with state government and civic leaders from across the nation as guests, arrived at Bedloe's Island aboard the *Bay Ridge*, bedecked in the *Tricoleur* and the Stars and Stripes. After an Army band played *La Marseillaise* and *Hail Columbia* the cornerstone was laid by Grand Master William A. Brodie.

Despite excited publicity about the statue throughout the United States since the Centennial, many Americans still hesitated to help pay for the pedestal. The reasons were complex. Fostered by hostility in some sections of the press—especially complaints about the cost, estimated to be as much as the statue itself—public apathy persisted. It was argued also that such a huge statue was impossible to make and that it was "New York's lighthouse" anyway, with no national relevance. That raised disagreements over location. Many took to heart the old adage, "Beware of Greeks bearing gifts"; of course, the Statue of Liberty was the gift of a friend, not an enemy, but American xenophobia stirred "suspicions about implications of such an international gift."

Neither was the parsimony of the general public the only impediment to the growth of the fund. In 1884 New York's Governor Grover Cleveland vetoed a $50,000 grant from the state legislature. Costs rose and the American Committee's capital dwindled, and with a shortfall of $100,000 (the amount of federal funding vetoed by President Chester Arthur), work stopped in fall 1884, when only 1/6 of the masonry had been completed.

The feisty publisher Joseph Pulitzer renewed the fund-raising appeal through the pages of *The New York World* in March 1885. He contended, "It would be an irrevocable disgrace to New York City and the American Republic to have France send us this splendid gift without our having provided even so much as a landing space for it. . . . " Daily, his editorials castigated the rich for failing to contribute to the pedestal, and the middle class for its complacency: "Let us not wait for the millionaires to give this money. It is not a gift from the millionaires of France to the millionaires of America, but a gift of the whole people of France to the whole people of America." That was his constant

theme: because the statue had been paid for by "the masses of the French people," Americans—because it was not just for New York City but the whole nation—should "respond in like manner." He offered to publish the name of every contributor in the *World*, no matter how small the donation.

Some cynics have suggested that Pulitzer cannily recognized a chance to increase *The World's* circulation while raising funds and having a chance to censure the rich. Indeed, sales of the paper grew by nearly fifty thousand copies, largely among blue-collar workers. Whatever the case, his campaign brought results. The press in other cities and many African American newspapers supported his cause, and together stimulated nation-wide interest and ownership of the statue. The *Baltimore American* claimed that Baltimore would pay for the pedestal if Liberty were located there; similar offers were received from Boston, Cleveland, Minneapolis, Philadelphia and San Francisco. More important, the fund began to grow, with "single-dollar donations from grandmothers, pennies from schoolchildren [from] as far away as California, Colorado, Florida, and Louisiana." Work on the pedestal resumed on May 11, 1885.

HANDS ACROSS THE SEA

Just 10 days later the three hundred fifty components of "Liberty enlightening the world," carefully packed in 214 enormous custom-built wooden crates—seventy railroad truckloads—were dispatched from Rouen, France, aboard the steam-and-sail gunboat *Isère*. Each piece was marked to expedite reassembly. Having weathered a 3-day storm during which the shifting crates threatened to sink her, *Isère* hove to at Sandy Hook, New York, on June 17. Two days later, Major General Stone, on a tug surrounded by a welcoming flotilla of dinghies and about sixty pleasure yachts, steamers, and naval ships that were then in the harbor, formally accepted the title deeds of the statue.

The momentous event may have given Pulitzer's fund a final boost: on August 16 the *The World's* banner headline proclaimed, "One Hundred Thousand Dollars!" The amount donated by over one hundred twenty thousand people was in fact $101,091. Although businesses and some individuals had given up to $2,500, 80 percent of the contributions were under $1. It was agreed by the American Committee that $1,000 of this should be spent on a testimonial gift for Bartholdi, made by Tiffany and Co.

The pedestal was finished in April 1886. It has been estimated that $390,000 was spent by the American Committee before Liberty finally stood in place, looking across the Atlantic toward France. The pedestal cost about $250,000, the interior structure $25,000, and the labor to erect the statue, another $25,000, bringing the total cost, including the Lady herself, to about $740,000.

LIBERTY HAS HERE MADE HER HOME

Four months after arriving in America, "Liberty enlightening the world," stood at last on her massive granite base. On Dedication Day, October 28, 1886, Bedloe's Island was swept by icy winds and shrouded in mist. Heedless of the weather, New York dressed itself in red, white, and blue bunting and declared a holiday. *The World* described the city as "one vast cheer." Wall Street was the only district that went to work; but then, business is business. About a million people lined the streets to watch a twenty-thousand-strong military and civic grand march led by General Stone. Beginning from 57th Street at 10 A.M., the pageant took the salute from President Cleveland and his cabinet, New York's Governor David B. Hill and his staff, the French ambassador and "other French and American notables" in Waverly Place before moving through Broadway, Mail Street, and Park Row, reaching the waterfront at 12:30 P.M. *The New York Times* told how office boys from hundreds of windows spontaneously showered the parade with the paper tape used by stock ticker machines, thus inventing the ticker-tape parade, whose name has stuck long after the machines have disappeared.

The official party boarded the presidential yacht *U.S.S. Despatch* and led about three hundred other vessels of all kinds down the North River into the Upper Bay. They arrived at 2.45 P.M. around the eastern end of Bedloe's Island, where eight U.S. Navy ships and several French vessels lay at anchor. *The New York Herald* reported that as *Despatch* drew near "the men-of-war's men were seen springing aloft. . . . Spryly they ran out along the yards and stood elbow to elbow. . . . The rainbow of fluttering bunting that arched each frigate and corvette contrasted prettily with the blue suits of the jolly tars." A twenty-one gun presidential salute thundered from ships' cannon and the harbor defenses. The Twenty-second Regimental Band's rendition of "Hail to the Chief!" was drowned out by the noise of the crowd as the presidential party moved to a platform where the American Committee, State governors, members of Congress, military officers, the French delegation, and other dignitaries faced a seated audience of about twenty-five hundred. One observer remembered: "The platform looked small like a poppy at the base of the statue. . . . The whole island seemed to be one human being." Although light drizzle and artillery smoke masked the view from the hundreds of boats on the river, even the sight of Liberty herself, one report claimed that "a million people, afloat and ashore, saw through the mist at least a part of the inauguration."

All did not go as intended. On behalf of the French people de Lesseps presented "Liberty enlightening the world" to William Evarts. The senator began an eloquent, not to say loquacious, reply; it was planned that as his speech ended, Bartholdi and David King, waiting in the statue's head for a signal from a boy on the ground, would pull a rope to release the *Tricoleur* that swathed Liberty's head to reveal her burnished copper face. Of course, at that

moment she did not have the green copper oxide complexion that she wears today. It all would be very dramatic. But when the audience applauded a rather fine piece of the orator's prose the boy, confusing the speaker's pause with his conclusion, signaled prematurely. Bartholdi and King released the flag, providing "the signal for another enthusiastic outburst of the steam-whistles from the flotilla anchored in front of the island, and a national salute from the ships of war, drowning out completely . . . the strains of the *Marseillaise* from the band."

The uproar was sustained for about 15 minutes before President Cleveland's succinct acceptance speech followed. Forgetting that, as governor of New York, he had refused to fund the pedestal, he now promised, "We will not forget that Liberty has here made her home, nor shall her chosen altar be neglected. Willing votaries will constantly keep alive its fires and these shall gleam upon the shores of our sister Republic thence, and joined with answering rays a stream of light shall pierce the darkness of ignorance and man's oppression, until Liberty enlightens the world."

The stirring closing address was by Chauncey Mitchell Depew (incidentally, also a Freemason), known as "the orator of silver words." Although the French delegation numbered fifteen, the only official French speaker, besides Bartholdi, was the *Ministre Plenipotentiaire et Delegué Extraordinaire* W. A. LeFaivre. The Assistant Episcopalian Bishop Henry C. Potter (yet another Freemason) ended the program with a benediction, and *Despatch* bore the President away to the echo of another salute from forts and warships.

Across the Atlantic, *The London Daily News* reported the occasion. Perhaps still smarting over the American Revolution—the British name for the War of Independence—and America's victory in the War of 1815, or reflecting England's centuries-old antagonism to France, the newspaper sulkily asserted, "It is a great mistake to think the statue will increase the friendship between the two countries. America did not want the statue. She took it because it was offered to her. When the last cannon boomed New York was richer by a remarkable statue, and that is about all."

Lady Liberty was conceived as a beacon, and on November 22, 1886, her torch became, for a while, a navigational aid for ships entering New York Harbor. It was the first lighthouse in the United States to use electricity—the technology had been available for only a few years. General Stone wanted to install lights that would shine into the air from the torch, and to illuminate the whole statue with five floodlights strategically positioned at the angles of the star fort. A steam turbine plant was installed on the island. After "weeks of false starts, confusion, and grappling with the new technology," when the nine arc lamps in the torch were switched on they cast a deep shadow over the upper part of the statue: their angle had been wrongly calculated. The torch could be seen from 24 miles out to sea, but as a critic has observed "the dimness of the lighting was little help to vessels entering the harbor." Attempts were made to increase the illumination, and an oil-powered generator was

installed in 1897. But the light levels were still inadequate, and in March 1902 the U.S. Lighthouse Board ceased to use the flame as a navigational aid and turned the station over to the War Department.

Of course there were changes, administrative and material, made throughout the twentieth century. On October 15, 1924, a Presidential Proclamation declared Fort Wood (and the Statue of Liberty) a National Monument and set its boundary at the perimeter of the fort. Nine years later responsibility for the monument was transferred to the NPS, and in September 1937 its boundaries were extended to include all of Bedloe's Island. In 1956, as noted, the island was renamed Liberty Island. Then in May 1965 Ellis Island was transferred to the NPS by President Lyndon B. Johnson to become part of the Statue of Liberty National Monument. Toward the end of the 1900s the statue was showing her age. The copper surface was pitted with thousands of holes caused by a century of salt-air exposure; the iron framework was distorted by continuous stress and metal fatigue; and previous repair "solutions" had generated different problems and more deterioration. President Ronald Reagan appointed Lee Iacocca to direct a public/private partnership between the NPS and The Statue of Liberty-Ellis Island Foundation to restore the statue. Fundraising began for the $87 million project in 1984, just as UNESCO designated Lady Liberty as a World Heritage Site. The Statue reopened to the public on July 5, 1986.

REDUCING THE SUBLIME TO THE RIDICULOUS

Doubtless with publicity in mind, Bartholdi's 14-year patent licensed images of his statue for use in advertising in Europe and the United States, permitting representations in "any manner known to the glyptic art in the form of a statue or statuette, or in alto-relievo or bas-relief, in metal, stone, terra-cotta, plaster-of-paris, or other plastic composition." Within only a few years a wide range of American and foreign spoons—those most collectible of collectibles—was internationally available. But wait, there's more!

Liberty has appeared on U.S. and French postage stamps, including an American–French joint issue for her centenary in 1986. She was featured on War Bonds in 1917 and on patriotic posters for both World Wars. She has graced the covers of hundreds of magazines and figured in thousands of political and editorial cartoons. Iconic as a tourist destination (every year she has more than five million visitors) she has been the subject of countless variations of postcards.

Images of the Statue of Liberty continue to proliferate dizzyingly in American folk art and in popular culture, including advertising. One company in Arkansas offers an "incredible, life size [*sic*] version," assuring potential customers that "Like most 7 ft. tall women, this lady of liberty catches the attention of every passerby. She would be at home just about anywhere and would

make a great photo-op for any business. . . . Made from heavy-duty resin material."

Liberty is represented in gold and silver jewelry and medallions; on ornaments; as a theme in pageants and parades; and in such kitsch souvenirs—many bearing the legend "made in China"—as pill- or candy boxes, cookie jars, paperweights (with or without a clock or a "light-up torch"), and snow domes. The list descends to the ridiculous and irreverent: "patriotic balloons and patriotic inflatables" are produced, as well as stress balls, "genuine hand crafted and painted [and grotesque] plastic bobble heads," chocolate bars, and costumes comprising plastic diadems and gowns (one size fits all) in pale green to evoke the patina on Liberty's copper skin. In France she has even been used to sell cheese. In the electronic age, she has appeared in video games. The examples are too numerous to list.

She is used as a "location image" in television series and movies and has been a significant element in literally dozens of films since 1917, as well as an incidental inclusion in hundreds more, too many to deal with in detail. Her most familiar (albeit by no means literal) evocation in movies is in various incarnations of the Columbia Pictures logo that first appeared in 1924. From the 1930s through the 1990s the *stola*-clad, torch-bearing "Columbia Lady" has undergone many changes, but at only a glance association with Lady Liberty is immediate and inescapable.

At many levels and in every way the Statue of Liberty holds a place in the hearts and minds of the American people. That is what makes it an icon, although not an icon of the idea for which she was first intended; that adjustment has been made by people: as her creators would have put it, "*Chacun à son goût* (to each his own)."

NOTES

1. Garnett, John J., ed., *The Statue of Liberty. Its Conception. Its Construction. Its Inauguration.* New York: Dinsmore, 1886. www.endex.com/gf/buildings/liberty/libertyfacts/LibertyCCI/LibertyCCI.htm

2. Glassberg, David, "Rethinking the Statue of Liberty: Old Meanings, New Contexts." www.libertyellisplan.org

3. Jewish Women's Archive, "JWA—Emma Lazarus—The New Colossus," http://jwa.org/exhibits/wov/lazarus/el9.html

4. Trachtenberg, Marvin, *The Statue of Liberty*, New York: Viking Penguin, 1976, 30.

5. Townsend, James B., "The Statue of Liberty," *Frank Leslie's Popular Monthly*, 20(August 1885), and extensively elsewhere.

6. Hargrove, June, "Liberty: Bartholdi's *Quest for a Visual Metaphor.*" July 1986. www.worldandi.com

FURTHER READING

Allen, Leslie Beth. *Liberty: The Statue and the American Dream.* New York: Statue of Liberty-Ellis Island Foundation and National Geographic Society, 1985.

Baker, Paul R. *Richard Morris Hunt.* Cambridge, MA: MIT Press, 1980.

Bartholdi, Frédéric Auguste. *The Statue of Liberty Enlightening the World.* New York: North American Review, 1885. Reprinted New York: New York Bound, ca. 1984.

Bermond, Daniel, and Robert Belot. *Bartholdi.* Paris: Perrin, 2004.

Cunningham, John T. *Ellis Island: Immigration's Shining Center.* Charleston, SC: Arcadia, 2003.

Dillon, Wilton S., and Neil G. Kotler, eds. *The Statue of Liberty Revisited: Making a Universal Symbol.* Washington, D.C.: Smithsonian Institution, 1994.

Garnett, John J., ed. *The Statue of Liberty. Its Conception. Its Construction. Its Inauguration.* New York: Dinsmore, 1886.

Gilder, Rodman. *Statue of Liberty Enlightening the World.* New York: New York Trust Co., 1943.

Gschaedler, Andre. *True Light on the Statue of Liberty and Her Creator.* Narberth, PA: Livingston, 1966.

Hayden, Richard Seth, Thierry W. Despont and Nadine M. Post. *Restoring the Statue of Liberty.* New York: McGraw-Hill, 1986.

Joseph, Rebecca M., et al. *An Inquiry into the History and Meaning of Bartholdi's Liberté éclairant le Monde.* Boston: National Park Service, 2000.

Lemoine, Bertrand. *The Statue of Liberty.* Brussels, Belgium: Mardaga, 1986.

Moreno, Barry. *The Statue of Liberty Encyclopedia.* New York: Simon & Schuster, 2000.

Stakely, J. Tracy. *Cultural Landscape Report for Ellis Island: Statue of Liberty National Monument: Site History, Existing Conditions, Analysis.* Brookline, MA: National Park Service, Olmsted Center for Landscape Preservation, 2003.

Trachtenberg, Marvin. *The Statue of Liberty.* New York: Viking Penguin, 1976.

INTERNET SOURCES

Official NPS website. www.nps.gov/stli/

Glassberg, David. "Rethinking the statue of Liberty: old meanings, new contexts." www.libertyellisplan.org

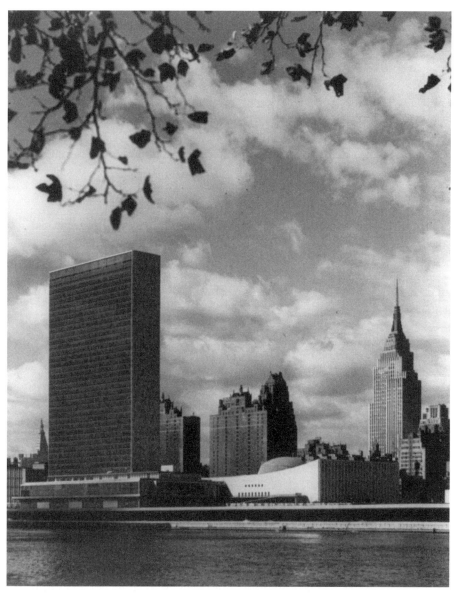

Courtesy Library of Congress

United Nations Headquarters, New York City

"Peace, justice and well-being"

The United Nations Organization (UN) Headquarters is bounded by First Avenue west, East 42nd Street south, East 48th Street north, and the East River in New York City. The Organization says that the complex of six buildings "remains both a symbol of peace and a beacon of hope."

> To its eighteen acres come representatives of the earth's 6 billion people, to discuss and decide issues of peace, justice and economic and social well being. Here, about 4,900 employees of the . . . Secretariat work to implement these decisions. Each year the 192 Member States send over 5,000 delegates to the annual sessions of the General Assembly; 700,000 visitors yearly; and more than 3,600 permanently accredited journalists—over 10,000 are present during major meetings.[1]

New York tourist authorities list the UN Headquarters as one of the major tourist attractions in the City. Since 1952, approximately thirty-eight million visitors have taken the guided tour of the buildings; numbers peaked at more than 1.2 million in 1964. The Secretariat Building, rising above the flags of the 192 member nations on a 500-foot curve along United Nations Plaza is universally familiar as an icon of world architecture. The view from across the river is equally well known.

THE UN IN POPULAR CULTURE

Because of its prominent role in world politics, the UN has been widely represented (often under an alternative name) in popular media—films, books, music, and latterly computer games. Early among these appearances was Metro-Goldwyn-Mayer's *The Man from U.N.C.L.E.*; shown in the United States on NBC television from 1964 until 1968, it featured an agency called the United Network Command for Law and Enforcement, with New York headquarters and an international staff. The following year Marvel Comics created Supreme Headquarters International Espionage Law-enforcement Division (S.H.I.E.L.D.), another New York-based "extra-government intelligence and security organization." And *Batman*, a 1966 Twentieth Century-Fox movie pilot for ABC's television series (1966–1968), featured the United World Organization, complete with a nine-member Security Council and headquarters on East Gotham Drive.

Since then the UN has been rebadged in other fictional works and has even been used to religious ends. In Russell S. Doughten's 1980 movie *Image of the Beast*, based on the *Left Behind* series of pop-eschatology novels, it became the United Nations Imperium of Total Emergency (UNITE), a future, maligned one-world government (some of the books use the alias Global Community). The 2000 movie adaptation of *Left Behind* flopped at the box office, and its sequel *Left Behind II: Tribulation Force* was released on video only. The

"understudies" of UN Headquarters are plausible in neither; in the earlier film, Canada's provincial and territorial flags are flown as those of member nations.

But why stop at Earth? As early as 1966 a parallel version of the UN was launched into the final frontier as *Star Trek*'s United Federation of Planets. A decade later other cosmic clones appeared, beginning with the Galactic Republic in the *Star Wars* movies and books of the films. The 1993 film *Babylon 5* and its 1994 spin-off TV series included the Earth Alliance, the Interstellar Alliance, and the League of Non-Aligned Worlds. The animated sitcom *Futurama,* seen on pay TV in the United States from 1999 until 2007, had an interplanetary organization called the Democratic Order of Planets (DOOP), whose flag bore a striking resemblance to that of the United Nations. All these productions made oblique references to the UN *Organization*, but none included the UN building. That was left to moviemakers. The Internet Movie Database lists almost one hundred films made since 1947—acted and animated, dramatic and documentary—dealing with the UN. Thirteen of the dramas were based on novels, and three on stage plays. Not all especially feature the building, but in some (for example, *The Art of War*, *U.S. Marshals*, and *The Second Renaissance*) it is germane to the plot. Here, comment is offered upon a few.

The 1959 Disney animated feature, *Donald in Mathmagic Land*, significantly cited the UN building as an example of theoretical proportion applied to modern architecture. Such systems were important to Le Corbusier, one of the building's designers, who wrote two treatises on the subject. *Vers une architecture* (*Towards One Architecture*), that analyzed buildings according to the mathematics of the "golden mean," appeared in 1923. A 1927 English translation bore the inaccurate title, *Towards a New Architecture*. In 1948 Le Corbusier published a personal mathematical theory that appeared in English in 1951 as *The Modulor: A Harmonious Measure to the Human Scale, Universally Applicable to Architecture and Mechanics.*

Also in 1959, Alfred Hitchcock made his classic movie *North by Northwest*. The famous director wanted to film a scene in the UN General Assembly, where one of the ambassadors is murdered; it was not allowed. The opening credits against a green grid evoke the Secretariat building's expansive glass curtain wall—although by the time the film was made, such walls were common in New York. Hitchcock took a still photographer to secretly photograph the public lobby (it is said) so that it could be re-created on a sound stage. Ground-level exterior shots of the hero entering the building were filmed from a carpet-cleaning truck that concealed a VistaVision camera. The scene showing the hero's precipitate exit was totally different: a tiny figure is glimpsed fleeing from the building, dwarfed by an aerial shot of Le Corbusier's Secretariat tower. Because of the UN prohibition of photography, that image was a montage. But Hitchcock was good at montage: 4 years later, the final scene in *The Birds* was combined from twenty-eight visual elements!

To date, Sydney Pollack's $80 million thriller *The Interpreter* (2005) is the only movie shot on location in the UN—albeit just on weekends. Former Secretary-General Kofi Annan, with whom Pollack personally negotiated, insisted that "the intention was really to do something dignified, something that is honest and reflects the work that this Organization does. And it is with that spirit that the producers and the directors approached their work." *The New York Observer* opined that Pollack's success was related to the UN's need at that moment for good publicity, because its worth was being questioned. Anthony Lane reviewed the film in the *New Yorker*, "We get a disappointingly slim grasp of UN life. I can tell you no more now about the layout of the place . . . than I could before watching the movie. . . . The single UN scene in *North by Northwest*, for which Hitchcock had to use mockups, delivers a more colorful punch than Pollack's respectful panoramas of the General Assembly."[2]

The UN headquarters has been destroyed in a few movies. In Toho Studios' *Destroy All Monsters* (released in Japan as *Complete Monster Attack* in 1968), a difficult-to-believe Godzilla destroys it with his radioactive breath. The special effects were hardly better in Blake Edwards' *The Pink Panther Strikes Again* (1976), in which the crazy chief inspector Charles Dreyfus uses a Doomsday Machine to disintegrate the building. And in DreamWorks' "infuriatingly predictable and wholly uninvolving" *The Peacemaker* (1997) a Serbian terrorist, blaming the UN for the death of his family, sets out to blow up its headquarters with nothing less than a nuclear bomb. There are outside location shots, but nothing was filmed inside the building. By the way, the attempt was foiled. Not so in the Animatrix short film *The Second Renaissance* (2003) where destruction is wrought by a machine ambassador to the UN.

The gift center in the UN Headquarters public concourse does not specialize in the usual kitsch. The merchandise—aprons, tote bags, mugs, coasters, T-shirts and key chains—is available for those visitors who must have a souvenir, but it is all exclusive to the center, embossed with the UN logo and appropriately dignified. The center sells flags, handicrafts, and souvenirs from member states. New York shopping guru Dana Schuster writes that its "real goodies are far more global. . . . Haitian, Columbian or Ethiopian dolls and Kenyan Woodcarung statues, meant to protect the home [and] an impressive collection of jewelry, like 18th-century Austrian enamel lockets and . . . necklaces from the Democratic Republic of Congo."

AN IDEA THAT FAILED: THE LEAGUE OF NATIONS

World War I (1914–1918) surpassed all earlier wars in its scale of devastation. The complicated underlying issues are beyond our present scope, but the conflict was sparked in June 1914 by the assassination in Sarajevo of the

Austro-Hungarian Archduke Franz Ferdinand and his wife. To avenge their deaths—pretext or not—Austria invaded Serbia, and the dominoes began to fall: Serbia turned to Russia for help; Germany, bent on imperial expansion, invaded Belgium and Luxembourg and declared war on Russia and France, both which mobilized to defend their respective territories. Britain declared war on Germany because it had violated Belgium's neutrality.

Most thought the conflict would last only months, but for over 4 years a total of sixty-five million men and boys fought in a war between the Central Powers (Germany, the Austro-Hungarian empire, Bulgaria, and Turkey) and the Allied Powers (the British Empire, Belgium, France, Italy, Russia, and—from 1917—the United States). About ten million died in battle, twice as many were wounded; and ten million civilian lives were lost. The conflict extended into the antagonists' colonies in Asia and Africa; sea battles were fought in the South Atlantic and the Pacific. Eventually, Germany's spring 1918 offenses on the western front failed, and by midyear her armies began to be driven back by the Allies. In the fall, as German workers at home were "suffering from food and fuel shortages [and] threatened revolution," Germany, afraid of a communist coup, pressed U.S. President Woodrow Wilson for an armistice. Fighting ceased at 11 A.M. on November 11, 1918.

Wilson, a passionate advocate of "a general association of nations," chaired the Paris Peace Conference (of the victors) in December. He led a committee optimistically charged with setting up a body "whose purpose was to preserve world peace through open diplomacy and global consensus." France's Minister of War Georges Clemenceau remarked that Wilson's ideal "was a very high one, but it involved great difficulties, owing to these century-old hatreds between some races." Nevertheless, on April 29, 1919, the final version of the Covenant of the League of Nations was adopted, and almost exactly 2 months later it became Part I of the Peace Treaty of Versailles that formally ended what was believed to be "the war to end all wars." The Covenant had three essential objectives: to ensure collective security, to assure functional cooperation, and to execute the mandates of peace treaties. Because it could begin to function officially only after the Treaty of Versailles came into effect, the thirty-two member League of Nations was inaugurated on January 10, 1920; thirteen other states—on the fulfillment of certain conditions the League was open to all—were invited to join.

The U.S. Senate, in an assault led first by Idaho Republican William E. Borah, strenuously opposed the League. Political historian Robert C. Byrd writes, "Known as 'the Great Opposer' . . . [Borah] was . . . a staunch defender of the Constitution, and a confirmed isolationist. . . . [He] emerged as the leader and spokesman of the "irreconcilables"—the group of predominantly Republican senators [with] unbending opposition to American participation in the League of Nations." While President Wilson was engaged in treaty negotiations in Paris, Borah toured the United States, claiming, "America has arisen to a position where she is respected and admired by the entire world.

She did it by minding her own business." In July 1919 Henry Cabot Lodge launched his ultimately successful campaign to defeat the League by delaying the final vote while adding reservations to the treaty that would render it unacceptable to Wilson's supporters. The irreconcilables opposed the League in any form. According to Byrd, on November 19,

> Several other senators spoke against or in support of the League of Nations during the grueling five-and-a-half-hour debate [Borah filled two of those]. The Senate voted . . . as the session drew to a close. The Democrats, who, at Wilson's insistence, refused to accept the reservations, combined with the irreconcilables to defeat the treaty with the "Lodge reservations" by a vote of 39 to 55. In a subsequent vote, the treaty without reservations was defeated by a vote of 38 to 53. Four months later, on March 19, 1920, [it] once again failed to receive the two-thirds Senate vote needed for approval.[3]

That rejection was ironic. Twenty-five years later America would scramble to become the permanent location of the United Nations Organization, successor to the League of Nations.

The League had four main components. The Council, of four permanent and up to ten nonpermanent States, met three times a year; its principal role was to settle international disputes. The Assembly addressed issues affecting world peace, membership of the League, amendments to the Covenant, the election of nonpermanent members of the Council and the budget. The Secretariat, appointed by the Secretary-General, was responsible for all administrative matters. The Court of International Justice sat in the Hague to determine disputes an international character.

In 1920, the League's temporary office moved from London to Geneva, and throughout the decade its Council meetings and conferences were also held there. At the urging of Woodrow Wilson, Switzerland was chosen as the seat of the new organization because had maintained neutrality since 1515. That status became void when it joined the League but was regained in the 1930s. As Harry Lime remarked in the 1949 movie *The Third Man*, "In Switzerland, they had brotherly love and 500 years of democracy and peace, and what did that produce? The cuckoo clock." In 1927 an international design competition was held for a "palace" in Geneva intended to house all the organs of the League of Nations. Reviewing almost four hundred submissions, the jury awarded nine first prizes; five architects—Swiss, French, Italian, and Hungarian—were asked to develop the final proposal. The surrounding scandal would affect, in a measure, the eventual design of the UN Headquarters.

The League of Nations started well, resolving quarrels between Sweden and Finland, and Greece and Bulgaria. In October 1925 it brokered the Locarno Agreements, paving the way for diplomatic reconciliation between Germany and its former enemies; the Weimar Republic became a member in 1926. By the end of the decade, the French delegate even had suggested forming a

federated Europe, prophesying the twenty-seven–state European Union that exists today. But the League was unable to prevent the Japanese invasion of Manchuria in 1931. And when in 1935 Italy attacked Ethiopia without declaring war, the organization, while unanimously condemning Italy's aggression, took no effective action. Neither did it act in 1938 when Adolf Hitler, in violation of his earlier declaration that Nazi Germany had no intention of annexing Austria, proclaimed *anschluss*. In the course of the 1930s Japan, Italy, and Germany withdrew from the League.

Altogether, from 1918 until the outbreak of World War II there were about sixty civil and international wars of various size and duration. The impotence of the League to prevent further world conflict, the alienation of some member states, and the war itself contributed to its death from 1940. But there had been successes too, in a "secondary aspect of its objectives: international technical cooperation . . . in areas as diverse as health and social affairs, transport and communications, economic and financial affairs and intellectual cooperation. . . . The work on behalf of refugees carried out by the Norwegian Fridtjof Nansen from 1920 should also be stressed."[4]

At the end of World War II, although in every practical sense the League of Nations had ceased to function, it still had forty-three member states. Formal closure was necessary, and its real estate, buildings, library, archives, and historical collections were passed to its successor, the United Nations, at a London meeting between the League's Supervisory Commission and the UN's Preparatory Commission, established in 1945. The last Assembly—the twenty-first—of the League of Nations was held in Geneva on April 8, 1946. Lord Robert Cecil encouraged the members that its efforts had not been futile, because without them the new organization could not exist. He closed the Assembly with the words: "The League is dead, long live the United Nations!" Ten days later the remaining forty-three member states unanimously declared that as of April 20, 1946, the League of Nations would cease to exist.

To go back five years . . .

"THE LEAGUE IS DEAD, LONG LIVE THE UNITED NATIONS!"

In August 1941, together with high-ranking military officers of their governments, President Franklin D. Roosevelt and British Prime Minister Winston Churchill met secretly on HMS *Prince of Wales*, "somewhere at sea" off Newfoundland to devise what became known as the Atlantic Charter, "a set of common principles that repudiated territorial aggression by [the Berlin-Rome-Tokyo Axis] and supported the right of self-determination." On January 1, 1942, representatives of twenty-six Allied nations, jointly pitted against that axis, met in Washington, D.C., to sign the declaration by "United Nations"—the first official document to use the term coined by Roosevelt—and guarantee their support for the Charter.

In Moscow toward the end of 1943 the leaders of Britain, the United States, the Soviet Union, and China called for the urgent establishment of an international organization to maintain peace and security, an intention reaffirmed in Teheran on December 1. The four powers agreed upon the first draft of the aims, structure, and functioning of the UN at talks in autumn 1944, held at Dumbarton Oaks, a private mansion in Washington, D.C. According to official UN sources, "discussions were completed on October 7, 1944, and a proposal for the structure of the world organization was submitted . . . to all the United Nations governments, and to the peoples of all countries, for their study and discussion." It stated that within the UN organization there was to be "a General Assembly composed of all the members. Then came a Security Council of eleven members. Five . . . were to be permanent and the other six were to be chosen from the remaining members by the General Assembly, to hold office for two years. The third body was an International Court of Justice, and the fourth a Secretariat. An Economic and Social Council, working under the authority of the General Assembly, was also provided for." It was an almost exact reflection of the League.

> The essence of the plan was that responsibility for preventing future war should be conferred upon the Security Council. The General Assembly could study, discuss and make recommendations in order to promote international cooperation and adjust situations likely to impair welfare. It could consider problems of cooperation in maintaining peace and security, and disarmament, in their general principles. But it could not make recommendations on any matter being considered by the Security Council, and all questions on which action was necessary had to be referred to the Security Council.[5]

Later generally adopted as a Charter, the plan provided that members were to make armed forces available to the Security Council in its task of preventing war and suppressing aggressive acts, The League of Nations' Covenant had contained no such provision—a "fatal weakness in [its] machinery for preserving peace." But it may be observed as an aside that since the foundation of the UN, with its access to "peacekeepers," about 170 wars have been fought in the world. As the organization admits, the term *peacekeeping*, not found in the Charter, defies simple definition. Dag Hammarskjöld, the UN's second Secretary-General, placed it between diplomatic means of dispute resolution (negotiation and mediation) and forceful action. But we anticipate.

The plan was fully discussed throughout the Allied countries. In the United States the State Department distributed almost two million copies and enlisted the press, radio, and even the film industry to explain what was involved in this "new plan for peace." The Dumbarton Oaks talks had not established the Security Council's voting procedure. On February 11, 1945, Churchill, Roosevelt, and Stalin, again meeting with their foreign ministers and chiefs-of-staff, this time at Yalta on the south shore of the Black Sea, decided that issue and "resolved upon the earliest possible establishment with [their] Allies

of a general international organization to maintain peace and security." To that end, they agreed that a Conference of United Nations should be called to meet at San Francisco on April 25, 1945, to prepare a Charter along the lines proposed at Dumbarton Oaks.

In November 1943 a forty-four nation summit at the White House had initiated the United Nations Relief and Rehabilitation Administration (UNRRA). During World War II over one hundred million soldiers and civilians were killed, wounded, or disabled; an estimated twenty-one million people had been dispossessed or dislocated. By 1949 the UNRRA would return about seven million displaced persons to their European or Asian homelands and provide refugee camps for another million who were afraid to go home, especially to the Soviet Union. Cooperating with over sixty voluntary organizations from fifty-two countries, the UNRRA provided emergency food, medication, and restoration of public utilities for war-ravaged populations. Eventually, its role would be handed to specialized United Nations agencies: the International Children's Emergency Fund (UNICEF) in December 1946, the World Health Organization (WHO) in 1948, and the Office of the High Commissioner for Refugees (UNHCR) in 1950. In 1996 Sir Brian Urquhart, a former UN undersecretary-general, hailed the UNRRA as "the greatest relief operation ever launched. It put the world on its feet. Run by Governor Herbert Lehman of New York, it was the most extraordinary operation—This was an American idea . . . a tremendously far-sighted plan."[6] The UN would assume many functions formerly undertaken by the League of Nations. For example, economic activities were transferred to the new Economic and Social Council; the work of the Nansen Office was continued by the UNRRA and the UNHCR; the Health Organization was replaced by the WHO; the Nutrition Committee became the Food and Agriculture Organization (FAO); and the League's Committee of Intellectual Cooperation became the Educational, Scientific and Cultural Organization (UNESCO).

At the UN Conference on International Organization convened in San Francisco, the USSR, China, Britain, and the United States acted as the "sponsoring powers"; forty-six other states participated, all of whom had signed the January 1942 UN Declaration or had declared war on the Axis before March 1945. Together, they fielded 282 delegates; there were nearly fifteen hundred other "officially accredited" attendees and "representatives of scores of private organizations interested in world affairs." Following Germany's surrender in May, meetings continued for 6 weeks. On June 26, 1945, in the Veterans Auditorium (now Herbst Theatre) of San Francisco's War Memorial Opera House, fifty countries signed the UN Charter as founding members. President Harry S. Truman, in office for barely 2 months, told them,

Oh, what a great day this can be in history! There were many who doubted that agreement could ever be reached by . . . countries differing so much in race and religion, in language and culture. . . . History will honor you [for writing the

UN Charter] . . . If we had had this charter a few years ago—and above all, the will to use it—millions now dead would be alive. If we should falter in the future in our will to use it, millions now living will surely die. . . . That we now have this Charter at all is a great wonder.[7]

Almost exactly a month later he gave the order to drop the atomic bombs that devastated the Japanese cities of Hiroshima and Nagasaki.

Space was left on the Charter for the fifty-first signature, Poland's, added on October 15 because its government was not established until 2 days after the signing. The BBC reported that the UN was inaugurated on October 24, 1945, "at the State Department in Washington [when] twenty-nine countries ratified the UN Charter."

NEW YORK! NEW YORK!

On December 10, 1945, the U.S. Congress unanimously resolved to invite the UN to establish its permanent home in America. Although many offers and suggestions for permanent sites had been received, and despite opposition from Britain, France, and The Netherlands, the decision to locate UN headquarters near New York City was made on February 14, 1946, during the General Assembly's First Session in the Methodist Central Hall, Westminster, London.

A full 2 months before the U.S. invitation was accepted, American cities had vied for the honor. *Time* magazine humorously reported a "rich and raucous" debate in the "oak-paneled, semi-ecclesiastical room . . . where world statesmen were considering where the world's capital . . . should be." It is amusing enough to be cited at length:

> American boosters . . . trooped one by one to the lectern to air their local prides. First came Atlantic City's A.W. Phillips, in a neat blue suit and rimless glasses. He spoke for only three and a half minutes, since the committee was already well briefed by an elaborate brochure which included a spread of the Atlantic City beauty pageant.
>
> Boston's delegation was headed by Governor Maurice J. Tobin, armored in black coat and striped pants. . . . Tweedy President Karl T. Compton of Massachusetts Institute of Technology, made the committee sit up by announcing that [local unions] had promised that "there will be no strikes of their members in connection with any work done for the [UN] in the Boston area." Compton also pointed out Boston's library facilities. This gave Chicago's Barnet Hodes an opening; he claimed that Chicago's libraries had 125,000 more books than Boston's. . . . Chicago, like the other delegations, had a newsreel to show its beauties. As the commentator said, "This is the sort of thing worthy of study in Chicago," the reel stuck, and a bevy of fan dancers on ice skates froze on the screen, grinning toothily at the statesmen.
>
> Philadelphia was touted by Judge L. Stauffer Oliver. Colorado University's whip-smart Robert Stearns cried havoc on his coastal rivals for tidal waves,

earthquakes and tornadoes. Tongue in cheek, San Francisco's urbane Mayor Roger Lapham recalled being frozen fast in the harbors of both Boston and Philadelphia in his early yachting days.

The star performer was Paul Bellamy, a bull-necked businessman who represented no city, but the bleak Black Hills of South Dakota, where men are men and steaks are three inches thick. When he described the latter, . . . Stoyan Gavrilovic, the UNO subcommittee chairman, was visibly affected. Bellamy's best argument had a pessimistic undertone: Boston, Philadelphia and the other coastal cities were within easy reach of atomic bombings. "In the Black Hills there are no military objectives, and the gentlemen who are striving for the peace of the world can live at peace while the atomic bombs are falling." It was no part of Bellamy's job . . . to ask what the gentlemen would be doing at that point.[8]

New York City, not mentioned in the *Time* article, was supported by about half the delegates. By the end of October 1945 San Francisco had been struck from the short list, probably because of its remoteness from Europe. Boston's postwar financial problems were greater than even New York's. Philadelphia was so convinced that it would attract the UN that the city fathers had already initiated plans to clear land near the University of Pennsylvania.

It has been cynically but accurately observed that the UN came to have its headquarters in New York "largely as a result of substantial inducements." The progress toward the final choice of location makes a compelling story. A. M. Rosenthal summarized the first chapter in a tongue-in-cheek article:

> The first United Nations headquarters was room 786 at the Waldorf-Astoria. It was there that A. H. Feller, general counsel of the United Nations, checked in on Feb. 19, 1946, with orders to find first a temporary home in New York, then a permanent one. . . . [Later] more hotel rooms were rented as offices, a few more phones installed. . . . After the Waldorf, the United Nations wandered about New York for a couple of years, from the Bronx campus of Hunter College . . . whose students had been shifted downtown . . . by a city eager to collect the United Nations' $9,000 monthly rent; to a boardroom at 630 Fifth Avenue, to a dumpy hotel on West 57th Street.[9]

But the Henry Hudson Hotel "and a few borrowed board rooms at Rockefeller Center were far too small to conduct business with any regularity." The UN desperately needed a permanent home.

On March 25, 1946, it accepted the 40-acre Hunter College site (now Lehman College) in the northwest Bronx for its temporary headquarters. Within a fortnight the gym building became chambers for the Security Council and the Economic and Social Council; faculty offices and classrooms were occupied by the Secretariat and delegates. In Rosenthal's words, until mid-August the campus became the "diplomatic center of the universe." One romantic writer believed that "the bucolic treelined campus and broad vista over the waters of the Jerome Park Reservoir . . . coincided with the conventional

wisdom about what an ideal site for a permanent United Nations facility should look like." No, it didn't.

New York Mayor William O'Dwyer, determined to retain the UN, offered the New York City building at the 1939 World's Fair site in Flushing Meadows as a temporary venue for the General Assembly; he even "found" a little over $2 million to refurbish a skating rink for the purpose. The former Sperry Gyroscope plant in the dormitory community of Lake Success near Great Neck, Long Island—only 20 minutes away by car, and about 45 from New York City—was suggested for the Secretariat's and Security Council's interim base. Some of Lake Success' twelve hundred citizens initially resisted the conversion of the Sperry building, but an unofficial referendum voted to invite the UN to the village, and the General Assembly approved the relocation on February 14, 1946. Renovation was still incomplete in mid-August when the UN moved in 6 months later: the cavernous defense plant was partitioned to create office space and the Security Council met in a former conference room.

The search for a permanent location had included small towns in Nassau and Westchester counties, as well as Connecticut's Fairfield County, but the proposals aroused opposition in neighboring communities, who told the State Department that they didn't want the UN in their area. The feeling was mutual; the delegates didn't want to be isolated in suburbia. Manhattan was the only alternative, but there were problems. There was no vacant site large enough. Even if there were, the organization could not afford to buy it, much less develop it. The UN also insisted on exemption from city taxes, a confronting demand when New York City was broke; it could hardly afford to subsidize the UN when its priority was to rebuild public housing, hospitals, schools, and infrastructure, all neglected during the war.

O'Dwyer instructed the Parks Commissioner Robert Moses to assemble a task force to negotiate with the UN Headquarters Committee. Moses co-opted James A. Farley, the former postmaster-general; Thomas Watson, the president of IBM; Arthur Hays Sulzberger, publisher of *The New York Times*; James J. Lyons, the Bronx Borough president; and Nelson Rocke-feller and his cousin, banker Winthrop Aldrich. But by early November 1946 UN Secretary-General Trygve Lie had almost despaired of a New York City location. Then he was contacted by Moses, who told him that something had come up that might allow the city to find space in crammed Manhattan.

The Turtle Bay area on the island's eastern slope had long been home to cattle-holding yards, abattoirs, and meat-packing plants. William Zeckendorf, Sr. of Webb & Knapp Inc. saw it as ripe for redevelopment. He commissioned architect Wallace Harrison to design the speculative X-City, "a private, mixed-use development [that] included offices, apartments, waterfront parks and a domed, lozenge-shaped building intended for an opera house and an orchestra hall." Although they had long resisted selling, in December 1945 the Chicago owners of about 9 acres of the land offered it to Zeckendorf for $17 per square foot. His $12 counteroffer was declined, but when his partners

pointed out that redeveloped real estate three blocks away was bringing twenty-five times as much, he paid $6.5 million for the tract—$1 million down and a year to pay the balance. He then engaged a number of different brokers to clandestinely buy surrounding properties at $2 to $5 per square foot. Eventually he acquired about seventy-five properties for an average $9 a square foot. Webb & Knapp then owned 17 acres.

They had to finalize payment for the original nine acres on December 11, 1946—coincidentally, the date set by the UN Headquarters Committee to determine a permanent site. Five days before the double deadline, Zeckendorf read of the UN's problem in *The New York Times*. He phoned O'Dwyer to say that he would sell a large area of Manhattan to the UN for whatever they wanted to pay. O'Dwyer informed Moses, and Moses phoned Nelson Rockefeller, who had been dickering with his family and the UN about suitable sites. Over the next few days there was a "nonstop conclave" of Rockefeller family members, consultants, and friends. Negotiations that normally would have taken months were concluded in the 4 days before the UN Headquarters Committee met. Moreover, there were loose ends: land not under Webb & Knapp's control had to be acquired; access to the site would need to be gained by widening 47th Street, meaning that city property would have to be relinquished; New York State would have to allow the closing of some streets, and the federal government would have to be asked for an interest-free loan.

John D. Rockefeller, Jr. decided to make a cash gift to the UN, which would then buy the land from Webb & Knapp. On the night of Tuesday, December 10, Zeckendorf accepted Rockefeller's offer of $8.5 million. The next morning Warren Austin, America's delegate to the UN, announced the gift, "stipulating that the City would add another $2.5 million to build a half-mile tunnel beneath First Avenue, street widening and other improvements." On December 12 a UN committee voted overwhelmingly (but not unanimously) to accept Rockefeller's gift. Three months later Mayor O'Dwyer committed another $15 million to rehabilitate the area next to the UN compound.

As F. Peter Model comments, Zeckendorf's "seemingly impetuous decision to scrap twelve months of elaborate planning for [a large] urban complex . . . and make the land available to the United Nations at a huge financial sacrifice to himself and his partners is usually depicted as an extraordinary act of civic generosity." But, he argues, "The worldwide media exposure . . . gave him instant credibility in the financial world [and] launched one of the most spectacular careers in the annals of modern real estate development."[10]

INTERNATIONAL ORGANIZATION, INTERNATIONAL STYLE, INTERNATIONAL ARCHITECTS

The second half of the 1920s had seen a generally free interchange within Europe of the radical ideas of contemporary architecture, largely through the

modernist domination of professional journals. Thirty years earlier a similar phenomenon had spread the Arts and Crafts message. But whereas the Arts and Crafts movement was essentially unified, the modernists of France, Germany, Holland, and—for a moment—Russia saw the need to adapt to the structural changes in society and to meet the demands of industrialization, and mutually moved by the perceived urgency to reform urbanistic and especially housing policies, sang the anthem of Internationalism in several part harmony.

> Three events were especially significant. In 1927 the *Deutscher Werkbund* appointed its first vice president, Ludwig Mies van der Rohe (who would later become head of architecture at IIT) to manage a collaboration between itself and the municipality of Stuttgart. He organized the construction of the Weissenhofsiedlung, a settlement of twenty-one prototype houses (comprising sixty dwellings) for lower- and middle-income families, designed by prominent modernists. Most of the thirteen invited architects were German but one was Swiss and two were Dutch. The settlement formed part of an exhibition, "*Die Wohnung*" ("The dwelling"), held from July to October.

The following year Friedrich T. Gubler, secretary of the *Werkbund*'s Swiss chapter, persuaded Madame Hélène de Mandrot to make available her chateau at La Sarraz, Switzerland, for a meeting of Europe's leading architects. The outcome of that gathering was the establishment of the *Congres Internationaux d'Architecture Moderne* (CIAM, the International Congress of Modern Architecture). Many of the twenty-five attendees (from Austria, Belgium, France, Germany, The Netherlands, Spain, and Switzerland) commanded great moral authority and already enjoyed a European, if not universal reputation. They identified rationalization and standardization as priorities in humanely solving the housing and city planning problems that each faced in his own country.

Le Corbusier would later write in *UN Headquarters*, "In 1928 . . . the CIAM was born. Real precursor of our United Nations, this Congress, having harmonized what might be called the 'dissenters' of architecture and urbanism, worked 20 years perfecting a doctrine of architecture and urbanism."

CIAM held four more congresses and had planned a sixth, aborted just as Europe was plunged into World War II. For the duration of the conflict the group was sustained in the United States as CIAM, Chapter for Relief and Postwar Planning. The first postwar conference was organized by the British Modern Architectural Research Group (MARS) at Bridgewater, England in 1947, followed by others at Bergamo, Italy, Hoddeston, England, and Aix-en-Provence, France. At the Dubrovnik, Yugoslavia, congress in 1956 CIAM was replaced by a "loose association of friends" of the modern movement. Although its philosophies were centered on housing and city planning, they greatly affected the design of UN Headquarters.

In February–March 1932, New York's Museum of Modern Art (MoMA) mounted "Modern architecture: international exhibition" that introduced the American public to the work of the European modernists. The work of Le Corbusier, J.J.P. Oud, Walter Gropius, Mies van der Rohe, and (by contrast) Frank Lloyd Wright formed the bulk of the show, but there was also work by other Americans—altogether some forty architects representing fifteen countries. In the catalogue the organizers—Alfred Barr, Jr., MoMA's director; Philip Johnson, curator of its Architecture and Design department; and historian/critic Henry-Russell Hitchcock—credited Le Corbusier, Mies, Gropius, and the Hollander Oud with the foundation of what they dubbed the "International Style." Hitchcock and Johnson also published *The International Style: Architecture Since 1922* to coincide with the exhibition. They concluded that there was indeed an international *style*—Barr capitalized the word in his preface but the authors did not—recognizable by several elements: space enclosed, regularity, and rejection of ornament. Certainly those commonalities are instantly observable in Modernism, but the product of each of the architects mentioned was diverse, distinctive, and recognizable as his own.

Of course, the idea of an "international architecture"—an aesthetic that would reflect the role of the organization—was important to the United Nations. Participating designer Ssu-Ch'eng Liang believed that "this group of buildings should be not only international in character, but un-national—expressing no country's characteristic but expressive of the world as a whole." That goal was achieved: Jeanne Kirkpatrick, erstwhile U.S. ambassador to the U.N. (1981–1985) said that the building had a "universal style but it has achieved that by adopting the personality of no country and no culture."

In 2003 K. Normandin and M. Petermann wrote that "United Nations Headquarters is considered a highly significant living monument because it was created to symbolize an accord to unified world peace. [It was] meant architecturally to symbolize new political ideals and their aesthetic embraced a formal unadorned style of modernism to create large complexes representing political power."[11]

Recalling that the 1927 competition had "drawn scandal to the League of Nations" and despite demands by the AIA and others that there should be an international competition, the UN appointed a design committee of architects, engineers, and planners from ten member nations; it was headed by New York architect Wallace Kirkman Harrison. Questions were raised about the propriety of his appointment; after all, he was the Rockefeller family's personal architectural adviser and the designer of William Zeckendorf's cancelled City-X project. *And* his brother-in-law was married to John D. Rockefeller, Jr.'s daughter, Abby. After the UN Headquarters was complete, *Time* magazine ingenuously reported that UN Secretary General Trygve Lie, who appointed Harrison as director of planning, believed that he was specially qualified for the post of top UN architect: he had helped build Rockefeller Center, he had been on the committee that brought the UN to Manhattan,

and he helped Rockefeller in his "purchase and gift of the building site." There was nothing about his skill as an architect.

A consulting Board of Design—a "politically selected consortium of internationally recognized architects"—was recruited from member nations. Architectural historian Eric Mumford comments on what many resented as the "seemingly arbitrary selection."

> Other members . . . whom Le Corbusier suggested to Harrison for appointment were [Alvar] Aalto, [Walter] Gropius, Mies, [Oscar] Niemeyer, [Jose Luis] Sert, [the Ukrainian engineer Vladimir] Bodiansky, Eero Saarinen . . . , Edward Durell Stone, and Mathew Nowicki. . . . The first three were not acceptable because Finland and Germany were not then members of the UN, and Harrison rejected Saarinen and Stone on the grounds that they were not New York architects. Sert was rejected because Harrison considered him "more of a planner." Of Le Corbusier's candidates Harrison accepted Niemeyer for Brazil, Sven Markelius for Sweden and Gaston Brunfaut . . . for Belgium. Harrison also nominated . . . from Australia (Gylè Soilleux), Canade (Ernest Cormier), China (Ssu-ch'eng Liang), USSR (Nikolai Bassov), and Uruguay (Julio Vilamajó), who were not CIAM members. For Britain [he named] Howard Robertson.[12]

Clearly, the selection was fraught with nepotism and politics. Harrison appointed his junior partner Max Abramovitz as deputy director of planning. It seems that Le Corbusier also enlisted his associate, Yugoslavian Ernest Weissmann. The five permanent nation-members of the Security Council ensured that they were all represented. Bassov was sent to present Moscow's requirements. Greece insisted that Jean Antoniades, a former city planner in Athens, be appointed as a consultant.

The Board met forty-five times between February and June 1947, "playing with blocks, scribbling sketches, and disagreeing in a half dozen languages." In essence the members were unanimous: all shared Harrison's preference for strict functionalism. More than twenty years earlier Le Corbusier had coined "*machine-à-habiter* (machine for living in)" to describe the modern house; the Board of Design saw the headquarters as a "machine for working in." Because the participants decided that their personal contributions would be anonymous, exact questions of authorship remain unanswered. But guesses can be made. Le Corbusier's urban concepts dominated the proceedings. He and Harrison tussled for 4 months.

At first, the Board considered a single building but finally agreed on a separate high-rise slab for the Secretariat and an expressive form to distinguish the General Assembly. Open esplanades complemented the whole, . . . tied together in an elegant composition devised by Niemeyer. In fact, writes Phipps, Harrison convinced the Brazilian (who "had consistently declined to do so, in deference to his former mentor, Le Corbusier,") to put forward his scheme. In *A Workshop for Peace*, Harrison's assistant George Dudley, who observed and documented the 4-month design process, remarks that

Niemeyer's presentation was a major breakthrough that, with changes suggested by Le Corbusier and others, formed the basis of the final design. Tom Dyckhoff recently wrote in *The Times*, "Niemeyer's design won over the jury but . . . he agreed to collaborate with Le Corbusier. The result, many argue, is mostly Niemeyer's—though Le Corbusier got most of the glory."

Other sources, not least himself, have credited the design to Le Corbusier, based on his conceptual "Scheme 23A." Nevertheless, as Phipps observes, "Accused by Le Corbusier of stealing the UN design, and denigrated by others as a 'committee architect,'" it was Harrison "who moved the design forward through countless small arguments and efforts by individual architects to promote their own schemes. . . . " Harrison made the design buildable. He wrote in his final report to Trygve Lie, "The world hopes for a symbol of peace. We have given them a workshop for peace." And he would tell a meeting of the Royal Institute of British Architects that one of the greatest problems he had ever had to face, "was that of trying to build, quickly and well, a headquarters for the UN. [Trygve Lie] assembled . . . a group of architects and engineers (speaking at least 10 languages and from 14 different countries) to design . . . a home for the UN. We disagreed, we fought, but we worked hard and each day we returned ready to start anew. We knew we had to succeed."

The now-hackneyed axiom, "A camel is a horse designed by a committee," does not apply in the case of the UN Headquarters. Dudley writes, "The design of the UN was an international effort . . . resulting in a landmark building that was functionally and symbolically important in its time, and marking the emergence of modern architecture as the dominant language of postwar institutions and cities." Architecture critic Herbert Muschamp agrees: "The committee produced not a camel but an icon, an architectural sign that modernity and world peace were mutually reinforcing."

CONFLICT WITH THE CRITICS: ROUND ONE

In June 1947 publication of the design (albeit a "tentative layout scrawled on an envelope by 'an authoritative source'") in *The New York Times* (and reinterpreted in *Life* magazine) inevitably brought the critics out of the woodwork. *Time* reported that "generalized but nonetheless official sketch [was] enough to raise the hackles of conservative architects." Architect Charles C. Platt, president of Manhattan's Municipal Art Society, [said]: "It seems to me simply slabs turned up and slabs lying on their belly, with no unity of composition. . . . A diabolical dream." Another architect, Perry Coke Smith, remarked that it looked like "sandwich on edge and a couple of freight cars." Asked by a British architectural journalist for his opinion of the proposal, the great Frank Lloyd Wright replied, "Architecture has never come out of collaboration alive. Each laborer could do better by himself. Out of this committee for designing UNHQ has come a sinister emblem for world power.

This monstrous commercialized tombstone for the graveyard of peace." Lewis Mumford, in his *New Yorker* "The Sky Line" column, hoped that "the present designs for the buildings will no doubt be improved, perhaps radically modified."

The first estimate of $85 million proved unacceptable to the UN, so the budget was trimmed to $65 million by reducing the number of floors in the Secretariat from forty-five to thirty-nine. In February 1948 President Truman persuaded Congress to approve an interest-free loan to build and furnish the complex; the last $1 million installment was repaid in 1982. Eleven months later the construction contract was awarded to a consortium of four Manhattan companies, Fuller-Turner-Walsh-Slattery; the cornerstone was ceremonially laid on October 24 and at the peak of activity twenty-five hundred building workers were engaged on-site. Secretariat employees occupied their offices in August 1950 and the UN Headquarters opened on January 10, 1951.

The most prominent of the four buildings—the one that attracted the most comment—was the 550-foot, thirty-nine-story steel-framed Secretariat tower at the south end of the complex. Its orientation was decided partly because otherwise it would have cast a shadow over much of the site. It had east and west curtain walls of blue-green Thermopane glass in aluminum frames. The spandrels masking the between-floor spaces were painted black on the inside and there were bands of louvered air intakes on the sixth, sixteenth, twenty-eighth, and thirty-eighth floors. Its windowless end walls were clad with Vermont marble. Three basement levels, connecting with the Conference Building, housed parking garages, an automobile service station, and mechanical plant rooms.

The five-story General Assembly Building, a sloping structure with concave sides, stood beyond a small plaza to the northwest of the Secretariat. The main public entrance to the complex, through another landscaped plaza, was at its north end; at its other end a 54-foot high window provided a view from the delegates' lobby across the Secretariat plaza. The east and west exterior walls were clad with English limestone with Vermont marble dressings. The gold, blue, and green Assembly Hall, measuring 165 by 115 feet occupied the second, third, and fourth floors. Its 75-foot ceiling was crowned with a shallow dome. The General Assembly chamber was originally designed to seat delegates from seventy member states (that allowed for some expansion of the UN, but it now serves 192 nations) and also provided rows of seats for the news media and the public. The space was flanked by glass-walled interpreters' booths. The building's lower two levels housed one large and four smaller conference rooms and the communication hub of the complex, as well as visitor facilities.

The Conference Building extended 400 feet along the waterfront and connected the other buildings; in fact, it was cantilevered over Franklin D. Roosevelt Drive. Most of its second and third floors housed the chambers of

the Security Council, the Economic and Social Council, and the Trusteeship Council. Each room was 135 by 72 feet with a 24-foot ceiling. The second floor also provided a large delegates' lounge, overlooking extensive gardens to the north end and a smaller lounge at the south end. The delegates' dining room, private dining rooms, and a staff café were on the fourth floor; the first floor had three capacious conference rooms.

The complex expressed *zeitgeist*—the spirit of the age. In *The Guardian* in April 2006, Jonathan Glancey called it "a glorious time warp, an international wonderland, its interiors pickled in a curious kind of cold war-meets-Festival of Britain aspic. For fans of authentic period design, it is a slap-up banquet for the eyes." In keeping with the international spirit, materials were selected from many lands: British limestone, Italian and American marble, furniture and furnishings from Britain, Czechoslovakia, France, Greece, Scandinavia, and Switzerland. Decorative interior timbers came from Belgium, Canada, Cuba, Guatemala, The Philippines, Norway, and Zaire (now the Democratic Republic of the Congo).

Even the gardens were international. When developed, they would contain "some 1,500 prize-winning rose bushes, 140 flowering cherry trees, 95 pin oak, 59 honey locust, 48 London plane-trees and 30,000 daffodil bulbs, as well as a fine group of hawthorn, sweet gum, pin oak [sic] and sycamore trees. Lining the asphalt walks are Texas ilex, California privet, azaleas, English ivy [and] wisteria."

CONFLICT WITH THE CRITICS: ROUND TWO

In 1951, many reputable architects hailed the UN Headquarters as a great architectural achievement. Not everyone agreed. Mumford, for example, dismissed the Secretariat as "a Christmas package wrapped in cellophane" and "a triumph of irrelevant romanticism," offering a scathing detailed critique:

> In this building . . . the [movement that] sought to identify the vast and varied contents of modern architecture with its own arid mannerism . . . has reached a climax of formal purity and functional inadequacy. Whereas modern architecture began with the true precept that form follows function . . . this new office building is based on the theory that . . . function should be sacrificed to form.
>
> . . . If anything deserves to be called picture-book architecture, this is it, for all the fundamental qualities of architecture seem to have been sacrificed to the external picture, or rather, to the more ephemeral passing image reflected on its surface. Should one look behind this magician's mirror, one should not be surprised to find, if not a complete void, something less than good working quarters for a great world organization. . . . [This] is not a building expressive of the purposes of the UN, but an extremely fragile aesthetic achievement. . . . As a conscious symbol, the Secretariat adds up to zero; as an unconscious one, it is a negative quantity, since it symbolizes the worst practices of New York, not the best hopes of the UN.[13]

GROWTH AND OUTGROWTH

The first major addition to the UN complex was the Dag Hammarskjöld Library, linked to the Secretariat Building at the southwest corner of the site. It was dedicated on November 16, 1961, in honor of the second Secretary-General, who had died in a plane crash in September. The library, funded by a gift from the Ford Foundation and designed by Harrison, Abramovitz, and Harris, was "erected to meet the Organization's growing demands for library services" and had six stories, three of which were below ground; it was intended primarily for the use of Secretariat staff, delegations to the United Nations, members of permanent missions, and other official users. Three years later, also in memory of Hammarskjöld and fifteen other victims of the accident a stained-glass "Peace window" by the French artist Marc Chagall was placed in the lobby of the Secretariat Building.

When the UN complex was first designed there were fifty-seven member states and, as noted, the architects were asked to allow for an increase to seventy. That number was exceeded by 1955 and an expansion, mainly of meeting areas, for a membership of 126 was carried out by 1964. In 1976 the General Assembly authorized further enlargement of the seating capacity and refurnishing of its own Hall, the Trusteeship Council Chamber and the Security Council office and lounge area, as well as the large conference rooms; the work was completed in September 1980. By mid-1981 a two-level documents reproduction plant had been built under the lawn north of the Assembly Building, and in 1982 a new structure to house an interpreters' offices, meeting rooms, and a cafeteria for staff and delegates was built at the southeast corner of the Secretariat Building.

Inevitably, growth meant that the UN overflowed its site and office buildings outside of the complex (most of them in UN Plaza) accommodate specialized agencies. According to official sources,

> Since the growth of the staff could not be accommodated in the existing Secretariat Building, it has been necessary to rent office space in adjacent buildings. A large number of staff, including the personnel of the United Nations Development Corporation, are located across First Avenue on 44th Street. The Corporation is a public-benefit, non-profit Organization created by New York State to provide facilities for the United Nations and related Organizations. The multi-use buildings also house a luxury hotel, an apartment hotel and a health club on floors not occupied by the United Nations. A third building was erected in early 1987 by the Corporation to house the United Nations Children's Fund (UNICEF).[14]

"AN INTERNATIONAL SYMBOL OF NEGLECT"

In the early 1990s the UN became aware that its iconic but aging Modernist buildings were not only failing, but—had they been subject to New York

City's fire and safety codes—were actually illegal. According to Senator Charles E. Schumer, it posed "a risk to the lives of those who work in the building, the neighborhoods adjacent to the building, and the first responders who would be called onto the scene in the event of an emergency." At the end of the decade Christopher S. Wren, writing in *The New York Times*, called the UN Building "an international symbol of neglect," and listed a number of problems:

> Roofs leak. A marble wall in the Dag Hammarskjöld Library has threatened to collapse. Asbestos insulation needs to be replaced. Plastic sheeting was installed to protect library desks and computers from dripping water. And some motors and water pumps that keep the building running are so antiquated that spare parts are no longer made. . . . Perhaps more alarming is that [the 39-story Secretariat] is . . . without a sprinkler system, which the city's fire code normally requires. One of the emergency exits available to delegates in case of fire is the third-floor roof of the Conference Building, which "has deteriorated beyond repair and needs to be replaced," according to a proposed new budget. . . . The headquarters now cost nearly $10 million a year to heat in winter and cool in summer, partly because of 5,400 windows installed . . . when energy was cheap. And asbestos insulation in place for nearly 50 years is drying out.[15]

Despite the development of a renovation plan by 2000, remedial action was delayed for many reasons. Most were political issues between the UN and the federal government—"concerns over preserving national sovereignty, isolationist attitudes towards international law, negative attitudes towards certain countries and social systems, disagreements over UN efficiency and cost, and the frequent minority status of the U.S. in the General Assembly"—or minor disagreements with New York State and City governments. They are compelling issues, but outside the scope of this essay.

In July 2007 the UN announced that Swedish-owned Skanska USA Building Inc. had been engaged to undertake the preconstruction phase of a $1.9 billion refurbishment of the Secretariat, General Assembly, and Conference buildings, beginning with a "Capital Master Plan" scheduled to start early in 2008. It is planned for completion in 2014.

Curtain Walls

Throughout history, the walls of buildings have served structural and environmental functions. That is, they carried the weight of the building to the ground and, while providing light, ventilation, and access through openings, protected occupants from the intrusions of weather, noise, and unwanted visitors. The introduction of framed structures—seen first in later medieval cathedrals—in which loads are carried by beams and columns, allowed the

wall to serve solely as a relatively thin "environmental filter." This liberation would not be complete until the advent of metal- and reinforced concrete-framed architecture in the nineteenth century. The curtain wall, a metal and glass membrane hung on the structural frame, is associated principally with multistory buildings after about 1880.

Early Chicago skyscrapers, such as the Rookery (1885–1886) and Monadnock Building (1889–1891), both designed by Burnham and Root, had conventional load-bearing walls, but soon the economic necessities of efficient construction and space optimization demanded buildings whose outer walls consisted almost entirely of windows supported by columns and beams. This was a first step toward the true curtain wall, continuous *in front of* the structural frame. The earliest was in Albert Kahn's Packard Motor Car forge shop in Detroit (1905), followed by his Brown-Lipe-Chapin gear factory (1908), and Ford T-model assembly plant in Highland Park, MI (1908–1909). The idea was taken up in Europe: Peter Behrens emulated it in the A.E.G. Turbine Factory (1909–1910) in Berlin; so did Walter Gropius and Adolf Meyer in the iconic Fagus Works in Alfeld-an-der-Leine, Germany, a year later.

Most historians agree that Willis Jefferson Polk's eight-story Hallidie Building (1917–1918) in San Francisco was the first curtain wall office block. Despite florid cast-iron ornament, the street façade, bracketed to cantilevered floor slabs, presented an unbroken glass skin 3 feet 3 inches in front of the structure. Others dreamed (and only dreamed) of crystal-sheathed towers. Among them was H. Th. Wijdeveld's *Amsterdam 2000* (1919–1920), Le Corbusier's *Ville contemporaine* (1922), and—probably the best known—Ludwig Mies van der Rohe skyscrapers projected for Berlin between 1919 and 1923. But available technology could not turn vision to reality. Holabird and Root's A.O. Smith Research Building in Milwaukee, Wisconsin (1928–1930), with large sheets of glass in aluminum frames, was the first full curtain wall multistory building.

Defense technologies developed in World War II increased the possibilities for tall curtain wall buildings. Key among them was economic aluminum production; it is light, its surfaces can be hardened by anodizing, and it can be extruded into the complicated profiles needed to frame the glass and stiffen the wall against wind loads. Reliable cold-setting synthetic rubber sealants also became available. And more efficient sheet glass manufacture, especially polished cast glass and float glass (after 1952) was another important factor; more of that later. Eventually it became possible to shop-fabricate large wall frame components that could be transported to the site, fixed and glazed, avoiding the "wet" processes that slow down conventional building operations. The final phase would be to employ preglazed elements. Beside curtain walls, other engineering developments included reverse-cycle air conditioning (after 1928) and fluorescent lighting, first demonstrated at the 1938 Chicago

World's Fair. All these innovations could be seen in Pietro Belluschi's twelve-story Equitable Building in Portland, Oregon (1944–1948), described by one historian as "an ethereal tower of sea green glass and aluminum." The United Nations Secretariat building closely followed.

In 1927 Le Corbusier had entered the design competition for the League of Nations' Geneva headquarters. It has been said that his proposal probably would have shared a first prize but was disqualified because he had not drawn it in Indian ink as specified in the competition rules. "However, with its wall of insulating and heating glass [*mur neutralisant* (neutralizing wall)], it is one of the finest examples of [his] gift for functional analysis. For the first time anywhere, he proposed an office building that corresponded in its structure and design to a strict analysis of function." Between 1929 and 1933 he refined—but could not afford to apply—the *mur neutralisant* for his Salvation Army hostel, the *Cité de Refuge* in Paris. And as early as 1947 he warned that it was "senseless" to construct a building in New York, "where the climate is terrible in Summer, [if its] large glass areas . . . are not equipped with a *brise soleil*. I say this is . . . very seriously dangerous." The *brise soleil*, invented by him in 1934, was simply an independent sun screen. Anyway, as British academic Michael Wigginton asserts, "If the *mur neutralisant* had been tried for the UN Building, it would probably have worked."

But Le Corbusier was preempted. In 1930 the American refrigeration engineer C. D. Haven invented "Thermopane"—hermetically sealed double glazing units with a half-inch air gap. It was first marketed in 1935 by Libbey Owens Ford. Harrison specified it for the UN Secretariat's curtain walls. Although it presented huge area of glass to the east and west, the building "worked" because it was air conditioned. Mechanical engineers produced a heating/cooling system that could overcome with the associated thermal problems. Conditioned air was delivered from the ceiling and through convector units just inside the glass, to moderate heat loss or gain. Together with Mies van der Rohe's Lake Shore Drive Apartments (1951) in Chicago and Gordon Bunshaft's Lever House (1952) on Park Avenue, New York, the UN Headquarters contributed to the universal standard for high-rise buildings.

But curtain walls had other latent problems that offset their advantages. By the end of the twentieth century, the immaculate façades of these admirable buildings had failed in several ways—among them, water penetration, corrosion, and glass breakages. The design of curtain wall systems has been revised continually, mostly in attempts to reduce weight while retaining strength. Stiffened sheet aluminum, enameled steel and insulation sandwiches, and even thin sheets of stone have been used for spandrel panels. Joint design—joints are problem spots for leaks—has been improved and more durable sealants developed. The availability of reliable adhesives (derived from space technology) allowed architects to indulge in so-called fish tank jointing of

glass panels, eliminating frames. "Thermopane" gave way to nonactinic (heat-absorbing) glass and in the 1960s to reflective glass, used to reduce heat gain within buildings. In 1984 heat mirror glass was developed; combined with double glazing, its insulating value approaches that of masonry, but aesthetically it denies the building's form, merely reflecting what's around it.

Given that the curtain wall's two significant advantages are the reduction of weight and speed of erection, it might be concluded that it cost less than conventional construction. Although probably true in terms of capital outlay, its thermal performance often resulted in higher costs of air conditioning over the life of the building. The curtain wall was in vogue, so to speak, when energy was cheap and climate change was not on the social agenda; but such factors are critical in the age of global warming.

In his confronting 1967 comedy *Playtime,* the French filmmaker Jacques Tati pronounced judgment upon the anonymous tall building. To shoot the movie, he built a huge scale-downed city ("Tativille") of moveable model skyscrapers on the outskirts of Paris. Critic Nik Huggins writes that the main character, the bumbling Monsieur Hulot (played, as usual, by Tati) ambles "through a fully modernised Paris of sleek glass and steel office towers, now transformed to resemble every other major city in the world, as depicted in numerous tourism posters . . . The Eiffel Tower, the Arc de Triomphe and numerous other icons of . . . French culture are spotted in reflections as people pass through the clear glass doors. . . . " Appearing in the background of many scenes, tourism posters are *almost* identical. Each illustrates an identical row of curtain wall skyscrapers (exactly the same as those in Tativille); the only differences being "Visit London" has a red double-decker bus in the foreground, "Visit Mexico" has a cactus, and so on.

The tall glass prism was America's major contribution to what some believe was an International style of Modern architecture. But, thankfully (at least in some cases) it was eclipsed by the rise of Postmodernism, and the crystal towers that a German Nazi publication dismissed as resembling "greenhouses with chimneys or glass boxes on stilts" were superseded with less monotonous structures. Even Philip Johnson, Mies' most ardent disciple and imitator, finally forsook the minimalist curtain wall in favor of a less incongenial architecture.

NOTES

1. United Nations Fact Sheet No. 23, January 2006, www.un.org/geninfo/faq/factsheets/FS23.HTM

2. Lane, Anthony, "In Translation." *The New Yorker* (April 25, 2005).

3. Reprinted from Robert C. Byrd, *The Senate, 1789–1989: Classic Speeches, 1830-1993.* Washington, D.C.: Government Printing Office, 1994.

4. "The United Nations at Geneva." www.unog.ch/80256EDD006AC19C/

5. "History of the United Nations Charter." www.un.org/aboutun/charter/history/dumbarton.shtml

6. "United Nations Photo Archive." www.un.org/av/photo/un60/chapter2.htm

7. "United Nations Photo Archive." www.un.org/av/photo/un60/chapter1.htm. For Truman's full speech see www.presidency.ucsb.edu/ws/print.php?pid=12188

8. "In the U.S. Tradition," *Time* (December 10, 1945).

9. Rosenthal, A. M., "The U.N. at 50: The History; the Early Days: Threadbare Furniture, Wonton Soup and the I.R.T." *New York Times* (October 22, 1995).

10. Model, F. Peter, "The United Nations at 50: The Zeckendorf Connection," *Real Estate Weekly* (November 1, 1995).

11. Normandin K. and M. Petermann, "The International Power Style of the Modern Movement: Part One." www.unesco.org/archi2000/pdf/normandin.pdf

12. Mumford, Eric Paul, *The CIAM Discourse on Urbanism, 1928–1960*. Cambridge, MA: MIT Press, 2000, 160.

13. Mumford, Lewis, "Picture Book Skyscraper." www.time.com/time/printout/0,8816,821740,00.html

14. United Nations Fact Sheet No. 23. www.un.org/geninfo/faq/factsheets/FS23.HTM

15. Wren, Christopher S., "International Symbol of Neglect; U.N. Building, Unimproved in 50 Years, Shows Its Age," *New York Times* (October 24, 1999).

FURTHER READING

Betsky, Aaron, and Ben Murphy. *The UN Building*. New York: Thames and Hudson, 2005.

Bleecker, Samuel, and Ezra Stoller. *The Politics of Architecture: A Perspective on Nelson A. Rockefeller*. New York: Rutledge Press, 1981.

Dudley, George. *A Workshop for Peace: Designing the United Nations Headquarters*. New York: Architectural History Foundation; Cambridge, MA: MIT Press, 1994.

Frampton, Kenneth, and Yukio Futagawa. *Modern Architecture 1851–1945*. New York: Rizzoli, 1983.

Harrison, Wallace K. "The United Nations Building in New York." *Royal Institute of British Architects Journal*, 58(March 1951), 171–175.

Hunt, William Dudley. *The Contemporary Curtain Wall*. New York: F.W. Dodge, 1958.

Irace, Fulvio. "ONU: The United Nations Building." *Abitare* (April 1998), 186–197.

Le Corbusier. *UN Headquarters*. New York: Reinhold, 1947.

Mills, E. D. "The Curtain Wall: Practical and Aesthetic Aspects." *Building Materials* (March 1960), 77–82.

Model, F. Peter. "The United Nations at 50: The Zeckendorf Connection." *Real Estate Weekly* (November 1, 1995).

Mumford, Lewis. "United Nations Conference Building, East River Bank. . . . " *New Yorker* (January 17, 1953), 70–74. See also "United Nations General Assembly Building. . . . " *New Yorker* (March 14, 1953), 66–73.

Newhouse, Victoria. *Wallace K. Harrison, Architect.* New York: Rizzoli, 1989.

Olivarez, Jennifer Komar. "The United Nations: True International Style." *Echoes*, 7(Spring 1999), 52–57.

Schlesinger, Stephen C. *Act of Creation: The Founding of the United Nations.* Boulder, CO: Westview, 2003.

Volger, Helmut, ed. *A Concise Encyclopedia of the United Nations.* The Hague; London; New York: Kluwer Law International, 2002.

Wright, Sylvia Hart. *Sourcebook of Contemporary North American Architecture: from Postwar to Postmodern.* New York: Van Nostrand Reinhold, 1989.

Yeomans, David. "The Pre-History of the Curtain Wall." *Construction History*, 14(1998), 59–82.

INTERNET SOURCES

United Nations Organization official site. www.un.org/ (accessed March 2008).

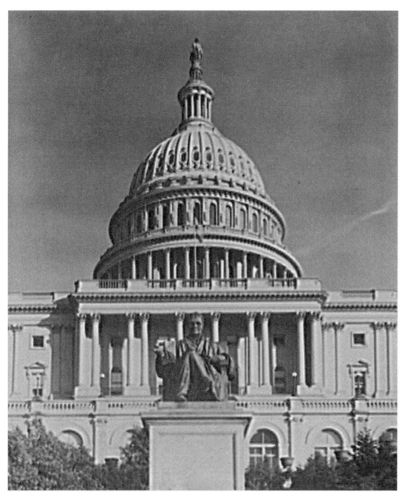

Courtesy Library of Congress

United States Capitol, Washington, D.C.

"The Cathedral of Our National Faith"

Across the world, there are a few seats of government whose buildings, mostly modern, that architects admire. Examples include Oscar Niemeyer's National Congress complex in Brasilia, of the late 1950s, Louis Kahn's National Assembly in Dhaka, Bangladesh (1962–1974), considered one of the great monuments of International Modernism, and the Australian Parliament House in Canberra, Australia (20 years old, and still known as "new" Parliament House), designed by the American Romaldo Giurgola. But they are held as iconic by an elite, and we would be hard-pressed to find—at least, outside those countries—many people who could recognize them. There are other seats of government whose very names, much less their appearance, strike a chord with the person in the street: the Kremlin in Moscow; the Houses of Parliament in London; and of course the United States Capitol in Washington, D.C. All are known by millions at home and abroad, buildings that evoke the institutions they represent—in short, they are icons.

According to the University of Virginia's American Studies Project, "The National Capitol [is] an American icon—the cathedral of our national faith, the map of our public memory, and the monument to our *official* culture. . . . The Building itself, at once an icon and a remarkable collection of icons— paintings, frescoes, sculpture, reliefs, architecture, and a miscellany of material objects."[1] The U.S. government justifiably claims a place for the Capitol among the most symbolically important and architecturally impressive buildings in the world. The Complex includes the Capitol itself, the House and Senate Office Buildings, the U.S. Botanic Garden, the Capitol Grounds, the three Library of Congress buildings, the Supreme Court Building, the Capitol Power Plant, and support facilities. As focal point of the government's Legislative Branch, the Capitol is the centerpiece, having housed the meeting chambers of the Senate and the House of Representatives for almost 200 years. Here, space permits neither a discussion of the whole Complex nor a description of the Capitol itself; this essay, then, is about the genesis of the building.

The Capitol building has five levels. The first is occupied mostly by committee rooms and spaces for various congressional functionaries. The second houses (in the south wing) the House of Representatives chamber and (in the north wing) the Senate chamber, as well as the congressional leaders' offices. There are also three main public areas on this level: the 100-foot diameter domed ceremonial Rotunda linking the wings; the semicircular Hall of the House (since 1857, the National Statuary Hall); and the Old Senate Chamber (used until 1859). The third level provides access to the public galleries of the House and the Senate; the remainder houses press galleries, offices, and committee rooms. The fourth floor and the basement/terrace level contain more offices, plant rooms, workshops, and other auxiliary spaces. In all, the 540 rooms have a floor area of more than 16 acres; the building's "footprint," to use modern jargon, is about 4 acres.

The capitol welcomes an estimated three million visitors each year (some sources give a figure of five million). In fall 2001 work began on a three-level

underground Visitor Center on the west side of the Capitol; originally planned for completion in July 2007, it remains unfinished at the time of writing (February 2008). It will house a Great Hall, a large exhibition gallery, two orientation theaters, a six-hundred-seat restaurant, two gift shops, and accommodation for the legislature, including a four-hundred-fifty-seat auditorium, additional office space, and more meeting rooms. During peak periods as many as two hundred guides will be available; permanent staff—administrators, curators, and technicians—will number about thirty. *USA Today* reported in May 2007 that government auditors had estimated the cost at close to $600 million, increased from a 1999 figure of $265 million.

THE CAPITOL IN POPULAR CULTURE

Almost daily, images of the Capitol—especially the west front, seen from the National Mall—appear on TV screens as the proceedings of the U.S. Congress are reported internationally. In an age when it seems that every spoken word is assigned an image, *Capitol* is visually synonymous with "U.S. government," just as *White House* is with "the presidency." *Broadcasting and Cable* magazine reported in September 2003 that CNN's Washington news studio was "the latest . . . to literally tear down walls and let viewers see the outside world," explaining that "the goal [was] to provide a backdrop (the Capitol) that is more dramatic than the back wall of a studio." The bureau chief added, "It's a great view of the Capitol and . . . it makes more sense if we share it with the viewers."

In the light of such constant international exposure, there seems little need to discuss the building as a popular icon. It has appeared in many fictional movies "throughout cinematic history." In 2007 the Washington, D.C. Convention and Tourism Corporation published convenient alphabetical lists:

> The North Front was used in *Being There*, *Eraser*, and *Live Wire*. The East Front is featured in *Clear and Present Danger*, *Contact*, *The Contender*, *The Distinguished Gentleman*, *Eye of the Beholder*, *G.I. Jane*, *In the Line of Fire*, *Protocol*, *Quiz Show*, *Random Hearts*, and *Strangers on a Train*. The West Front can be seen in *Along Came a Spider*, *Chain Reaction*, *Clear and Present Danger*, *Contact*, *The Contender*, *DC Cab*, *The Day the Earth Stood Still*, *Deep Impact*, . . . *Enemy of the State*, *Hannibal*, *A Few Good Men*, *In Country*, *Independence Day*, *JFK*, *Live Wire*, *Mars Attacks!*, *National Lampoon's Senior Trip*, *The Net*, *Nixon*, *Protocol*, *Quiz Show*, *Random Hearts*, *Rules of Engagement*, *Shadow Conspiracy*, *Starman*, *Timecop*, and *Wild Wild West*.

There are probably others; in many movies the building has a "bit part." The earliest film (1914), now lost, in which it is germane to the plot seems to have been *The Lion and the Mouse*; adapted from Charles Klein's "well-worn" stage play of 1905, it was shot on location, remade in 1919 and again by Warner Brothers in 1928. A couple of others deserve mention.

Frank Capra's 1939 classic *Mr. Smith Goes to Washington*, based on Lewis R. Foster's unpublished novel, *The Gentleman from Montana*, is about an idealistic man appointed to the Senate. The studio constructed a perfect replica of the Senate chamber. Capra later alleged that a number of senators had attempted to buy the film to prevent its release. Needless to say *Mr. Smith* was an immediate hit. In 1962 and 1963 ABC broadcast a 24-episode TV series based on the movie. And in 1977 Tom Laughlin remade it as *Billy Jack Goes to Washington*; it was a flop and never theatrically released. For it, the chamber again had to be re-created because the producers' application to film in the real space was refused. A second remake of sorts, *The Distinguished Gentleman*, of 1992, was critically panned.

Advise and Consent (1962), Otto Preminger's "Kennedy-era look at the post-McCarthy Senate" based on the Pulitzer Prize-winning novel by Alan Drury created "more than passing interest" among members of the Senate, after "for several months in the fall of 1961 film crews had swarmed over public and private spaces within the Russell Senate Office Building, turning its corridors, offices, and especially its Caucus Room into stage sets." The official Senate website recounts that

> A patient host, the Senate drew the line at using its chamber [so] Preminger updated the [*Mr. Smith Goes to Washington*] Hollywood set. . . . Senators offered predictably mixed reviews. Ohio Democrat Stephen Young, mindful of ongoing cold war crises, considered this "a bad time in world history to downgrade the U.S. Senate" and introduced legislation to prohibit the film's distribution outside the United States . . . , South Dakota Republican Karl Mundt . . . pronounced the film "fictionalized entertainment with a touch of reality, while the U.S. Senate is a lot of reality with a touch of entertainment."[2]

Movies about politics, or rather about politicians, usually touch a nerve, so cooperation with the studios could hardly be expected. A July 2007 *Washington Post* article noted that though the Capitol's "towering structure" looms large in movies, no filming is allowed on the grounds. It continued,

> Two particular favorite shots: the "bustling city" shot down Pennsylvania Avenue from the U.S. Treasury steps . . . and a closer-in shot in front of the Senate Garage Fountain and smaller Capitol Reflecting Pool, [are] as close as filmmakers are allowed. Filming there was already rare, but after major problems with *Billy Jack Goes to Washington*, Congress barred the filming there of all fictional movies to maintain "the aura of dignity that appropriately surrounds the Capitol as a worldwide symbol of freedom and democracy."

So Hollywood had to find architectural stand-ins. *Dave* (1993) and *The Contender* (2000) both used the Virginia Capitol. Samantha Stainburn revealed in *Government Executive* that in *Contact* (released in 1997), the Treasury Building was the capitol's understudy, because the "filmmakers needed

a location that provided the same stately backdrop as the real Capitol, but was smaller, so it took fewer people to fill the screen." *Legally Blonde 2: Red, Hot and Blonde* (2003) chose to film "on location" at the Utah and Illinois state capitols.

The opportunity to sell souvenirs and memorabilia to upwards of three million visitors a year is not to be ignored. With appropriate dignity, the U.S. Capitol Historical Society's online gift shop caters to the higher end of the market, offering cut crystal bowls, bookends, a range of paperweights, gold jewelry, "sculptured" (read, "cast") jewel boxes, scarves, ties, and cufflinks (no tatty T-shirts and baseball caps here!). There is also a "Hologram Dome Capitol Block," Christmas tree ornaments, and a "Capitol Fresco Inspired Wall Plaque," with the blurb, "featuring an image of the . . . Capitol inspired by the Kiplinger Washington Collection, this classic wall hanging has the look and feel of a classical fresco treasure." The most expensive strictly relevant souvenir costs just under $400; among the least expensive are books with the riveting titles, *Outstanding African American Members of Congress* and *Outstanding Environmentalists of Congress*, slim volumes at under $2.

At the other end of the spectrum from the Society's merchandise is the usual range of lesser quality stuff—what the English call "tat." One vendor's description of a "United States Capitol Building" memento paints a telling picture: it "sits on a attractive brown lacquered base with 'U.S. Capitol' on the sculpture and 'Washington, D.C.' [as if we didn't know] on a metal sign on the base. . . . Shrubbery is added to give it just the right amount of color." A companion value-for-money piece is described as "The perfect souvenir gift—a musical snow globe with the US Capitol inside [it], with the White House, Lincoln Memorial, Iwo Jima Memorial, Washington Monument, and Jefferson Memorial featured on the landscaped base. The tune?—the Star Spangled Banner, of course." The dazzling list goes on, but we need not.

WHAT'S IN A NAME?

In a June 1791 report to President Washington, Pierre Charles L'Enfant, planner of the nation's capital, described the site of the "Congress House" as "a pedestal waiting for a monument." By mid-March 1792 "Congress House" had become "Capitol." Architectural historian James D. Kornwolf has pointed out that in correspondence between L'Enfant and Thomas Jefferson the planner consistently used "Congress House," while the secretary of state always called the building "Capitol." In fact, Jefferson painstakingly changed the wording of the notes on the Frenchman's plan. Former architect of the Capitol William C. Allen notes,

> This seemingly minor clarification was significant, for it spoke volumes of the administration's aspirations for the Capitol and the nation it would serve. Instead

of a mere house for Congress, the nation would have a capitol, a place of national purposes, a place with symbolic roots in the Roman Republic and steeped in its virtues of citizenship and ancient examples of self-government.[3]

Historian Charles M. Harris agrees that "in determining to construct a national Capitol, rather than a 'Congress Hall' or 'Federal Hall,' Washington and Jefferson had made it clear that they had in mind a national temple" and points out that "the model they had in mind was an idealized conception of the Temple of Jupiter Optimus Maximus . . . on the Capitoline Hill in ancient Rome. The principal building of the new republic was to be an emblem of the nation's republican experiment."[4] The most sacred site in ancient Rome was the highest of the city's seven hills between the Forum and the Campus Martius. The great Temple of Jupiter Optimus Maximus—the Capitol—on its southern summit was the historic and religious center of the city and the symbolic centre of the Roman world. English art historian Harry Mount writes, "The American love of Rome—or, more specifically, Roman Republican virtues—intensified with the birth of the American Republic. . . . The [Founding Fathers] sought a virtuous model of government that could be separated from the monarchy they had just overthrown; the Roman Republic was ideal—pure, but not too dangerously democratic." Because of that, the Founding Fathers "even went as far as placing their principal government building on a raised piece of ground, like the Romans."[5]

In his recent disturbing book, *Are We Rome?: The Fall of an Empire and the Fate of America*, Cullen Murphy observes that from Washington's Capitol Hill,

> The view to the west takes in a vast expanse of classical porticoes and marble monuments. . . . Washington rose out of a malarial marsh on a river upstream from the coast, as Rome did. . . . The Romans cherished their myth of origin . . . and on the Palatine Hill you could be shown a thatched hut said to be the hut of Romulus . . . , but on Capitol Hill you can find sacred national touchstones of other kinds. . . . Washington resembles Rome in many ways.

Noting that the physical similarities are clearly visible, he goes on to say, "The similarities of spirit are more salient. . . . Washington, too, has been animated by a special outlook. Long ago it was a notion of republican virtue that Romans of an early era would immediately have recognized. Today it's a strutting sense of self and mission that Romans of a later era would have recognized just as readily."[6]

BEGINNINGS

Before 1788 Congresses gathered in eight different cities: New York; Philadelphia; Baltimore; Lancaster, Pennsylvania (for just one day); York, Pennsylvania;

Princeton, New Jersey; Annapolis, Maryland; and Trenton, New Jersey. The subject of a permanent national capital was broached first in 1783, and 4 years later the U.S. Constitution gave Congress legislative authority over "such District (not exceeding ten Miles square) as may, by Cession of Particular States, and the Acceptance of Congress, become the Seat of the Government." Maryland ceded two-thirds of the specified area and Virginia the remainder. The *Residence Act*, establishing the seat of federal government, was passed on July 16, 1790. A few months later, after a less-than-meticulous review of other locations, President Washington—a former surveyor—chose the site between the Anacostia and the Potomac rivers that is now the District of Columbia, on land formerly belonging to Maryland; Virginia's land was returned to it in 1846. Washington appointed three commissioners—the jurist Thomas Johnson, representing Maryland; Dr. David Stuart, representing Virginia; and Daniel Carroll, a "framer of the Constitution"—to survey the site and oversee the design and construction of the capital city and its government buildings. All were the president's business associates. As noted, the planning of the city was put into the hands of Pierre Charles L'Enfant.

Paris-born L'Enfant, who had studied urban design, architecture, and engineering at France's Royal Academy of Painting and Sculpture, had moved to America in 1776 and volunteered for the Continental Army during the War of Independence. He attained the rank of major in the Corps of Engineers. In 1789, just 5 months after Washington became president and 10 before the *Residence Act* was passed, the Frenchman lobbied for the commission to design a federal capital. When in early 1791 his war-time friend Alexander Hamilton, now secretary of the Treasury, recommended him as the best qualified person for the task, L'Enfant was duly commissioned, and in June he presented a sketch proposal to Washington. The president—as was his wont—had suggestions of his own, and by late August a resolved city plan was "projected agreeable to the direction of the President of the United States."

L'Enfant and Washington collaborated closely for several months. Then the *prima donna* Frenchman caused "more than a little trouble and vexation" for the commissioners, whose ideas he continually discounted; he made himself answerable only to Washington. Part of the conflict had to do with the Capitol. Infuriated that someone was building a mansion close to the proposed site, L'Enfant ordered it removed; when the owner—Daniel Carroll of Duddington (not the commissioner, but his relative)—refused, L'Enfant unilaterally authorized its demolition. The outraged citizen complained directly to the president. Washington and Thomas Jefferson acted to mollify the three commissioners, who threatened to resign—and after several attempts to retain his services Washington grudgingly gave up trying to control the Frenchman. With a little nudge, L'Enfant quit in February 1792.

Washington then engaged Andrew Ellicott, who had surveyed the federal district boundaries, to develop the "L'Enfant-Washington" proposal. Despite L'Enfant's unwillingness to cooperate, Ellicott, working from memory,

completed it within a month. There were some changes but it was the same essential plan: diagonal avenues with circular plazas at their intersections were overlaid with a grid pattern of streets—a "functional and aesthetic whole in which government buildings (were) balanced against public lawns, gardens, squares, and paths." The scheme reflected the baroque opulence of Europe: central Dresden, Wren's and Evelyn's rebuilding proposals for London, and especially Le Nôtre's setting for Versailles. Jefferson had wanted to locate the Capitol west of the Executive Mansion (White House), but L'Enfant and Washington preferred the east end of what is now the National Mall, on "Jenkins' Hill," 88 feet above the level of the Potomac. It was to be Jefferson's "Capitol" on L'Enfant's "pedestal waiting for a monument."

"THE MOST APPROVED PLAN"

When L'Enfant was eased out, the promised Capitol design was already 5 months behind schedule. Jefferson suggested that the commissioners invite plans, and Commissioner Johnson submitted, for Washington's approval, a draft advertisement, which Jefferson amended. Dated March 14, 1792, it was sent to newspapers in Boston, Baltimore, Charleston, New York, Richmond, and Philadelphia:

> A premium of a lot in the city, to be designated by impartial judges, and $500, or a medal of that value, at the option of the party, will be given by the Commissioners of Federal Buildings to persons who, before the 15th day of July, 1792, shall produce them the most approved plan, if adopted by them, for a Capitol to be erected in the city, and $250 or a medal for the plan deemed next in merit to the one they shall adopt; the building to be of brick and to contain the following compartments to wit:
>
> A conference room. A room for Representatives. (To contain 300 persons each). A lobby or antechamber to the latter.
>
> A Senate room of 1,200 square feet of area. An antechamber and lobby to the latter. (These rooms to be of full elevation [that is, two stories high])
>
> Twelve rooms of 600 square feet area each for committee rooms and clerks to be of half the elevation of the former.
>
> Drawings will be expected of the ground plats [plans], elevations of each front, and sections through the building in such directions as may be necessary to explain the material, structure, and an estimate of the cubic feet of the brick work composing the whole mass of the wall.

The minimalist brief contained no indication of architectural style. But it was generally known that Jefferson, for one, favored a building based on "one of the models of antiquity, which have had the approbation of thousands of

years." The reference to brick seems to be in conflict with that vision. And there also appears to have been confusion about republican Rome and imperial Rome. The first emperor Augustus Caesar is said to have boasted, "I found Rome a city of brick and left it a city of marble." Brick was the material of the republic, stone and "the models of antiquity" the trappings of empire.

As to accommodation provided in the Capitol . . . It has been the experience of many architects that clients project their requirements on the basis of what they already have, despite its inadequacy and taking no account of future needs. In 1789 and 1790 Congress had met in Federal Hall—the century-old City Hall, albeit rebadged, remodelled, and enlarged—overlooking Wall Street in New York. It contained "two legislative chambers, ten committee rooms, three offices, a two-story vestibule, a caretaker's apartment, a machinery room, an audience room, and a room for the New York Society library." The commissioners probably had Federal Hall in mind when the program for the Capitol was written. The only additional space they asked for was the large conference room. Even before the new building was finished, its functions would call for more space than it provided.

It is still unclear exactly how many Capitol designs were submitted. The competitors included Étienne Sulpice (Stephen) Hallet—the only professional architect—Judge George Turner, Samuel Blodget, John Collins, James Diamond, Samuel Dobie, Abram Farris, Philip Hart, Leonard Hasborough, Robert Goin Lanphiere, Samuel McIntire, Jacob Small, and Charles Wintersmith; there may have been others, including Thomas Carstairs, Andrew Mayo (possibly Andrew Mayfield Carshore), and Collen Williamson. Allen argues that the surviving drawings expose "the state of architectural draftsmanship and design ability in America at the close of the eighteenth century . . . when most design services were provided by carpenters or master masons." He explains,

Two [entrants] were veterans of General Burgoyne's army, one was a school teacher from upstate New York, one was a prominent builder and furniture maker from New England, one would later become mayor of Baltimore, another was a builder and politician, two were carpenters, three were master builders, one was a territorial judge, and one was a businessman. . . . Despite their diverse backgrounds and training, each would have called himself an architect. To some of their contemporaries, being an architect was a learned hobby or skill. . . . To others, [it] was synonymous with being a master builder.[7]

Jefferson, for one, must have had low expectations. In the letter suggesting the competition, he had anticipated difficulty in obtaining craftsmen—how much more, capable designers? Washington, disappointed with the entries, remarked, "If none more elegant [schemes] than these should appear . . . the exhibition of architecture will be a very dull one indeed." Architect Glenn Brown wrote in 1900, "The plans submitted were, with few exceptions, peculiarly indifferent. The larger number . . . were made by amateurs or contractors

who did not have the first idea as to what constituted either good draftsman-ship or design. . . ."

At first, only Lanphiere's, Hallet's, and Turner's plans were seriously con-sidered. Months before the competition was announced, Hallet, who had briefly worked for L'Enfant, had shown Jefferson and others what he called his "fancy piece"—a domed central pavilion flanked by wings expressing the Congress' bicameral legislature. But his competition entry, "a peripteral tem-ple derived from . . . Roman architecture," was totally different. In August 1792 he and Turner were invited to present their schemes to the Commission-ers. The brief had changed. Each was then encouraged to submit a revised design. Each was subjected to political pressure. Washington told Turner of his "best hopes for the building" and was regaled with gratuitous advice from the president, Jefferson, and the commissioners. Turner's new designs were rejected at the beginning of November; the commissioners, in what they saw as an urgent situation, engaged Hallet.

A JEALOUSY OF ARCHITECTS

No collective noun for architects can be found, although one wit has percep-tively suggested "a jealousy of architects." In the context of the Capitol build-ing, at least until 1830, that seems quite appropriate. The source, by the way, may have been a distortion of the English landscaper Humphrey Repton's complaint that he often had to "contend with . . . the jealousy of architects and builders."

In October 1792 the commissioners received a letter from Dr. William Thornton. Then living in the British Virgin Islands, the Philadelphia-based physician was a naturalized American. An amateur architect, he successfully applied to submit a late entry for the Capitol competition. His first plans, presented later in the month, had been made before he was aware of the site details. In December Thornton told the commissioners that because his origi-nal proposal had been "calculated upon a five hundred feet front" he was revising it to make it "more suited to the situation." Perhaps he had learned more about the site and the client's preferences from Turner, after returning to Philadelphia. Turner's drawings had been returned to him, so Thornton may have had the advantage of studying a design that the commissioners had almost accepted. In essence, Thornton's Capitol was like Hallet's "fancy piece."

Meanwhile, through fall and into the winter Hallet worked on changes to his earlier proposals. His first revision, a less expensive version of the "fancy piece," was finished by October; a second revision, made by late January 1793 and after consultation with Washington, "restored [its] iconographical and architectural richness." But on February 1 Jefferson told the commission-ers that he and Washington preferred Thornton's scheme. For the republican secretary of state, it was "simple, noble, beautiful, excellently arranged and

[importantly] moderate in size"; the president praised its "grandeur, simplicity and convenience." Two months later the commissioners accepted it, and Washington formally approved it on July 25.

Its passage was not without incident. Hallet and James Hoban, architect of the White House, attacked it, the former's sour grapes being pressed into five manuscript folio volumes. It was "too expensive and unbuildable." Samuel Blodget, superintendent of Public Buildings, also considered it "impracticable." It must be remembered that Thornton was a doctor, not a builder, and a major problem was that it "restricted light and air to the wings and contained structural faults in supporting the House of Representatives' dome." Desperate to resolve the quarrel, Washington had Jefferson convene a conference with Hallet, Hoban, and Thornton, who brought as his "advisors" Philadelphia builders William Williams and Thomas Carstairs; Washington himself attended for at least part of the time. Both the shortlisted designs were reviewed, and a "conference" design was evolved by hybridizing Hallet's revised plan and Thornton's elevations—a recipe for trouble. Anyway, Jefferson reported to the president:

> This alteration has ... been made by Mr. Hallet in the plan drawn by him wherein he has preserved the most valuable ideas of the original, & rendered them susceptible of execution, so that it is considered as Dr. Thornton's plan, rendered into practicable form. The persons consulted agreed that in this re-formed plan, the objections before stated were entirely remedied, and that it is on the whole a work of great merit."

But while Thornton, and his prospective clients viewed the conference—a better word would be *compromise*—design as an altered form of Thornton's winning proposal, Hallet considered it to be an adaptation of his own modified plan. He was given a similar prize to Thornton and charged with supervising the construction of the good doctor's design. The location of the Senate and Representatives chambers would be reversed, and their forms altered from Thornton's rectangles to Hallet's "hippodrome-shaped" rooms. According to Harris, those changes, though made "ostensibly to correct engineering problems and to admit more light to the interiors," were politically motivated by "differences within the Washington administration." The foundations, based on the conference plan, were started in August. But that did not end the squabbling. For the next 10 years Thornton would defend his design that "proved in the execution to be difficult and controversial."

BUILDING THE CAPITOL

On September 18, 1793, at a Masonic ceremony preceded by a parade and followed by a party, President Washington laid the cornerstone in the building's

southeast corner. Five days later, the commissioners formally approved his suggestion, mooted more than a year earlier, that the Capitol's facings should be dressed stone, not brick as specified in the newspaper advertisement. Stone construction was uncommon in that part of America, and suitable material was not close at hand. Although it yielded sandstone unsuited for wall construction, the Aquia Creek quarry in Stafford County, Virginia, was acquired by the government in 1791. Slaves were trained to rough-cut huge blocks that were taken on schooners 40 miles up the Potomac and hauled to the building site, where they were dressed and set by immigrant stonemasons. The change from brick to stone exacerbated the difficulty of finding skilled labor; indeed, the availability of *any* labor was problematical.

William Reed points out an irony about the construction of the Capitol: "slaves [would toil] from dawn to dusk building the temples to represent a country were 'all men are created equal.' [They would clear] the trees and brush for the Mall and boulevards that led to the seat of a government 'with liberty and justice for all.' "[8] The commissioners insisted that they preferred to employ white workers, whether skilled and unskilled, but paid labor was difficult to obtain because wages were depressed by the abundance of African American slaves—about half the nation's slaves lived in Virginia and Maryland. Efforts to bring indentured workers from Europe also failed, so slaves provided most of the labor on the Capitol building. Historian Bob Arnebeck estimates that in a workforce that peaked at two hundred, the number of slaves increased from about sixty in 1793 to about 120 in 1798. They were employed in haulage, excavation, brick-making and laying, carpentry, nail making, and as masons' laborers. Thornton—an avowed abolitionist but paradoxically a slaveowner—put two proposals to the commissioners: he wanted to allow fifty "intelligent negroes" to earn their freedom by earning wages while working for 6 years on the Capitol project; and he wanted to purchase these enslaved men, train them to be stone cutters, and free them after 6 years of work. There is no record of the board's response.

Defying his clients' instructions to restore Thornton's east portico (which Hallet had eliminated in his final design), the Frenchman changed his rival's proposal and created a square court that projected from the center, with flanking wings to house the respective legislative chambers. He set out the foundations accordingly. Whether Hallet misconstrued his instructions is unknown, but 2 months earlier the president had appointed Thornton as one of three commissioners of the Federal District, with instructions to "restore the central rotunda and other features of the premiated plan." Whatever the case, Jefferson dismissed Hallet on November 15, 1794.

George Hadfield, feted as a "young English architect of great promise," succeeded Hallet 11 months later and no sooner had taken the reins before he recommended several alterations, including the addition of an attic story and major changes to the façade. Hoban and Thornton rejected his proposals and referred them to the president, who disapproved of them. Hadfield quit. When

he withdrew his resignation, he was reappointed on condition that he would "superintend the execution of the plan without alteration." As might be expected, Thornton "did not become increasingly cordial toward his employee-critic." At the end of June 1796 Hadfield gave 3 months' notice of his resignation, only to be told by the commissioners that he could go whenever he chose. He again had second thoughts and agreed to toe the line. The commissioners tolerated him until May 1798, when *they* gave *him* 3 months' notice. But it seems that he left immediately, and at the end of the month Hoban was given the superintendence of the Capitol. Hadfield was dismissed in June, having proved inefficient as a superintendent. Among Thornton's archives is a statement that Hadfield admitted "that he had never superintended a building before his employment on the Capitol."

By August 1796 the commissioners were anxious to complete the north wing, intended for the Senate, so that it could be occupied by the scheduled date of 1800. Although some third-floor rooms were unfinished, the first session of Congress held in the Capitol was on November 17, 1800. Some historians suggest that President John Adams insisted upon the premature move—the White House was not finished, either—to secure enough Southern votes to ensure his reelection.

In 1802 the commission was abolished, and Thomas Monrow was made superintendent of the City of Washington. The following year, Congress appropriated funds for the House of Representatives wing. The Philadelphia architect Benjamin Henry Latrobe was appointed architect and began work in 1804. He modified Thornton's plan to provide committee rooms and offices and introduced practical alterations to simplify the construction. His changes incurred Thornton's wrath, but that was hardly difficult. Although the blame was not entirely Thornton's, his plans and interiors had serious faults and overall, his design was not buildable. Moreover, he deeply resented Latrobe telling him that changes were needed. So Thornton did all he could to "frustrate and discredit" Latrobe.

By 1807 the south (Representatives') wing was ready for occupation. While it was being finished Latrobe began rebuilding the north wing, which already had fallen into disrepair. He redesigned the interior and added a basement space for the Supreme Court. By 1811 he had completed the south wing and the eastern half of the Senate wing. But Congress needed money to fund an impending war with Britain, and construction of the Capitol was deferred.

The United States declared war on Britain on June 18, 1812; among more complicated reasons, the conflict was about the press-ganging thousands of (allegedly) British sailors from U.S. vessels, to fight in the Napoleonic wars. In April 1813 an American force burned the parliament buildings in what is now Toronto, Canada, and in August 1814 a British reprisal mission landed at Chesapeake Bay. Washington, D.C. was its ultimate target; the British believed that for symbolic reasons, sacking of the embryonic capital would demoralize the Americans and even, they hoped, bring about the demise of the United States.

On August 24 they torched the White House, the Treasury, the War Department, and of course the Capitol. Historian Anthony S. Pitch graphically writes,

> The central part of the Capitol was not built; the two wings were linked by a covered 100-foot-long wooden walk-way. . . . When the British entered the halls of the House and Senate, they passed through monumental interiors of stone adorned with fluted columns and arched entrances below domed vestibules. They raced up grand staircases into ornate rooms with vaulted ceilings. One young officer, expecting to find "republican simplicity," was astonished by evidence all around him of "monarchical splendor." The foreigners were so awed by the grandeur of the buildings that a number of junior officers were dismayed by the order to set it all on fire.
>
> [Latrobe] had supervised with a perfectionist's rigor as he created a national capitol that, in its formidable beauty, could compare with many of its counterparts across the sea. There were no sculptors of note in the young republic, so Latrobe had [hired] two worthy Tuscans . . . Giovanni Andrei had worked too slowly for the impatient Latrobe, but when he finished the first of his columns the architect had rejoiced at this "artist of first rate excellence." Latrobe had commissioned from . . . Giuseppe Franzoni, a grand American eagle, with a wingspan of more than twelve feet. . . . It hung high above the Speaker's chair, facing the British invaders when they entered the . . . House of Representatives. The colossal eagle suffered the same fate as the Capitol's other glorious works of art when the vandals lit bonfires made from piles of furniture spread with the combustible content of the Congreve rockets. The heat was so fierce that glass oil-burning lamps and one hundred panes of English plate glass skylights melted into the sizzling debris. Sheets of flame created such heat that the outer stone of the columns expanded and fell off, leaving the deformed shafts wobbly and grotesque. The heavily timbered Library of Congress, stacked with about three thousand volumes of rare books, burned to oblivion.[9]

The building was gutted, and only a sudden torrential rainstorm prevented its complete destruction. One account, relayed by Pitch, reports, "The inferno was so great that the glow in the night sky was seen from fifty miles away by British crewmen aboard warships in the Patuxent River and by anxious Americans in Baltimore and in Leesburg, Virginia." The occupation lasted about 26 hours; within a week the invading force was dispatched to Baltimore. Immediately after the fire, Congress met for one session in Blodget's Hotel in northwestern Washington, and until the end of 1819 it occupied what became known as the "Old Brick Capitol" on the site of the present Supreme Court Building.

In January 1815 about a third of the Congressmen, rather than rebuild on the mosquito-infested Potomac, wanted to relocate seat of government in Cincinnati, Ohio, deep inland. But a victory over the British in New Orleans, Louisiana, restored national pride and the idea of rebuilding in Washington, D.C., became "symbolic of triumph." Congress voted funds to reconstruct public buildings on their original sites. Peace with Britain was secured through

the Treaty of Ghent, ratified in February. Nobody won the war that had cost over seven thousand lives.

Latrobe was recalled to Washington in 1815 to restore the Capitol. Historians Paul F. Norton and E. M. Halliday write that his "brave wife Mary . . . without her husband's knowledge . . . wrote eloquent and persuasive letters to the James Madisons and to her other important Washington friends, urging that Latrobe's talents be used in rebuilding the ruined United States Capitol." The president agreed, and by July 1815 Latrobe was back in Washington, already producing drawings for the reconstruction. He redesigned the Representative's chamber as a semicircle and made other "imaginative improvements." But Colonel Samuel Lane, who was the official liaison between President James Monroe and Latrobe, convinced the president that the architect was "extravagant with public money" and "slow to achieve results" because of his commitment to his private practice. Latrobe was driven to resign in November 1817. It is widely believed that the interior design of the Capitol is his major contribution to American architecture.

In January 1818, the Boston architect Charles Bulfinch succeeded Latrobe as architect of the Capitol. One historian writes of Bulfinch:

> In all his previous work there had been no fundamental change in his style of architecture, and he remained essentially what he had always been, the gentleman amateur designing in a tasteful variant of the classical mode. That is how he approached the U.S. Capitol. But there . . . he was forced to meet a new concept of architecture, and it frustrated him. On first studying the [Latrobe's] drawings . . . he wrote: "My courage almost failed me . . . the design is in the boldest stile"[10]

Modifying Thornton's and Latrobe's proposals, Bulfinch completed the wings. Construction of the central pavilion, crowned with a low copper-covered wooden dome—until then, the wings had been joined by a wooden link—was started in 1818; the design was much more traditional than his predecessors had suggested, and he was criticized for making the dome higher than they had envisaged. According to Allen, it was taller than Bulfinch himself wanted it to be (he said) "at the request of James Monroe's administration." Bulfinch completed chambers for the House, the Senate, and the Supreme Court by 1819 and built the dome in 1822 and 1823; 3 years later the whole building was finished, including the western approach, rotunda, and portico. Bulfinch spent 3 more years on landscaping and decoration. At least one writer believes that his changes made the design "all the more acceptable generally. As far as the contemporary public was concerned, Bulfinch was the 'designer of the Capitol'; and, though little is left of his work because of later alterations, he still enjoys that reputation."

There was no architect of the Capitol between 1829 and 1851, and minor architectural services were provided by Robert Mills and other Washington

architects, working under the aegis of the commissioner of Public Buildings. Even by 1829 the Capitol was already too small to accommodate the growing number of congressmen as states were added to the Union. The next 20 years saw several proposals to enlarge it, and in 1850 and 1851 a second design competition was held, with a $500 premium. The submissions offered alternatives: extending the eastern side; building directly on the ends of the wings, or creating new north and south wings by corridors linked to the "old" building. Faced with several options, the Senate Committee on Public Buildings decided not to adopt any design as a whole but selected the four sets of drawings that they considered "the most meritorious." Five architects—Charles F. Anderson, William P. Elliot, Philip Harry, F. McClelland, and Robert Mills— shared the prize. The committee "passed the buck" and left President Millard Fillmore to decide on a plan and select a supervisor. He chose the Philadelphia architect Thomas Ustick Walter.

On July 4, 1851, Fillmore laid the cornerstone of the extensions. For the next 14 years, Walter superintended new wings to the north and south of the Capitol, designed in context with the existing architecture. The original sandstone, as should have been foreseen, was badly weathered, so the architect faced his additions with marble from Lee, Massachusetts; for the columns he used marble from Cockeysville, Maryland. His first problem arose in 1853 when the arrogant 36-year-old Montgomery C. Meigs, captain of Engineers and a protégé of the then Secretary of War Jefferson Davis, was appointed project manager. Prompted by Meigs, in 1853 President Franklin Pierce instructed Walter to reverse the legislative chambers, wing for wing. Worse was to come.

The extensions more than doubled the length of the Capitol, making Bulfinch's dome disproportionately small. Plans were put in hand in May 1854 to remedy the problem, and Walter designed a 288-foot high fire-resisting, cast-iron structure; within a year Congress passed enabling legislation. The old dome was removed in 1856, and the existing Rotunda walls were reinforced to carry its 4,500-ton replacement. Not everyone was happy with Walter's cast-iron proposal. Engineer Robert O. Woods writes that the "iron painted to look like marble" was perceived as "a counterfeiting that provoked controversy before the dome was built." One Maryland congressman was concerned because there was no precedent for such a use of iron (in fact, there was, and had been in Britain since 1779). Nevertheless, for the next 11 years—with one significant interruption—the dome rose over Washington, D.C. Its elegant structure consisted of cast iron modules, some weighing 10 tons, each with flanges for fixing to its neighbor with massive bolts, forming ribs; integrally cast cross-members stiffened it.

Meigs claimed the credit for this "product of inspired design combined with hard-headed engineering." According to Woods, he even signed his name to Walter's drawings, claiming that Walter had simply put Meigs' ideas on paper. Nothing short of open warfare existed between the two men, and the

conflict was carried as far as President Buchanan before it was temporarily settled. In 1859 Meigs was posted to the Dry Tortugas, "the closest thing the United States had to Siberia." Architect Vernon Reed asserts that Meigs' claim to the dome "was a phony one, for those who knew Walter knew that he was probably the most competent architect of his day, even in the engineering disciplines."

Notwithstanding the soldier's "persistent interference," the project progressed rapidly: the Representatives convened in their new chamber in mid-December 1857 and the Senators in theirs early in January 1859. Yet it must be said that Meigs made a valuable contribution to the Capitol. As Scott explains,

> Until 1859 he chose the painters and sculptors who decorated [the extension], suggesting themes to them that expressed Euro-American dominance of the continent. Italian-born fresco painter Constantino Brumidi spent twenty-five years decorating walls and ceilings of committee rooms, offices and corridors, as well as the rotunda's frieze and canopy painting. His subjects ranged from a visual dictionary of American flora and fauna to American history primarily told through classical allegories.[11]

The abrasive soldier returned from the Tortugas in 1861, asserting that it was "God's will" that he complete the Capitol. The outbreak of the Civil War in April ended an acrimonious correspondence between him and Walter. Meigs went on to a distinguished career as Quartermaster General of the Union Army. Official documents later said of him, "the Army has rarely possessed an officer who combined within himself so many valuable attainments and who was entrusted by the Government with a greater variety of weighty responsibilities, or who has proved himself more worthy of confidence."

Construction of the Capitol was deferred in 1861, and the building was temporarily used as a barracks, hospital, and bakery. But despite the war, work resumed the following year because Lincoln believed that the Capitol "must go on, just as the Union must." At the beginning of December 1863, Walter oversaw the final placing of Thomas Crawford's 20-foot high allegorical bronze figure of "Freedom triumphant in War and Peace" to crown his dome. In 1866 Brumidi finished *The Apotheosis of Washington*, the vast fresco in the oculus.

In August 1865 Walter resigned over a minor contract dispute and retired to Philadelphia. It has been asserted that his work on the Capitol firmly established his place in American architecture and "shaped the image and iconography of American governmental building for a century to come." His student and assistant Edward Clark, whom President Andrew Johnson appointed following Walter's resignation, completed the extensions in 1868. A year earlier, the office of Commissioner of Public Buildings had been abolished, and the entire Capitol was put in Clark's control. He introduced technical innovations—steam heating, electricity, and elevators—and between 1874 and 1892, the

landscape architect Frederick Law Olmstead was commissioned to design the expansion of the Capitol grounds: lawns, planted areas, walkways, streets and the north, west, and south marble terraces, altogether covering about 274 acres.

The Capitol building "had been transformed from a sedate and self-contained building on a rather small scale to an exuberant and complex one of much greater size," spreading 750 feet across Capitol Hill. The visual weight of the new dome overpowered the proportions of the east portico, which the architects Carrère and Hastings were engaged to rebuild in 1904. Apart from that building, with the exception of the east front extension of 1958 to 1962 (which added 102 rooms), and courtyard infill areas of 1991 to 1993, had reached its present size and appearance by 1892. Clark died in office in January 1902.

Much of the twentieth-century work involved relocating offices to other buildings, reshuffling of spaces to accommodate growing demand, and the conservation and maintenance of the exterior and interior. And as the architect of the Capitol recently reported, "As the twenty-first century opens . . . the Capitol dome is being rehabilitated in a project that will abate lead-based paint, repair cracks in the cast-iron skin, apply new paint inside and outside, and effect other related work."

Reflecting on Benjamin Franklin's remark—"in a Government like ours the Belief creates the Thing"—made to Robert Morris, a fellow-signatory to U.S. Constitution, Pamela Scott writes,

> Certainly the belief in what the Capitol could convey about that government sustained the many statesmen and architects who created the building. Conceived in the spirit of ancient republics, slowly built to embody the political and social values of the Constitution, and nurtured by the continuous unfolding of national events, the Capitol's art and architecture presents the broad sweep of American aspirations and history. Today the Capitol is a distillation of two hundred years of what Henry James, writing in *The American Scene* in 1907, called the "whole American spectacle."[12]

"A Jealousy of Architects"

William Thornton (1759–1828)

Thornton, the son of a sugar planter, was born on the island of Jost Van Dyke in the West Indies. He was raised by his father's relatives—strict Quakers—in Lancashire, England. Although independently wealthy, William "was to be trained for a useful life," and after a 4-year apprenticeship to a physician-apothecary in northwest England, in 1781 he enrolled to study medicine at Edinburgh University. Two years later he moved to London to continue his studies. Always interested in the fine arts, he also attended lectures at the

Royal Academy. In 1784, having received his degree from the University of Aberdeen and bearing a letter of introduction to Benjamin Franklin, then America's ambassador to France, he undertook a the grand tour of Europe. In May 1785 he returned to his birthplace, for the first time since he left. Influenced by combination of "Quaker humanitarianism and Enlightenment rationalism," Thornton had become a fervent republican and intended to deal with the troubling issue of his ownership of about seventy slaves.

He set up a medical practice in Philadelphia in fall 1786. It failed; the city had its own medical school, and fierce professional competition led him to complain, "The fees are small, the attendance required is great; and the different branches of the profession are not divided. . . . It is thus not only laborious, but disgusting." At the beginning of 1788 he became an American citizen in Delaware, where he courted (sadly, in vain) the governor's daughter. Eighteen months later, back in Philadelphia, he indulged his "hobby"—architecture—by entering a design competition for the Library Company's new hall. Despite his inexperience, he won the commission for the city's first building in the Modern (Classical) style, and it was completed in 1790.

In that same year he married Anna Maria Brodeau, and in October they moved to the West Indies for 2 years. While there he learnt of the Capitol design competition; it had closed by the time he returned to Philadelphia, but he submitted a design anyway and won. Relocating in the incipient capital, he would work with (and against) a succession of experienced professionals—a "jealousy of architects"—to realize the building. In September 1794 George Washington made him a commissioner of the Federal District; when that commission was abolished 8 years later President Jefferson appointed him superintendent of the Patent Office, a post he held for the rest of his life.

Although trained in medicine, Thornton's interests were wide ranging: he attempted to found a settlement in Puerto Rico for freed slaves; he advocated U.S. intervention in liberating Greece from the Ottoman Turks and South American countries from Spanish rule; he published a discourse on the teaching of the deaf; and he planned a national university. In December 1799, when Washington lay critically ill at Mount Vernon, Thornton wanted to transfuse blood into him from a lamb. Before it could be done, the president died. Supported by Representative John Marshall, the doctor/architect then proposed a mausoleum "of American granite and marble, in pyramidal form 100 feet square at the base and of proportionate height" under the dome of his capitol building. Fortunately, it was never realized. Thornton died in 1828, and his body was interred in the congressional cemetery.

Étienne Sulpice (Stephen) Hallet (1755–1825)

Étienne Sulpice Hallet (aka Stephen Hallet) was born in France. Little is known of his training—except that was *not* at the Royal Academy, where

most architects studied—or of his early career. In the mid-1780s he was a li-censed architect in Paris, specializing in "middle-class buildings," whatever that meant. He emigrated to the United States around 1789: some historians believe that he was engaged to teach in Quesnay de Beaurepaire's failed *Acad-emie des Sciences et Beaux-Arts* in Richmond, Virginia; others suggest that he has been confused with the Hallett family of New York, who supported that abortive scheme. Alternatively, Pamela Scott suggests, he "may have come to America to work for the Holland Land Company"; he was employed by them in Washington in 1795 after his dismissal as the Capitol architect.

Around the beginning of 1790 Hallet moved to Philadelphia. As well as scratching out a meager living in his own practice, he worked as a drafter for L'Enfant. Possibly because his neighbors found his French name difficult to pronounce, he took the name *Stephen* Hallet. He entered the White House and Capitol design competitions in 1792, and when Thornton's submission for the Capitol was accepted, Washington asked Hallet to work out the practi-cal details and to oversee construction. The Frenchman moved to the capital in 1792, but a "misunderstanding" about how much Thornton's design could be altered led to Hallet's dismissal in 1794.

Finding financial survival difficult in the Federal District, he returned to Phil-adelphia in 1796 and established an evening school of architecture, which seems to have enjoyed only sporadic success. His life, post-Washington, D.C., is obscure. In 1800 he moved to Havana, Cuba, and designed the Neo-Classical *Cementerio General* (aka Espada Cemetery), returning to America when it was completed in February 1806. He was in New York in 1809, where he possibly remained until his death at New Rochelle in February 1825.

Benjamin Henry Latrobe (1764–1820)

Latrobe is widely (but not universally) considered to be the first professional architect in America. He was born near Leeds in England; his father was a Moravian church minister and his mother a third-generation Pennsylvanian of Moravian parentage. His early education in the liberal arts and classical and modern languages was gained first in England, then in Germany, and rounded off in 1783 by a grand tour of Germany and France.

The following year, he began work at the Stamp Office in London. By around 1787 (by his own account) he had started his professional training under the engineer John Smeaton. He soon developed an interest in architecture and (again by his own account) was articled to the Greek revivalist Samuel Pepys Cockerell, whose office he claimed to have managed in 1791 and 1792. One historian notes that "Latrobe was . . . drawn into the orbit of England's three most advanced architects: Cockerell . . . , George Dance the Younger . . . and Sir John Soane." But recent scholarship has cast the shadow of doubt over those claims. Paul F. Norton observes, "As to his own architectural work in

England, it was scanty indeed. The sum total is two country houses and repairs or renovations to a few other houses and some London public offices. Yet when Latrobe arrived in [America] he would have his adopted countrymen believe that he was a seasoned professional."

Latrobe arrived in Norfolk, Virginia, in March 1796. The Virginia State Penitentiary in Richmond (1797–1798) was his first public building in the United States and in 1798 he moved to Philadelphia, with a commission for the Bank of Pennsylvania (1798–1801). The following year he designed "Sedgeley" a Gothic Revival country house and began the Philadelphia Waterworks (also completed in 1801). He asserted, "I have changed the taste of a whole city" and later boasted, "I am the only successful architect and engineer [in Philadelphia]. I have had to break the ice for my successors." Beyond Philadelphia, his designs included a canal linking the Chesapeake River and Delaware bays (1801–1802), Princeton's Nassau Hall (1802), and a few domestic works.

For all his self-promotion, it seems that his practice was hardly profitable, and when in 1803 President Jefferson offered him the appointment as surveyor of public buildings, he seized the chance. Like his predecessors, and because of his arrogant unfavorable criticisms, he soon offended Thornton, who uncovered Latrobe's lack of experience, greatly embarrassing him. By 1813 Congress was preoccupied with the war with Britain; without work in Washington, Latrobe left. He returned in 1815, engaged to restore the fire-ravaged Capitol—in his own words, "a most magnificent ruin." But under the increasing pressure of construction delays (mostly beyond his control) and budget overruns, he resigned in November 1817.

He designed buildings in other U.S. cities, among them Lexington, Kentucky, Philadelphia, Pennsylvania, New Orleans, Louisiana, and St. Louis, Missouri, where he died of yellow fever in September 1820. His influence on American architecture and architects is considerable. Although the U.S. Capitol and the Baltimore Roman Catholic Cathedral (1804–1820) are his best-known works, others, especially those in Philadelphia, "profoundly altered the look of American architecture in the first decades of the nineteenth century." Another critic agrees: "He was the most clever, the best educated, and the one whose influence spread the farthest by introducing the revival of Greek architecture to this country."

Charles Bulfinch (1763–1844)

Bulfinch was born in Boston, the son of a prominent physician. He was educated at the Boston Latin school and at Harvard, graduating in 1781 with a degree in mathematics and perspective. A few years later he toured Europe, seeing at firsthand the architecture of France and Italy. In Britain he was impressed by the work of the Scots Neo-Classicist architect-city planner Robert Adam and on returning to Boston in 1787, he set up a practice to translate

English town planning and European architecture into an American setting. Although self-taught, he is held to be Boston's first professional architect.

His "dignified Adamesque Federal style" output was prolific and ubiquitous. A few of his projects will demonstrate: the Massachusetts State House (1787–1798); the first monument to the American Revolution on Boston's Beacon Hill (1789); the sixteen-house Franklin Crescent and the Federal Street, (both in Boston, 1793); and the Connecticut State House, Hartford (1792–1796). In the first decades of the nineteenth century Bulfinch built several residences, expanded Faneuil Hall (1804–1805), and built the India Wharf (1807), all in Boston. He also designed, among other churches, the Church of the Holy Cross (1800–1803); New North Church (1802–1804) and the First Church of Christ in Lancaster, Massachusetts (1815–1817). He also built the Massachusetts State Prison (1803) and a number of courthouses; University Hall at Harvard (1813–1814); and Massachusetts General Hospital (1818–1820).

Besides all this, from 1797 until 1818 Bulfinch was (unpaid) permanent chairman of Boston's Board of Selectmen. In that role he oversaw the modernization of the city—drainage, street lighting, rationalized and widened streets—and reorganization of the police and fire departments.

In January 1818 President James Monroe appointed Bulfinch as architect of the Capitol. While in Washington, he also designed the State House in Augusta, Maine (1829–1832). In 1830 he returned to Boston, where he died on April 15, 1844. One critic writes, "Bulfinch's work was marked by sincerity, simplicity, refinement of taste and an entire freedom from affectation, and it greatly influenced American architecture in the early formative period." Another observes that his works "bear a distinctive stamp of his own. Their elegance, repose, and refinement of detail rank them among the best products of the nation's early years."

Thomas Ustick Walter

Philadelphia-born Thomas Ustick Walter was apprenticed to his father as a bricklayer and stonemason from 1819 to 1824. After briefly working in William Strickland's architectural office, he returned between 1828 and 1831, also studying under John Haviland and the landscape artist William Mason at the Franklin Institute's School of Mechanic Arts. By 1829, he was a member of the Institute and would become its professor of architecture in 1841.

In the 1830s Walter achieved prominence with designs for buildings in and around Philadelphia: Portico Row (1830), a row of sixteen up-market houses on Spruce Street; the Gothic-style Philadelphia County Prison at Moyamensing (1831–1835); Founder's Hall, the original classroom building for Girard

College (1833–1848)—the "last word in American Greek Revivalism and unquestionably its grandest monument"; and the south wing of Nicholas Biddle's house "Andalusia," on the Delaware River (1834). By 1843 he had designed more than two hundred projects, including a breakwater for the port of LaGuayra, Venezuela, and a church in Shanghai, China.

Walter entered the competition for the Capitol extension in December 1850 and 6 months later moved to Washington, D.C. While there he also designed and constructed extensions to the Patent Office, Treasury and Post Office buildings, built the Marine barracks in Pensacola and Brooklyn, and made additions to the Library of Congress. Resigning in 1865, he returned to Germantown, Pennsylvania, where because of financial straits he reopened his practice in the early 1870s; few commissions came his way. When his associate John McArthur Jr. won the Philadelphia City Hall competition in 1871, he made Walter consulting architect, a role he fulfilled for the rest of his life.

Walter was "concerned about the place of architecture in society and the development of the architectural profession." In 1836 he helped found a short-lived "American Institute of Architects" (later changed to American "Institution" of Architects), which "paved the way for the formation of the present American Institute of Architects (AIA). In 1857 Walter was elected first vice-president of the AIA and served as president from 1876 until his death in Philadelphia in 1887.

NOTES

1. University of Virginia, "The Capitol Project." Available at http://xroads.virginia.edu/~cap/cap_home.html

2. U.S. Senate, "Historical Minute Essays, March 20, 1962. Hollywood on the Hill." www.senate.gov/artandhistory/history/minute/Hollywood_on_the_Hill.htm

3. Allen, William C., *History of the United States Capitol. . .* Washington, DC: U.S. Government Printing Office, 2001, 10.

4. Hill, Charles M., "William Thornton." www.loc.gov/rr/print/adecenter/essays/B-Thornton.html

5. "Conversation with Harry Mount, author of Carpe diem," 3. www.hyperionbooks.com/pdfs/carpediemQA.pdf

6. Murphy, Cullen, *Are We Rome?: The Fall of an Empire and the Fate of America.* Boston: Houghton Mifflin, 2007.

7. Allen, 16.

8. Reed, William, "Slaves *Helped Build* White House and Capitol." www.final-call .com/perspectives/slaves08-13-2002.htm

9. Pitch, Anthony S., "The Burning of Washington." www.whitehousehistory .org/08/subs/08_b04.html

10. "Charles Bulfinch," *Encyclopedia of World Biography*. www.encyclopedia
.com/doc/1G2-3404700981.html

11. Scott, Pamela, "Freedom Triumphant in War and Peace. . . ." www.loc.gov/
exhibits/us.capitol/s5.html

12. Scott, "Temple of Liberty: Building the Capitol for a New Nation." www
.loc.gov/exhibits/us.capitol/s8.html

FURTHER READING

Allen, William C. *The Dome of the United States Capitol: An Architectural History*.
Washington, D.C.: U.S. Government Printing Office, 1992.

Allen, William C. *History of the United States Capitol: A Chronicle of Design, Construction, and Politics*. Washington, D.C.: U.S. Government Printing Office, 2001.

Bushong, William B., ed. *Glenn Brown's History of the United States Capitol*. Washington, D.C.: U.S. Government Printing Office, 1998. Annotated edition of Glenn Brown, *History of the United States Capitol*, 2 vols. Washington, DC: U.S. Government Printing Office, 1900-1903. Text and illustrations available at www.gpoaccess.gov/serialset/cdocuments/hd108–240/index.html

Butler, Jeanne Folley, and George M. White. "Competition 1792: Designing a Nation's Capitol." *Capitol Studies*, 4(no. 1, 1976), the issue.

Ennis, Robert B. "Nineteenth-Century Profile: Thomas U. Walter." *Nineteenth Century*, 5(Autumn 1979), 59–60.

Gereau, Gerald R. *The Capitol, a Pictorial History of the Capitol and of the Congress*.
Washington, D.C.: U.S. Government Printing Office, 1981.

Kapsch, Robert J. "Building Liberty's Capital: Black Labor and the New Federal City." *American Visions* (February-March 1995).

Kennon, Donald, and Thomas P. Somma. *American Pantheon: Sculpture and Artistic Decoration of the United States Capitol*. Athens: Ohio University; New York: Norton, 2005.

Kimball, Fiske, and Wells Bennett. "William Thornton and the Design of the United States Capitol." *Art Studies* (1923), 76–92.

Kirker, Harold. *The Architecture of Charles Bulfinch: Enlarged Edition*. Cambridge, MA: Harvard University Press, 1998.

Letson, Neil. "Thomas U. Walter: Designer of the Capitol Dome." *Victorian Society in America. Newsletter*, 5(no. 2, 1972), 3–5.

Preston, D. "William Thornton." In J.A. Garraty and M.C. Carnes, eds., *American National Biography, New York*: Oxford University Press, 1999.

Scott, Pamela. "Stephen Hallet's Designs for the United States Capitol." *Winterthur Portfolio*, 27(Summer- Autumn 1992), 145–170.

Scott, Pamela. *Temple of Liberty: Building the Capitol for a New Nation*. New York: Oxford University Press, 1995. See also www.loc.gov/exhibits/us.capitol/s0.html (accessed February 2008).

Stearns, Elinor and David Yerkes. *William Thornton: A Renaissance Man in the Federal City*. Washington, D.C.: American Institute of Architects Foundation, 1976.

"Thomas U. Walter, Edward Clark and the United States Capitol." *American Society of Architectural Historians. Journal*, 23(1964), 210–213.

Wolanin, Barbara Ann. *Constantino Brumidi: Artist of the Capitol*. Washington, D.C.: U.S. Government Printing Office, 1998.

INTERNET RESOURCES

Architect of the Capitol official website. www.aoc.gov/

Library of Congress. Temple of Liberty: Building the Capitol for a New Nation. February 24–July 4, 1994. www.loc.gov/exhibits/us.capitol/s0.html

Thomas Ustick Walter: Historic Architecture for a Modern World. www.philaathenaeum.org/tuw/index.html

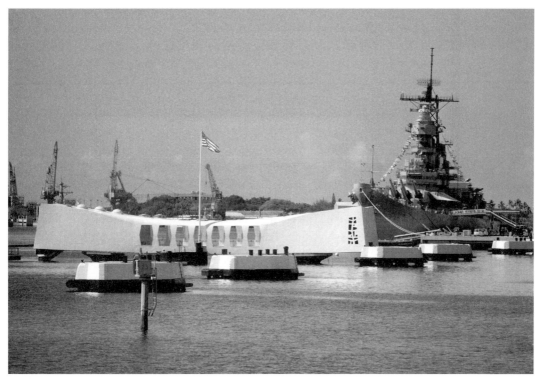

USS *Arizona* Memorial, Pearl Harbor, Honolulu, Hawaii

The View from Space

Most people are familiar with those computer-generated images used in television advertising that simulate a zooming lens, drawing away from a product, through a room, a house, a city, and a continent to finally become a view from space. An analogy may be drawn with the symbolic significance of the USS *Arizona* Memorial. The perforated white cuboid—extremely competent but not brilliant architecture—is about twice the floor area of the average modern house and in spatial organization much simpler than it. Yet it has become an icon, not only of the destroyed battleship, but also of the December 1941 attack on Pearl Harbor, the U.S. World War II involvement in the Pacific and further afield, and by extension the genesis of the nuclear age with its incalculable effect upon the entire planet.

The wreck of the USS *Arizona* was declared a National Historic Landmark in May 1989. The memorial, although it had been added to the National Register of Historic Places 23 years earlier, does not share that status. Nevertheless, its status as an American icon was argued well (as though it needed to be argued at all) by National Park Service (NPS) historian James P. Delgado in the Historic Places nomination of the battleship:

> [The remains of the] USS *Arizona* (BB-39) are the focal point of a shrine erected by the people of the United States to honor and commemorate all American servicemen killed on December 7, 1941, particularly *Arizona*'s crew, many of whom lost their lives during the Japanese attack on the United States Pacific Fleet at Pearl Harbor. . . . *Arizona*'s burning bridge and listing masts and superstructure, photographed in the aftermath of the attack . . . and emblazoned on the front pages of newspapers across the land, epitomized to the nation the words "Pearl Harbor" and form one of the best known images of the Second World War in the Pacific. *Arizona* and the *Arizona* Memorial have become the major shrine and point of remembrance not only for the lost battleship but also for the entire attack.
>
> Indelibly impressed into the national memory, *Arizona* is visited by millions who quietly file through, toss flower wreaths and leis into the water, watch the iridescent slick of oil that [still] leaks . . . from *Arizona*'s ruptured bunkers . . . , and read the names of [her] dead carved in marble on the Memorial's walls. Just as important as the shrine, as embodied in the form of the modern memorial . . . is the battleship herself. Intact, unsalvaged, and resting in the silt of Pearl Harbor, USS *Arizona* is a partially frozen moment of time, her death wounds visible and . . . her intact hulk holding most of the battleship's crew [is], the greatest victim of the Pearl Harbor attack and the nation's focal point for remembering a day of infamy, [and] is of exceptional national significance.

According to the *Arizona* Memorial Museum Association (AMMA), the Memorial is "an icon of America's past. It [embodies] the tragedy and grief of the nation within an edifice of dignity and grace . . . a place where the world comes to remember Pearl Harbor and Americans still come to mourn." Every year, it is visited by 1.6 million people. NPS historians assert that Pearl Harbor has an almost religious significance, being "one of the most emotion-laden

and important war sites in the world for two generations of Americans and Japanese."

> The ultimate symbolism of USS *Arizona* and the memorial, however, is the basic perception of war and its conduct. To many Americans of an older generation, *Arizona* ... also symbolizes the need for preparedness, for military strength, and for alertness. It is also an object lesson for those who vow "never again." To a later generation that fought in Vietnam or protested the war, USS *Arizona* has been seen as a memorial to the futility of war and the inevitability and finality of death brought by the use of force between nations.[1]

They continue, "Whatever the perception, however, *Arizona* is a symbol, and the ultimate significance of the vessel and its memorial lies in the ability to be all things to all people." To reiterate an observation made elsewhere in this book, meanings are in people.

PEARL HARBOR IN POPULAR CULTURE

Souvenirs of a visit to the Memorial are almost mandatory, because the AMMA's functions are supported in part by sales to the many visitors. The merchandise offered in the museum shop, although including all the usual memorabilia—clothing, coffee mugs, collectors' cards, coins and medallions, DVDs, jigsaw puzzles, key chains, lapel pins, patches, posters, and even decks of cards—is dignified and appropriate.

In 2008 there were in print thirty-five nonfiction books and six children's books specifically about Pearl Harbor; about ten more were due for release in the course of the year. The Library of Congress holds almost one thousand titles, including film, photographs, recordings, and pamphlets. About 80 percent of the material is post–World War II; about one-fourth is post–2001. There are fewer than a dozen publications about the USS *Arizona* Memorial.

The movies have always provided an effective populist vehicle for propaganda, and Hollywood responded urgently to the attack on Pearl Harbor. The very next day Twentieth Century Fox studios suspended work on *Pearl Harbor Pearl* to begin production of what has been called a "slapdash melodrama," *The Secret Agent of Japan*. Released only 4 months later with the tag line, "Now! The first, inside story behind the 'stab in the back'!," the critical flop became what the movie industry calls a "box office smash." *The New York Times* reviewer dismissed it as "third-rate drama," noting that "despite the rather hair-raising implications of a lobby display showing goggle-eyed ladies helplessly caught at bay by squat and unmistakable little men, the movie turns out to be a very mild hate-brew after all. To be sure, ... [at one point the hero] mutters at a Japanese secret agent, 'You son of a rising son.' "[2]

Three months later Fox also released the quasi-documentary style *Little Tokyo, USA*, "sixty-three minutes' worth of speculation about pre-war

Japanese espionage activities." Set in late 1941, the story concerns a series of crimes that cover up a Japanese-American group's plot to facilitate Japan's bombing of Pearl Harbor. Its racist message is that even U.S.-born Japanese Americans were untrustworthy, and it lobbies for their internment. (In fact, not one charge of espionage was ever brought against a Japanese American during wartime.) *Little Tokyo, U.S.A.* reflected the views of Texas Democrat Martin Dies, chairman of the Special Committee of the House on Un-American Activities, who asserted that fifteen thousand Japanese nationals were guilty of spying against the United States. The Office of War Information (OWI) condemned the hate film as an "invitation to the Witch Hunt" and as a result "took a much more active role in the regulation of Hollywood propaganda [and] stepped up its demands that the studios submit screenplays to it before shooting began."

Released in September 1942, Warner Brothers' "fine, noir-ish thriller," *Across the Pacific*, directed by John Huston (and after Huston signed up, by Vincent Sherman)—like the Fox productions—was not about the bombing of Pearl Harbor, but about an imminent Japanese plot to do so. At least, that was to start with: while the film was in production, the attack actually happened, so the fictional target was changed to the strategically important Panama Canal—a not altogether implausible scenario.

Republic Pictures' *Remember Pearl Harbor*, produced in less than a month and released in May 1942, was claimed to be the "first fictional film dealing with the attack on Pearl Harbor." That is, some of the action was set during and after the bombing. Its wordy tag line was, "America's stirring war cry! . . . ringing across the oceans . . . striking fear into the heart of a sneaking foe who dared to stab Uncle Sam in the back!" Republic Pictures registered the title for copyright. The "small budget quickie" was a paragon of recycling: the movie was a rehash of the 1940's *Girl from Havana*, itself a remake of the 1939 Roy Rogers western *Rough Riders' Roundup*, in turn a remake of another 1939 effort, *Forged Passport*, first filmed in 1936 as *The Leathernecks Have Landed!*

Columbia Pictures' "really insignificant" melodrama *Submarine Raider* also was released in 1942. Set immediately before and after the attack, it was (like *Remember Pearl Harbor*), largely speculative. But, as Jeanine Basinger and Jeremy Arnold comment, "it initiates a ritual event, re-enacting Pearl Harbor in narrative form, a phenomenon that would continue to occur long after the war was over. It unites narrative with reality by using newsreel footage, but this accident of poverty cannot claim too much significance without cheating the truth."[3]

Hollywood director John Ford joined the Navy at the age of 47, and as chief of the Field Photographic Branch of the Office of Strategic Services he filmed and supervised several wartime documentaries. He won an Academy Award for his 1943 "bizarre Pearl Harbor docu-drama," *December 7th*. Cut to 30 minutes on the Navy's instructions because it criticized the military's

lack of preparation, it used clips of the actual attack to re-create the bombing and its aftermath. The 84-minute full version, eventually released in 1991, amalgamated fact and fantasy. The opening sequence shows Uncle Sam on vacation in Hawaii on December 6th, when the "Voice of Responsibility" warns him of the danger of ignoring Japanese immigrant Fifth Columnists; at the end, the ghost of a serviceman killed in the attack discusses with the ghost of a Revolutionary War soldier in Arlington National Cemetery how the U.S. will prevail over Japan. Bizarre, indeed! After *December 7th* war movies merged events at Pearl Harbor into the broader canvas of the war in the Pacific.

There is another more recent movie—also B-grade and also bizarre—worth mentioning. In United Artists' *The Final Countdown*, released in 1980 and described by one reviewer as "a 'Twilight Zone' episode produced as a Navy recruiting film," the nuclear aircraft carrier USS *Nimitz* is sucked through a time warp to December 6, 1941, presenting her crew with the time-travel chestnut: do they risk changing the course of history by launching a preemptive strike against the Japanese fleet?

It was inevitable that the Japanese, too, would make films about Pearl Harbor. All were produced by the Toho Company, now best-known for *Godzilla* and other monster movies. *Hawaii mare oki kaisen* (very loosely translated, *Battle of Pearl Harbor and the Malay Coast*) was made as propaganda in 1942. One writer notes that its special effects—touted in Japan as actual footage—were "so convincing that General Douglas MacArthur's film unit confiscated the film and sold the footage to Frank Capra and Movietone News." (For those who have seen the original *Godzilla*, that may come as a surprise.) Capra subsequently used it for a historically accurate reconstruction in *December 7, 1941*, part of his *Why We Fight* series. In 1961 Director Shue Matsubayashi made *Hawaii Middouei daikaikusen: Taiheiyo no Arashi*, a drama about a young Japanese pilot; a dubbed version was released in the U.S. as *I Bombed Pearl Harbor* and a subtitled version appeared as *Storm over the Pacific*. In 1968 Toho produced *Rengo kantai shirei chôkan: Yamamoto Isoroku*, a biography of the supreme commander of the Japanese fleet.

Of course, Pearl Harbor has been the theme of television documentaries, sometimes as "stand-alone," but mostly within a series. The following list is indicative but not exhaustive: *You Are There* (1953); *Air Power* (1956); *The Twentieth Century* (1961); *Pearl* (1978-1979); *The Winds of War* (1983); *War and Remembrance* (1988); *The American Experience* (1991); *Encounters with the Unexplained* (2001); *Deep Sea Detectives* (2003); *Conspiracy* and *Days that Shook the World* (both 2004). There have been a few foreign language productions.

The few major (read, big budget) movies specifically about Pearl Harbor have been savaged by the critics. The notable exception was Fred Zinnemann's *From Here to Eternity*, released by Columbia Pictures in 1953, that stands at number fifty-two on the American Film Institute's list of best movies. Based on the novel by James Jones, who was stationed in Hawaii during the attack,

the film won eight Academy Awards, including best picture, out of thirteen nominations. Although not the major theme, the Pearl Harbor attack is impending throughout the film, and the climax used "stock shots from John Ford's Navy films of WW2, which featured a few re-creations" of the bombing. According to one critic, "Packed with implicit criticism of the military milieu, [the movie] would have been even more controversial if . . . Zinnemann had been allowed to retain the original ending." In February 1954 the *Honolulu Star Bulletin* reported that "the Army, which didn't like the book, applauded the movie . . . General [Kendall J.] Fielder said, 'military authorities were most concerned over the possibility of a picture that the Communists could use as propaganda.'" And a few days later the *Bulletin* noted that a "high-level" Navy conference in Washington decided not to show *From Here to Eternity* to its personnel for "moral" reasons and because it was "derogatory of a sister service" and a "discredit to the armed services." It was remade as a television miniseries in 1979.

Of Twentieth Century-Fox's Japanese-U.S. coproduction *Tora! Tora! Tora!* (jointly directed by Richard Fleischer, Toshio Masuda, and Kinji Fukasaku) of 1970, *Newsweek* wrote that it was "put together like a Fourth of July celebration—a long procession of predictable speeches leading to a spectacular fireworks display." Faint praise enough to condemn it, echoed by a *Time* review: "The first half of the film is devoted to apple-pie softness and bamboo resilience. . . . Three directors . . . have managed to move crowds and planes, but not the viewer." Indeed, many critics thought the movie was too long and boring but a few hailed it as the "greatest and most accurate war movie ever made." *The New York Times* struck a balance: though acknowledging that "as history, it seems a fairly accurate account of what happened," the reviewer went on, "as film art it is nothing less than a $25-million irrelevancy." Nominated in seven categories, it won an Academy Award for best visual effects. It also used clips from Ford's 1943 film.

With a deafening fanfare of media hype, in 2001 Disney's Touchstone Pictures released its $135 million plus blockbuster *Pearl Harbor*. In that sixtieth anniversary year of America's entry into World War II, television viewers were bombarded with such programs as *Pearl Harbor: Legacy of Attack*; *Unsung Heroes of Pearl Harbor*; *Pearl Harbor: Death of the Arizona* and *History Undercover: Road Map to Pearl Harbor*. Of course, all were good publicity for the movie, quite apart from the overtly promotional *Journey to the Screen: The Making of "Pearl Harbor"* and *Beyond the Movie: Pearl Harbor*. The most remarkable television offering was the absurd *Pearl Harbor II: Pearlmageddon* in which (as if the Japanese attack were not bad enough) Pearl Harbor was threatened on December 7, 1941, by splinters of a giant meteor headed for Earth. Two new video-only releases also appeared in 2001: *Pearl Harbor: Day of Infamy* and *Pearl Harbor: Dawn of Death*, and there was an absolute storm of DVD rereleases of old war movies of mixed quality.

Anyway, the premiere of *Pearl Harbor*, held aboard the aircraft carrier USS *John Stennis* at Pearl Harbor (where else?), was attended by survivors of the bombing and the press. Some critics accused the moviemakers of exploiting the attack as mere backdrop for what one of them called "a *Titanic*-meets-Pearl Harbor love story."

Most critics were scathing. Los Angeles' *New Times* declared, "*Pearl Harbor* has no interest in the hows and whys that led to the Japanese attack, only in the booms" and added "*Tora! Tora! Tora!*—told from the Japanese and American perspectives with all the passion of a 3-hour classroom lecture—was about the details, peace talks, and betrayals. But *Pearl Harbor* can't be bothered with history. It's war porn, a movie that revels in the carnage." Roger Ebert's derisive review in the *Chicago Sun-Times* called *Pearl Harbor* "a two-hour movie squeezed into three hours, about how . . . the Japanese staged a surprise attack on an American love triangle. Its centerpiece is forty minutes of redundant special effects, surrounded by a love story of stunning banality. [It] has been directed without grace, vision, or originality." And across the Pacific, the BBC dismissed it as "a great, bloated mess of a picture with a weak script and bland performances." It seems that only the *Los Angeles Times* offered fulsome praise. Some others commended the "sheer eye-popping spectacle" of the special effects, but the film received only one Oscar—best sound editing—of the four for which it was nominated.

Sociologist Patricia Leavy remarks that "the commodity-based phenomenon associated with the release of *Pearl Harbor* is a direct and traceable aspect of corporate commercial culture. During the marketing campaign before the movie's release bookstores began to display Pearl Harbor books, most of which had been first published years earlier; that had not happened on past anniversaries of the attacks—even the tenth, twenty-fifth and fiftieth—indicating that the film prompted the re-emergence of the older books." Several new Pearl Harbor histories were published in 2000 and 2001, all written or released during the making and marketing of the film. Noting that after the events of September 11, 2001, almost all Pearl Harbor books were removed from display, Leavy suggests that Pearl Harbor and the attacks on the World Trade Center and the Pentagon "have been constructed as interrelated iconic events," and American collective memory regarding Pearl Harbor implicitly changed.[4]

Changed perhaps—even eclipsed—by a new "day of infamy," that memory persists. Despite the fact that "living memory" belongs to people now in their seventies, events at Pearl Harbor linger in America's collective consciousness. An Ebay search made early in 2008 yielded over 660 items—vintage newspapers, magazines (and replicas of them), photographs, books, posters, caps, pins, pressed pennies bearing an image of the USS *Arizona* Memorial and the legend "Remember Pearl Harbor," postage stamps, CDs, DVDs, computer games, mouse pads, and even commemorative bourbon bottles.

THE RISE OF THE RISING SUN

Following its industrial modernization in the late nineteenth century, and emulating European strategies, the *Dai Nippon Teikoku* (Empire of Greater Japan) sought to extend its territories. By 1874 its military had grown strong enough to annex Ryuku, Ogasawara, and the Kurile Islands surrounding the mainland; using the conquered peoples for labor, the Japanese built supply ports for the Imperial Navy. Next, modeling his approach on the unequal treaties imposed on Japan by the U.S. and other western powers, Emperor Mutsuhito (reigned 1867–1912) applied gunboat diplomacy to open Korea to exploitative trade. Japanese insurgencies into the poorly defended Korean peninsula provide a beachhead into eastern Russia and China. By 1895 the defeat of China in several wars and the annexation of Formosa (now Taiwan) resulted in Japan's political recognition from many European countries, freeing the emergent Meiji empire from some of the treaties earlier forced upon it by the West.

Japan formed an alliance with Britain in 1902, which was renewed in 1905 and 1911. In 1904 the Japanese went to war with Russia over dominance in Korea and Manchuria, and in May 1905 Japan destroyed the Russian Baltic Fleet at the Battle of Tsushima. Four months later a peace treaty mediated by President Theodore Roosevelt at Portsmouth, New Hampshire, gave Japan control of the Liaotung Peninsula in Manchuria, the southern half of Sakhalin Island and the South Manchurian railroad, and as well as Korea. Japan annexed the whole Korean peninsula in 1910 and planned for further conquest in mainland Asia. During World War I the empire joined the Allied powers to displace Germany's "spheres of influence," and after the Treaty of Versailles, that collaboration was rewarded with membership of the League of Nations and control of the Shandong peninsula. But the United States and Britain—not without their own mutual tension—aware that Japan's growing naval strength threatened their own maritime dominance, sought ways to limit it. The 1921–1922 Washington Conference, convened by President Warren Harding, generated a number of treaties that would remain in force until the beginning of 1937. They included the Five-Power Treaty establishing an acceptable ratio of aircraft carriers and heavy warships for Great Britain, the United States, Japan, France, and Italy. In the Four-Power Treaty, France, Japan, Great Britain, and the United States agreed to respect each other's possessions in the Pacific. The *status quo* of naval fortifications in the (West) Pacific was to be maintained. Japan was to return Shandong to China, which was assured of territorial integrity.

Nevertheless, by 1930 Japan's Imperial Army and Navy were strengthening their hold on national politics, and military expansion became the country's principal goal. Nationalism was increasing, and Japan was unwilling to be subjugated by outside forces again. Moreover, the island nation was already feeling the economic impact of the Great Depression, and its increasing

population was making territorial expansion imperative. More potently, there was a deep belief that Japan's divinely ordained destiny was to rule Southeast Asia. According to British historian Chris Trueman,

> The civilian government found that it had no solutions to the problems . . . and to the army the civilian government looked weak. Many people admired the more robust response of the army. The unemployed of Japan looked to the strength of the army to assist their plight rather than to what weak politicians were doing. The voices of senior army generals were heard and they argued for a campaign to win new colonies abroad so that the industries there could be exploited for Japan. The most obvious target was a full-scale invasion of Manchuria.[5]

Acting upon a complaint from China, in 1933 the League of Nations—a toothless tiger—decreed that Japan should withdraw from Manchuria; Japan responded by withdrawing from the League, instead. More germane to this essay, in the wake of the invasion of Manchuria diplomatic relations between Japan and the United States (which was not a member of the League), would deteriorate through the 1930s. Japan ignored America's protests and in summer 1937 launched an all-out invasion of China. But neither the United States nor any other nation was willing to use military force to halt Japanese expansion in the Far East.

In September 1940, a year after the outbreak of World War II in Europe, Japan signed the Tripartite Pact, linking it with Nazi Germany and Fascist Italy. Although the United States remained isolationist, the alliance heightened tensions with Japan, which now initiated the invasion of European and American territories in Southeast Asia. That inevitably meant war with America, Britain, and The Netherlands. When, with the approval of Vichy France, Japan occupied French Indochina in July 1941, President Franklin D. Roosevelt immediately applied diplomatic pressure and economic sanctions to show that the United States would oppose Japanese expansion into the Pacific. America discontinued exports to Japan of scrap steel, other raw materials, oil, and high-octane gasoline—all needed by Japan's military machine—and it also seized Japanese assets in America. The Japanese government viewed these measures, especially the oil embargo, as threats to its national security. By summer 1941, the two countries had reached an impasse; to step back then would be to lose face.

At a meeting of the paramilitary, ultra-nationalist right-wing *Kokury kai* (Black Dragon) Society in Tokyo on August 26, 1941, Hideki Tojo, then Japan's war minister, ordered that preparation be made for total war against the United States, and that by November 1941 Japanese military assets be concentrated in the Marshall and Caroline Islands, which had been Japanese mandates since World War I.

By the late 1930s America had strengthened its defenses at Guam, Midway, the Philippines, and Wake Island in the North Pacific and stationed the U.S.

Pacific Fleet at Pearl Harbor. Admiral Isoruko Yamamoto, commander-in-chief of the Japanese Combined Fleet, recognized that the Pacific Fleet "posed a formidable obstacle to Japanese conquest of Southeast Asia." He and the Japanese high command knew that, should there be a protracted war, America's greater wealth and industrial power would give it a great advantage. Yamamoto believed that Japan should do its best "to decide the fate of the war on the very first day" by a surprise attack on the Pacific Fleet while it lay at anchor. In spring 1940 he and Rear Admiral Shigeru Fukudome had evaluated aerial torpedo exercises; although the strategy was not novel, neither Japan nor the United States believed that an aerial torpedo attack on Pearl Harbor could succeed, and only after months of argument were the Japanese Naval commanders convinced of its practicability. Tojo approved the operation on September 6, 1941.

On the same day, a deadline was fixed in Imperial conference for concluding negotiations with the United States. On October 14 the deadline passed without progress having been made. Two days later, Prime Minister Konoe resigned. Tojo was appointed in his place. On November 2 Tojo and Chiefs of Staff Hajime Sugiyama and Osami Nagano reported to Hirohito that the negotiations had been futile; the emperor then consented to war. The following day Nagano explained details of the planned Pearl Harbor attack to him, and on November 5 Hirohito formally approved the operations plan for a war against the West. On December 1 another imperial conference finally sanctioned action against the United States, Britain, and The Netherlands.

TORA! TORA! TORA!

Under the command of Vice Admiral Chuichi Nagumo the First Air Fleet's *kido butai* (strike force), including the aircraft carriers *Akagi*, *Hiryu*, *Soryu*, *Kaga*, *Zuikaku*, and *Shokaku*, secretly rendezvoused in Hittokapu Bay in the remote Kurile Islands in northern Japan. There were also two battle cruisers, two heavy cruisers, one light cruiser, and ten destroyers. Radio operators from the carriers remained in Sasebo and Kure to "bat out imaginary traffic" to deceive Western radio eavesdroppers. Sailors from other ships were given public bus tours of national shrines to give the impression that the fleet was staying in home waters.

Early on November 26, 1941, the strike force weighed anchor for Hawaii, following a course far to the north of the normal shipping lanes; a screening submarine flotilla traveled 200 miles ahead. As it approached Hawaii, the fleet received reports from the submarines and Japanese agents on Oahu. At six in the morning of Sunday December 7 it hove to 230 miles north of its target. The previous night five two-man submarines, each carrying two torpedoes, were launched from "mother" submarines 10 miles outside Pearl Harbor; they had orders to enter the harbor, remaining submerged until the air

strike began, then surface and "cause as much damage as possible"—clearly a suicide mission. Yamamoto had ordered that, should the negotiations with America—still proceeding—succeed, the Japanese fleet would immediately return to Japan.

At 6:20 A.M. the first wave of aircraft left the carriers, the second following about 25 minutes later. Altogether there were 324 planes—torpedo bombers, high-level bombers, dive bombers, and fighters.

Hawaii had two warnings of the impending attack. At around 6:40 A.M. the destroyer USS *Ward* depth-charged and sank one of the midget submarines. Bureaucratic delay meant that an hour passed before the incident was reported to Admiral Husband Kimmel, commander-in-chief of the U.S. Pacific Fleet. Less than a half-hour after the sinking of the minisub, Army radar operators on Oahu's north shore detected a large formation of planes approaching the island. The operators notified the watch officer at Fort Shafter, but, believing the aircraft to be a flight of B-17s arriving from the USS *Enterprise* or from California, he took no action.

Because of thick cloud cover, Commander Mitsuo Fuchida, leading the first wave, thought at first that he had overflown Oahu, but he soon saw its north coast. Realizing that his force was undetected, he ordered his flight leaders to attack. Certain that they had caught the American fleet by surprise, he ordered his radio operator, Petty Officer Tokunobu Mizuki, to transmit the now famous *Tora! Tora! Tora!* code word to Tokyo.

Ninety-six of the Pacific Fleet vessels were in port; seven of its nine battle-ships were moored in "Battleship Row" on the southeast shore of Ford Island. American aircraft were lined up at Ford Island and Kaneohe Bay Naval Air Stations, at Ewa Marine Corps Air Station, and at the Army's Hickam, Wheeler, and Bellows airfields. But the carriers USS *Lexington* and USS *Enterprise*—intended to be prime targets of the attack—were at sea. The first Japanese wave hit at 7:55 A.M., quickly crippling the fleet's main battle line. Hit by several torpedoes, the *Oklahoma* listed severely, trapping over four hundred men inside. The *California* and the *West Virginia* sank at their moorings, while the *Utah*, then being used as a training ship, capsized with the loss of fifty lives. The *Maryland*, the *Pennsylvania*, and the *Tennessee* all suffered significant damage. The *Nevada*, attempting to escape to sea, was hit several times and had to be run aground to avoid sinking and blocking the harbor entrance. Japanese dive bombers and fighters struck Schofield Barracks and the airfields. Within 2 hours, three-fourths of America's air power in Hawaii was lost; 164 aircraft were destroyed and another 159 damaged. The first assault wave ended at about 8:45 A.M.

The second wave—dive bombers and high-altitude bombers—arrived about 5 minutes later, destroying the USS *Shaw* and a dry dock and wreaking havoc inside the harbor. As it withdrew, Fuchida ordered his pilots to return to their carriers, their mission of destruction accomplished. They left behind the corpses of 2,340 American servicemen and forty-eight civilians; another 1,143

servicemen and thirty-five civilians were wounded. From the Japanese perspective the attack had been a great, although not complete, success. Although America's Pacific Fleet was devastated, its aircraft carriers were still afloat and the base at Pearl Harbor was relatively undamaged; the shipyards, fuel storage areas, and the submarine pens suffered only slight harm. More significantly, the Japanese action had served to unite the American people, hitherto divided over the question of U.S. involvement in World War II, in a commitment to victory over Japan and its Axis allies.

It was almost ten o'clock when the first returning aircraft reached the Japanese carriers. The aggressors had lost the midget submarines with their crews, and twenty-nine planes with fifty-five men. Aware that many targets were still intact, Fuchida expected that a third wave would be launched, but aboard the flagship *Akagi*, Admiral Nagumo asserted that the mission was accomplished. NPS chief historian Daniel A. Martinez writes, "Furthermore, the fleet's fuel was running low. More important, American carriers and other ships not in port were now searching for him. At one o'clock the task force altered course and began its journey back to Japan . . . a major blunder that greatly minimized the long-term effects of the attack on the American war machine."

THE LIFE AND DEATH OF USS *ARIZONA*

USS *Arizona* was the most seriously damaged target of the raid.

The keel of the USS *Arizona* (with the hull designation BB-39) was laid on March 16, 1914; the ship was launched on June 19, 1915. The second of two Pennsylvania class battleships, she was 608 feet long, with a 97-foot beam and an average draft of almost 29 feet; her displacement was 31,400 tons. Four screws (propellers), driven by paired turbines, generated a top speed of 21 knots. She was well armed: originally she had three 14-inch 45-caliber guns in each of four turrets; twenty-two 5-inch 51-caliber guns; four 3-inch 50-caliber guns; and two 21-inch submerged torpedo tubes. She was protected by 18 inches of armor at its maximum thickness. Her intended complement was fifty-five officers and 860 seamen.

A month after being commissioned under the command of Captain John D. McDonald, the *Arizona* sailed in November 1916 for 2 months' training in the Atlantic before returning to Norfolk, Virginia, to test-fire her guns. A "postshakedown" overhaul was completed in the New York Naval Shipyard by early April 1917. During World War I she served as a gunnery training vessel with Battleship Division 8 at Norfolk and also patrolled America's East Coast waters; at war's end, she sailed for Portsmouth, England, to operate with the British Grand Fleet.

In summer 1920 the *Arizona* became the flagship in the Caribbean for Battleship Division 7 and in July 1921 she took on the same role in the Atlantic Fleet Battle Force for McDonald, now a vice admiral. In September she was

transferred to the Pacific and for a decade served as flagship for Battleship Divisions 2, 3, and 4. From May 1929 though March 1931 she underwent extensive modernization at Norfolk. Tripod masts replaced her traditional cage masts fore and aft. New 5-inch antiaircraft guns replaced the outdated 3-inch mounts. New armor was added below the upper decks, and "blisters" were added to the outer hull to defend her against torpedo attack. Modern boilers and turbines were installed. Like much of the Pacific Fleet, she had a two-tone gray color scheme, designed to obscure her profile at a distance; however, it "had no value to vessels in port." In August the *Arizona* left Norfolk to be stationed again in the Pacific for 10 years. She made her last voyage to the West Coast in June, returning to Hawaii in early July; for the rest of the year her crew undertook battle-readiness drills. Her exact movements in November are unknown, but on Saturday December 6 she entered Pearl Harbor and moored at berth F-7 in "Battleship Row," with the repair ship *Vestal* alongside.

The *Arizona* was destroyed and sunk about 15 minutes into the first wave of the attack on Pearl Harbor. Some of the crew had received weekend passes, and about forty were ashore; most had returned to the ship. An 800-kilogram, specially converted projectile penetrated her deck armor near turret two and detonated in the forward magazine; the terrific explosion of ammunition and 1.5 million gallons of fuel oil instantly separated most of forward section of the ship and actually lifted the 33,000-ton vessel out of the water. She was hit by several bombs and strafing. Martinez writes that "about 8:10 A.M. the battleship took a death blow. Petty Officer Noburo Kanai, in a high-altitude bomber . . . was credited with dropping the bomb that blew up the *Arizona*." He adds graphically,

> In an instant, most of the men aboard were killed, including Rear Admiral I.C. Kidd and Capt. F. van Valkenburgh . . . The blast from the *Arizona* blew men off the decks of surrounding ships and threw tons of debris, including parts of bodies, all over the harbor. . . . The fury of the attack continued unabated, with the *Arizona* reportedly receiving eight bomb hits as it sank. Abandoned at 10:32 A.M., the ship's burning superstructure and canted masts loomed through the smoke that blanketed the harbor.[6]

Within just 9 minutes the mighty *Arizona* sank in 40 feet of water with 1,177 of her complement of sailors and marines. She continued to burn for 2½ days, cremating every man left on board; there were fewer than 340 survivors. Most bodies could not be reached, and only 107 were recovered and identified. The Navy had to give priority to raising the ships that could be salvaged. The *Arizona* was not among them; on December 13, 1941, it was officially reported that she was "a total loss, except the following is believed salvageable: fifty-caliber machine guns in maintop, searchlights on after searchlight platform, the low catapult on quarterdeck and the guns of numbers 3 and 4 turrets." Even after the war requests for the recovery of the bodies of the lost men were refused. The Navy regarded them as being "buried at sea."

THE USS *ARIZONA* MEMORIAL

Soon after the attack the Navy raised and repaired all the sunken vessels except the *Arizona* and the *Utah*. Of the others, only the *Oklahoma* did not return to duty. When the limited salvage work on the *Arizona* was done, she was left as a memorial to her crew, and in 1942 a new battleship berth was constructed on the hulk. In 1950, Admiral Arthur Radford, commander in chief of the Pacific Fleet, ordered that a timber platform and flagpole be constructed on *Arizona*'s boat deck, beginning a daily tradition began of hoisting the U.S. flag on a pole welded to what remained of her main mast.

Proposals for a memorial to those lost at Pearl Harbor had begun as early as 1943: Navy personnel preferred a tribute to the sailors who died; other groups wanted to commemorate wider aspects of the event. In 1946 H. Tucker Gratz, an Oahu businessman, organized civilian efforts to establish a shrine to the *Arizona*, but it was not until 3 years later that the Territory of Hawaii established the Pacific War Memorial Commission (PWMC) to plan and raise funds for war memorials on the island. In 1951 its seven honorary members—civic leaders, businesspeople, and Japanese American veterans, and chaired by Gratz—proposed a system of memorials that included the Marine parade ground, sites, and structures at Red Hill, the main gate of Pearl Harbor Naval Station, the wreckage of the USS *Arizona*, and a boulevard connecting Kamehameha and Nimitz Highways. On the fourteenth anniversary of the attack, the Navy Club erected a 10-foot high piece of basalt on Ford Island, with a plaque to the memory of U.S. servicemen—the first permanent memorial at Pearl Harbor.

President Eisenhower authorized the creation of the *USS Arizona* Memorial on March 15, 1958; it was to be built without federal funding. The PWMC set out to raise $500,000, and the Territory of Hawaii contributed the first $50,000. In an episode scheduled to coincide closely with the anniversary of the attack—in fact, on December 3, 1958—NBC's television series *This Is Your Life* featured Lieut.-Commander Samuel G. Fuqua, the USS *Arizona*'s senior surviving officer (by then a rear admiral). This first major national exposure of the fund-raising campaign attracted $95,000 in private donations, much of it in a little over a month. But 2 years later the planners had reached about only half their goal.

George Chaplin, editor of the *Honolulu Advertiser*, contacted about fifteen hundred daily papers throughout the United States, seeking publicity for the Memorial. Prompted by a *Los Angeles Examiner* editorial, Colonel Tom Parker, Elvis Presley's manager, offered a benefit performance to fit in with location filming for *Blue Hawaii*. Parker stipulated that all proceeds from admissions—ticket prices ranged from $3 to $10, with one hundred ringside seats at $100—must go to the fund. The March 25, 1961, concert at the four-thousand-seat Bloch Arena in the Navy Base sold out, netting almost $64,700. Moreover, Presley's personal appearance more permanently fixed the Memorial

in the public consciousness. Furthermore, it was a good marketing move for the singer.

The Fleet Reserve Association (FRA), a national organization of active and retired Navy, Coast Guard, and Marine Corps personnel, collaborated with the Revell Model Company to sell plastic model kits of the *Arizona*, originally released in 1958. Each included donation information on the instruction sheet and the project generated $40,000. Since May 2006 Revell again has been producing 133-piece, 1:426 scale kits that include "a historical book on the [Pearl Harbor] attack written exclusively for Revell."

Although federal funding for the Memorial initially had been denied, Hawaii Senator Daniel K. Inouye secured $150,000 from Congress in September 1961. The related legislation stipulated that the Memorial was "to be maintained in honor and commemoration of the members of the Armed Forces of the United States who gave their lives to their country during the attack on Pearl Harbor, Hawaii on December 7, 1941." The design was already developed.

The brief had called for a "bridge" to span the *Arizona* without touching it that could accommodate two hundred visitors at a time. A collaborative committee of Navy personnel and the PWMC reviewed several proposals from architects before commissioning the Austrian expatriate Alfred Preis of Johnson, Perkins, and Preis Associates of Honolulu. Preis' earlier ideas included a permanent platform connecting the *Arizona* hulk with Ford Island, where there would be an archives, a museum, and an observation tower. He also suggested incorporating a submerged compartment from which visitors could view the sunken ship through portholes. Historian Edward Tabor Linenthal records Michael Slackman's imaginative assertion that because

> Preis was raised in Vienna [he] had been impressed by the "jewel-encrusted crypts of the Hapsburg emperors and the immanent presence [*sic*] of death they conveyed." As a result, Preis initially proposed a structure in which visitors would be able to view "the underwater remains of the ship, encrusted with the rust and marine organisms" that reminded the architect of the royal sarcophagi.[7]

Perhaps. Preis also suggested a floating eternal flame. The clients were less than enthusiastic about the "stark confrontation of death" in his original proposal so he submitted an alternative design. The little white building that resulted will never be listed among the world's greatest architecture, but that is hardly the point of it. Besides, quite apart from the easily understood symbolism underlying its form, the Memorial stands up well under close scrutiny for its integrity and careful detailing. There may be a temptation to dismiss it as a child of its time (although which building isn't?), but that would be to deny its honesty, dignity, and serenity. Some buildings are monuments to their architects; others must, as this one does, point away from themselves to deeper values.

Preis' Memorial appears to be suspended above the sunken Arizona. It is supported on two huge steel beams that are in turn carried by thirty-six piles

driven into the harbor bed. The subtly configured superstructure of white painted in-situ reinforced concrete is 184 feet long. At each end it is 36 feet wide and 21 feet high, and it is waisted (so to speak) to 27 by 14 feet at the center. Its sloping walls and apparently sagging roof prompted one critic to call it a "squashed milk carton," a comparison that annoyed Preis—naturally enough—who explained, "Wherein the structure sags in the center but stands strong and vigorous at the ends, expresses initial defeat and ultimate victory. . . . The overall effect is one of serenity. Overtones of sadness have been omitted to permit the individual to contemplate his own personal responses . . . his innermost feelings."

NPS historians later commented that "the ship itself . . . is not the war memorial. That distinction belongs to the concrete arched structure that spans the sunken hulk but—symbolically—does not touch it. . . . The sunken ship [as the artefact and reminder of 7 December 1941] is a potent symbol that is enhanced and interpreted by the memorial structure." They reiterate the architect's design rationale, explaining that it "is less a memorial to the *Arizona* than it is to the great experience of American World War II," and that Preis

> viewed the United States as an essentially pacifistic nation, one that inevitably would sustain the first blow in any war. Once aroused by that shock, the nation could overcome virtually any obstacle to victory. Because of that characteristic, it was unavoidable—even necessary, in Preis' view—that this nation suffer the initial defeat at Pearl Harbor. He meant his design for the memorial to be a reminder to Americans of the inevitability of sustaining the initial defeat, of the potential for victory, and the sacrifices necessary to make the painful journey from defeat to victory.[8]

The interior, while not completely enclosed, consists of three separate spaces along a single axis. Entered through a plain façade redolent, perhaps consciously, of an Egyptian pylon, the Entry Room, lit from above by a central row of three dome lights, contains the flags of the nine states for whom the eight battleships and the *Utah* were named. Visitors pass one of the *Arizona*'s bells to reach the central Assembly Room, a large area used for ceremonial occasions but more often completely unfurnished. Its side walls and its roof are open to the sea and sky, each through seven lozenge-shaped "windows"; the number is said by some to commemorate the date of the attack. An opening in the floor allows visitors to drop flowers and leis into the sea above the sunken battleship. The final space, farthest from the entrance, is the Shrine Room, whose white marble end wall is engraved with the names of those killed on the USS *Arizona*. Its ends are illuminated by abstract sculptures of the *Tree of Life*, made by perforating the side walls of the Memorial.

The $532,000 contract was won by Walker-Moody Construction Company, that had been established just months before the Japanese attack, and the Pearl Harbor Public Works Center. The contractors later remarked that

though it was "not a major undertaking in terms of dollars, the Memorial was important [to them] in intangible ways. . . . It was an honor to be able to construct the Arizona Memorial and also a real challenge."

On completion of the work, the Navy gave the builders a Certificate of Appreciation, noting "cooperation beyond the terms of the contract for the convenience of the Government and the general public; . . . outstanding cooperation in the scheduling of construction work to meet a stringent deadline; . . . the providing of a superior end product to that specified; [and] savings of money to the Government." The letter also noted that, "The Contractor's effective and conscientious safety program resulted in a total of 17,587 man-hours of work without a single lost-time accident. This is more significant considering that all work was done over water and was accessible by floating craft only." A barge was purchased to support the crane, but it soon began to leak. It was careened . . . and the bottom repaired. A surplus LCM (landing craft mechanized) carried all materials to the site including concrete in buckets. It was named the *Cactus* [Arizona's state flower]."

The "eloquent, yet understated structure" was completed just a few days before Memorial Day 1962, when it was officially dedicated by Congressman Olin E. Teague, chairman of Veteran Affairs, and Hawaii's Governor John A. Burns. Over two hundred guests attended the ceremonies on the memorial; another eight hundred invited guests watched from Ford Island as Teague declared, "Upon this sacred spot, we honor the specific heroes who surrendered their lives . . . while they were in full bloom, so that we could have our full share of tomorrows." Journalist Charles Turner reported,

> Teague's audience included military and high civic dignitaries, and relatives of the dead, There were floral tributes to the men of the *Arizona*—red roses, anthuriums, orchids. One was inscribed "Beloved Son, Clyde." Another, "Mother and Father." . . . There was no applause after Teague's speech, in respect for the solemnity of the occasion and in deference to the grieving Gold Star Mothers and others who came to honor the 1,176 men who lost their lives on the USS *Arizona*. . . . Many of the women, and some of the men, shed tears as they read the names of the dead, engraved on the marble plaque.[9]

The gathering heard speeches; prayers were said, hymns were sung, and a bugler sounded "taps." A rifle salute by a Marine Honor Guard ended the proceedings. Years later, the *Honolulu Advertiser* would accuse enigmatically and unfairly, "When the Arizona Memorial was officially dedicated . . . it was so new, and unfinished, that the general public wasn't invited."

The joint administration of the memorial by the Navy and the NPS was established on September 9, 1980, their mission to "preserve the cultural and historic integrity of the USS *Arizona* and to provide a framework for visitors to understand the events that unfolded on December 7, 1941." Located on U.S. Naval Station, an 11-acre Visitor Center includes a twin movie theaters and book store; curatorial and work spaces for NPS and *Arizona* Memorial

Museum Association (AMMA) staff, and refreshment and rest areas for visitors. The Remembrance Circle, a waterfront memorial to the servicemen, women, and civilians (other than those who were aboard the USS Arizon)a killed in the Pearl Harbor attack. A museum houses major exhibits, attack memorabilia, and depictions of the battleship "as she was." Part of the funding is provided by the AMMA.

Built on landfill, the Museum and Visitor Center it has been subjected to greater subsidence than was expected, resulting in water leakages and (more significantly) in threats to the building's structural integrity. Moreover, designed to accommodate two thousand visitors each day, by early in the twenty-first century the center was straining under 2½ times that number. As noted, the USS *Arizona* Memorial has over 1.6 million visitors annually. On December 7, 2004, the AMMA, the NPS, and Pearl Harbor survivors established the Pearl Harbor Memorial Fund to raise funds from public and private sources for a replacement center. The Seattle-based Portico Group were architects for the project. Revisions to the design added $20 million to the original estimate of $32 million, and construction was scheduled to start in 2008.

REMEMBER PEARL HARBOR!

The day after the Pearl Harbor attack President Franklin D. Roosevelt made his famous "Day of Infamy" speech to Congress. He said (in part):

> Yesterday, December 7, 1941—a date which will live in infamy—the United States of America was suddenly and deliberately attacked by naval and air forces of the Empire of Japan. . . . It will be recorded that the distance of Hawaii from Japan makes it obvious that the attack was deliberately planned many days or even weeks ago.
>
> During the intervening time the Japanese Government had deliberately sought to deceive the United States by false statements and expressions of hope for continued peace. The attack . . . has caused severe damage to American naval and military forces. Very many American lives have been lost. In addition American ships have been reported torpedoed on the high seas between San Francisco and Honolulu.
>
> Yesterday the Japanese Government also launched an attack against Malaya. Last night Japanese forces attacked Hong Kong. Last night Japanese forces attacked Guam. Last night Japanese forces attacked the Philippine Islands. Last night the Japanese attacked Midway Island. Japan has, therefore, undertaken a surprise offensive extending throughout the Pacific area. The facts of yesterday speak for themselves. The people of the United States have already formed their opinions and well understand the implications to the very life and safety of our Nation. . . .
>
> Hostilities exist. There is no blinking at the fact that our people, our territory and our interests are in grave danger. With confidence in our armed forces—with

the unbounded determination of our people—we will gain the inevitable triumph—so help us God. I ask that the Congress declare that since the unprovoked and dastardly attack by Japan . . . a state of war has existed between the United States and the Japanese Empire.

In a polemic titled "From Pearl Harbor to Hiroshima: the Beginning and the End of World War II," New England academic John Lamperti asks, "Exactly why was Pearl Harbor 'infamous'?" Noting that the Japanese attacked only military targets and that there were relatively few civilian casualties, he argues that in wartime every military commander would like to attack by surprise if possible. He denies that "the bitter facts of U.S. defeat and heavy losses make the raid criminal," concluding, "There is just one reason the operation was 'infamous': because it was an act of aggression." Although hostilities were imminent, Pearl Harbor was a crime because the Japanese struck first.

> Over the years few Americans have disagreed with that judgment. . . . [But in 2002] "pre-emption" [became] an avowed part of U.S. national policy. . . . The National Security Strategy . . . states that "The greater the threat, the greater is the risk of inaction—and the more compelling the case for taking anticipatory action to defend ourselves, even if uncertainty remains as to the time and place of the enemy's attack. To forestall or prevent such hostile acts by our adversaries, the United States will, if necessary, act pre-emptively." In other words, if it is to our advantage we will strike first—begin a war—when we see a potential threat.
> That is just what Japan did in 1941. Clearly the United States posed a huge threat to what Japanese leaders considered her vital national interests. . . . Since war was coming, a high-risk, high-gain surprise attack, intended to disable U.S. naval power in the Pacific, would give Japan the best chance to achieve its goals. In other words, they decided on pre-emption.[10]

That, Lamperti advises, is something to ponder when we remember Pearl Harbor. As the NPS literature points out, The USS *Arizona* Memorial "has different meanings for the millions who visit [it] but to all of them, it speaks silently and eloquently of the distance yet to be traveled before the world lives in peace."

Alfred Preis (1911–1993)

Alfred Preis, the architect of the USS *Arizona* Memorial, was born in Vienna, Austria, in February 1911. After completing his high school education in 1929, he undertook architectural studies until 1936. Being Jewish, and doubtless aware of growing anti-Semitism in the Third Reich, he converted to Roman

Catholicism. In 1938—the year that the Nazis annexed Austria into "Greater Germany"—he worked for the building contractors Redlich and Berger, while executing freelance interior and furniture design commissions and preparing for the state examination in architecture. But in 1939, assisted by the Catholic Refugee Association, he emigrated to the United States. It is not known exactly when he arrived in Hawaii, but from 1939 he worked as an architect and designer in Dahl and Conrad's Honolulu office.

The young man thought that he escaped all wars and come to "the most peaceful place in the world." The Japanese attack on Pearl Harbor changed his mind—at least, temporarily. He was taken to police headquarters almost as soon as the fury of the Japanese raid abated and, because he could speak several languages, he assumed that he was needed as a translator. But the pressure of a bayonet against his back convinced him that he had been arrested as an enemy alien. He was not alone; the former conductor of the Honolulu symphony orchestra was there, and most of the chefs of Hawaii's tourist hotels. The next day, they were taken to the 500-acre Sand Island at the entrance to Honolulu harbor, that had been converted from a quarantine station into an Army Internment Camp. The camp commander told them that they were prisoners of war.

Within a week the island would hold about three-hundred internees: men and women of Japanese descent, as well as Austrian, Finnish, German, Italian, and Norwegian nationals. The accommodation was primitive. Preis later recalled that there were no floorboards in the tents and that the cots had no mattresses; when the prisoners lay on them they sank into the mud "and kept on sinking." The camp was divided into sections, one for Japanese men, one for German, Italian, and other European men, and a third for women of all ethnicities—Preis' new wife, Russian born, was imprisoned there. In total, "about 10,000 people in Hawaii were investigated shortly after the Pearl Harbor attack. Buddhist priests, ministers, Japanese school principals and community leaders were detained."

To keep intellectually active, prisoners—and many were intellectuals—formed "The University of Sand Island." One knew by heart nine of Anton Bruckner's symphonies. There was a violinist from Germany. Some gave talks on city planning and others on anatomy. At night the group studied astronomy. When the camp became too overcrowded some internees were transferred to mainland detention centers, and when others complained that few other Italian Americans or Austrian Americans were being held, they were released, only to be rearrested, sent back to Hawaii and imprisoned again.

The Preises, separated, remained on Sand Island until March 1942. Alfred spent the time "sharing stories with the other internees, teaching them calisthenics and trying to keep everyone in good spirits." According to his son Jan

Peter Preis, "he believed in the good of the country. He understood that he was considered the enemy, and he understood why he was put there." He could see his house from the camp but because the mortgage was not paid for several months, the bank foreclosed on the property.

Upon his release he returned to architecture, although the war had stopped most building activity. In 1942 he designed only war workers' concrete housing for Clarke-Halawa before finding employment in the Honolulu office of Hart Wood, who was then territorial architect. After a year Preis established his own practice, and for the next 20 years produced buildings characterized by "clean lines and spaces opening to the outdoors." His better-known postwar works include the Laupahoehoe Elementary and High School (1951); the prize-winning First United Methodist Church, Honolulu (1955); the University of Hawaii Library (1956); Honolulu Zoo entrance, Kapiolani Park (1960); the International Longshore and Warehouse Union headquarters, and several residences. Four times Preis received the design award of the American Institute of Architects Hawaii Chapter. When in August 1959 he won the commission for the USS *Arizona* Memorial, he was associated with architects Allen R. Johnson and Thomas D. Perkins, whose partnership continued until 1992.

From 1963 until 1967 Preis was the State of Hawaii's planning coordinator under Governor John Burns, and he had an important role in designing Honolulu's Capitol district, with its "great park" concept. In 1965 he founded the Hawaii Alliance for Arts Education and became the first executive director of the State Foundation on Culture and the Arts (SFCA), to "promote, perpetuate, preserve, and encourage culture and the arts" as "central to the quality of life of the people of Hawaii." Two years later, Hawaii became the first state in the nation to pass a law mandating that 1 percent of the construction cost of every new state government building would be used for purchasing public art. Preis "advocated the purchase of sometimes controversial works of art to grace government offices and community spaces," and had visions of a public museum that could exhibit the state's collection. The Hawaii State Art Museum opened in November 2001.

Preis died in March 1993. His monument is not the USS *Arizona* Memorial; neither is it any of his generally ordinary buildings. Rather, it is his lifetime commitment to the arts and arts education. The Alfred Preis Award, established in 1982, "recognizes an individual who has demonstrated in word and action [such a commitment] for Hawaii's children and their families." He once said, "I do believe deeply that the arts [reside] in the truly human area, where each individual is going to do something he or she does because he or she wants to do something well, and does it better and better and better until he or she is gratified; that this is the essence of a successful life. Because you can do that as a cook, you can do that by making beds."

NOTES

1. USS *Arizona* Preservation Project 2004 (NPS). www.pastfoundation.org/ Arizona/MythsandMemorials_3.htm

2. T.S. "*Secret Agent of Japan* [review]," *New York Times* (March 23, 1942).

3. Basinger, Jeanine Jeremy Arnold, *The World War II Combat Film: Anatomy of a Genre*. Middletown, CT: Wesleyan University Press, 2003, 264.

4. Leavy, Patricia, "The Memory-History-Popular Culture Nexus: Pearl Harbor as a Case Study in Consumer-Driven Collective Memory." *Sociological Research Online*, 10(March 2005). www.socresonline.org.uk/10/1/leavy .html, 6.6.

5. Trueman, Chris, "Manchuria." www.historylearningsite.co.uk/manchuria .htm

6. Martinez, Daniel A., USS *Arizona*." www.library.arizona.edu/exhibits/us-sarizona/nps_survey/az_hist.htm

7. Linenthal, Edward Tabor, *Sacred Ground: Americans and Their Battlefields*. Urbana, IL: University of Illinois Press, 1993, 181.

8. Martinez, Daniel A., *Significance: Memorials, Myths and Symbols*. www .nps.gov/archive/usar/scrs/scrs6b.htm

9. Turner, Charles, Attendants at *Arizona* Rites Hear of U.S. Might." http:// mediaclips.uss-buchanan-ddg14.org/Hawaii.htm

10. Lamperti, John, Remember Pearl Harbor!" www.math.dartmouth.edu/~ lamperti/PearlHarbor.htm

FURTHER READING

Agawa, Hiroyuki. *The Reluctant Admiral: Yamamoto and the Imperial Navy*. Tokyo: Kodansha International; New York: Harper & Row, 1979.

Cohen, Stan, and Mary Beth Percival. *East Wind Rain: A Pictorial History of the Pearl Harbor Attack*. Missoula, MT: Pictorial Histories Publishing, 1981.

Delgado, James P. USS Arizona *Wreck (Honolulu County, Hawaii) National Register of Historic Places Registration Form*. Washington, D.C.: U.S. Department of the Interior, National Park Service, 1988.

Friedman, Norman, Arthur D. Baker III, Arnold S. Lott and Robert F. Sumrall. *USS Arizona: Ship's Data, a Photographic History*. Honolulu, HI: Fleet Reserve Association, 1978.

Fuchida, Mitsuo. *From Pearl Harbor to Calvary*. Denver, CO: Sky Pilots Press, 1959. Originally published as *From Pearl Harbor to Golgotha*, 1953.

Hoyt, Edwin P. *Pearl Harbor Attack*. New York: Sterling, 2008. Originally published as *Pearl Harbor*, 2001.

Jasper, Joy Waldron, James P. Delgado and Jim Adams. *The USS Arizona: The Ship, the Men, the Pearl Harbor Attack, and the Symbol That Aroused America*. New York: St. Martin's Press, 2001.

Prange, Gordon William. *At Dawn We Slept: The Untold Story of Pearl Harbor*. New York: Penguin, 2001. Originally published 1981.

Prange, Gordon William (with Donald M. Goldstein and Katherine V. Dillon). *God's Samurai: Lead Pilot at Pearl Harbor*. Washington, D.C.: Brassey's, 2004.

Preis, Alfred. "Hawaii and Her Architects." *American Institute of Architects Journal*, 16(December 1951), 249–252.

Richardson, Kent D. *Reflections of Pearl Harbor: An Oral History of December 7, 1941*. Westport, CT: Praeger, 2005.

Rosenberg, Emily S. *A Date Which Will Live: Pearl Harbor in American Memory*. Durham, NC: Duke University Press, 2003.

Sakamaki, Kazuo. *I Attacked Pearl Harbor*. New York: Association Press, 1949.

Seiden, Allan. *Pearl Harbor: Images of a National Memorial*. Honolulu, HI: Mutual, 2005.

Slackman, Michael. *Remembering Pearl Harbor: The Story of the USS* Arizona *Memorial*. Honolulu, HI: *Arizona* Memorial Museum Association, 1984.

Slackman, Michael. *Target—Pearl Harbor*. Honolulu: University of Hawaii Press; *Arizona* Memorial Museum Association, 1990.

Smith, Carl. *Pearl Harbor 1941: The Day of Infamy*. Westport, CT: Praeger, 2004. Originally published Oxford, UK: Osprey, 1999.

Victor, George. *The Pearl Harbor Myth: Rethinking the Unthinkable*. Washington, D.C.: Potomac, 2007.

Wisniewski, Richard A. *Pearl Harbor and the USS* Arizona *Memorial: A Pictorial History*. Honolulu, HI: Pacific Basin Enterprises, 1986.

INTERNET SOURCES

Arizona Memorial Museum Association. http://arizonamemorial.org

Leavy, Patricia. "The Memory-History-Popular Culture Nexus: Pearl Harbor as a Case Study in Consumer-Driven Collective Memory." *Sociological Research Online*. www.socresonline.org.uk/10/1/leavy.html

Pearl Harbor Memorial Fund. www.pearlharbormemorial.com

USS *Arizona* Memorial (NPS). www.nps.gov/usar

USS *Arizona* Preservation Project 2004 (NPS). www.pastfoundation.org/Arizona/

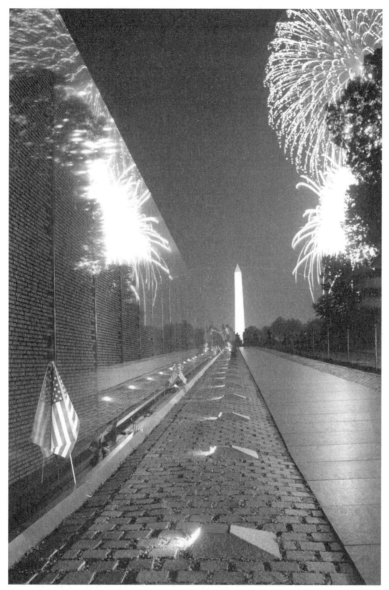

Courtesy Associated Press

Vietnam Veterans Memorial, Washington, D.C.

"Happy birthday, Grandpa."

Of the inspiration for his 2006 book *Letters on The Wall*, Michael Sofarelli recalls, "In 1996, I went back to visit The Wall. It was not planned, just a spur of the moment walk through D.C. one evening."

> As I walked through the memorial, a strange feeling of tranquility came over me. The sun was fading and it was getting dark. There were only two other people there that night. They were at the opposite end of The Wall from where I was standing. I could see them only from a distance. I stopped and watched what appeared to be a father and his young son. They were pointing at a name. The man touched it. The little boy then put something on the ground. I watched as they walked away. As quickly as I had noticed them, they were gone.
>
> I walked over to see what they had left. . . . As I slowly approached where they had been, I noticed a piece of paper at the base of The Wall. I knelt down to see what it was. On a small piece of paper was the writing of a child. In red crayon, it simply read "Happy Birthday Grandpa."
>
> I was twenty-two years old then. The same age as many of the soldiers whose names appear on The Wall. The same age as my father when he enlisted. . . . There I stood, alone in front of The Wall that had once evoked so many unanswered questions. And now, all the questions had returned. "Who was that person?" "Why is his name there?" "Why did that name make that man cry when he touched it?"
>
> I walked closer to The Wall, closer than ever before. And for the very first time, I touched The Wall. I touched a name. A name I did not know. For the very first time, I cried at The Wall.[1]

There is no need to expound why the National Vietnam Veterans Memorial is an icon of American architecture. It was listed on the National Register of Historic Places the day that it was dedicated. It received the American Institute of Architects (AIA) Honor Award in 1984, the Presidential Design Award in 1988, and the AIA Twenty-Five Year Award in 2007.

The precinct now includes four elements: the Memorial Wall (dedicated in 1982) designed by Maya Ying Lin with architects of record Cooper-Lecky Partnership and landscape architects Arnold Associates; Frederick Hart's "Three Fighting Men" statue in a plaza designed by EDAW, with a 60-foot flagpole designed by Cooper-Lecky (all dedicated in 1984); the Women's Vietnam Memorial sculpture by Glenda Goodacre, set in a plaza designed by George Dickie (dedicated in 1993); and the In Memory Plaque, a granite tablet dedicated in 2004 to those who died later as a result of what happened to them in Vietnam. There are more than 4.5 million visitors every year.

As Kurt Andersen commented in *Time Magazine*, it is the Wall above all

> that vets approach as if it were a force field. It is at the wall that families of the dead cry and leave flowers and mementos and messages. . . . [Near it], a young Boston father tells his rambunctious son, "Hush, Timmy—this is like a church." The visitors' processionals do seem to have a ritual, even liturgical quality. Going slowly down toward the vertex, looking at the names, they chat less and

less, then fall silent where the names of the first men killed (July 1959) and the last (May 1975) appear. The talk begins again, softly, as they follow the path up out of the little valley of the shadow of death.[2]

A DIFFERENT KIND OF WAR

The Vietnam War—also known as the Second Indochina War, and in Vietnam as the American War (or the "War against the Americans to Save the Nation")—was a protracted conflict in which the South Vietnamese government and the United States fought North Vietnam's communist government and its southern collaborators. Vietnam now puts its war dead at two million civilians and 1.1 million North Vietnamese and Viet Cong soldiers. Almost fifty-nine thousand American and an estimated two hundred thousand to two hundred fifty thousand South Vietnamese servicemen died; among the South's allies, over four thousand South Koreans, 520 Australians, 350 Thais, and 35 New Zealanders were lost. The following somewhat simplistic overview is adapted largely from Robert K. Brigham, professor of history and international relations, Vassar College. Of course, other interpretations of the historical data have been widely and passionately debated for five decades.

In the 1940s and 1950s Vietnamese communist Nationalists struggled against colonial rule, first of Japan and later France. The 8-year French Indochina War, in which France was largely funded and supplied by the United States, ended in July 1954 at the Battle of Dien Bien Phu, with the defeat of the colonial powers. They were forced to leave Indochina. In summer the Geneva Peace Accords were signed, in which Vietnam's delegates agreed to the temporary partition of the country at the seventeenth parallel. So soon after the Korean War, neither Russia nor China wanted another confrontation with the West; they feared that a "provocative peace" would anger the United States and its allies. Although the South Vietnamese government wanted the country to be aligned with the West, North Vietnam (Democratic Republic of Vietnam, DRV) was fixed upon a single regime modeled on the U.S.S.R. and the People's Republic of China.

Believing the Geneva Accords gave the Communists too much power, U.S. Secretary of State John Foster Dulles and President Eisenhower—through multilateral agreements that established the Southeast Asia Treaty Organization (SEATO)—supported the creation of a counterrevolutionary alternative. With massive American aid, South Vietnam was born in 1955. The following year the staunchly anti-Communist (albeit corrupt) Ngo Dinh Diem was elected president in a questionable election. Grave problems lay beneath the regime's apparent success: Diem was an ineffective manager, unwilling to delegate authority because of his distrust of anyone from outside his family. His brother Ngo Dinh Nhu directed an "extensive system of extortion, payoffs, and influence peddling."

Almost immediately, Diem claimed that South Vietnam was under attack from communists in the north. In late 1957, arguing that North Vietnam wanted to take his territory by force, he enlisted American military aid to launch a counteroffensive. The CIA helped identify threats to his government, and he arrested thousands under laws allowing him to detain suspected communists without formally laying charges. There was an immediate reaction to his oppressive policies from Buddhist monks and nuns, students, intellectuals, businesspeople, and peasants. But the more trouble they made, the more he accused the communists of trying to overrun South Vietnam.

As the White House vacillated over its Vietnam policy, the northern communists changed their strategy. Having failed to reunify the country and overthrow Diem solely by exerting political pressure, and provoked by his draconian action against their southern comrades, in January 1959 the Party approved turning to violence to liberate south Vietnam. In May and again in September 1960, it confirmed its "use of revolutionary violence and the combination of the political and armed struggle movements." In December 1960 the Party's National Liberation Front (NLF), was created. Anyone who opposed Diem and wanted to unify Vietnam could join. From the NLF's inception, U.S. government officials claimed that the communists in Hanoi directed its violent response to the Saigon regime. Washington officially denounced the NLF as a puppet of Hanoi and accused its noncommunist elements of being communist dupes. Although the NLF insisted that it was autonomous and independent of Hanoi—indeed, that most of its membership was *not* communists—Washington continued to brand it the "Viet Cong," a pejorative term meaning Vietnamese communist.

In December 1961 President John F. Kennedy received a report from some of his staff recommending that he provide greater economic and military aid for South Vietnam (including sending helicopters, armored transports, "advisers" and technical experts, as well as a limited number of combat troops). Others in the White House urged him to withdraw from Vietnam. He took a middle path, choosing to escalate military involvement but without extra troops. The number of U.S. military personnel in Vietnam grew from fewer than eight hundred in the 1950s to about nine thousand by mid-1962. When intelligence from Vietnam told of more NLF victories, Washington and Saigon launched the counterinsurgency Strategic Hamlet Program in the rural Vietnam, rounding up and interning villagers—the NLF's support base. That served to further estrange the rural population from the Saigon regime.

That regime was tottering by summer 1963. Some in the Kennedy administration believed that Diem could not be a "viable leader in the nation-building experiment"; others thought him the best of a bad lot. On the pretext that they had given asylum to the communists responsible for political instability in the South, Ngo Dinh Nhu raided Buddhist monasteries, creating unrest in Saigon. By late September the Buddhist protest, reaching a climax with the self-immolation of several monks and nuns, had caused such an international

furor that the Kennedy administration chose to turn a blind eye to a coup by Diem's own generals. On November 1 Ngo Dinh Diem and Ngo Dinh Nhu were captured and later killed. Just 3 weeks later, Kennedy was assassinated.

There were then sixteen thousand U.S. military advisers in Vietnam. Washington had managed to run the war without large numbers of American combatants. Saigon's continuing political problems convinced incoming President Lyndon Baines Johnson, who had inherited "a legacy of indecision, half-measures, and gradually increasing involvement," to take direct aggressive action. In August 1964, provoked by a North Vietnamese attack on a U.S. ship in the Gulf of Tonkin, Johnson called for expansive war powers. Into the winter the White House considered its strategy. The Joint Chiefs of Staff wanted to expand the air war over North Vietnam quickly, while the Pentagon civilian planners preferred to "apply gradual pressure to the Communist Party with limited and selective bombings."

In early 1965, after the NLF attacked two U.S. army installations in South Vietnam, Johnson ordered the prolonged bombing missions over the North. In March he sent the first combat troops to Vietnam, and by 1969 over a half million U.S. military personnel were stationed there. The communists responded by launching their protracted war tactic, confident of its success because America would tire of the war and seek to negotiate a settlement. They knew that a large part of the country's population had an "ideological commitment to victory."

Washington believed that it could fight a "limited war" without affecting America's domestic culture. On the contrary. As the conflict drew on, there were not enough volunteers to fight, and the U.S. government introduced a draft. As casualties grew, so did antiwar feelings; protests spread from college campuses and through larger cities. By 1967 many Americans were becoming increasingly dissatisfied with the war. Some, especially students, academics, clergymen, and intellectuals criticized America's involvement on ethical grounds, citing that most of the victims on both sides were civilians and that the U.S. was supporting a corrupt dictatorship in Saigon; others opposed the war because of the increasing American casualties in a conflict which America showed no sign of winning. By the summer 1967 fewer than half of polled citizens supported the Johnson administration's conduct of the war. In October 1967 around thirty-five thousand demonstrators attended a protest outside the Pentagon.

At the beginning of 1968 communist forces attacked the major cities in South Vietnam. These assaults—known as the Tet Offensive—were intended to force America to the bargaining table. At the end of March Johnson announced that he was halting the bombing of North Vietnam and that the United States was "prepared to send representatives to any forum to seek a negotiated end to the war." He did not intend to seek reelection. Over the next 8 weeks thirty-seven hundred Americans were killed and eighteen thousand were wounded in the fiercest fighting of the war. Discussions with Hanoi, albeit fruitless, began in Paris on May 13.

The incoming president, Republican Richard Nixon, claimed he had a "secret plan." He continued a process called "Vietnamization"—handing control of the war to South Vietnam and withdrawing U.S. troops while America intensified bombing in the North. Bombing campaigns intended to destroy communist safe havens and supply routes were extended into neighboring Laos and Cambodia. In 2002, when the National Archives released hundreds of tapes of Nixon's conversations his other ideas would come to light. *USA Today* reported,

> "I'd rather use the nuclear bomb," Nixon told Kissinger, his national security adviser, a few weeks before he ordered a major escalation of the Vietnam War. "That, I think, would just be too much," Kissinger replied softly . . . Nixon responded matter-of-factly, "The nuclear bomb. Does that bother you?" Then he closed the subject by telling Kissinger: "I just want you to think big." He also said, "I don't give a damn" about civilians killed by U.S. bombing.[3]

In June 1969 Nixon started to withdraw the first twenty-five thousand troops from Vietnam. Three months later he announced more withdrawals, and within 9 months plans were made public for the phased return to the United States of one hundred fifty thousand over the next year. The decisions were enormously popular, and the White House soon found them "politically indispensable."

It has been remarked that the withdrawals from Vietnam around 1970 demoralized servicemen by implying that what their comrades were dying for was pointless. The dejection showed itself in drug abuse, racism in the ranks, and even "the murder or deliberate maiming of . . . officers by their own troops." The public exposure of atrocities such as the infamous 1986 My Lai massacre also cast deep shadows over the morality of America's presence in Vietnam. In the 8 year period before 1973 over thirty thousand military personnel were dishonorably discharged for desertion; another ten thousand deserters remained at large. Over the same period about half a million young Americans evaded conscription. Draft calls were ended in 1972, and a year later the draft was abolished altogether.

Nixon's use of mass bombing to provide cover for a retreat angered the American public. In the week bracketing Christmas 1972, "in the approximately 4,000 sorties [some sources give 3,000] flown [over North Vietnam] in . . . Operation Linebacker II, [bombers] concentrated on the major cities of Hanoi and Haiphong. The missions executed so-called area bombing, never precise or pinpoint. Their goal: To kill as many civilians as possible."[4] The action drew immediate international condemnation.

Meanwhile the Communist Party had continued to press its claims at the negotiating table and by fall 1972, Kissinger and DRV representatives Xuan Thuy and Le Duc Tho had worked out a preliminary peace draft. But South Vietnamese leaders rejected the document. However, within 11 days of the "shock and awe" bombing, the U.S. and North Vietnam resumed the delayed

negotiations, and within a week a cease-fire agreement under international supervision was forged in terms acceptable to the United States. North Vietnam was allowed to retain control over large areas of the south. The United States had enough time to withdraw its troops and obtain the release of American POWs. The White House convinced the Saigon regime to ratify the peace accord, and Nixon announced the suspension of offensive action against DRV on January 15, 1973. The Paris Peace Accords "ending the war and restoring Peace in Vietnam" were signed 12 days later, officially terminating direct U.S. involvement.

However, the agreement did not stop hostilities. From March 1973 until the fall of Saigon on April 30, 1975, the Army of the Republic of Vietnam fought on, desperately trying to save the South from political and military collapse. On that spring morning North Korean tanks rumbled along National Highway One into the capital and into the courtyard of the presidential palace. The Second Indochina war had ended. Vietnam was in the hands of the Communists, and 2 years late Saigon became Ho Chi Minh City.

"GOD HELP ME, I WAS ONLY NINETEEN."

In 1983 John Schumann of the Australian rock group Redgum wrote a song, "I Was Only Nineteen," about serving in Vietnam. Equally relevant for Americans and Australians, the lyric speaks of the horrendous experiences, and the aftermath, of so many draftees—hardly more than boys. Many were "only nineteen," but in fact the average age of the 2.59 million Americans who served in Vietnam was 22. At any time between 1965 and 1969 there were half a million of them in the country. A third of front-line combatants were conscripts, not professional soldiers, and they represented a broad socioeconomic cross-section. Of those who died, 86 percent were Caucasian, 12½ percent were black, and the remainder were of other ethnicities; their average age was a little over 23. They were trained in conventional warfare, unsuited to the conflict. The Viet Cong, on the other hand, were guerrillas—not wearing uniforms; attacking and then moving away; often indistinguishable from ordinary villagers—and the Americans found it difficult to identify their enemy or to know whom they could trust among the South Vietnamese population. And the undefined battleground was scattered with land mines and other booby traps.

Whether in the Marines or the Army, an infantryman in Vietnam bore the epithet "grunt," reflecting his lowly status in the scheme of things. One dictionary defines it as an "affectionate name for 'ground pounders'—'ground replacement usually not trained.'" After a 12-month tour of duty—usually including 240 days of combat—most grunts were rotated back to the United States, either to complete their commitment to national service or to make the difficult readjustment to civilian life. Whatever their path, they received a

mixed welcome, or none at all. Perhaps because they arrived in small groups or even singly, they were not greeted with parades; but, contrary to widespread belief, neither were most World War II and Korean veterans. Most servicemen returning from Vietnam encountered indifference, but there were also occasional expressions of appreciation for their service—and hostility. Of course, American society had radically changed during the nation's involvement in Vietnam—in a considerable measure, *because* of it—and

> some of the young people coming home from Vietnam could not relate to their civilian peers, although others embraced aspects of the counterculture, including its fashions, music, and drugs. For wounded and disabled veterans, the homecoming was even more difficult. Veterans' hospitals did not always provide adequate treatment. Returnees were well aware that Americans were divided over the war, with growing numbers opposing it.[5]

A common, inaccurate stereotype of the Vietnam veteran has been a drug-addicted, psychologically disturbed latent killer, "permanently damaged by [his] experiences in war and further scarred by [an unhappy homecoming]." However, surveys show that only 15 percent of veterans were unable to make a successful transition to civilian life. Many continued to suffer physically and psychologically after the war; about a third, men and women, experienced some form of post-traumatic stress disorder—known as "shell shock" or "battle fatigue" in earlier conflicts. Of about nine million men and women who were in uniform between 1965 and 1975, 1.3 million are thought to have seen combat. Nearly three hundred thousand were wounded; seventy five thousand were significantly disabled by their wounds. But there is no statistic of those who returned with psychological scars, or with lethal poisons in their systems.

The dedication of the Vietnam Veterans Memorial Wall in 1982 was long awaited. Charles L. Grimold remarks that the patriotism expressed on that occasion "was informed by the healthy willingness to question the decisions of the politicians of the day about where and when Americans should die for their country." He reflects that if the monument "momentarily separates war and politics, it is in order to give us a more secure foundation for understanding both." He also notes that those who spoke at the dedication made their sentiments clear: "America is worth dying for, but she must not fight a war when there is no popular consensus for doing so, and she must not fight without the intention to win decisively. Correspondingly, she must not fight under conditions where it is impossible to win."[6]

THE VISION OF JAN SCRUGGS

The Vietnam Veterans Memorial Fund (VVMF) makes it clear that the Memorial was "initially conceived to bring long overdue honor and recognition

to the men and women who served and sacrificed their lives in Vietnam. . . . Because so many veterans met with ridicule and contempt upon returning home, it was hoped that the memorial would be a place where that injustice could at long last be rectified."

The memorial was the vision of a 31-year-old veteran, Jan Craig Scruggs, who had gone to Vietnam in 1969, straight after graduating from high school in Bowie, Maryland. During a one-year tour of duty as a corporal in the 199th Light Infantry Brigade, he was injured—he had nine shrapnel wounds in his back—and decorated for bravery. On returning home he resumed his studies and eventually earned a bachelor's and a master's degree from the American University in Washington, D.C., and a law degree from the University of Maryland. In his own words,

> The idea that led to the creation of the . . . Memorial began to develop in my mind while I was studying psychology in graduate school. America needed a memorial to the men and women lost in Vietnam in a war that many Americans preferred to forget. . . . But in 1977 this was just the dream of one Vietnam vet—a college student with no money or political connections. In 1979, after I saw the movie *The Deer Hunter*, the dream became an obsession. No one remembered the names of the people killed in the war. I wanted a memorial engraved with all the names. The nation would see the names and would remember the men and women who went to Vietnam, and who died there.[7]

Director Michael Cimino's movie that so affected Scruggs has been summarized as a powerful, disturbing and compelling look at the Vietnam War through the lives of three blue-collar, Russian American friends in a small steel-mill town before, during, and after their service. It won five of the nine Academy Awards for which it was nominated in 1978. Scruggs envisioned a memorial that would serve to heal "the [wound] inflicted on the national psyche by the war. By identifying the issues of individuals serving in the military during the Vietnam era and U.S. policy carried out in Vietnam as quite separate, it would begin a process of national reconciliation."

Early in 1979 Scruggs, then employed by the Department of Labor as a civil-rights investigator, shared his ideas at a meeting of veterans; it held little appeal for them. But in late April, with former Air Force officer Robert Doubek, he initiated the nonprofit VVMF and launched it with $2,800 of his own money. Most members of the group of Washington-based veterans were lawyers and other professionals; none had any background in the arts and were less interested in producing a "good or bad work of art than simply an appropriate memorial." On May 28 he announced their plans at a press conference. Fund-raising started slowly; at first the VVMF received touching letters with small donations but by July 4 on the *CBS Evening News* reported that only $144.50 had been collected.

In the fall, the VVMF adopted a design philosophy suggested by one of its directors, John Wheeler. It called for a landscaped garden, of a "reflective and

contemplative nature" that would harmonize with its surroundings. Scruggs appeared before a Congressional committee seeking a site in Washington, D.C. In January 1980 the VVMF engaged the Virginia landscape architects and planners EDAW, Inc. to evaluate fourteen potential alternatives. It is not surprising that the consultants recommended Constitution Gardens in the northwest corner of the National Mall, "since the Fund already had its mind set on this location." Republican Senator Charles McC. Mathias, Jr. introduced legislation to authorize three acres in the area, the Senate promptly passed the bill, and President Jimmy Carter signed it into law on July 1.

The first significant contributions to the national fund-raising campaign—a $5,000 personal donation and help in raising another $50,000—were made by another Republican senator, John W. Warner, who was then married to actress Elizabeth Taylor. Warner recalls that he was impressed by Scruggs' "extraordinary humility" and was immediately compelled to work with him. One of the Senator's first fund-raising events was a breakfast in his Georgetown house; as he was putting the VVMF's case to potential contributors his wife unexpectedly entered the room and as the attendees were preparing to leave, she asked, "How much are you fellows putting in?" Eventually, $8.4 million was raised, all from private sources—not only civic institutions, charitable foundations, corporations, trade unions, and veterans groups—but over two hundred seventy-five thousand individual Americans, who donated most of the money.

In July 1980 the VVMF engaged the Washington-based architect Paul Spreiregen as professional architectural adviser for a nationwide design competition. He later wrote, "I had no illusions about the likelihood of achieving anything. At the time the American public wanted to forget Vietnam." His plan of approach comprised four main phases, to take place over 11 months. Planning and preparation was scheduled from July through September 1980; the second, through December, involved announcing a design competition and clarifying requirements for potential entrants. The third phase, ending in March 1981, was allowed for the competitors to complete their proposals. The fourth entailed "receiving the designs, displaying them, [selecting] a winning design . . . , and announcing the result." It was to conclude in May 1981.

Spreiregen recommended a jury of eight internationally recognized American artists and designers to judge the entries: architects Pietro Belluschi and Harry Weese; sculptors James Rosati, Costantino Nivola, and Richard H. Hunt; landscape architects Hideo Sasaki and Garrett Eckbo; with the environmental design journalist Grady Clay as chairman. Spreiregen said that he wanted "senior gray eminences on the jury—people of broad and deep knowledge of design." Later, the fact that none was a Vietnam veteran became a bone of contention that was to be noisily gnawed by opponents of the scheme. And without consulting Spreiregen, the VVMF unsuccessfully attempted to

add a "general humanist" to the jury, inviting (among others) Alistair Cooke, Eric Sevareid, and Walter Cronkite.

In October, with the support of the National Endowment for the Arts and the American Institute of Architects (and a gift of $160,000 from billionaire H. Ross Perot), the VVMF announced the competition, open to any U.S. citizen older than 17 years and carrying a $20,000 prize. There were four major design criteria, the first two expressing the VVMF's broad policy: the memorial should be "reflective and contemplative in character" and it should harmonize with its surroundings, especially the neighboring national memorials. The other two: it should display the names of all who died or were still missing; and it should make no political statement about the Vietnam War. By year's end there were 2,573 registrants in the competition—the largest of its kind ever held in America. By the March 31, 1981, the deadline for submissions, 1,421 entries were in hand, their authorship identified by only a number. Very few well known architects entered, and it has been suggested that the reason was "because of the long-standing modernist antipathy towards monument building and the limited chance of winning."

The VVMF arranged to use a hangar at Andrews Air Force Base to display the submissions—over 2,300 yards of them that "required three and a half hours simply to see, walking by slowly." Judging began on Monday April 27, 1981, and took 5 days to complete. Architecture critic Wolf von Eckardt described some of the entries

> They illustrate our time's bewildering embrace of almost anything: from architectural stunts to sculptural theatrics, from the pompous to the ludicrous, from the innovative to the reactionary. The rejected entries include such kitsch as a house-high steel helmet and a number of handsomely styled columns, pylons, tablets and structures that belong at a world's fair or amusement park. Other designs accommodate the thousands of names on various layouts of slabs, blocks and other geometric stones and look depressingly like constructivist graveyards.[8]

The first cull produced 232 "could-be's"; by noon Wednesday just ninety had been short-listed, and that number was reduced to thirty-nine by the following morning. That afternoon the winning design was selected. Spreiregen asserted that the jury's deliberative process was the most thoughtful and thorough discussion of design that he had ever heard. At noon on Friday he and Clay presented about thirty members of the VVMF with an outline of remarks by the jury members. He recalled that after a brief silence "Jan Scruggs rose, came forward, gestured towards us and proclaimed, 'I like it!' Immediately, everyone from the VVMF jumped to their feet in a joyous expression of acceptance, hugging each other in congratulation." Chosen unanimously, the winner was entry number 1,026 by Maya Ying Lin, a 21-year-old Yale undergraduate.

THE WALL

Each of the two wings of the memorial, known as The Wall, is a little under 247 feet long and comprises seventy-two separate panels of black granite from Bangalore, India, highly polished "to form a surface that reflects the sky and the ground and those who stand before it" and inscribed with the names of the lost and fallen on the Vietnam War. The wings meet at an angle of 125 degrees; at that apex they are just over 10 feet high. They point to the north-east corners of the Washington Monument and Lincoln Memorial respectively. The tallest panels have 137 lines of names; the shortest, at the ends of the wings, are blank. There is an average of five names per line, inscribed in upper-case letters a little over a half inch high in Optima typeface; a symbol associated with each name indicates whether the person's death was confirmed, or he or she was missing at the end of the war.

The inscription on Panel 1 East reads, "In honor of the men and women of the Armed Forces of the United States who served in the Vietnam War. The names of those who gave their lives and of those who remain missing are inscribed in the order they were taken from us." The inscription on Panel 1 West reads, "Our nation honors the courage, sacrifice, and devotion to duty and country of its Vietnam veterans. This memorial was built with private contributions from the American people. November 11, 1982." Those are the cold, hard facts about the Vietnam Veterans Memorial.

But of course there is much more . . .

Lin later wrote of her experimentation with the design, originally presented for a senior-year seminar on funerary architecture, "We had been questioning what a war memorial is, its purpose, its responsibility. I felt a memorial should be honest about the reality of war and be for the people who gave their lives." She continued:

> I didn't want a static object that people would just look at, but something they could relate to as on a journey, or passage, that would bring each to his own conclusions. . . . I had an impulse to cut open the earth . . . an initial violence that in time would heal. . . . It was as if the black-brown earth were polished and made into an interface between the sunny world and the quiet dark world beyond, that we can't enter. . . . The names would become the memorial. There was no need to embellish.[9]

It is remarked in the PBS *Art in the Twenty-First Century* program that the memorial "proposes neither winners nor losers, but only the of the dead inscribed in a polished, black granite":

> A corner submerged into the earth, the work is welcoming in its open-ended, book-like form, and yet disconcerting to those who realize that to read the names is to stand below the horizon—six feet under—conversing in the space of the dead. The work is outspoken and angry in the way in which it functions as

a visual scar on the American landscape . . . and yet is dignified for the way in which it carves out a space for a public display of grief and pain. . . . [It] makes no grand statements about politics or American ideals. Its sole proposition is that the cost of war is human life.[10]

Lin lucidly explained her concept in a hand-lettered single page rationale that accompanied her abstract pastel renderings of The Wall. Although it is long, it is appropriately cited in full text here:

Walking through this park-like area, the memorial appears as a rift in the earth, a long, polished, black stone wall, emerging from and receding into the earth. Approaching the memorial, the ground slopes gently downward and the low walls emerging on either side, growing out of the earth, extend and converge at a point below and ahead. Walking into this grassy site [paving was added later] contained by the walls of the memorial we can barely make out the carved [names that] convey the sense of overwhelming numbers, while unifying these individuals into a whole.

The memorial is composed not as an unchanging monument, but as a moving composition to be understood as we move into and out of it. The passage itself is gradual; the descent to the origin slow, but it is at the origin that the memorial is to be fully understood. At the intersection of these walls, on the right side, is carved the date of the first death. It is followed by the names of those who died in the war, in chronological order. These names continue on this wall appearing to recede into the earth at the wall's end. The names resume on the left wall as the wall emerges from the earth, continuing back to the origin where the date of the last death is carved at the bottom of this wall. Thus the war's beginning and end meet; the war is 'complete,' coming full-circle, yet broken by the earth that bounds the angle's open side, and continued within the earth itself. As we turn to leave, we see these walls stretching into the distance, directing us to the Washington Monument, to the left, and the Lincoln Memorial, to the right, thus bringing the Vietnam Memorial into an historical context. We the living are brought to a concrete realization of these deaths.

Brought to a sharp awareness of such a loss, it is up to each individual to resolve or come to terms with this loss. For death is in the end a personal and private matter, and the area contained with this memorial is a quiet place, meant for personal reflection and private reckoning. The black granite walls, each two hundred feet long, and ten feet below ground at their lowest point (gradually ascending toward ground level) effectively act as a sound barrier, yet are of such a height and length so as not to appear threatening or enclosing. The actual area is wide and shallow, allowing for a sense of privacy, and the sunlight from the memorial's southern exposure along with the grassy park surrounding and within its walls, contribute to the serenity of the area. Thus this memorial is for those who have died, and for us to remember them.

The memorial's origin is located approximately at the center of the site; its legs each extending two hundred feet towards the Washington Monument and the Lincoln Memorial. The walls, contained on one side by the earth, are ten feet below ground at their point of origin, gradually lessening in height, until

they finally recede totally into the earth, at their ends. The walls are to be made of a hard, polished black granite, with the names to be carved in a simple Trojan letter. The memorial's construction involves recontouring the area within the wall's boundaries, so as to provide for an easily accessible descent, but as much of the site as possible should be left untouched. The area should remain as a park, for all to enjoy.[11]

ORTHODOXY AND OPPOSITION

Philip Kennicott recently wrote in the *Washington Post* of Maya Lin's "good fight, arguing for a less-is-more monument design, proving herself, fresh out of college, a formidable force against the crass manipulations and demagoguery that so often attend the design and use of public space in the Federal City." He recalled how she "endured a lot of shabby treatment . . . from people who wanted to scuttle her design because it lacked bombast." Others could not—or would not—accept "the ideas and vision of a woman, an Asian American, a young person, a Washington outsider."[12]

Despite the VVMF's enthusiasm—indeed, that of most veterans—for Lin's apolitical, abstract proposal, a few were not convinced. Then, why should there have been agreement about anything concerning a war that so sharply divided a nation? Almost as soon as the winning design was announced, it was vehemently resisted by a small but vocal group of influential veterans in Washington, who denounced it for its color, its below-ground placement, and its repudiation of conventional "heroic" quality. Among the loudest voices was attorney Tom Carhart's, who had formerly served on the VVMF board (and, incidentally, who had been unsuccessful in the design competition); he described Lin's Wall as a negative symbol, accusing it of "pointedly insulting to the sacrifices made for their country by all Vietnam veterans . . . by this we will be remembered: a black gash of shame and sorrow, hacked into the national visage that is the mall."

The dissenters were liberally financed by billionaire H. Ross Perot (who, despite his earlier generosity to VVMF, condemned the design). Attacks also came from conservative politicians, notably James Webb, secretary of the Navy, who dubbed The Wall "a nihilistic slab of stone." He demanded in a *Wall Street Journal* article, "At what point does a piece of architecture cease being a memorial to service and instead become a mockery of that service, a wailing wall for future anti-draft and anti-nuclear demonstrators?" James Watt, secretary of the Interior, added his opposition, significant because his jurisdiction extended to the National Mall, giving him virtual veto power over the project. Representative Henry Hyde also lobbied the president and fellow congressmen about "a political statement of shame and dishonor." He later "marshalled" Watt to issue an ultimatum: "Lin's wall must be redesigned to include the suggested changes, or it will never be built."

Others took occasion to reject the design. Milton R. Copulos of the Heritage Foundation complained, "It [is] just names on the wall. There [is] no mention of what they had done, no flag, none of the things you would associate with a memorial. It was just two long black walls"—a conservative position if ever there was one. Journalists and commentators joined in the denigration: the *National Review* called The Wall "Orwellian glop"—whatever that meant. Other detractors included the *Chicago Tribune* 's Pulitzer prize-winning architecture critic Paul Gapp and the "media personality-turned-presidential-candidate" Pat Buchanan, who even asserted that competition jury member Garrett Eckbo was a communist (he wasn't). There were also personal and racist attacks on Maya Lin. Hugh Sidey, responding in *Time* magazine, defended Scruggs' determination,

> Lovely irony. Like life. An infantry corporal with nine pieces of shrapnel in his back carried on the fight for three years, pressing, retreating, always recovering and trudging wearily ahead, overcoming protesting generals (Air Force Ace Robinson Risner) and multimillionaires (Ross Perot) and politicians (Congressman Phil Crane) and pundits (Columnist Pat Buchanan) and bureaucrats (Secretary of the Interior James Watt). Stupidity, narrow-mindedness and indifference were even greater enemies, just as Jan Scruggs found they were in Viet Nam.[13]

COMPROMISE

Kristin Ann Hass analyzes the objections in her 1998 book *Carried to the Wall: American Memory and the Vietnam Veterans Memorial*: "the V shape hinted at the peace sign, or a reference to the Vietcong; the black stone was more mournful than heroic. It seemed to many too clear an admission of defeat." Moreover, the nay-sayers believed Lin's design to be "too abstract, too intellectual, too reflective. It was, to the minds of many, high art, the art of the class that lost the least in the war. It was not celebratory, heroic, or manly." They wanted a white marble memorial with a conventional sculpture and a flag.

On March 11, 1982, the Commission of Fine Arts (CFA) and the National Capital Planning Commission approved the design. But Watt blocked the project because of the controversy. Consequently, Senator Warner set up a meeting between VVMF representatives and their politically influential antagonists. At the packed meeting the VVMF was outnumbered five to one. But it had its champions. J. Carter Brown, CFA chairman and director of the National Gallery of Art, said that adding a flag "would be like interrupting the national anthem with some country-western song." Retired Brigadier-General George Price objected to the repeated "black gash of shame" epithet with, "I'm tired of hearing you talk about black as the color of shame. We've gone through a civil-rights movement to prove that's not so." After four hours of argument, former General Michael S. Davison offered a solution: "Let us

build this admittedly nonconformist memorial but add to it a statue to symbolize the spirit of the American fighting soldier."

Carhart insisted that there should also be an American flag "at the intersection of the walls, and the statue would be below that, somewhere within the V made by the walls." Despite Lin's objections, the VVMF agreed that a 60-foot flagpole and a "group of three realistically-modeled, seven-foot bronze figures," standing above ground, would be added (see sidebar). A final compromise was reached when these elements were placed far enough away on the memorial site so that The Wall's artistic integrity was not affected.

Lin, who was not yet eligible for an architect's license, needed an architect of record to realize the design, and on the advice of Cesar Pelli, then dean of Yale's School of Architecture, she recommended the Washington, D.C., firm of Cooper-Lecky to VVMF, who had engaged the architects in August 1981. Site works began on March 16, and the official groundbreaking took place 10 days later. The Gilbane Building Company acted as the general contractor. The Memorial was completed in late October 1982.

"THE VIETNAM VETERANS MEMORIAL IS NOW DEDICATED."

On Saturday November 13, 1982, the Vietnam Veterans Memorial was officially dedicated as the climax of a 5-day National Salute to Vietnam veterans, organized to give the nation an opportunity to publicly honor all who had served in the Vietnam War. Although the war had been over for nearly 10 years, Vietnam veterans were finally to have positive recognition for answering the call to an unpopular war. Many who came to Washington for the occasion still felt let down by their government and "spoke openly of bitter memories and ungrateful homecomings."

On the Wednesday evening before the dedication, a candlelight vigil was begun at the National Cathedral, attended by veterans, family members of those lost in Vietnam, as well as congressmen and senators. For 56 hours, more than 230 volunteers read the names that were inscribed on The Wall. The vigil ended at midnight on Friday, November 12.

There were formal and informal social events, too, in a week "filled with open displays of emotion and camaraderie." Joel Swerdlow writes in *To Heal a Nation* that "Washington's hotels, restaurants, and streets filled with vets. It was, said one happy ex-GI, 'one helluva party.'" Swerdlow rehearses some poignant anecdotes:

> After many beers, a veteran said he had won the Medal of Honour but was afraid of how people would react. To the cheers of a crowded bar, he opened his suitcase, took out the medal ... and put it on for the first time. A man in a wheelchair slowly pushed through another bar that was filled to capacity. At first no one noticed him. Slowly, the noise faded, and then people reached out to

touch him. A former medic sat in a comer, crying. He pushed away all who tried
to console him. "I should have saved more, " he kept saying.

The long-overdue parade in tribute to Vietnam Veterans began at ten the
following morning. Over fifteen thousand men—mostly the veterans—
marched down Constitution Avenue in separate formations representing the
fifty states and three territories, accompanied by high school and military
bands. At noon there was a flyover of F4 (Phantom) bombers and UH-1 Iro-
quois (Huey) helicopters—an iconic tool of U.S. forces in Vietnam. The dedi-
cation ceremony began at half past two, watched by one hundred fifty
thousand people; ubiquitous live radio and cable TV coverage, including some
foreign networks, added millions to the audience. The ceremony lasted an
hour and a quarter. Following speeches by dignitaries, the crowd sang *God
Bless America* and paused for a moment of silence. "Ladies and gentlemen,"
Jan Scruggs said, "the Vietnam Veterans Memorial is now dedicated."
 Swerdlow writes, "The tightly packed mass surged forward, crushing fences
erected for crowd control. As thousands of hands strained to touch names, a
lone GI climbed to the top of the wall, put a bugle to his lips and played."

> All afternoon, all night, the next day and the next and the next for an unbroken
> stream of months and years millions of Americans have come and experienced
> that frozen moment. The names have a power, a life, all of their own. Even on
> the coldest days, sunlight makes them warm to the touch. . . . Perhaps by touch-
> ing, people renew their faith in love and in life, or perhaps they better under-
> stand sacrifice and sorrow. "We're with you," they say. "We will never forget."

A FINAL WORD

Forrest Brandt refused to go with his Vietnam veterans group to the dedica-
tion. To him The Wall was "anything but heroic, it looked like a trench, low,
dark, brooding, a seemingly endless list of names. It made me angry to look
at it. . . . One more mean-spirited jibe at all of us who had served in Viet-
nam." But on his buddies' return he was deeply affected by the reports of their
experience, each one with a story of how The Wall had *changed things.* "The
people of the city opened their arms and their hearts to the vets. They were
cheered, they were honored, they were respected; but more importantly every-
where they went common, ordinary Americans of every description came up
to them and said, 'Welcome home.' . . . " Then, following several visits to the
Memorial over the years, he wrote in 1998,

> But my concerns about The Wall have been dispelled. No matter what its artistic
> merits, or demerits, it works. The genius of Maya Ying Lin; the oriental-Ivy
> League-non-veteran designer whom I dismissed with anger, and the vision of the
> committee of veterans I thought had lost touch with the rest of us have created

a space that allows this nation's sons and daughters of Vietnam to find peace in their own hearts, pride in their service and thus begin the long journey to reconciliation with the rest of the nation.

I'm not sure why it works. How can black granite, angled slabs, lists of names, all deliberately below ground level, elevate doubting, confused minds? Pull a generation back together? Heal those who have suffered unimaginable pain? Bring us all to some important understanding of the costs of democracy's decisions?

Perhaps it is because The Wall has compelled us to help each other come home, veteran and non-veteran, soldier and protester, arm-in-arm as Americans on this sacred piece of ground. Perhaps it is because, like me, other veterans have allowed The Wall to open up the doors they have held closed for so long. The reason doesn't matter. The reality of a healing wall does.[14]

Maya Ying Lin

Maya Ying Lin was born in 1959 in Athens, Ohio, a small agricultural and manufacturing town 75 miles southeast of Columbus. Her parents, who had emigrated from China just before the 1949 communist coup, were professors at the University of Ohio: Henry Huan Lin was a ceramicist and then dean of the College of Fine Arts; Julia Chang Lin was a poet and professor of Asian and English literature. Maya Lin has an older brother, Tan, also a poet.

Her art was influenced her parents' creativity, and "the Asian aesthetic of grace and simplicity that they nurtured in their home." Although she thought of herself as a typical Midwesterner—she liked the outdoors, worked at McDonald's, and was hardly conscious of her ethnic distinctives—her adolescence was atypical: she didn't date, didn't wear makeup, and took college classes before completing high school. From childhood on, she enjoyed solitude

At high school Lin excelled in art and mathematics, graduating as covaledictorian. She was accepted to Yale, where, obliged to choose between a major in either sculpture or architecture, she decided upon the latter. Although officially enrolled in the architecture school, she used to "sneak over" to the art school for sculpture classes. In 1981 she received her bachelor's of arts, *cum laude*.

In her senior undergraduate year Lin designed a memorial as part of a seminar on funerary architecture; it became her winning entry in the Vietnam Veterans Memorial competition. After the project was completed she enrolled for graduate architectural studies at Harvard but withdrew in 1983 to work in a Boston practice. In fall she returned to Yale, where she was awarded a master's of architecture in 1986. In that year she set up her design office and "a sparely furnished living area" as the Maya Lin Studio in a loft in New York's Bowery, where she produces small-scale sculpture. After The Wall and beyond the studio several of her projects have been critically acclaimed.

The first, dedicated in November 1989, was the Civil Rights Memorial in the Southern Poverty Law Center, Montgomery, Alabama—a "sculptural genre called a 'water table,' in which the interaction between spectator and monument occurs when the former is moved to disturb a thin layer of water flowing over the monument's horizontal, circular face." She used a similar device for *The Women's Table* (1990–1993), a 3-foot-high slab of green granite in front of Yale University's Sterling Memorial Library, that commemorates women at the university. A third piece, commissioned by Helen Bing, Lin's *Timetable* (2000), a slowly revolving circular 16-ton granite water table stands in the forecourt of Stanford University's David Packard Electrical Engineering Building in Palo Alto, California.

In 1992 and 1993, when she was artist-in-residence at the Wexner Center (architect, Peter Eisenman, 1983–1989) at Ohio State University, Lin created an environmental sculpture, *Groundswell*—a garden of recycled crushed automobile safety glass heaped in mounds to create wave-like forms in some of the otherwise inaccessible spaces between the buildings. Her next major landscape work was *Wave Field* (1993–1995)—fifty grassy "waves" in eight rows over a 10,000-square-foot patch beside the University of Michigan's FXB Aerospace Engineering building in Ann Arbor. She has undertaken similar projects in collaboration with her brother Tan.

In 2000, a group of Native American tribes and civic groups from Washington and Oregon asked Lin to participate in a project to commemorate the bicentennial of the Lewis and Clark Expedition. The Confluence Project comprises seven installations in the Columbia River Basin. Her other recent large-scale environmental artworks include *Eleven Minute Line* (2004), a 1600-foot long, 12-foot high earth wall across a meadow in Kniesling, Sweden, for the Wånas Foundation, and *Flutter* (2005), a 20,000-square-foot sculpted earthwork in Miami, Florida. In all these, writes one critic, "she has made works that merge completely with the terrain, blurring the boundaries between two- and three-dimensional space and setting up a systematic ordering of the land that is tied to history, time and language."

Lin has also worked as an architect on buildings that "clearly reflect the design issues that have consistently engaged her." Her first residential work was the Weber Residence (1992–1994) in Williamstown, Massachusetts (with William Bialosky). Other products of their long association include the Rosa Esman Gallery, New York (1990); the Riggio-Lynch chapel for the Children's Defense Fund in Clinton, Tennessee, (2004), and the Box house, Colorado (2005). She has also worked with David Hotson on New York City's Museum of African Art (1992–1994); the Norton residence in New York (1996–1998); and the Asia/Pacific/American Studies Department, New York University (1997). A notable solo work is the Langston Hughes Library (1997–1999) on Alex Haley Farm in Clinton—a "marvelous example of adaptive re-use" of a

nineteenth century barn. In 1994 Lin designed the Mock/Sanders residence in Santa Monica, California (Frieda Mock directed the American Film Foundation production *Maya Lin: A Strong Clear Vision* that won the Best Documentary Academy Award in 1995).

Lin's studio artwork has been shown in solo exhibitions New York, Los Angeles, Winston-Salem, North Carolina, Cleveland, Ohio, Des Moines, Iowa, Houston, Texas, Columbus, Ohio, and Italy, Denmark, and Sweden, as well as in group shows. She has received many private and professional awards, including Honorary Doctorates of Fine Arts from Yale, Harvard, Williams College, and Smith College; the 2003 Finn Juhl Prize; the Presidential Design Award; the American Academy of Arts and Letters Award in Architecture; the Industrial Designers Society of America Excellence Award; and the National Endowment for the Arts Visual Artists Fellowship for Sculpture. She is a member of the American Academy of Arts and Letters and the American Academy of Arts and Sciences, as well as the National Women's Hall of Fame. She is on the board of trustees of the Natural Resources Defense Council and is a member of the Yale Corporation. In 2003 she served on the selection jury of the World Trade Center Site Memorial Competition. She is married to Daniel Wolf, a New York photography dealer; they have two daughters: Rachel and India.

Frederick Hart's "Three Fighting Men"

Frederick Hart's "Three fighting men (aka "The Three Soldiers" or "The Three Servicemen") is a bronze statuary group, "figurative in style and humanist in substance," near the Vietnam Veterans Memorial Wall. According to one source, a 21-year-old Marine stationed in Washington, D.C., in 1983 posed for the central figure; the man with the machine gun on his shoulder is "modeled after a Cuban-American," and the third figure is a composite of several African American models. There is an apocryphal story that at the statue's unveiling on Veterans Day 1984, Maya Lin asked Hart "if it hurt the models to pull the molds off of them. It was foreign to her to think that a sculptor could actually sculpt figures so perfect in detail and form." But another writer says that she refused to attend the dedication.

For the design competition for the main Memorial, Hart proposed a sculpture incorporating a wall with the names of all the dead and missing (as specified in the brief) and a medic running to the aid of a wounded soldier. It was placed third. He dismissed Lin's winning minimalist design as "a telephone book listing of dead people." As a result of the controversy that followed the

judges' decision, discussed in the body of this essay, a compromise was reached—a figurative element would be placed near the apex of the The Wall. In the face of Lin's strenuous objections Hart modified the proposal and instead of placing his "Three Servicemen" at the apex, he located them approximately 400 feet from The Wall among trees near the west entrance.

A full-size mock-up was carried around the memorial site trying many locations. Hart's own description: "I see the wall as a kind of ocean, a sea of sacrifice that is overwhelming and nearly incomprehensible in the sweep of names. I place these figures upon the shore of that sea, gazing upon it, . . . reflecting the human face of it." Someone has noted that "despite the earlier controversy, the statue today fittingly complements The Wall." As Kurt Andersen wrote in *Time* in April 1985,

> The three U.S. soldiers . . . stand a bit larger than life, carry automatic weapons and wear fatigues, but the pose is not John Wayne-heroic: these American boys are spectral and wary, even slightly bewildered as they gaze southeast toward the wall. . . . Hart now grants that "no modernist monument of its kind has been as successful as that wall. The sculpture and the wall interact beautifully. Everybody won." Nor does Lin . . . still feel that Hart's statue is so awfully trite. "It captures the mood," says Lin. "Their faces have a lost look." Out at the memorial last week, one veteran looked at the new addition and nodded: "That's us."

Nearby, a flag flies day and night, and at the base of the flagstaff are the seals of the five branches of military service, with the following inscription: "This flag represents the service rendered to our country by the veterans of the Vietnam war. The flag affirms the principles of freedom for which they fought and their pride in having served under difficult circumstances." That is a masterpiece of understatement.

After five years of opposition, in April 2000 Congress authorized the In Memory Plaque (aka the Vietnam Veterans Memorial Commemorative Plaque), which honors those Vietnam veterans who died after their service in Vietnam, but as a direct result of it, and whose names (because of Department of Defense policy) are ineligible for inclusion on The Wall. Dedicated in November 2004, the plaque was initiated by a coalition of the VVMF, the Vietnam Women's Memorial Project, and the Vietnam War In Memory Memorial, Inc. The simple 3 foot by 2 foot black granite slab is set in the paving in the northeast corner of the Three Servicemen Statue Plaza; its inscription, in a typeface matching The Wall, reads: "In memory of the men and women who served in the Vietnam War and later died as a result of their service. We honor and remember their sacrifice."

The Vietnam Women's Memorial

The Vietnam Women's Memorial, a short distance south of The Wall, is dedicated to the eleven thousand women who served in the armed forces during the Vietnam War. Placed in a garden designed by landscape architect George Dickie, the bronze sculpture group is the creation of Texas-born sculptor, Glenna Goodacre. It presents three uniformed women, appropriately larger than life, with a wounded soldier. The first memorial in America's history that honors women's patriotic service, it was dedicated on November 11, 1993.

An estimated two hundred sixty-five thousand military women served in various occupations and many places: Guam, Hawaii, Japan, the Philippines, and stateside, on hospital ships and in evacuation aircraft. Nearly all of them were volunteers. Almost 90 percent were nurses in the Army, Navy, and Air Force; others were physicians and physical therapists in the Medical Service Corps; still others were air traffic controllers, communications specialists, intelligence officers, and clerks. Eight were killed—their names are inscribed on The Wall—and many more were wounded. It has been estimated that almost half the women who served in Vietnam are affected by some form of post-traumatic stress disorder, while others have health problems resulting from exposure to the toxic defoliant, Agent Orange. Some have committed suicide. American civilian women were in Vietnam as war correspondents or as workers in humanitarian organizations; many of them, too, were wounded and over fifty died; there is still (2007) no official, accurate record of the total number of women who served in some way.

The Vietnam Women's Memorial Project (now the Vietnam Women's Memorial Foundation) was initiated in 1984 as a nonprofit organization by a former Army nurse, Diane Carlson Evans. In 1998 she wrote that after she had seen Hart's sculpture, "a whole and true portrait of the women who served during the Vietnam War, depicting their professionalism, dedication, service, and sacrifice, had yet to be seen,—their stories yet to be heard." She believed that women, too, needed a healing place and a healing process. Just as Vietnam combatants had not been welcomed home as America tried to put the war behind it, serving women too, most of whom were still in their early twenties when they returned to a country that could not empathize with what they had been through, received the same hostile treatment. They "had disappeared off the landscape of the Vietnam era." Others joined Evans "to promote the healing of Vietnam women veterans . . . ; to identify the military and civilian women who served during the Vietnam war; to educate the public about their role; and to facilitate research on the physiological, psychological, and sociological issues correlated to their service."

Although many veterans' and related groups supported the idea of a women's memorial, others who nourished inaccurate stereotypes about women's roles in Vietnam, denounced it. After all, they argued, only eleven thousand

women served in Vietnam, and only eight gave their lives. Does that merit a memorial? Evans countered that those "few" women helped save the lives of three hundred fifty thousand wounded Americans. In November 1987, J. Carter Brown, chairman of the U.S. Commission on Fine Arts, wrote in the *Washington Times* that any statue of women would "detract from the enormous power of the memorial." Some conservative commentators, including the *Newsweek* columnist George F. Will, agreed. Moreover, when it came to raising funds and engendering public interest, women lacked the resources and the corporate status of those who moved for the Frederick Hart statue. It was "men's business."

The Hart statue had been opposed because of an anticipated negation of The Wall's impact, but it was installed about 3 years after it was proposed, without separate legislation. The women's memorial took 10 years to realize, after two Congressional bills. Evans recalled, "The opposition tried to beat us down and throw obstacles in our way and they did it through a variety of methods and activities, some very public some very behind the scenes, but we just really felt that we were doing the right thing," and added triumphantly, "The reason that we have the memorial . . . is because we would not give up."

NOTES

1. Sofarelli, Michael, "Letters on the Wall" (2006). www.lettersonthewall.com/letter.htm

2. Andersen, Kurt, "Hush, Timmy—This Is Like a Church," *Time* (April 15, 1985), 61.

3. "Nixon Had Notion to Use Nuclear Bomb in Vietnam," *USA Today* (February 28, 2002). www.usatoday.com/news/washington/2002/02/28/nixon-tapes.htm

4. Pulvers, Roger, "Ghosts of Christmas Past: The Christmas Bombing of Vietnam," *Japan Focus* (January 3, 2007). www.japanfocus.org/products/topdf/2301

5. "Vietnam Veterans: Vietnam War." www.lycos.com.br/info/vietnam-veterans—vietnam-war.html

6. Griswold, Charles L. and Stephen S. Griswold, "The Vietnam Veterans Memorial and the Washington Mall: Philosophical Thoughts on Political Iconography," *Critical Inquiry*, 12(Summer 1986), 688–719.

7. Scruggs, Jan, [Introduction] *Reflections on The Wall.* Available at http://photo2.si.edu/vvm/scruggs.html

8. Eckardt, Wolf von, "Storm over a Viet Nam Memorial," *Time* (November 9, 1981).

9. Abbott, Bill, "Names on The Wall: A Closer Look at Those Who Died in Vietnam," *Vietnam Magazine* (June 1993) and widely elsewhere.

10. Vietnam Veterans Memorial." www.pbs.org/art21/artists/lin/card1.html

11. Statement by Maya Ying Lin, March 1981 (presented as part of her competition submission). www.vvmf.org/index.cfm?SectionID=77. The statement is widely cited elsewhere.

12. Kennicott, Philip, "Why Has Maya Lin Retreated from the Battlefield of Ideas?" *Washington Post* (October 22, 2006), 142–144.

13. Sidey, Hugh, "Tribute to Sacrifice," *Time* (February 22, 1982).

14. Brandt, Forrest, "A Salute to my Fellow Buckeye Vets" (2006). www .buckeyeplanet.com/forum/open-discussion-work-safe/31978-salute-my-fellow-buckeye-vets.html

SUGGESTED READING

Abramson, Daniel. "Maya Lin and the 1960s: Monuments, Time Lines, and Minimalism." *Critical Inquiry,* 22(Summer 1996), 679–709.

Branch, Mark Alden. "Maya Lin: After the Wall." *Progressive Architecture*, 75(August 1994), 60–63 ff.

Capasso, Nicholas J. "Vietnam Veterans Memorial," in Tod Marder, ed., *The Critical Edge: Controversy in Recent American Architecture*. Cambridge, MA: MIT Press, 1985.

Davidson, Phillip. *Vietnam at War: The History 1946–1975*. New York: Oxford University Press, 1988.

Eppridge, Bill and Naomi Cutner. *The Wall: A Day at the Vietnam Veterans Memorial*. New York; Avenel, NJ: Wings Books, 1996.

Evans, Diane Carlson. "Moving a Vision: The Vietnam Women's Memorial." In Diana J. Mason and Judith K. Leavitt, eds., *Policy and Politics in Nursing and Health Care*. Philadelphia: W.B. Saunders, 1998.

Figley, Charles R. and Seymour Leventman, eds. *Strangers at Home: Vietnam Veterans Since the War*. New York: Brunner/Mazel, 1990. First published New York: Praeger, 1980.

Finkelpearl, Tom. "The Anti-Monumental Work of Maya Lin." *Public Art Review*, 8(Fall-Winter 1996), 5–9.

Griswold, Charles L. and Stephen S. Griswold. "The Vietnam Veterans Memorial and the Washington Mall: Philosophical Thoughts on Political Iconography." *Critical Inquiry*, 12(Summer 1986), 688–719.

Hass, Kristin Ann. *Carried to the Wall: American Memory and the Vietnam Veterans Memorial*. Berkeley, Los Angeles: University of California Press, 1998.

Hess, E. "A Tale of Two Memorials." *Art in America*, 71(April 1983), 120–127.

Lin, Maya Ying. *Boundaries*. New York: Simon & Schuster, 2000.

Lin, Maya Ying. *Maya Lin*. Milan, Electa, Rome, Italy: American Academy in Rome, 1998. Catalogue.

Marling, Karal Ann and Robert Silberman. "The Statue Near the Wall: The Vietnam Veterans Memorial and the Art of Remembering." *Smithsonian Studies in American Art*, 1(Spring 1987), 4–29.

Marling, Karal Ann, and J. Wetenhall. "The Sexual Politics of Memory: The Vietnam Women's Memorial Project and 'The Wall.'" In Jack Salzman, ed., *Prospects: An Annual of American Cultural Studies*. New York: Cambridge University Press.

Marshall, Kathryn. *In the Combat Zone: An Oral History of American Women in Vietnam*. Boston: Little, Brown, and Company, 1987.

McLeod, Mary. "The Battle for the Monument: The Vietnam Veterans Memorial." In Hélène Lipstadt, ed., *The Experimental Tradition*. New York: Architectural League; Princeton Architectural Press, 1989.

Morganthau, Tom and Mary Lord. "Honoring Vietnam Veterans—At Last." *Newsweek* (November 22, 1982), 80–81, 86. See also William Broyles, Jr. "Remembering a War We Want to Forget," *Newsweek* (November 22, 1982), 82–83.

Morrissey Thomas F. *Between the Lines: Photographs from the National Vietnam Veterans Memorial*. Syracuse, NY: Syracuse University Press, 2000.

Moss, George Donelson. *Vietnam: An American Ordeal*. Upper Saddle River, NJ: Prentice Hall, 2006.

Platt, Susan. "Maya Lin's Confluence Project." *Sculpture*, 25(November 2006), 54–59.

Scruggs, Jan Craig, and Joel L. Swerdloe. *To Heal a Nation: The Vietnam Veterans Memorial*. New York: Harper and Row, 1985.

Sofarelli, Michael. *Letters on the Wall: Offerings and Remembrances from the Vietnam Veterans Memorial*. New York: Smithsonian Books/Collins, 2006.

INTERNET SOURCES

Brigham, Robert K. *The Viet Nam War: An Overview*. http://vietnam.vassar.edu/. For a more detailed analysis, see Ronald H. Spector, "Vietnam War," in *Encyclopædia Britannica Online*: www.britannica.com/eb/article-234639

Gallagher, Edward J. "The Vietnam Wall Controversy." http://digital.lib.lehigh.edu/trial/vietnam/about/

Vietnam Veterans Memorial Fund. www.vvmf.org/

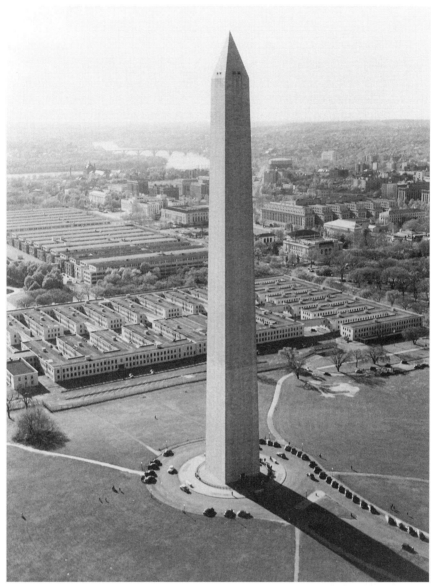

Courtesy Library of Congress

Washington Monument, Washington, D.C.

"The Thing about Towers"

The monument built to honor George Washington is the largest free-standing masonry structure in the world, a 91,000-ton marble-faced granite obelisk tower standing over 555 feet high in the National Mall at the spiritual epicenter of Washington, D.C.

Such landmark buildings have not been uncommon. To start at the beginning. . . . According to *Genesis*, after the deluge Noah's descendants settled in what is now Iraq. "They said to one another . . . 'Let's build a city for ourselves and a tower with its top in the sky. Let's make a name for ourselves so that we won't become scattered all over the face of the earth.'" God's response to such hubris was to confound their language, resulting in their dispersion—what poetic justice! The practical purpose of the so-called Tower of Babel is not indicated (although some believe it to be a Babylonian ziggurat), but clearly it is *not* the same thing as a city. The resolution to "make a name" for themselves suggests that the tower the people began to build was intended to be a landmark, a civic symbol—an icon of place and national identity.

Even today, travelers across the Netherlands' wide, flat landscape, whether in the mists of winter or the heat haze of summer, will see in the distance cities that can be identified by the distinctive profiles of their towers. Those towers, then new, were drawn accurately on medieval maps to guide people; visitors to the District of Columbia use the Washington Monument in the same way. Like the ancient towers, it is a landmark, a civic symbol, an icon of place and identity. For over 500 years the tallest European towers rose from churches. Completed in 1880, the spire of Cologne Cathedral in Germany was, at 516 feet, the loftiest building in the world—until the Washington Monument. And since then there have been many higher and still higher structures; most have a primary pragmatic commercial or communications function, although all are expressions of a "bigger is better" mentality. Cyberspace is littered by the scribbling of bloggers in Freudian overload who see sexual connotations in these structures; their views, although sometimes amusing, must be discarded.

The Washington Monument was the last great single-purpose symbolic tower. And its permanence *is* a defining quality; even the taller Eiffel Tower, built for the Paris *Exposition Universelle* of 1889, was only a temporary structure, after all. Some American writers identify the Monument as a symbol of the spirit of America. Still others see it symbolizing peace or liberty; one English commentator, with not a little chagrin, calls it an icon of America's birth and power in the world. In a rather fulsome statement the U.S. National Park Service (NPS) fuses the building with the man whom it honors:

> Among his fellow countrymen [*sic*], George Washington presented an impressive appearance, was a powerful influence, and yet had a simplistic elegance to his manner. Today, the monument reflects these characteristics in its design: it presents an impressive appearance from a distance, asserts a powerful influence on the National Mall, and has a simplistic elegance in its architecture. Just as Washington's tall frame [he was six feet three] stood above his fellow patriots, the monument towers above the skyline like a mighty watchman.

The monument was listed on the National Register of Historic Places on October 15, 1966, and in 2007 it was given twelfth place in the American Institute of Architects' nation-wide popular survey of America's favorite architecture.

Historian Mary Kay Ricks comments, "Contemporary architectural historians now tout the monument's sleek geometric scale as an ancient paradigm become timelessly modern." But originally it was not *designed* to be "timelessly modern"; it is suggested that that is a modernist interpretation inferred from the absence of any accretions on the essentially simple form. In fact (as will be shown), if the architect Robert Mills had been given his way the great memorial, like many of its contemporaries, would have been stranded somewhere between classical Greece and imperial Rome. Yet stripped of historical add-ons the obelisk evokes the stability of the Egyptian culture that remained virtually immutable for centuries, if not millennia. That gives the Washington Monument its enduring power as an American icon—but only so long as the nation embraces the values defined by the father of his country and his illustrious fellow-founders.

GEORGE WASHINGTON: SURVEYOR, SOLDIER, PLANTER, PRESIDENT

So much has been written about George Washington that even a brief biographical note seems superfluous. But man and monument are indeed inseparable, and the following sketch may help establish the motivation for the tower that has dominated the national capital's skyline since 1885.

George Washington was born on his father's plantation at Popes Creek in Westmoreland County, Virginia, in February 1732. Little is known of his childhood. His father, Augustine, died when the boy was age 11, leaving him a smallish farm at Fredericksburg, which his mother, Mary Ball Washington (he was the eldest of her six children) managed for him.

Seeking a life beyond agriculture, George studied geometry and surveying, and in 1748, despite his lack of practical experience, George William Fairfax and James Genn invited him to go to the Shenandoah Valley on a surveying trip for Lord Thomas Fairfax. That expedition would lead him into the profession of surveying. It also "marked the beginning of a lifelong relationship [with] the powerful and influential Fairfax family," with whose sponsorship he was appointed, in the following year, as surveyor for Culpeper County. About 16 months later he established a lucrative practice in the Northern Neck, which he maintained until November 1752.

Washington's life changed markedly in 1752, when he bought about 1,500 acres in Frederick County, Virginia. From that time he extended his land holdings and eventually acquired numerous rural properties covering more than 52,000 acres in Virginia, Kentucky, Maryland, New York, the Ohio Valley, and Pennsylvania. He also bought urban lots in the Virginia towns of Alexandria, Bath (now Berkeley Springs), and Winchester, as well as in the national

capital. His half-brother Lawrence died in 1752, and George took his place as a soldier in the Virginia Militia.

In fall 1753, when Lieutenant-Governor Robert Dinwiddie learned that French troops from Canada were building forts south of Lake Erie (a region claimed by Virginia), he sent Washington to demand their withdrawal. George's personal account of the expedition, *The Journal of Major George Washington*, published in Williamsburg and London by Dinwiddie, would "catapult him onto the world stage" when he was only age 22. Anyway, the French rejected the ultimatum, and a few months later Washington, by then a lieutenant-colonel, was dispatched to eject them from the Ohio Valley. In a skirmish between his one-hundred-fifty-strong force and the French, ten of the enemy, including their commander, died. The Virginians then retreated to Fort Necessity but were forced to capitulate when the French besieged the flimsy palisade. Washington resigned his commission, but when in 1755 General Edward Braddock arrived from England to drive out the French he returned to the military as a volunteer aide. Braddock's army was routed, but as reward for his bravery Washington was given command of the Virginia Militia—a few hundred men responsible for defending a 350-mile frontier. After two unsuccessful attempts he was elected to Virginia's House of Burgesses and served for 15 years from 1758.

The peace of Virginia was assured when the British took the forks of the Ohio in 1758, and Washington returned to civilian life at Mount Vernon, the 2,000-acre plantation that he had leased from Lawrence's widow, Anne, 4 years earlier. In January 1759 he married Martha Dandridge Custis, a wealthy young widow. Upon Anne's death 2 years later, he inherited the Mount Vernon estate and until 1775 became an innovative gentleman farmer. By the end of the decade he had expanded his holdings there to 8,000 acres, consisting of five farms.

Following the French and Indian War, the British parliament passed legislation to help recoup its cost from the American colonists. But its first attempt to impose a direct tax, the 1765 *Duties in American Colonies Act*, led to civil disobedience. Two years later the so-called *Townshend Acts* followed, a series of laws that (among other things) taxed imported necessities in the colonies. The Americans' refusal to purchase only British-manufactured goods defeated the purpose of those acts; in Boston, some colonists went so far as to dump tea into the harbor to protest the *Tea Act*—the now-famous Tea Party of December 1773. The parliament reacted angrily and to punish Massachusetts expedited four more pieces of legislation—the Coercive Acts—in the middle of 1774.

The American colonists labelled them "the Intolerable Acts," and twelve of the Colonies—Georgia's governor prevented delegates from attending—called the First Continental Congress at Philadelphia in September; Washington was one of Virginia's seven representatives. The Congress set out to define colonial rights, to identify how the parliament had violated them, and to find a way to

have them restored. Although no one spoke of seeking independence from the crown, Britain saw the gathering as treasonable and launched punitive expeditions. On April 19, 1775, the first armed conflict in the American Revolutionary War—in effect, a civil war—took place in Massachusetts. The Second Continental Congress, with sixty-five delegates from *all* the thirteen colonies, met in Philadelphia on May 10 and established the "United Colonies of America." It reformed, under the banner of the Continental Army, the New England militia which then was besieging the British in Boston. On June 19 George Washington was unanimously elected commander in chief. His background in frontier warfare was hardly appropriate training for the role; he had commanded only small numbers of soldiers and had no experience maneuvring large military formations, directing cavalry or artillery, or providing logistical support for thousands. He would have to learn on the job, so to speak. Washington had no illusions about the task facing him.

In 1789 he reflected that America was "not then organized as a Nation, or known as a people upon the earth—we had no preparation. Money, the nerve of War, was wanting. The Sword was to be forged on the Anvil of necessity: the treasury to be created from nothing." But he also recognized that the colonists "had a secret resource . . . the unconquerable resolution of [their] Citizens, the conscious rectitude of [their] cause, and a confident trust that [they would] not be forsaken by Heaven."[1] For those reasons he was able to lead his Continental Army—someone has called it "rag-tag"—successfully against the world's most powerful nation. Baron Ludvig von Closen, an officer in the French army, commenting upon that leadership, found it incredible that "soldiers composed of men of every age, even children of fifteen, of whites and blacks, almost naked, unpaid, and rather poorly fed, can march so well and stand fire so steadfastly." He acknowledged that their success was due to the "calm and calculated measures of General Washington, in whom [he daily discovered] some new and eminent qualities."

On July 4, 1776, the Second Continental Congress published the Declaration of Independence. The colonial rebels had become a nation fighting for freedom from England and King George III, and the civil war had escalated into a War of Independence. For the next 5 years battles raged along the East Coast. Washington won only three of them, but his decisive siege of Yorktown, Virginia, forced Lord Cornwallis' British force to surrender on October 19, 1781. After much debate the Treaty of Paris was signed in September 1783, and the British fleet departed New York in November. Washington submitted his resignation 2 days before Christmas and returned—at least, for a while—to rebuild Mount Vernon. At that time he also served as president of the Potomac Company, formed to improve the navigation of the river. At the end of the Revolutionary War his name was synonymous with its success; no other American commanded more respect. Frederick Harvey writes that the new nation "celebrated his ability to win the war despite limited supplies and inexperienced men, and they admired his decision to refuse a salary and accept

only reimbursements for his expenses. Their regard increased further when it became known that he had rejected a proposal . . . to make him king."[2]

Washington was "appalled by the excesses of the state legislatures and frustrated by the diplomatic, financial, and military impotence" of the Articles of Confederation that had left the new federal government without the power to collect taxes, pay its debts, regulate trade, or control its borders. So in summer 1787 he went again to Philadelphia, representing (with others) Virginia at a convention that would recommend changes to the Articles. He was unanimously elected to preside over the 4-month long deliberations, the outcome of which was the U.S. Constitution. Afterwards, against some opposition, he worked for months to garner support for ratification of the document, after which he hoped to return to private life. Instead, he was made the only president in American history to be elected by the unanimous voice of the people.

President Washington served two terms. The first (1789–1793) was necessarily engaged with ordering the executive branch of the federal government; the second (1793–1797) brought with it more critical issues, as he maintained America's neutrality in a general European war and dealt with deepening divisions between Federalists and Republicans in his own administration. In the latter years of his presidency the Indian war on the northwest frontier was won, Britain surrendered its northwestern forts, and Spain opened the Mississippi to American trade. Resisting pressure to stand for a third presidential term, Washington turned over the government to John Adams and again retired to Mount Vernon.

In 1798 he was constrained to reenter public life for several months when Adams made him commander of a provisional army that could be raised in the event of an anticipated French invasion. He once more declined a suggestion that he should stand again for the presidency in 1800. On December 12, 1799, Washington developed respiratory problems after being caught in a snowstorm. He died at around ten that night, and 2 days later his body was interred at Mount Vernon. Political historian Matthew Spalding asserts,

> Without Washington, America would never have won its war of independence; he was the catalyst of the American founding. Even more significant, he proved that republican government was not only possible but indeed noble. . . . No one did more to put the United States on the path to success than Washington. No one did more to assure a government with sufficient power to function but sufficient limits to allow freedom to flourish. No one walked away from power with more dignity or did more to assure the prosperous society we enjoy today. This is why Washington and Washington alone . . . is the father of this country.[3]

BLENDING "STUPENDOUSNESS WITH ELEGANCE"

The apotheosis of George Washington began in his lifetime. Peter Joseph wrote in *Lost* magazine in 2006, "Popular adoration ranged from Gilbert

Stuart's . . . portraits to the more overtly worshipful paintings that depicted
the ex-President poised to enter heaven guided by peach-cheeked cherubs.
Amidst this fervent veneration of the man who was 'first in war, first in peace,
and first in the hearts of his countrymen,' a physical memorial seemed
inevitable."[4]

Plans for a memorial to Washington had been afoot from as early as 1783.
On the recommendation of Major Pierre Charles L'Enfant, planner of the
national capital, the Continental Congress resolved that a bronze equestrian
statue of Washington "be erected at the place where the residence of Congress
shall be established." It was to carry a legend explaining its purpose: to honor
"the illustrious Commander-in-Chief of the Armies of the United States of
America during the war which vindicated and secured their liberty, sover-
eignty, and liberty." At first, Washington agreed to the proposal; then, faced
with the priority of raising funds to build the city itself, he changed his mind.
Besides, the undemocratic—not to say imperial—message conveyed by "a
general on horseback in Roman garb" offended influential Republicans and
widened what was already a "rancorous" split with the Federalists. The heroic
statue never eventuated.

Other schemes followed but disagreements over style, location, and cost
doomed them all. A year after Washington's death Representative John Mar-
shall, with the guarded consent of his widow Martha, proposed that a sepul-
cher—a "mausoleum of American granite and marble, in pyramidal form 100
feet square at the base and of proportionate height"—be built under the dome
of the Capitol. In 1801 the House of Representatives voted $200,000 for the
project, but the Senate opposed it. Congress unsuccessfully revived the idea in
1816 and again in 1832, inspired by Washington's birth centennial. But his
executors—Martha had died in 1802—decided that his body should remain
at Mount Vernon, and the whole idea was shelved.

Instead, Congress provided $28,000 to pay the Boston sculptor Horatio
Greenough to carve a seated marble figure of Washington that would stand in
the Capitol Rotunda. He produced a toga-draped, bare-chested, and muscle-
bound figure—someone has called it "Schwartzneggerian"—based on descrip-
tions of Phidias' statue of the Olympian Zeus (ca. 470 B.C.), one of the
wonders of the ancient world. In his *Visual Shock* historian Michael Kammen
writes,

> Greenough's *Washington* touched off one of the earliest conflicts in the United
> States involving aesthetic criteria. . . . A particularly problematic question in-
> volved style: how should the Father of His Country be depicted, as an ideal-
> ized deity or as a revered native statesman? Classical or "American"? Godlike
> and spiritual or secular yet like-no-other? Greenough's solution turned out to
> be a hybrid: the head based upon Houdon's life mask certainly resembled
> Washington, but the body evoked Jupiter and Roman statuary. Hence the
> work got nicknamed George Jupiter Washington when it wasn't given more
> insulting designations.[5]

When it arrived from Florence in 1840 the statue was greeted with critical condemnation and almost universal scorn. The scandalous sight of the revered president as a half-naked Zeus in a contrived pose dismayed Americans. Anyway, the 12-ton piece proved far too weighty for the floor of the Capitol, which it cracked. It was removed to the Capitol grounds in 1875 and from there to the Smithsonian Institution Building in 1908. Since 1962 it has been in the National Museum of History and Technology (now the National Museum of American History).

In 1833, frustrated by the government's dithering about an appropriate monument, a group of influential Washingtonians established the Washington National Monument Society (WNMS). Marshall, then chief justice, was its first president; when he died 2 years later former U.S. President James Madison took the role. Other officers included Thomas Carbery, a former mayor of Washington; Chief Justice William Cranch of the District Court; Samuel Harrison Smith, founder of the *National Intelligencer*; and George Watterson, chief librarian of the Library of Congress. There were thirteen other charter members. The Society envisioned a monument "like him in whose honor it is to be constructed, unparalleled in the world, and commensurate with the gratitude, liberality, and patriotism of the people by whom it is to be erected . . . [It] should blend stupendousness with elegance, and be of such magnitude and beauty as to be an object of pride to the American people, and of admiration to all who see it."

Publicizing its goals in the press and making a direct appeal to churches, societies, and individuals, the WNMS set about fundraising. All U.S. citizens were invited to contribute up to a limit of one dollar—that would give everyone a chance to share in the project—for which they received a certificate. The limit, set for altruistic reasons, was hardly prudent, and within 3 years, contributions totaled only $20,000. Occasionally various groups conducted special fund-raising events.

On August 10, 1836, a subcommittee appointed by the Board of Managers invited American artists to submit designs for the monument. Optimistically and unrealistically, the budget was set at a minimum of a million dollars, and entries were to "harmoniously blend durability, simplicity, and grandeur." The competition opened a stylistic Pandora's box. Peter Force, mayor of Washington and a founding member of the Society, proposed an enlarged out-of-doors version of the 1800 pyramid. Thomas McClelland of Philadelphia submitted a design for a huge castellated monument in the Gothic Revival style then becoming popular; one account says that he "frequently beseeched the society to accept the design that he obsessively continued to modify, but a few years later, he despondently wrote from debtor's prison that his consuming attention to the . . . project had ruined him." Calvin Pollard, a self-styled architect from New York, proposed an even larger Gothic building, and another New Yorker, Representative Zadoc Pratt, collaborated on a neoclassical design with the Philadelphia architect William Strickland.

The winning architect was Robert Mills. His original design, later to be drastically revised, comprised a 500-foot high obelisk, with an almost flat pyramidal peak, rising from the center of a gargantuan 250-foot diameter rotunda, whose thirty Doric columns were interspersed with statues of America's heroes. The colonnade was crowned with a 20-foot high entablature; a 15-foot balustrade brought the total height of the base to 110 feet. It was decorated with friezes emblazoned with the seals of the States and frescoes of Revolutionary War battles. Above a central portico an enormous toga-draped figure of Washington held the reins of a *quadriga*—a Roman four-horse chariot. The base housed a museum and archives, and Mills even hoped that the remains of the general and his peers would be interred in a crypt beneath the building. "Stupendousness with elegance," indeed! The architect's own description of the "pantheon" went into great detail; he explained the appearance of the obelisk with lots of verbiage but little clarity:

> In the centre of the grand terrace . . . rises the lofty obelisk shaft of the monument, seventy feet square at the base, and 500 feet high, diminishing as it rises to its apex, where it is forty feet square; at the foot of this shaft, and on each face, project four massive zocles [short plinths], twenty-five feet high, supporting so many colossal symbolic tripods of victory, twenty feet high, surmounted by facial columns with their symbols of authority. These zocle faces are embellished with inscriptions, which are continued around the entire base of the shaft, and occupy the surface of that part of the shaft between the tripods. On each face of the shaft above this is sculptured the four leading events in General Washington's eventful career, in [deep relief], and above this the shaft is perfectly plain to within 50 feet of its summit, where a simple star is placed, emblematic of the glory which the name of Washington has attained.[6]

To reach the top, Mills proposed a gallery within the shaft that could "be traversed by a railway, terminating in a circular observatory, twenty feet in diameter, around which at the top is a lookout gallery, which opens a prospect all around the horizon." He estimated the cost of the whole monument at a little over $1.22 million; the obelisk alone would cost $552,000. In the event, just an obelisk—not *this* obelisk—would be built, and it would cost a great deal more.

Mill's search for an appropriate symbolic form for a monument had led him to the Egyptian obelisk, a form already for the Battle Monument at Lexington, Massachusetts, of 1799. Mills had joined the Lodge of Freemasons in 1814, and a covering letter with the sketches for a Bunker Hill Monument that he prepared in 1832 for the Massachusetts Grand Lodge asserted that an obelisk was "particularly adapted to commemorate great transactions, for its lofty character, [its] great strength, and furnishing a fine surface for inscriptions— There is a degree of lightness and beauty in it that affords a finer relief to the eye than can be obtained in the regular proportioned column." And Mills' design was consistent with contemporary Neo-Classical fashion and with his

personal opinion that "solidity, simplicity, and a degree of cheerful gravity [whatever that meant] should characterize all monuments," "The proposal was not well-received by his professional colleagues"; some critics called an "ill-assorted blend of Greek, Babylonian, and Egyptian architecture." Then, they had not won the competition. Anyway, that is exactly what it was.

WHO WAS ROBERT MILLS?

Mills claimed to be America's first native-born professionally trained architect. He is best known for buildings in Washington, D.C., including the Treasury Department, the National Portrait Gallery, the Post Office Headquarters, and of course the Washington Monument. Over a 55-year career he was associated with James Hoban, first architect of the White House, Benjamin Henry Latrobe, designer of the Virginia State Capitol and the Bank of Pennsylvania, and Thomas Jefferson. Someone has said, "With this circle of friends, Mills was instrumental in creating the physical design of the new republic."

Mills was born in Charleston, South Carolina, in 1781, the son of Scots émigré William Mills and his wife Ann. Little is known of his early life and education; some historians say that he attended the College of Charleston and that he also had tuition in architecture. In the early 1790s his older brothers Henry and Thomas returned from a visit to Scotland with copy of *The Modern Builder's Assistant*, a pattern book of designs by "architects and carpenters" William and John Halfpenny. Mills's biographer John Morrill Bryan comments that the book was "the earliest evidence of an architectural interest in the family." Probably in 1800, Robert began an apprenticeship with James Hoban, designer of the White House and (at that time) supervisor of the Capitol building in Washington, D.C. Soon after arriving in the capital, Mills met Thomas Jefferson, for whom he occasionally would execute drawings and who, for the next 25 years, lent him books from his vast architectural library. Having gained a hands-on education in construction and project management, after 2 years, introduced by Jefferson, he became an assistant in the Philadelphia office of the prominent British-trained architect Benjamin Henry Latrobe; their 10-year relationship had a lasting influence on Mills.

Sidney Fiske Kimball believed that these mentors "represented three phases of architectural progression in style: the Palladian, the Roman, and the Greek; in practice, the builder-architect, the amateur, and the professional." He explained:

> From honest Hoban, who on occasion contracted for buildings as well as designed them, he acquired the rudiments of construction and of draughtsmanship and rendering. From Jefferson, who took him into his family in 1803, he derived a compelling impulse of the classic and a recommendation to Latrobe whom Jefferson had encouraged and placed in a position of authority. It was Latrobe

... who placed on Mills the deepest impress. To him Mills owned not only his knowledge of Greek forms but his principles of professional practice and his scientific engineering skill.[7]

To these invaluable inputs Mills, urged by Jefferson (who had done the same thing 20 years earlier), added the experience of extensive travel to survey American architecture on the East Coast. Mills worked for Latrobe first as a draftsman, and then as a work superintendent on several architectural and engineering projects, including the Baltimore Cathedral, the Bank of Philadelphia and the Chesapeake and Delaware Canal. In 1808, while still engaged on the bank, he established—with testimonials from Jefferson—his own practice. The reason? In October he married Eliza Barnwell Smith and needed to more money. For the next 6 years he struggled to establish himself.

His earliest Philadelphia commissions—none has survived—included a speculative row-house development, Franklin Row (1809–1810); he is thought to have designed Carolina Row (ca. 1812–1815) also. He produced nondomestic works in the city, among them the six-thousand-seat auditorium, Washington Hall (1809 and 1814–1816), "designed in the inspirational Greek Revival style" for the Pennsylvania Benevolent Society; the wings of the State House (now known as Independence Hall, 1813–1815); and the tollhouse in the form of triumphal arch entrances and covering for Lewis Wernwag's "Colossus," the Upper Ferry Bridge across the Schuylkill River (1813–1814).

Mills built several centrally planned churches that housed "large congregations in a comfortable auditorium with good sight lines and curved pews." They included the circular Sansom Street Baptist Church (1811–1812) and the Octagon Unitarian Church (1812–1813), both in Philadelphia, and the Monumental Church in Richmond, Virginia (1812). Latrobe also had participated in the design competition for the latter and accused his former employee of stealing his idea: "Mills is a wretched designer. . . . He is a copyist and fit for nothing more!" But architectural historian Charles Brownell believes that with this building Mills "began his ascendancy over Latrobe as a molder of the American civic monument."

Certainly he was being recognized. One source points out that he was accepted into the St. Andrew's Society and the Society of Artists of the United States (after 1814, the Columbian Society of Artists), and that his "works were regularly exhibited at the Pennsylvania Academy of the Fine Arts." Although the Monumental Church had attracted much attention and endorsed Mills' credibility, no number of honors could feed him and Eliza and their three children. Pursuing work, they moved to Baltimore late in 1814. His arrival led to four "notable" commissions, including a major church and residence, and a row of houses. Also in Baltimore Mills was responsible for several engineering projects: canals, a drainage system, and a waterworks system. As well as being involved with three railroads, he was made president and chief engineer of the Baltimore Company.

In 1815 Mills began to supervise construction of his premiated entry in an 1813 competition for the city's Washington Monument. But an economic slump in 1819 affected the city's building industry—always an early victim of recession. Funding for the monument ran out and the project lapsed. Mills complained, "The state of business in my profession [has] put it entirely out of my power to support my family."

Because South Carolina's state legislature had authorized the expenditure of a million dollars for infrastructure development, in 1820 he returned with his family to his native Charleston. By December he was appointed as acting commissioner of Public Works and within about 2 years became superintendent of Public Buildings, responsible for major public projects: the County Records Office in Charleston, completed in 1827; the South Carolina Asylum in Columbia, then the state's largest building, completed in 1828; and nearly thirty courthouses and jails across the state. In December 1828 his office was discontinued, although he sporadically worked on transportation development until 1830. It has been observed that "his works during this decade reflect the Greek Revival style incorporated with Latrobean and Palladian influences." That was hardly surprising.

Financial security still eluded Mills, so Eliza took to teaching drawing and music. That was hardly enough to make ends meet; on one occasion she almost was forced to sell her piano. Mills augmented their income by publishing *The Atlas of the State of South Carolina* (1825), "the first systematic, state-wide atlas ever in the US." He had earlier published *Treatise on Inland Navigation* (1820), which "demonstrated his competence in the important field of transportation" and *Internal Improvement of South Carolina* (1822) to which he added *Statistics of South Carolina* in 1826. All told, more than fifty projects—buildings, canals, and monuments—came from his hand. In 1829 he returned to Baltimore to complete its Washington Monument.

The following year he went again to Washington, D.C. with an introduction from James Monroe and sought commissions from Andrew Jackson's administration, winning the appointment of "Draftsman of Public Surveys." In 1836 Jackson approved his preliminary design for a fire-resistant Treasury Building to replace the old one that burnt down in 1833; delayed and derailed by controversies, the Greek Revival building was not completed according to his design. He worked on the Patent Office (1836–1840) in an "uneasy relationship" with its architects Alexander J. Davis, William Parker Eliot, and Ithiel Town. Indeed, alterations to public works were symptomatic of the political and economic problems that "plagued the final phase of his career."

Congress abolished his office in 1842, but he continued to work on other government commissions. He designed the Post Office (now the International Trade Commission, 1839–1842) and supervised construction of James Renwick's Smithsonian Institution (1847–1855). In fact, he had a hand in almost all major projects in the national capitol for the next two decades. But his public commissions slowly dwindled until 1851, when Thomas Ustick Walter

replaced him as architect for additions to the Patent Office and the U.S. Capitol. That "precipitated his departure, at age seventy, from federal service." Mills would write to a friend in 1853, "Twenty years of my life have been spent in the Government service here, and my works there will prove my faithfulness to the interests of the Government." He died at home in Washington in March 1855 and was buried in the Congressional Cemetery.

As noted, 22 years earlier he had won the national competition for his most famous building, the Washington National Monument, the most recognizable monument in America.

CORNERSTONE, "POPE STONE," CRUMBLING STONES

Fund-raising for the monument to George Washington was slow, hindered by a depressed economy—the "Panic of 1837"—but also by the $1 donation limit imposed by the Society. In 1845 that restriction was removed and subscriptions temporarily increased. But 3 more years passed before the government finally decided upon a location; the swampy place proposed by L'Enfant at the cross-axis of the White House and the Capitol was incapable of supporting the intense loads that would be imposed by the huge structure, and Congress assigned 37 acres of firmer ground, about 100 yards to the southwest. By then $87,000 had been collected, and the Society, believing that the sight of construction activity would stimulate further donations, decided to start building Mills' obelisk; the "pantheon" could be left until later. Nevertheless, "in the interest of economy" the Board was constrained to reduce the height of the needle from 600 to 500 feet, and the base from 70 to 55 feet square. Excavation for the granite foundation began in spring 1848. The rough-hewn blocks were set to form an 80-foot square stepped, truncated pyramid about 23 feet deep; one-third was below ground.

For the cornerstone, Thomas Symington donated a 12-ton block of white Maryland marble from his quarry, about 11 miles from Baltimore. A ceremony on Sunday July 4, 1848, was marked by masonic pomp and pageantry, the highlight of which was a parade led by President James K. Polk, followed by members of Congress and assorted artillery, cavalry, and infantrymen, the Marine Band, and volunteer fire companies. A crowd estimated at fifteen thousand to twenty thousand assembled for the foundation-laying ceremony. A temporary vault festooned with red, white, and blue bunting had been set up; an American bald eagle was tethered at its apex. Many spectators with foresight or the money to do so had paid for reserved seats in sheltered bleachers that surrounded the site. That had been a good idea: the House Speaker Robert C. Winthrop delivered a 2-hour speech, after which Grand Master Benjamin B. French of the Grand Lodge of Masons of the District of Columbia formally set the cornerstone according to Freemasonic ritual. He wore the same Masonic apron and sash that had belonged to President Washington

and used the same Mason's trowel that had been used by the late president to lay the cornerstone of the Capitol.

Over the next few years the Society actively solicited cash contributions from Freemasons through the Grand Lodges all over America. When the fund-raising appeal was reinvigorated in 1853, it was extended to include other institutions—the Oddfellows, the Sons of Temperance, and other fraternal orders—and the states and territories. But building progress slowed to a crawl as the money was spent; in the first 2 months of 1855, only $695 was raised. The obelisk had reached a height of 152 feet; its 15-foot thick granite walls were faced with white marble ashlar in two-foot courses, 15 to 18 inches thick.

As an alternative to cash, the State of Alabama offered a "decorative stone" that could be incorporated in the monument. The notion appealed to the Society, who invited other states to donate an inscribed "block of marble or other durable stone, a product of its soil." A few writers speciously suggest that some Society members believed this would reduce materials costs; in fact, the optimistic appeal attracted just 199 stones of the total 36,500 in the monument. Later, the opportunity was afforded foreign governments, and that caused a problem.

On March 6, 1854, a block of marble from the ancient Temple of Concord in Rome, the gift of Pope Pius IX, was stolen from the site by masked thieves. Whatever its fate—it was either broken into pieces, or dumped into the Potomac River—it was never found and no arrests were made. The incident dramatically reduced the number of commemorative stones being sent to complete the monument; in fact it seriously dampened most kinds of contributions. The chief suspects were members of a white, Protestant, nativist, xenophobic, and secretive political faction known as the American Party that had been formed among New York's middle and working classes 5 years earlier. It resisted Catholic immigration, convinced that Catholics gave greater allegiance to the papacy than to America. Critics nicknamed it "Know-Nothing"—a title that it later adopted—because members hid their political agenda from outsiders. Worse was to come.

On the evening of February 21, 1855, about seven hundred and fifty members of the Know-Nothings, many of whom had infiltrated the WNMS, elected seventeen of their own officers into the Society; next morning they announced that they were "in possession of the Washington Monument." The following day Congress rescinded a $200,000 appropriation for the building work. For the rest of the year the Know-Nothing party managed to collect scarcely more than $50; under its regime, only thirteen courses of masonry were added—poor work in inferior marble, at that, which later needed to be replaced. Shortly after the group disintegrated in 1857, control of the monument reverted to the original Society. In February 1859 Congress legislated "to prevent a repetition of the debacle," by incorporating the Society "for the purpose of completing the erection now in progress of a great National Monument

to the memory of Washington at the seat of the Federal Government." Despite that, the monument would stand incomplete and desolate for decades.

Other events contributed to that hiatus, including the death of Robert Mills early in March 1855, and of course the Civil War. During that tragic conflict the monument site was used for the Union Army's temporary camps, staging posts, and parade grounds; it also became pasture and livestock holding pens for a nearby abattoir and was actually named the "Washington National Monument Cattle Yard." Following the war, President Andrew Johnson enthused, "Let us restore the Union, and let us proceed with the Monument as its symbol until it shall contain the pledge of all the States of the Union." Some states offered help on a matching dollar-for-dollar basis to complete the work. But without assistance from Congress, which had other spending priorities, the Society could not seize the opportunity. So nothing was done, and the site bore the epithet "Murderer's Row" as it became the haunt of "escapees, deserters and all other types of flotsam of the war." Tongue-in-cheek, Mark Twain and Charles Dudley Warner wrote in *The Gilded Age: A Tale of Today* (1873):

> The Monument to the Father of his Country towers out of the mud—sacred soil is the customary term. It has the aspect "a factory chimney with the top broken off. The skeleton of a decaying scaffolding lingers about its summit . . . The Monument is to be finished some day and at that time our Washington . . . will be known as the Great-Great-Grandfather of his Country. The Memorial Chimney stands in a quiet pastoral locality that is full of reposeful expression. With a glass you can see the cow sheds about its base . . . contented sheep nibbling pebbles in the desert solitudes . . . and the tired pigs dozing in the holy calm of its protecting shadow.

A LITTLE LATE FOR THE CENTENNIAL!

In 1874 the Society Secretary John Carrol Brent again importuned Masonic groups and others, this time with immediate success. At first Congress was less enthusiastic. Then, representing the original thirteen states and prompted by a popular groundswell of nationalism, a House of Representatives committee explored the feasibility of completing the monument in time for the Centennial on July 4, 1876. But since 1848 many had expressed doubts about the adequacy of the foundations. Now, after nearly 30 years the committee revived the question and appointed an engineering investigation. It was concluded that for safety reasons no extra load should be imposed on the foundation; that is, the shaft of the obelisk should not rise beyond the 176 feet already achieved.

At the beginning of August 1876 President Ulysses S. Grant signed into law a bill that appropriated $200,000 for the completion of the monument. Unanimously passed by both Houses, it also transferred ownership of the

partly finished structure from the Society to the United States, and created a Joint Commission, responsible to Congress. It was only to be expected that the Joint Commission would create a bureaucratic subset, a Building Commission—the first vice-president of the Society, the Architect of the Capitol, the supervising architect of the Treasury and General Andrew Atkinson Humphreys, chief of Engineers—to handle practical matters. Humphreys in turn appointed Lt. Col. Thomas Lincoln Casey as engineer in charge of the project. Reports in the first half of 1877 concluded that the existing foundation was inadequate, but that the problem could be fixed. The Joint Commission made its first report to Congress on November 8, almost 2 years after it had been established. The inordinate delay had caused yet another waning of public interest.

As noted, the pantheon had been deferred many years earlier for reasons of cost. Mills is alleged to have objected: that would make his monument look like "a stalk of asparagus." Many others thought a simple obelisk was too stark, offering "little to be proud of." Now the plan was that the pantheon was to be omitted completely. Even what remained of Mills' design was again attacked; in July 1877 *The American Architect and Building News* described it as a "monstrous obelisk, so cheap to design but so costly to execute, so poor in thought but so ostentatious in size" and called for it to be discarded.

Once again, plenty of alternatives were rolled out. John Fraser, then architect of the Treasury, proposed a Romanesque tower with an equestrian statue of Washington above its entrance. General Montgomery Meigs wanted to build an Italianate observation tower atop the existing structure, crowned with a seated statue. M. P. Hapgood, a Boston architectural student, suggested embellishing the stump of the existing column with elaborate Gothick detail. Henry Robinson Searle revised his Egyptian Revival entry from the 1830s competition—through a series of modifications it had evolved into a decorated obelisk atop a Mayan-like base. The sculptor William Wetmore Story presented Speaker Winthrop with "an almost cathedral-like design," considered (by some) to be "vastly superior in artistic taste and beauty." Winthrop responded that his "first wish was to finish the monument as a simple obelisk" but "if a change was unavoidable . . . [Story's] idea of turning it into ornamental Lombardy tower" was the best plan he had seen. The nation and the world should be grateful for Casey's January 1879 report: Story's design would overload the already reinforced foundation and—this was probably the clincher—it would cost more. Mills' obelisk was finally settled upon.

Earlier, economy had led to a 100-foot shortening of the original 600-foot proposal. By fall 1878 the intended height was increased to 555 feet 5⅛ inches, ostensibly to achieve a proportion 10: 1—claimed to be the standard ratio of height to base dimension for Egyptian obelisks. A steeply sloping 55-foot crowning pyramidion would replace Mills' flattish top. That case was put on the advice of obelisk *aficionado* George Perkins Marsh, then U.S. minister to Italy, who claimed to have studied the best-known ancient

examples. Incidentally, he dismissed Mills' pantheon as "gingerbread." The reasoning was specious and inaccurate, because that ratio would have yielded a height of 550 feet. Anyway, an analysis of the twenty-eight surviving Egyptian obelisks shows that there *was* no standard; proportions varied between 8.9: 1 and 11.85: 1. It must be remembered that the ancient "needles" were monolithic, their slenderness ratios determined by the tensile strength needed to avoid failure as they were raised into position. Few exceeded 100 feet in height; the tallest, abandoned in the course of quarrying at Aswan, would have been just under 137 feet high.

The proportions of the Washington Monument also have provided rich quasi-evidence about numerology for the ill-informed speculations of a lunatic fringe; all that can be asserted here is that the dimensions have no demonstrable historical precedent, and therefore probably no mystical significance.

Construction of the shaft resumed early in 1879. In the preceding months Casey spent almost $100,000 deepening the foundation and (more important) increasing its area it so it could support a structure that would ultimately weigh more than 40,000 tons. The first necessity of the second phase was the demolition of the inferior work carried out during the Know-Nothings' control of the monument. Next followed the construction of two wrought-iron frameworks within the shaft: one set of four hollow circular columns to support the stairs, and another set to carry the steam-powered elevator mechanism for raising the stone blocks. In July 1880 both parts of the iron structure were ready. A month earlier, a greatly augmented team of masons had started dressing the stones in enlarged stonecutting sheds. A new spur line was built from the Baltimore and Potomac railroad tracks to deliver marble directly from the Maryland quarry to the site. Olszewski describes how the obelisk then rose in 20-foot lifts:

> The eight columns . . . were built to a height of 30 feet above the masonry shaft and were firmly tied and braced with vertical and horizontal ties and braces. . . . To each of the four outer columns . . . a crane arm was attached so that it swung out over one-quarter of the top of the wall. By means of this arrangement, 20 feet of masonry could be added to the height of the walls of the monument at one time. The process was then repeated and 20 feet was added to the height of the iron frame and the elevator and stone-setting machinery was moved to its top so that another 20 feet of the wall could be built.[8]

Three different kinds of marble were used in the monument. The first 152 feet, completed before 1854, was faced with coarser-grained stone from Texas, Maryland. When work recommenced in 1879, four courses (6 feet) of white marble from Sheffield, Massachusetts, were laid; for a number of reasons that supplier's contract was cancelled in July 1880. The upper part of the shaft was finished with fine-grained marble from Cockeysville, Maryland. The three sections can be distinguished by quite noticeable color differences. Once the shaft was completed, the builders turned to the 200-ton pyramidion that

would crown the monument. It contained 262 pieces of Cockeysville marble and was assembled on the ground. In December 1884 it was lifted into place in one piece.

The pyramidal cast-aluminum apex, engraved on one side with the Latin phrase, *Laus Deo* (Praise be to God), was set December 6, 1884. Its other faces—the piece is about 5½ inches square and 9 inches high—are inscribed with significant dates and the names of the engineers, architects, and commissioners responsible for the monument. Aluminum, then a rare and valuable metal, was not chosen (as the myth asserts) because "Americans wanted only the best to commemorate George Washington" but because of its conductivity, color, and nonstaining qualities. Casey asked William Frishmuth, at that time the only U.S. aluminum producer, if he could make a metal pyramid to serve as the lightning rod. In fact, copper, bronze, or platinum- plated brass were the preferred materials.

The incomplete monument was dedicated on Washington's birthday, February 22, 1885. Regular servicemen and militia were on parade as invited dignitaries congregated—"executive, legislative, and judicial officers; . . . members of the diplomatic corps representing the entire world; . . . clergymen, jurists, scientists, venerable citizens [*sic*], and members of the Washington National Monument Society." Senator John Sherman, William W. Corcoran, the current secretary of the Society, and Lt.-Col. Casey each made a short speech (it was a very cold day). President Chester Arthur declared "the monument dedicated from that time forth 'to the immortal name and memory of George Washington.'" The official party then went in procession to the Capitol to hear two more speeches in the House of Representatives. That evening there was a reception at the White House.

The remaining work was completed by October 1888.

The Washington Monument remains the tallest building in the national capital. There is a popular misconception—indeed, tourists are often told—that its preeminence is established by law, out of deference to the father of his country. Not so. In 1899 the first *Heights of Buildings Act* was the city's response to a thirteen-story hotel, built in 1894. That law was superseded by another in 1910 that limited the heights of new buildings to 20 feet greater than the width of the adjacent street; under certain conditions it exempted "spires, towers, domes, minarets, pinnacles, penthouses over elevator shafts, ventilation shafts, chimneys, smokestacks, and fire sprinkler tanks."

The monument drew crowds of visitors even before it was officially opened to the public on October 9, 1888. In the 18 months following the dedication over ten thousand people labored up the steps to the 500-foot level; once the service elevator was converted to passenger use, the number grew rapidly; and it has been claimed that by 1888 the monthly average reached fifty-five thousand. In 2005 the NPS ranked the monument among the most-visited tourist sites in the capital, with about half a million visitors annually.

The NPS assumed responsibility for the monument in 1933; and the following year, as a job-creation project of the Works Progress Administration, it was

cleaned for the first time. A tubular steel scaffolding was erected, and for almost 5 months the faces were hand-scrubbed by steel brushes, using sand and water. The ring of fifty flagpoles—one for each state—was added in 1959.

The next (and much more ambitious) restoration project, jointly paid for by Congress and private corporations, was announced in October 1997; work started the following January. It was necessary to seal a number of exterior and interior cracks, clean and repair external surfaces, repoint 12 miles of external joints (and almost a mile of interior joints), and clean over an acre of interior surfaces. In addition, the commemorative stones were conserved; the heating and air-conditioning systems were upgraded; the lightning conducting system was replaced; the 500-foot observation level and the 490-foot exhibition level were improved; larger viewing windows were provided; and a new elevator cab was installed.

The spectacular scaffolding was itself an architectural achievement. Conceived by the postmodernist architect Michael Graves and jointly designed by engineer Alan Shalders and James Madison Cutts Consulting Structural Engineers, 37 miles of aluminium framework subtly sloped parallel to the monument's tapering faces. Concrete footings under the surrounding pavement carried its weight, and an ingenious bracing system meant that it touched the obelisk only lightly. Graves designed a sheath of transparent fabric whose pattern of blue horizontal and vertical lines reflected the masonry beneath. The Washington National Monument reopened to the public in late spring 2000; the restoration had cost around $9.4 million.

Changes to the immediate environment were occasioned by the disastrous events of September 11, 2001; a $15 million "security and landscaping enhancement project" was undertaken. The NPS closed the monument to the public in September 2004 to complete the final phase, reopening it on April 1, 2005. Changes by landscape architect Laurie Olin involved new pedestrian pathways and almost eight hundred new shade and flowering trees, increased external lighting, and granite paving on the plaza; benches of Georgia white marble surround the plaza. The key security element of the well-designed project is a series of interlocking rings of ash rose granite defensive wall, standing just 30 inches above the ground in depressions. They overlap at just the right points to stop an "explosive-laden Humvee." Retractable posts can be lowered for maintenance vehicles.

Robert Mills' Other Washington Monument

Built between 1815 and 1829, the Washington Monument in Baltimore's Mount Vernon neighborhood was the earliest architectural shrine honoring the first president. The statue atop the 178-foot structure could be seen from Baltimore's inner harbor; as Ishmael, the chronicler in Herman Melville's *Moby Dick*, observes, "Great Washington, too, stands high aloft on his towering main-mast in

Baltimore, and like one of Hercules' pillars, his column marks that point of human grandeur beyond which few mortals will go."

In December 1809 a group of prominent Baltimoreans petitioned Maryland's General Assembly for permission to hold a lottery to finance the monument. Passed on January 6, 1810, the legislation approved a sum of $100,000 and appointed "hand-picked leading Maryland citizens" to a Board of Managers to undertake the project. With only-to-be-expected red tape, the Managers in turn appointed a Lottery Committee, and the first of six lotteries was held in 1811. By 1813 enough money had accrued for the Board to announce a design competition, with a prize of $500. Of course, a separate Building Committee was needed to supervise construction.

The dates on the entries suggest that the competition was attenuated. They included a design by local dilettante architect Nicholas Rogers—one source hints at a "Masonic edifice"—and two for Neo-Classical triumphal arches, one by the French architect Joseph J. Ramée, and the other by Maximilian Godefroy, also a Frenchman who (imprudently in the circumstances) seems to have based his reputation on the fact that he was *not* American born. Robert Mills' sketches of November 1813 impressed the judges. His grand, expensive proposal envisioned a massive octagonal column resting on a base "with balconies at several levels, inscriptions, and a crowning statue representing Washington, dressed as a Roman warrior, riding in a horse-drawn chariot." Six months later Mills was awarded the prize and appointed architect. Godefroy, full of sour grapes, dismissed the scheme as a "Bob the small" pagoda, whatever he meant by that. As soon as the winner was made public, property owners around the proposed site protested, afraid that such a column—tall buildings were far from common in 1814—would collapse, or at the very least attract lightning. Colonel John Eager Howard donated a low hill on his rural estate at Howard's Woods, a mile north of the Inner Harbor, as an alternative site. About twenty-five thousand people attended the cornerstone-laying ceremony on July 4, 1815.

Construction progressed well enough for 5 years, and by the end of 1820 the column of Baltimore County marble was completed. The last monument lottery was held in 1824, but because the Board's revenues did not cover soaring construction costs, proceeds from the State Lottery met the shortfall. By 1843 the cost would pass $200,000—twice the estimated figure. Mills was forced to simplify his design. According to Roger Shepherd, it "went through four distinct phases, a process by which a very complex design [was] gradually simplified."

His final presentation drawing showed an unfluted, baseless column of white marble divided into seven levels with six "balustraded balconies set at decreasing intervals toward the top." As built, it alluded to (a term that architects use for "copied") the Austerlitz Column (1810) in Place Vendôme, Paris, which in turned evoked Trajan's Column of 113 A.D. in Rome. It stood on a low base and was crowned with an archeologically accurate Greek Doric

capital supporting a heroic statue of Washington. Mills wanted visitors to climb staircases within the double wall to reach the balconies where they could read historical inscriptions and view the city. The monument's iconography would present Washington as military hero. A stringent budget meant that his intentions were not fulfilled, but the detail is succinctly described by architectural historian Roger Shepherd:

> The major sculptural program consisted of a *quadriga*, or triumphal car, driven by George Washington guided by Liberty at the column's summit, a band of relief sculpture at the bottom, and four large groups of trophies of victory marking each corner of the monument's base. The progress of the Revolution could be followed, starting at the top with 1776 and descending year by year to 1781 at the base of the column. The names of heroes and battles were inscribed on the next top levels; a relief sculpture of Lord Cornwall's surrender at Yorktown encircled the column base, beginning 20 feet above ground level.

In the event, only a few elements of Mills' November 1813 design were used. As noted, the shaft was completely devoid of ornament, and he had to content himself with "the simplest of inscriptions in bronze letters" on the marble base, setting out Washington's Revolutionary War successes. He also designed an ornate cast-iron fence that evolved as design and construction progressed.

By 1824 the column and the capital were complete, but it was not until 1826 that the Board held another competition, this time for the crowning sculpture. The winner was the Italian Enrico Causici, who seems to have arrived in the United States in 1922 and had executed work in the Capitol in Washington, D.C. Prohibitive cost put paid to Mills' original vision of a toga-draped George Washington at the reins of a *quadriga* and flanked by Liberty. Instead Causici carved a 16-foot standing Washington—albeit toga-draped—"in the act of handing over his commission as Commander-in-Chief." To raise the three-section, 16-ton statue to its lofty perch, Mills enlisted the help of Captain James D. Woodside, a rigging specialist from the Washington Navy Yard. The final block was placed during the dedication ceremony on November 25, 1829. Frances Dean Whittemore wrote in 1933, "When the statue finally settled in position, it is said, a shooting star dashed across the sky and an eagle alighted on the head of Washington."

NOTES

1. Washington, George, "Undelivered First Inaugural Address." http://gwpapers.virginia.edu/documents/inaugural/fragments.html. Cited widely elsewhere.

2. "Washington and the Early Republic." www.nps.gov/history/NR/twhp/ wwwlps/lessons/62wash/62facts1.htm

3. Spalding, Matthew, "By George. It's Not Presidents' Day. It's Washington's Birthday." *National Review Online* (February 17, 2003). www.national review.com/flashback/spalding200402160805.asp

4. Joseph, Peter, "Public Works." *Lost Magazine* (October 2006), 1.

5. Kammen, Michael, *Visual Shock: A History of Art Controversies in American Culture*. New York: Knopf, 2006, 4.

6. Harvey, Frederick L., *History of the Washington Monument and Washington National Monument Society*. Washington, D.C.: Government Printing Office, 1903, 26–28.

7. Kimball, Sidney Fiske, "Robert Mills, Architect," in Frances Archer Christian and Susanne Massie, eds., *Homes and Gardens in Old Virginia*. Richmond: Garrett and Massie, 1931.

8. Olszewski, George J., *A History of the Washington Monument, 1844–1968*. Washington, D.C.: Office of History and Historic Architecture, 1971.

FURTHER READING

Allen, Thomas B. *The Washington Monument: It Stands for All*. New York: Discovery Books, 2000.

Binczewski, George J. "The Point of a Monument: A History of the Aluminum Cap of the Washington Monument." *JOM*, 47(no. 11, 1995), 20–25.

Bryan, John Morrill. *Robert Mills: America's First Architect*. New York: Princeton Architectural Press, 2001.

Crosbie, Michael J. "The Monument and the Mall; Architect of Monument (1848-1884): Robert Mills, Modern Landscaping by: Dennis Piper. . . ." *Architecture (AIA)*, 73(December 1984), 74–79.

Freidel, Frank Burt, and Lonnelle Aikman. *George Washington: Man and Monument*. Washington, D.C.: Washington National Monument Association, 1988.

Jacob, Judith M. *The Washington Monument: A Technical History and Catalog of the Commemorative Stones*. Lowell, MA: NPS, 2005.

Liscombe, Rhodri Windsor. *Altogether American: Robert Mills, Architect and Engineer, 1781–1855*. New York: Oxford University Press, 1994.

Olszewski, George J. *A History of the Washington Monument, 1844–1968*. Washington, D.C.: Office of History and Historic Architecture, 1971.

Savage, Kirk. "The Self-Made Monument: George Washington and the Fight to erect a National Memorial." *Winterthur Portfolio*, 22(Winter 1987), 225–242.

Torres, Louis. *"To the Immortal Name and Memory of George Washington"*: The United States Army Corps of Engineers and the Construction of the Washington Monument. Honolulu, HI: University Press of the Pacific, 2001.

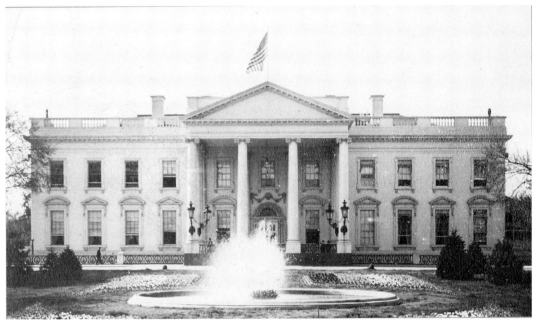
Courtesy Library of Congress

White House, Washington, D.C.

Always the same?

Even as far away as Australia, boys of past generations were encouraged always to tell the truth by the following cautionary tale. Mason Locke Weems included it—but not until the fifth edition, published around 1800—in *A History of the Life and Death, Virtues and Exploits of General George Washington*. When a boy, George used a new hatchet to chop down his father's cherry tree. Confronted by his angry parent, he was about to deny the crime; but then, "looking at his father with the sweet face of youth brightened with the inexpressible charm of all-conquering truth, he bravely cried out, 'I cannot tell a lie. I did cut it with my hatchet.'" His father forgave him, and the little axe passed into folklore. Later it would figure in another story, no less apocryphal: a traveler saw a sign in front of a Virginia farmhouse: "For Sale. The original hatchet used by Washington to chop down the cherry tree." When he asked the farmer if it was *really* the famous hatchet, he was told, "Well, it's had only six new handles and seven new heads, but it's still the original hatchet!"

In the same way the White House, built for George Washington, has been demolished and rebuilt, gutted and refurbished, altered and realtered but is still regarded as the "original" house. Historian William Seale believes that it is "perhaps the most remarkable artefact of the American nation" and claims despite the changes, "it is always the same. Its idea has become its essence." As will be shown, though the White House today *looks* substantially as it has for two centuries, it certainly is *not* the same. However, it is a national icon that is internationally associated with—even synonymous with—the American presidency.

Presently, what is known as the "White House Complex" is constituted by four main structures with a total floor area of 67,000 square feet—a little over 1½ acres. The Executive Mansion is the home of the U.S. president and his family; the East Wing serves as the formal entrance to the State Rooms in the Mansion; the Old Executive Office Building houses the presidential and vice-presidential executive offices; and the West Wing is the location of the "Oval Office," the hub of government made familiar to world-wide audiences through NBC's seven-season television series.

Bradley Patterson, a former staffer, wrote that in 2000 White House personnel extended far beyond the seventy-five people employed in the West Wing and the ninety-six in the Executive Mansion. Besides those in the Executive Office, there were 125 "separately identifiable offices in the total . . . staff community . . . employing nearly fifty-seven hundred men and women"—"cooks and ushers, security personnel, secret service, military officers, the people who fly and maintain Air Force One, and most important, a growing number . . . who make and execute government policy." The latter group, he added, "shrouded in anonymity, protected by executive privilege, and lacking legal or constitutional authority of their own, . . . shape, focus, and amplify the Presidential power."[1] A "White House *Complex*" indeed!

This essay is limited to a discussion of the origins and architecture of the Executive Mansion, and the succession of major changes made to it. In an

American Institute of Architects survey of eighteen hundred citizens published in February 2007 it was voted the people's second-favorite building. The residence has been known as the "President's Palace," the "Presidential Mansion," or simply the "President's House." Dolley Madison, wife of the fourth president, called it the "President's *Castle*." It seems that (because of its white-painted exterior) by 1811 the public knew it *de facto* as the "White House." However, "Executive Mansion" was its formal title until 1901; then President Theodore Roosevelt had "White House—Washington" engraved on his stationery. About 30 years later another Roosevelt, Franklin, changed the letterhead to "The White House" with "Washington" centered beneath it.

A "STYLE PROPER FOR THE CHIEF MAGISTRATE"

During the establishment of the federal capital of the United States, it seems that George Washington poked a finger into every pie. He personally chose the location of the federal district, and although he had appointed three commissioners to oversee its development, he engaged the city planner and worked on the layout with him. He selected the quarry from which stone for the public buildings would come; and (in a less than transparent process) he manipulated the outcome of the design competition for the president's house. Having placed his permanent stamp on the city which bore his name, in March 1797 he declined to run for a third term of office and retired to Mount Vernon. During his administration the seat of government was never in Washington, D.C. He never lived in the White House.

The Residence Act, that established the seat of federal government, was passed on July 16, 1790. A few months later, after a quite perfunctory assessment of alternative locations, the president chose the rather swampy site on the banks of the Potomac River. The State of Maryland willingly ceded two-thirds of the specified 100 square miles of the federal district, and the State of Virginia the remainder.

In 1776 Paris-born Pierre Charles L'Enfant, after training at the French Royal Academy of Painting and Sculpture as an urban designer, architect, and engineer, moved to America and volunteered for the Continental Army. During the War of Independence he served with distinction in the Corps of Engineers, reaching the rank of major. In September 1789, 5 months after Washington was elected president, L'Enfant petitioned him for "the favor of being employed in the business" of designing a federal capital, which (the Frenchman believed) should be "on such a scale as to leave room for that aggrandizement and embellishment which the increase of the wealth of the nation will permit it to pursue at any period."

Early in 1791 Alexander Hamilton, the secretary of the Treasury, recommended L'Enfant, his war-time friend, as the person best qualified to design the capital. L'Enfant was duly commissioned, and by the middle of the year

he had presented Washington with a sketch proposal. Kenneth Bowling asserts that the "exacting and uncompromising design" would be more aptly named the L'Enfant-Washington plan, because planner and president collaborated. Late August saw a resolved city plan, "projected agreeable to the direction of the President of the United States."[2] Within months, to use a modern phrase, everything went pear-shaped.

The conventional wisdom has it that L'Enfant was fired for insubordination. But according to Bowling, he "quit, but only after making Washington grovel, as the President desperately sought to retain his services." Fellow-historian Christopher Sterling agrees:

> The designer worked closely with Washington for several months, but then [he] ran afoul of the Presidentially appointed commissioners in charge of the city's development. After several attempts to keep L'Enfant employed on a project that he clearly loved, Washington reluctantly gave up trying to rein in his designer, and L'Enfant resigned. . . . [In early 1792] Washington and Thomas Jefferson both moved quickly to defuse the growing political crisis—the three commissioners had threatened to resign—and planning went ahead without L'Enfant's participation.[3]

The circumstances were these. The commissioners complained that the "capricious and malicious" L'Enfant, quite the *prima donna*, caused them "more than a little trouble and vexation" because although they had few ideas of their own "they could never bring [him] to take into account either their persons or their ideas; he would acknowledge no chief except Washington."[4] A couple of examples should suffice. In October 1791, to expedite land sales, they asked L'Enfant for a printed copy of the city plan. He provided only sketches because he believed that the sales were precipitate. Later, enraged to learn that someone was building a mansion near the Capitol site, L'Enfant ordered it removed; when the owner refused, L'Enfant unilaterally authorized its demolition. The influential owner was outraged and complained to the president, who reproved L'Enfant (but only publicly). Elise Hartman Ford has observed that "a more personable man might have won over the reluctant landowners and commissioners, inspiring them with his dreams and his passion, but L'Enfant exhibited only a peevish and condescending secretiveness that alienated one and all."

With his protégé gone, Washington hired the surveyor Andrew Ellicott, who earlier had set out the District of Columbia's boundaries, to complete a town plan based on L'Enfant's proposal. When L'Enfant refused to pass on his documents Ellicott, working from memory, had a plan "ready for the engravers" within a month. He made some changes, but the design remained essentially the same. Crossed by diagonal avenues with circular plazas at their intersections, and overlaid with a grid pattern of streets, the plan borrowed the baroque grandeur—actual and proposed—of Europe: central Dresden, Wren's and Evelyn's rebuilding plans for London, and André Le Nôtre's setting

for the Palace of Versailles. It had three main foci. The "Congress House" (now the Capitol) stood on high ground then known as Jennin's Heights; from it an axial "Grand Avenue" (the National Mall) extended westward to the Potomac, terminated by an equestrian statue of George Washington (where the Washington Monument now stands).

The "President's Palace"—Washington himself selected the spot—was at the end of a minor axis to the north, and linked to the Capitol via a mile-long diagonal thoroughfare (Pennsylvania Avenue). Although little detail of L'Enfant's notional palace is discernable on the early small-scale maps, it was grand and pompous—four times the ground area of the White House as eventually built, and 20 feet higher. Like the entire city plan, the house conveyed the Federalist Party's "exalted, monarchical notion of the Presidency." It seems that Washington himself, who at least as early as 1784 had referred to the Unites States as an "empire," was not averse to that idea. According to Seale, the Federalists argued that

> Americans wanted their President to establish a high tone, essentially as an elected king set apart from the people. Washington himself thought that, as President, it was his responsibility "to conform to the public desire and expectation with respect to the style proper for the Chief Magistrate to live in." This logic required that the Chief Magistrate live in a palace.[5]

Eighty-two acres had been reserved for a park around the house, with "reflecting pools, water cascades, groves and meadows" and a vista southward to the equestrian statue. Such unseemly pretentiousness in the city and the house stuck in the craws of the Republicans (not the same as modern Republicans), who believed that the center of government should "evoke simplicity rather than the aristocratic airs [of] the kingdoms of Europe." Their response to what they anticipated to be the potential abuse of presidential authority was to systematically undermine L'Enfant's plan as inappropriately grandiose for a democracy. They felt much the same way about the incipient proposal for the president's house.

JAMES HOBAN: "WASHINGTON'S MAN"

In March 1792 the commissioners told Jefferson, then secretary of State, that Washington had mentioned an architect whom he had met in Charleston, South Carolina, during his presidential tour in summer 1791, and who had had been "highly recommended" to him. They assured Jefferson, "If [the President] still approves of him . . . we will endeavor to engage him." When Washington said that he was unable to recall the man's name, Jefferson suggested that there should be two national design competitions, open to all—one for the house and another for the Capitol building. A newspaper advertisement of March 14, 1792, offered "a premium of 500 dollars or a

medal of that value [to the] person who before the 15 July next shall produce . . . the most approved plan . . . for a Presidents [*sic*] house." The format and content of the entries was prescribed: "Drawings . . . of the ground plats [*sic*], elevations of each front and sections through the building in such directions as may be necessary to explain the internal structure, and an estimate of the cubic feet of brickwork composing the whole mass of the walls." That was all. Interested parties were urged to seek a full briefing from the commissioners.

Nine proposals for the house were submitted. Jefferson anticipated "in view of the dearth of talent," that not all would meet the artistic standards required for such an important building. So although he was on the judging panel, he went to the "astonishing length" of making two designs of his own, one of which he anonymously entered. Among the other contenders were the recently-immigrated French architect Étienne-Sulpice (aka Stephen) Hallet; the Maryland inventor James Diamond; and one "A.Z." (probably John Collins, a Richmond, Virginia, builder whose design, without prize, was the runner-up). Jefferson had been right. One commentator has noted, "Although they represented a great effort to surpass the ordinary buildings of the colonies, few [submissions] conformed even to Jefferson's grammatical standards of detail." Another describes most of the designs as "awkward and naïve." Anyway, perhaps the competition was no competition at all.

Washington traveled to the federal capital site on July 16, 1792, the day after the competition deadline. The next day, after what must have been a very superficial review by him and two of the commissioners (Jefferson was absent), James Hoban of Charleston was awarded the premium. He was the man whose name Washington had claimed to have forgotten. Over the preceding 2 months, Washington had given him what seems to have been a private briefing about the type of design envisioned for the residence. The exact circumstances remain obscure, but one writer cryptically notes that "Hoban was making his own representations"; another calls him "Washington's man." It may be significant that the architect, although a devout Roman Catholic, was (like his presidential patron) a Freemason. At that time, Pope Clement XII's 1738 prohibition against lodge membership was not being enforced by American church leaders.

Hoban was born in 1762 on the Earl of Desart's estate in Co. Kilkenny, Ireland. There he was trained as a carpenter and wheelwright before studying architecture and drawing at the Royal Dublin Society. From 1780 he was a draftsman in the architectural office of Thomas Cooley, and he later worked for James Gandon. He also may have conducted—albeit briefly—an independent practice in Dublin before emigrating with his wife and children in 1783. Little is known of his American career before he won the competition for the president's house, except that he was employed as an architect in Philadelphia in May 1785. Two years later he moved to Charleston, South Carolina, where he designed domestic and commercial buildings.

Architectural ideas have been transmitted in many ways: traveling architects, craftsmen, or clients; images; and of course books. Besides those architects familiar with Palladianism—an aesthetic based on the writings of the Italian Andrea Palladio and "made English" in the early 1600s by the sole effort of Inigo Jones—lesser British designers, by-passing the theory, depended largely upon "pattern books," collections of standard designs for all kinds of buildings. After about 1780 over sixty such volumes were published and carried to British colonies throughout the world by dilettantes, architects, builders, and craftsmen. It is difficult to link specific buildings with specific patterns; because provenance of the books is often obscure it is hard to discover who owned what, and—whether to mask banality or celebrate creativity—many builders hybridized assorted sources, rather than copy entire designs.

Following a suggestion made by a German historian in 1826, many popular sources still insist that Hoban's "somewhat conservative" White House was modelled on Leinster House in Dublin, designed in 1745 by Richard Cassels for James FitzGerald. One writer even claims that "the projecting bow on the northern side of [Leinster house] is said to be the prototype for the bow-fronted White House." In fact, although they were common in Irish Palladian great houses, neither facade of Leinster House *had* a bow. Anyway, quite apart from major differences in the buildings, it is difficult to believe that Hoban could have remembered for almost 10 years anything more than a general impression of the Dublin mansion.

The architectural historian Sidney Fiske Kimball pointed out as early as 1916 that there are as many differences as commonalities between the two buildings: there were no similarities in their plans; while both had long façades with eleven bays and a similar central pavilion—common in contemporary great houses—Leinster House employed the Corinthian order, while Hoban used the Ionic; Leinster House's lowest level was above the ground, whereas Hoban's original design seems to have included a half-basement. It seems much more likely that Hoban's design was a composite, based on the pattern books—a plan from here, an elevation from there, a detail from somewhere else. Some scholars, including Kimball, believe that he was alluding to (an architect's expression for "copying") a plan and elevation in *A Book of Architecture, Containing Designs of Buildings and Ornaments*, self-published in 1728 by the Scots Palladianist James Gibbs. That design coincidentally may have been tempered with recollections of Leinster House. The Library Societies in Charleston, South Carolina, and Philadelphia, Pennsylvania, owned a copy in 1792; so did Thomas Jefferson.

Hoban's successful design suggests that Washington's aspirations had descended somewhat from the palace proposed by L'Enfant. Yet despite their earlier consultations, in which the architect almost certainly "tested" precompetition ideas with Washington, the president was not completely satisfied with the original proposal, for a three-story building. He thought it was too small and, although it was palatial by contemporary American standards, he

believed that it was not imposing enough for the first citizen and wanted to increase its size. On the other hand, and for the ideological reasons already outlined, the commissioners thought just the opposite; Jefferson would later complain that it was "big enough for two emperors, one Pope, and the grand Lama." He also contended that it should be built of brick—as the sloppily-drafted competition rules had specified—rather than of stone.

Perhaps because funds were limited, or perhaps because of a lack of skilled artisans, a compromise was reached. When the commissioners "protested the scale" Washington agreed to omit "the raised rustic base story and increased the volume of the house by twenty percent." But he insisted upon a *stone* house, "elaborately rendered in the grand Anglo-Palladian manner." And he would later claim, attempting to justify the extravagance, "It was always my idea . . . that the building should be so arranged that only a part of it should be erected at present; but upon such a plan as to make the part so erected an entire building." Seale writes,

> The White House broke with all American precedents not only because of its great scale, but also because of the richness of the stone carving. President Washington overrode the opinions of Thomas Jefferson and the city commissioners to make [the] house stone instead of brick. The elegant swags of oak leaves and flowers, the window hoods, the lofty pilasters, and the charming motif of cabbages roses were all executed to suit Washington's taste.[6]

FROM REVERIE TO REALITY

The choice of a remote, sparsely settled location for the national capital on land that had been ceded by the two states with the highest level of slave ownership—about half the country's slaves lived in Virginia and Maryland—inevitably had a bearing on the availability of labor to construct its public buildings. The federal commissioners conscientiously sought white artisans and unskilled workers, but the predominance of slave labor in the area depressed local wages, making it difficult to hire paid labor. When urged by Washington himself, the commissioners' attempts to import indentured workers from Europe also failed; they had to rely on African Americans to provide the bulk of labor on the White House and the Capitol Building. In April 1792, when the commissioners were "bragging" that more than two thousand mechanics and laborers were prepared to work in Washington, they were also advertising for hiring slaves on an annual basis. The number they employed as common laborers increased from about sixty in 1793 to perhaps as many as 120 five years later, among a total workforce of two hundred or so, when building operations reached their peak.

Each slave cost $60 a year; of course, all the money went to his master. Working beside paid white workers and free blacks, often every day during

the high-activity summer months, slaves were engaged in site excavation, haulage, brick-making and laying, carpentry, nail-making, and as masons' laborers. They lived in huts on the White House building site; beef, pork, mutton, Indian meal, and bread was provided, and a dispensary was set up for them. The commissioners rented only "slaves they described as 'laborers' and never trained [them] to do skilled labor." Their involvement limited the wage demands of white workers. However, records suggest that Hoban's own slaves and another belonging to one Peirce Purcell, who were already qualified as carpenters—the trade in highest demand—undertook skilled work, probably from 1794 until late 1797.

The remoteness of the capital site gave rise to another problem: apart from brick clay, building materials were unavailable close at hand. In 1791 the government acquired a privately operated sandstone quarry on Wigginton's Island—later known as Government Island—along Aquia Creek in Stafford County, Virginia, where a few years earlier Washington had bought paving and garden steps for his Mount Vernon estate. The beige and gray stone was not really suitable for construction; nevertheless, at Washington's request, it was specified for the foundations and the external facings of the house. The master mason Collen Williamson trained slaves to rough-cut giant blocks, that then were transported 40 miles up the Potomac on shallow-draft schooners and unloaded at Commissioners' Wharf. They were hauled by black laborers to the building site, to be cut, dressed or carved, and set by a team of eighteen stone masons, most of whom had been recruited in Scotland in 1793. The external walls were lined with bricks that were burnt in clamps on what is now the north grounds of the White House. Because the Aquia Creek stone was porous, a protective coat composed of lime, rice glue, casein, and white lead was applied. That gave the house its familiar color and name.

The finer timbers for flooring and joinery came from plantations in Virginia and North Carolina. The coarser stuff for structural framing came from White Oak Swamp near Richmond, Virginia, where it was felled by slaves and rough-cut at a mill before being carried on rafts 100 miles up the Potomac. It was pit sawn into joists and beams on-site. Much of the other skilled work was carried out by Irish and Italian immigrants.

A HOUSE FOR "HONEST AND WISE MEN"

In the face of these inconveniences, the White House took a long time to build. Freemasons from the Georgetown Lodge No. 9 of Maryland, Hoban among them, laid the cornerstone at the southwest corner of the Executive Mansion on October 13, 1792. By the time John Adams succeeded Washington in the presidency in 1797, the walls had been topped and the roof had been framed. Over the following 3 years the joinery was installed, and some interior walls were plastered. By then construction of the simple, rectangular

house already had taken slightly more than 8 years, and cost a little over $232,000.

When the federal government relocated from Philadelphia to Washington in November 1800, Adams moved into an unfinished White House, just 4 months before his term ended. Many of the plastered walls were still wet; about half were not plastered at all. Hoban's proposed Grand Staircase was not even started. On his second evening in the mansion the president wrote to his wife, "I pray Heaven to bestow the best of Blessings on this House and all that shall hereafter inhabit it. May none but honest and wise Men ever rule under this roof."

The Adamses were hardly delighted with their accommodation, and had the Secretary of Navy Benjamin Stoddert advise the city commissioners that it would "give the President and Mrs. Adams great satisfaction [if] something like a garden [is provided], at the north side of the President's House"; otherwise "that large, naked, ugly-looking building will be a very inconvenient residence for a family." Moreover, there was no plumbing, and servants had to cart water for five city blocks. Abigail Adams justifiably grumbled,

> We had not the least fence, yard or other convenience without, and the great unfinished audience room, I made a drying room of—nor were there enough lusters or lamps, so candles were stuck here and there for light—neither the chief staircase nor the outer steps were completed, so the family had to enter the house by temporary wooden stairs and platform.[7]

At the beginning of the nineteenth century the future of the yet-incomplete national capital was in doubt. The Senate voted $50,000 to expedite public works. In March 1803 Jefferson, the third president, offered the professionally trained English architect Benjamin Henry Latrobe what the latter bitterly described as the "magnificent appointment of surveyor to the public buildings of the United States, an office attended with enormous expense and small salary, and which has . . . furnished me with most laborious employment in detecting the villanies [*sic*] and correcting the blunders of my predecessors." Latrobe had emigrated to Virginia in 1795. In Philadelphia 3 years later he had set up an architectural and civil engineering practice, producing several notable works.

Although most of his time and budget was spent on the United States Capitol, in 1805 Latrobe collaborated with Jefferson—himself a dilettante architect who wanted to "apply his own architectural ideas"—on changes to the White House. To make it "less boxlike and more graceful," they proposed north and south porticoes, which, when built 20 years later, would become the house's most distinguishing features. Jefferson also designed low colonnades linking the mansion with single-story east and west wings that housed stables and store rooms. Latrobe, commissioned to build them, confided in a letter to his chief assistant (that, embarrassingly, was delivered to Jefferson by

mistake) that he was "cramped" by Jefferson's "prejudices in favor of the old French books," but allowed that "the style of colonnade he proposes is exactly consistent with Hoban's pile—a litter of pigs worthy of the great sow it surrounds and of the wild Irish boar their father." Latrobe also replaced the wooden bridge about which Mrs. Adams had complained with a permanent crossing of stone (it still constitutes part of the north portico); installed a grand staircase; re-covered the leaking slate roof with sheet iron and carried out some landscaping.

Succeeding Jefferson in 1809, President James Madison moved into a structurally complete President's House. Before his inauguration he appointed Latrobe "agent of the furniture fund" and commissioned him to design "an elegant suite of rooms" incorporating what is today the Blue Room, Red Room, and State Dining Room. After the inauguration Latrobe realized the schemes: "done up in high English Regency taste, the sumptuously outfitted suite featured neoclassical furniture. Silver and glass wall lamps shone on crimson velvet curtains in one room, and sunflower yellow in another." Mrs. Madison supervised Latrobe's designs for a set of thirty-six chairs, two sofas, and four settees for the newly decorated drawing room, as well as the purchase of furnishings and redecorating of other principal rooms. Tragically, when the British burned the White House only 5 years later, all would be destroyed. In 1811 war with Britain was looming, and Congress, withholding any more funds for building, abolished Latrobe's official position; although his work in Washington had ended, he continued to advise Dolley Madison until 1813.

"A UNIQUE AND POWERFUL SYMBOL"

The United States declared war on Britain on June 18, 1812. The conflict centered around the press-ganging from U.S. vessels of over ten thousand sailors—on the pretext that they were British—to fight in the Napoleonic Wars. There were other reasons, including festering disputes over Canada's border and an attempt to impose a trade blockade that had resulted in the impounding of about fifteen hundred American vessels. But that is not our theme. In April 1813 an American force burned the parliament buildings at York (now Toronto), the Upper Canadian capital. In August 1814, bent on retaliation, British troops landed at Chesapeake Bay and marched north, meeting little resistance; their fleet followed up the Patuxent River. Their primary target was the poorly defended federal capital, then "a meager village with a few bad houses and extensive swamps." But the invaders reasoned that sacking the city, because of its symbolism, would demoralize their enemies—perhaps even lead to the collapse of the United States. On August 24, following a victory at Bladensburg, the British vanguard advanced on Washington; the force was too small to occupy the capital and its intent was to create

havoc. They put to the torch the Treasury, War Department, and the unfinished Capitol. They then turned toward the President's House.

At about 11 P.M. one hundred and fifty British sailors entered the building. The Madisons had fled. Finding the table laid and dinner prepared for a party of forty, the seamen wolfed the food, then looted the house and set fire to it. Although the thick sandstone external walls survived, they were structurally weakened; only the basement level, the south front, and the pedimented central pavilion of the north front remained sound. The floors, inside walls, and the roof were destroyed. After a 26-hour orgy spent torching almost all of Washington's public buildings, as well as a few privately owned business premises, the British returned to their ships. Within a week the invading force was dispatched to Baltimore.

After the attack on the capital, some congressmen wanted to relocate the President's House in Cincinnati where the government would be more defensible. But when in January 1815 America's decisive victory over the British in New Orleans restored national pride, Congress approved the reconstruction of public buildings in Washington because the idea of rebuilding in the nation's capital became symbolic of triumph. A month later peace with Britain was secured through the Treaty of Ghent and the protagonists restored the *status quo*. More than seventy-two hundred men had died for nothing. Nobody won the War of 1812; then, nobody wins *any* war.

In 1817 Latrobe, who had been recalled to Washington to reconstruct the Capitol, finalized the designs for the White House's north and south porticoes. Madison insisted on restoring the executive mansion to exactly what it had been before the fire, and Hoban was commissioned to supervise the rebuilding. In autumn President James Monroe moved into the partially restored house. The formal entrance, reception rooms, and executive offices were on the first floor; the second was dedicated to private and family use, and the laundry, kitchen, and other domestic functions, together with household staff quarters were housed, in the "dank and poorly lit" groin-vaulted basement. The East Room was incomplete, plastered walls and joinery had not been decorated, and floorboards were still unfinished and bare.

Seven years later, working to Latrobe's specification, as noted, Hoban completed the south portico, with its now-famous double stairs curving up to a porch. In another 5 years, during Andrew Jackson's presidency he completed the north portico, also designed by Latrobe; it was built above the driveway to form a *porte cochere* at the level of the state rooms. As Jefferson intended, the porticoes "further distinguished the President's House as a unique and powerful symbol." And with their completion, regardless of later internal changes (of which there were many), the image of the White House as it is known globally today was achieved. Stylistically, its message was enigmatic: although its final form was achieved during the American Greek Revival, it is neither Greek Revival in style, nor really American. Influenced by contemporary English architectural fashion, it owes most to the eighteenth-century

English Palladian residences of the Whig aristocracy, who were hardly the wellspring of American republicanism.

MAKING THE HOUSE INTO A HOME

The White House is the president's private residence, no matter how long his tenure. From Jackson's administration until 1902, successive incumbents and their wives have refurbished the interiors in response to the needs of their families, to their different tastes, and to fashion.

It seems that only Abraham Lincoln, his mind on weightier matters, cared little about the house, which "was, he said, furnished well enough when they came—better than any house they had ever lived in." He strongly disapproved of his wife's overspending on "flub dubs for that damned old house!" because "it would stink in the land to have it said that an appropriation of $20,000 for furnishing . . . had been overrun by the President when poor soldiers could not have blankets." Yet it has been claimed that after Lincoln, the White House was "no longer just a house, but an icon of the Presidency and all that America stood for."

In 1873 President Ulysses Grant had the interiors redecorated in an elaborately ornamented high Victorian style officially described as "pure Greek" but ridiculed by some critics as "steamboat Gothic"—an epithet derived from its use in river paddle steamers. About 10 years later President Chester Arthur disposed of twenty-four wagon loads of "old furniture and junk," including "carpets . . . ; chandeliers; children's high chairs; marble-top tables; leather-covered sofas, ottomans, and dining-room chairs; cuspidors; lace curtains; globes; and rat-traps"—and commissioned the famous art nouveau designer Louis Comfort Tiffany to refurbish the state floor. It is said that "practically every surface was transformed with his decorative patterns." The floor-to-ceiling opalescent glass screen, with a geometric design depicting parts of the national emblem in red, white, and blue, that Tiffany designed for the Entrance Hall was disposed of on Theodore Roosevelt's specific orders during a "massive rehabilitation" of 1902.

Over the same period modern conveniences were introduced: running water in 1833, central heating in 1837, gaslight in 1848, a telephone in 1879, and electrical wiring in 1891; ironically, all contributed to the decline of the house. By the end of the nineteenth century, as one commentator drily notes, "the Executive Mansion could well have been described as a lavish menagerie of various tastes with an overarching maintenance problem." Before 1902 most *new* construction at the White House had taken place in the grounds: conservatories, stables (later converted to a garage), and repeated transformations of the gardens and landscaping. Because the mansion itself is the main theme of this essay, a summary of the major architectural changes that were effected in 1902 beyond the house must suffice.

"CONSERVATION MEANS DEVELOPMENT AS MUCH AS IT DOES PROTECTION."

The Park Improvement Commission of the District of Columbia—the "Mc-Millan Commission"—was convened in April 1901, with Beaux-Arts architect Charles Follen McKim as one of its four appointed members. Extending its purview considerably beyond the brief to "restore and develop the . . . plans of Major L'Enfant for Washington and to fit them to the conditions of today" it reported that the White House had been overcrowded for several years because of "the rapid increase in public business" with the consequence that the president's private spaces and those intended for receptions and social events had become "primitive to the last degree"—perhaps that was a slight hyperbole. The McMillan Commission offered three possible solutions. The first was to extend the house to the east and west, although it warned that measure would cause "the loss of those characteristic features which endear the edifice to the American people." A second alternative, which also held little appeal, was to use the existing building solely for public business, and build a new presidential mansion on one of the hills overlooking the city.

The third—a recommendation favored by the incumbent president Theodore Roosevelt—would be to relocate the executive offices and devote the White House "entirely to residence purposes." In accordance with his own aphorism, "Conservation means development as much as it does protection," and complaining of the "incongruous additions and changes" that had disfigured the mansion, Roosevelt opted for an extensive remodeling. He wanted to "tread lightly" (though, as noted, he carried a stick big enough to vandalize Tiffany's wonderful décor) and merely remove the Victorian encrustations of the previous 30 years to return the White House to its "Federal-period roots." In consultation with the president's wife Edith, McKim's changes to the house (including the basement) doubled the living space available to the Roosevelts with their "large and rambunctious family of six children." Roosevelt had ordered the architect to finish the work in 6 months; commenced in June 1902, it took only 4. The president approvingly and piously remarked, "It is a good thing to preserve such buildings as historic monuments which keep alive our sense of continuity with the nation's past."

But McKim's "preservation" (more accurately, "renovation") was a stylistic pastiche, much of which was poorly executed, perhaps because of the unseemly haste. One critic accuses the architect of holding "little regard for historical elements, and [working] fast to strip the house of most of its floors and cover over old walls with new plaster . . . the result was more Georgian than federal."

Besides the cosmetic changes, he removed the original grand stair and made the stair by the Entrance Hall "a grander affair." He also provided bathrooms on the residential floor, installed an elevator, and replaced most gaslights with electric lights. Congress also provided funds for separate

"wings." Although Roosevelt maintained another office in the house, McKim designed a rectangular "temporary office building"—the West Wing—with a basement and a first floor, on the former site of the conservatories. It seems that it also was jerry-built, and in 1909 President Taft engaged the architect Nathan C. Wyeth to extend it to include the first Oval Office. Following extensive damage by an electrical fire on Christmas Eve 1929, Herbert Hoover had the building repaired without making significant changes. In 1933 and 1934 Franklin Roosevelt commissioned the architect Eric Gugler to effectively double its area by adding a second floor and extending the office and services spaces in the basement. The Oval Office was relocated in the southeast corner. It should be noted that, the TV series *The West Wing* took liberties (to put it mildly) with its depiction of the building, probably for production reasons.

McKim's glass-enclosed East Wing was constructed on the foundations of Jefferson and Latrobe's original building that had been demolished in 1866. The new building, with a *porte cochere*, provided a formal entrance for state occasions; it served twenty-seven hundred guests. In 1942 President Franklin D. Roosevelt engaged the architect Lorenzo Simmons Winslow to redesign the wing "primarily to cover the construction of an underground bunker" (now the Presidential Emergency Operations Center). He also added a second floor for offices; the cloakroom became the family movie theater.

THE THIRD FLOOR

President Taft had a "sleeping porch"—a cool place to sleep on hot nights—built on the roof of the White House in 1909. The house always had an attic, originally used as storage space. There were also eight small sloped-ceiling bedrooms for servants—first for slaves and then for paid help; afraid of being trapped in a fire, most preferred to sleep in the basement, despite the dampness. The 1902 renovation had expanded the attic to provide guestrooms and a space later used as a painting studio by Woodrow Wilson's first wife, Ellen.

Calvin Coolidge discovered how leaky the roof was during a rainstorm. In 1927 he had the New York "upper-class" Beaux-Arts architect William Adams Delano enlarge the attic, replacing its floor with a steel and concrete one to create a complete third level of guest and service rooms under a new steel roof. The alterations further weakened the fabric of the old structure, already affected by the "somewhat hasty" changes made in 1902. The new third floor survived the Truman reconstruction of 1948 to 1952, described below, when more minor "improvements" were made. Since then it has undergone several interior refurbishments as each first family left its mark. It now houses several bedrooms, a billiards room, a workout room, a music room, and a sunroom—twenty rooms in all—and nine bathrooms.

THE TRUMAN BALCONY

In summer 1947 President Harry S. Truman decided that a second-floor balcony behind the south portico's columns would make his private quarters more "liveable." The notion, though approved by Delano, encountered "a tremendous outcry from the press and the general population—perhaps more political than anything else . . . [Many] regarded the issue as symptomatic of Truman's "blustery . . . style, his hard-headedness, his unbending certainty that he was right." The president justified his proposal on aesthetic and practical grounds. The portico columns (he said, perhaps under advice from a sycophantic architect) were of "outlandish, disproportionate height" and that a balcony would visually balance the south front. Moreover, the "dirt-collecting awnings" that shade the windows of the Blue Room could be replaced with "neat wooden shades [that could be] rolled up under the balcony."

When the Commission of Fine Arts opposed the plan because it would spoil the original design of the house Truman retorted in a peevish letter to its chairman:

> Of course, I wouldn't expect you to take into consideration the comfort and convenience of the Presidential family in this arrangement. . . . I certainly would like to have your reasons for preferring the dirty awnings to the good-looking convenient portico and then maybe I'll come to a conclusion on the subject. I don't make up *my* [emphasis added] mind in advance.[8]

By March 1948 the President got his way, and the $16,000 cost was met with money saved from his household account. It took some time for the shouting and tumult to die, and eventually many architectural gurus actually commended the addition. Most people agreed that it improved the look of the White House. Ironically, Truman was able to enjoy his balcony for less than half of his remaining time in office. The Executive Mansion was on the verge of collapsing.

A CLEAR AND PRESENT DANGER

When Truman moved into the house in 1945 he noticed extensive cracking in the plaster. Over the following months he observed that chandeliers were apt to sway and the floors in several rooms moved even under light traffic. In February 1948 he commissioned engineers and architects to undertake a structural survey of the second floor; one engineer told him that the state dining room ceiling "only stayed up from force of habit." The president wrote to his sister, "The second floor where we live . . . is about to fall down!" In May Congress voted $50,000 for an investigation of the overall structural condition of the house. Then in summer a spinet in his daughter Margaret's sitting

room broke through the floor. Temporary measures were taken to shore up the interiors until in November Truman wrote again to his sister, "The White House is in one terrible shape. There are scaffolds in the East Room, props in the study, my bedroom, Bess's sitting room and the Rose Room. . . . We've had to call off all functions. . . ." Indeed, the inspection revealed problems so alarming that it was decided that the first family should move Blair House on the other side of Pennsylvania Avenue until renovations were completed.

There were three major issues. First, the dryness of the timber throughout the interiors presented a fire hazard (Franklin Roosevelt dismissed a warning of this in 1941). Second, the footings of the old brick walls, resting on soft clay, were sinking. Third (and most critical), the uncoordinated alterations over a century and a half had dangerously weakened the structure. *Architectural Digest* reported

> There is scarcely a beam . . . that has not been bored or cut through dozens of times to accommodate water and sewer pipes, gas pipes, heating pipes, electric and telephone wires, automatic fire alarm and guard signal systems, elevators, a fire extinguishing system and other mechanical innovations. In the very structure of the building itself, generations of architects and builders have concealed the complete mechanical equipment of a modern office building, none of which was provided or even contemplated by the original builders.[9]

Early in 1949 the committee's report, including the recommendations of a $5.4 million reconstruction, led to the presidential appointment of the six-member Commission on Renovation of the Executive Mansion (all senators and congressmen); retired army chief of staff Major General Glen E. Edgerton was its executive director. The commission offered alternative courses of action: three entailed demolishing the White House and rebuilding it or with marble, granite, or limestone. But a couple provided for maintaining the White House as an icon: one of them proposed demolishing and rebuilding the interiors but dismantling and reassembling the external walls stone by numbered stone; the other, which the Commission recommended and Truman supported, was to retain the exterior walls, the third floor and the roof, and rebuild the interiors. Congress approved funding on June 23.

WHICH HATCHET? WHICH WHITE HOUSE?

Lorenzo Winslow directed what has been called "the dismantling and reinstalling" of the interiors. In fact, only the first part of that description is true. At the end of 1949 contractors began dismantling rooms; Truman had assured a congressman, "We are saving all the doors, mantels, mirrors and things of that sort so that they will go back just as they were." That simply did not happen.

A year later the White House, like the promise, was hollow. Inside the "original" exterior (most of which had been rebuilt in 1815) a steel structural

skeleton was erected on new concrete pile footings. Within about 15 months a *replica* stood within what was left of the ancient external walls. Most of the salvaged material had been consigned to the dump; some was sold as souvenirs. On the first floor, only the oak wall panels of the State Dining Room were "reinstalled," but then painted. Although many original lighting fixtures and other architectural ornaments were returned to the house after being restored, in just as many cases replicas of wood and plaster trim and other architectural details were substituted. In February 1952 furniture—much of it reproduction antique—was delivered.

Major changes had been made: mechanical and electrical services were modernized; air-conditioning was installed; service areas were built under the North Portico; two subbasements, one housing a nuclear shelter—ironic enough, during the Truman administration—were added; and the Grand Staircase was altered to open into the Entrance Hall. The interior was replete with new paint, wall coverings, parquet flooring, and tiles. In fact little except the general floor plan remained from the house's early history because, as William Allen writes, "the urge to preserve the past was not as strong as the love of modern amenities, nor as motivating as a frightening report from a structural engineer."

The Truman family returned to the Executive Mansion on March 27, 1952. About thirty years later William Ryan and Desmond Guinness asserted in *The White House: An Architectural History* that, though the structural engineering work was successful, from a preservationist's viewpoint the rebuilding was the "greatest calamity to befall the President's house since the fire of 1814." The White House that we see today is the house that Harry S. Truman rebuilt. One critic, admitting that Truman's project "seems more destructive than restorative"—an odd choice of word—claims that it turned "the national spotlight to the historic significance of the White House's architecture." The question must be asked, "Which White House?"

ICON OR ILLUSION?

Architectural historian David Gebhard noted Jefferson's conviction that "if a building was reflective of the cultural values of the nation in which it was constructed and if it was beautiful . . . it would reinforce the ideals of that country, improve the taste of its citizens, and raise its esteem in the world's eyes."[10] The doctrine of architectural determinism—the idea that good architecture (whatever that is) makes good people (whoever they are)—has become passé, and it is difficult to say whether successive presidents or their advisers were guided by Jefferson's dictum. But the flirtation with fashion of Chester Arthur and others, and especially the major architectural programs—reconstruction after the 1814 fire; McKim's hip-and-thigh revisions for Theodore Roosevelt; and the total rebuilding of the interiors for Truman—all involved retaining or

replicating James Hoban's exterior of the Executive Mansion. Was that preserving history or creating it? And what did such movements say about national culture values?

The White House, the only residence of a head of state in the world that is open to the public, has upwards of a million and a half visitors every year. Whatever the security measures are, such accessibility in itself reflects the underlying ideals of the Republic. But now the words, "the pioneer boy, and how he became President," describing Abraham Lincoln, or "from log cabin to White House," describing James Garfield, belong to distant myth that any American citizen could aspire to the nation's highest office; that goal belongs only to the very wealthy. The relationship between the president and the Congress often has been strained, and frequent shifts of ascendancy between the two major parties demonstrate that all the people are not happy all the time. But though some Americans may not love a particular president—perhaps because they believe he falls short of John Adams' standard of "honest and wise Men"—they love the idea of the presidency. Despite such tensions, insofar as it is the icon of an ideal (as many commentators have remarked), the President's House has been "a symbol and focal point of the government, . . . evoking a strong passion from almost every American."

In the twenty-first century the term *White House* more often conjures not a building, but the world's most powerful political office. The icon has become globally familiar as TV news reporters—with a seemingly pathological need to fit an image to every word—stand in front of the out-of-focus White House to tell the world of the machinations of the U.S. administration.

POPULAR CULTURE

The White House, not always accurately rendered, has been presented to international cinema audiences from the early days of the "talkies," because it is a necessary part of films about presidents and the presidency. Some movies were overt propaganda tools. In 1933—four years into the Great Depression—Metro-Goldwyn-Mayer released *Gabriel over the White House*, in which a newly elected president initially decides to leave "the problems of Depression America to local authorities until a personal tragedy steels him to take on every social evil and nothing, not even the nations of the world, will stop him" Towards the end of World War II, the patriotic "ponderous film marathon" *Wilson* won five Academy Awards; for all that, what *The New York Times* called "Darryl F. Zanuck's budget-busting valentine to the 28th president of the United States" was a box-office flop. During the Cold War Stanley Kubrick's film noir satire *Dr. Strangelove, or: How I Learned to Stop Worrying and Love the Bomb* and Sidney Lumet's *Fail-Safe*, both of 1964 and both dealing with the chilling possibility of nuclear strategy going wrong, inevitably were set partly in the White House. So was Paramount and Warner Brothers'

Seven Days in May, released in the same year, which also reflected the current tensions between the United States and the Soviet Union.

However, the most productive decade of "White House movies" was the 1990s. *Time* magazine reporter Bruce Handy wrote in 1997, " 'No one's interested in movies about the President,' an agent told me in the spring of 1992, explaining why we had seen relatively few presidential characters on the big screen since . . . the '60s. 'People get enough of him on the news every night. They don't want to see him at the multiplex.' " Handy continued, "[since 1993] we have . . . seen Presidents and ex-Presidents as the lead in a romantic comedy (*The American President*), as crabby partners in a road movie (*My Fellow Americans*), as an ambiguous foil for action hero Harrison Ford (*Clear and Present Danger*) [and as] battlers of alien invaders (*Independence Day, Mars Attacks!*)."[11]

Into the twenty-first century, the *genre* continues. Since the impeachment of Richard Nixon and his resignation in 1974 and the sexual scandal involving Bill Clinton, movies have not presented the fictitious presidents always in a good light: for example, in Clint Eastwood's *Absolute Power* (1997) the president is an accessory to murder; in *Murder at 1600* (1997) he is murder suspect; in the frighteningly plausible comedy *Wag the Dog* (2001) he is party to a monumental conspiracy to secure a second term in office. In all these films the White House, although indispensable to the plot, is (so to speak) a "bit player."

Given the need for accessibility when filming, some are remarkable for their attention to production-set detail, especially Oliver Stone's *Nixon—Director's Cut,* and Rob Reiner's *The American President,* both of 1995; the latter was written by Aaron Sorkin, creator of *The West Wing* for television. The rendition of the executive mansion and the West Wing in that series has been noted above. Other TV miniseries have included *Backstairs at the White House* (1979) based on the memoirs of African Americans Lillian Rogers Parks, a seamstress, and her mother Margaret "Maggie" Rogers, a maid, who each worked for 30 years in the house, and the two-part *Gore Vidal's Lincoln* (1988), which used an altogether *different* house for its location.

Both of these series and most of the films and are based on books. Historical and political nonfiction about the presidency for adults and children—and therefore about the White House—abounds, a fact attested to by a search of the Library of Congress catalogue. The list is far too long and broad to allow any to be singled out. There is a great deal of fiction, too, encompassing political thrillers, murder mysteries, and even horror.

A personal anecdote may underline the pervasiveness of the house's iconic status. The writer's granddaughter, when only 7 years old (our family has always lived in Australia), announced that when she grew up, she wanted to live in the White House, "the one in America." Only after it was explained that the residence probably would be occupied by someone else did she demur. Her second choice was the Taj Mahal.

NOTES

1. Patterson, Bradley H., Jr., *The White House Staff: Inside the West Wing and Beyond.* Washington, D.C.: Brookings Institution Press, 2000.

2. Bowling, Kenneth R., "[Review of] Joel Achenbach, *The Grand Idea: George Washington's Potomac and the Race to the West,*" *H-DC, H-Net Reviews* (January 2005). www.h-net.org/reviews/showrev.cgi?path=170571115837756

3. Sterling, Christopher H., "[Review of] Kenneth R. Bowling, *Peter Charles L'Enfant: Vision, Honor, and Male Friendship in the Early American Republic,*" *H-DC, H-Net Reviews* (May 2003). www.h-net.org/reviews/showrev.cgi?path=137561055741638

4. Jusserand, Jean Jules, "Major L'Enfant and the Federal City" in *With Americans of Past and Present Days.* New York: Scribner, 1916. www.bartleby.com/238/23.html

5. Seale, William, *The President's House: A History.* Baltimore: Johns Hopkins University Press; Washington, DC: White House Historical Association, 2008. 2nd ed., vol. 2, 5.

6. Seale, William, "Beauty and History Preserved in Stone." www.whitehousehistory.org/08/subs/08_b03.html

7. "White House Plumbing." *Plumbing and Mechanical* (July 1989). www.theplumber.com/white.html

8. Truman to Gilmore D. Clarke, December 2, 1947, cited in Giangreco, D. M. and Kathryn Moore, *Dear Harry—: Truman's Mailroom, 1945–1953: The Truman Administration Through Correspondence with "Everyday Americans."* Mechanicsburg, PA : Stackpole Books, 1999.

9. "White House Plumbing."

10. White, Jeff, "The Political Ideology in Thomas Jefferson's Civic Architecture" (2000). www.holycross.edu/departments/classics/wziobro/ClassicalAmerica/jwrpsp00.htm

11. Handy, Bruce, "Acting President," *Time* (April 14, 1997).

FURTHER READING

Abbott James A., and Elaine M. Rice. *Designing Camelot: The Kennedy White House Restoration.* New York: Van Nostrand Reinhold, 1998.

Breeden, Robert L., et al. "The Truman Renovation of the White House, 1948–1952," *White House History* (Spring 1999).

Freidel, Frank, and William Pencak, eds. *The White House: The First Two Hundred Years.* Boston: Northeastern University Press, 1994.

Garrett, Wendell. *Our Changing White House.* Boston: Northeastern University Press, 1995.

Library of Congress. *The White House: Resources for Research at the Library of Congress.* Washington, D.C.: The Library, 1992.

McEwan, Barbara. *White House Landscapes: Horticultural Achievements of American Presidents*. New York: Walker, 1992.

Monkman, Betty C. *Living White House*. Washington, D.C.: White House Historical Association, 2007.

Patterson, Bradley H., Jr. *The White House Staff: Inside the West Wing and Beyond*. Washington, D.C.: Brookings Institution Press, 2000.

Ryan, William, and Desmond Guinness. *The White House: An Architectural History*. New York: McGraw-Hill, 1980.

Seale, William. *The President's House: A History*. Baltimore: Johns Hopkins University Press; Washington, DC: White House Historical Association, 2008.

Seale, William. *The White House: The History of an American Idea*. Washington, D.C.: White House Historical Association, American Institute of Architects, 2001.

Seale, William, and Erik Kvalsvik. *The White House Garden*. Washington, D.C.: White House Historical Association, 1996.

INTERNET SOURCES

The White House Historical Association. www.whitehousehistory.org
The White House Museum. www.whitehousemuseum.org

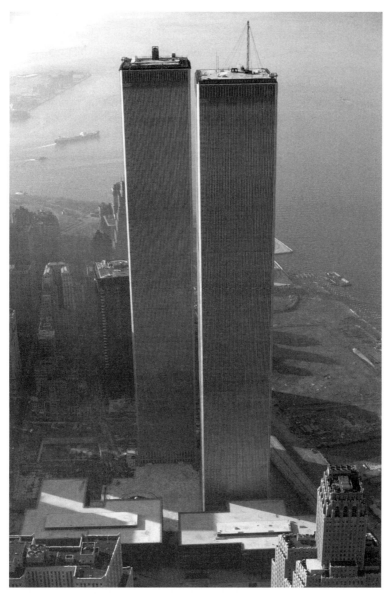

Courtesy Associated Press

World Trade Center, New York City

An icon that was, has ceased to be, and is yet to come

In 1963 *Time* magazine fulsomely promised that New York's World Trade Center (WTC) would house

> anyone and anything connected with world trade: U.S. Bureau of Customs, customs brokers, freight forwarders, foreign consulates, exporters and importers, trade associations, chambers of commerce, banks, insurance firms and finance agencies, now scattered blindly about the city. There will be trade fairs, steamship, air, truck and rail carriers, foreign trade publications, commodity exchanges, a hotel, shops, restaurants, a world trade institute and library and a bewildering assortment of information agencies.[1]

Looking back in 1990, Roger Cohen asserted that of all the public works undertaken by Austin Tobin, executive director of the Port of New York Authority, none was so big or ambitious as the development of the World Trade Center:

> Surely none stirred the blood in so many ways for so long a time. . . . When the final design plans for the Trade Center were unveiled at a Saturday morning press conference . . . in January 1962, the next day's *New York Times* editorial presciently declared: "Their impact on New York, for better or for worse, is bound to be enormous. . . . First a financial white elephant, the complex . . . has delivered on its promise to help rejuvenate Lower Manhattan. As a global symbol of New York, the Twin Towers are as identifiable as the Eiffel Tower, the Capitol dome or Big Ben are of their respective cities.[2]

Little more than a decade later, the impact on the city of the sudden destruction of the Center was indeed enormous. Rather, it was an enormity. It struck the city of New York to its heart and forever changed America's role in the world. As James Glanz and Eric Lipton observe, when its creators "shaped [the trade center] into an icon of international financial prowess and . . . when they drew the blueprints for its construction, they had unwittingly written the script for its eventual destruction." And as art critic Sharon Mizota points out, it was the so-called Twin Towers (One and Two World Trade Center) that instantly became "iconic, permanent fixtures of the Manhattan skyline, two giants sprung fully formed out of the ground."

> Once the tallest buildings in the world, the Twin Towers were symbols of U.S. dominance and the reign of global capitalism. Their demise was unthinkable. Minoru Yamasaki's architectural vision . . . was an act of hyperbolic faith in the potential of American society. It also expressed a profound conviction that buildings provide more than physical shelter: they are the symbolic homes of our beliefs, values and aspirations.[3]

The Twin Towers were an "icon that was." Their destruction and collapse, the consequent demolition of the entire WTC, and the 8-month removal of the debris exposed 16 acres of Manhattan that were physically empty but

replete with memories, anger, grief, and regret; "Ground Zero," as it came to be called, will remain an icon of things that have ceased to be. The creation of Freedom Tower and "Reflecting Absence" (neither complete at the time of writing), because they are reminders of what has gone before, promise to be an icon that is yet to come.

A WORLD TRADE CENTER

Construction of a world trade facility had been on New York City's agenda since the end of World War II. Basking in victory, the United States was preparing for the surge in economic growth engendered by the reconstruction of Europe; that would involve a commensurate increase in transatlantic trade. Seizing the day, in 1946 the New York Legislature created a World Trade Corporation to explore the feasibility of establishing a trade center in Manhattan.

The earliest conceptual designs proposed a $140 million complex of twenty-one buildings covering about ten city blocks and providing 5 million square feet of exhibition space and offices. When more detailed analysis suggested that to make the center financially viable nearly five thousand of America's largest companies would need to become tenants, the project was shelved. But it was not forgotten and would be revived when changes to the economic geography of the United States at the end of the 1950s meant that New York had consolidated itself as North America's financial capital. Most of the commercial growth was in midtown, and Lower Manhattan was at first overlooked as a location for new enterprises. One notable exception was the sixty-story Chase Manhattan Bank (commenced 1957) designed by Gordon Bunshaft of Skidmore, Owings and Merrill (SOM). Chase's president, David Rockefeller, "seeing [the bank's] massive investment at risk from the continuing relative decline of the district's real estate values," formed the Downtown-Lower Manhattan Association (DLMA). Collaborating with other powerful interests, the DLMA sought ways to "restore downtown's former luster."

In 1958, it commissioned SOM to develop a plan for a new Lower Manhattan—a scheme for "rebuilding and expansion of the financial district: the narrow streets would be closed, others widened, traffic redistributed and over 100 blocks razed." Elements of the SOM plan were implemented in some form or other—a Civic Center east of City Hall, a large marina on the East River, and an East River heliport. SOM also suggested establishing a World Trade Center, a notion that especially interested Rockefeller.

By January 1960 the DLMA had announced plans for a $250 million development with 5 million square feet of office space on a 13.5-acre East River site. It was on a scale that Rockefeller would later describe as "catalytic bigness"—catalytic in the sense that it would give impetus to later developments while keeping his own property values high. Rockefeller laid out the

mega-scheme before his brother Nelson (then governor of New York), New Jersey Governor Robert Meyner, and the Port of New York Authority (later the Port Authority of New York and New Jersey), whose staff had had provided input to the initial plan. Superimposed on the existing street grid, it included a seventy-story hotel-cum-office block, an international trade exposition, a retail arcade, and a securities exchange building, all surrounding a large plaza on a two-story podium.

In May 1960 Tobin proposed that the Port Authority should build the project. Under its former architect and planner, Richard Adler, the agency mustered a panel comprising architects Gordon Bunshaft, Edward Durrell Stone, and Wallace K. Harrison, the Rockefeller family's "in-house" designer. Ten months later the Authority announced an 11 million square foot development, estimated to cost $335 million, that would include a seventy-two-story world trade mart, with a hotel, trade institute and exhibition facility; a thirty-story commerce exchange (housing government offices and agencies); a twenty-story trade center "gateway" for international banking, law and other business services; and a securities exchange building.

It was anticipated that the complex would "stimulate the flow of commerce through the Port, would be economically feasible, and, due to its unique problems of financing, organization and operation . . . could only be undertaken by a public agency." The panel of architects argued that the efficiency of co-located world trade functions, "would bring savings in time and money, which would in turn attract greater cargo tonnage" and "provide an appropriate symbol of the Port's pre-eminence."[4]

Although the proposal was well received generally, not everyone was thrilled by it. As soon as details became public, New Jersey politicians demanded to know what benefit the scheme held for their state. The Port Authority responded by proposing to move the trade center to the west side of Lower Manhattan on a superblock defined by Vesey, Liberty, Church, and West Streets, and then occupied by the commuter terminal of the near-bankrupt Hudson and Manhattan Railroad linking Manhattan and New Jersey—the "Hudson Tubes." Despite the probability of annual losses of millions of dollars, the Authority offered to expand, modernize, and run the Hudson Tubes; the system would be rebadged as the Port Authority Trans-Hudson Corporation (PATH) that by 2007 would carry over seven million passengers annually. On February 13, 1962, the New Jersey Legislature unanimously passed the Hudson Tubes-World Trade Center bill; about 3 weeks later it was passed by New York State also; after another 3 weeks Governor Rockefeller signed it into law.

However, opposition to the Trade Center continued, launched from different beachheads—notably New York City Hall, and later a succession of various business interests. New York Mayor Robert F. Wagner voiced his "very strong displeasure" at being excluded from the discussion about relocation and being treated (he said) "as an outsider rather than a central figure." On a

less peevish note, he demanded that the New York Stock Exchange be excluded from the plans because "its relocation would . . . depress the rental market in the central spine of the financial district." He also challenged the Port Authority's intention to make payments to the city in lieu of taxes, whether the bi-state agency would adhere to New York's municipal procedures, and (perhaps most significantly) who would control any urban renewal funds that might be made available by the federal government.

> Tobin offered either to turn the entire project over to the city if Wagner could assure both governors it would be promptly built, or enter into a joint venture in which the city and Port Authority split the capital costs. On both suggestions, the mayor begged off. However, on each substantive issue the city raised Tobin yielded to Wagner's satisfaction, explaining that the alternative might have been months and possibly years of "dreary bargaining, recrimination and counter-charges."[5]

A group called the Downtown West Businessmen's Association, representing a number of retailers threatened with relocation should the project proceed, led much of the business opposition. Another group representing landlords objected to the potential of the WTC to depress the local real estate market. A series of litigations resulted, some won by the Port Authority, others lost. Finally the New York Court of Appeals upheld the agency and the U.S. Supreme Court refused in December 1963 to review the matter further.

THE TALLEST BUILDING IN THE WORLD

In February 1962 Tobin gave the engineer Guy F. Tozzoli responsibility for planning, building, and operating the WTC. About 30 years earlier, New York City had watched a "race to the sky"—rivalry for the tallest building status—initially between the 927-foot Bank of Manhattan Trust Company on Wall Street (completed in April 1929), and the 1,048-foot Chrysler Building, completed 6 months later. Both were surpassed in May 1931 by the 1,472-foot Empire State Building, which would hold the record for 42 years. Acting on a suggestion from Lee K. Jaffe, the Port Authority's public relations director, Tozzoli took the decision to make the buildings the tallest in the world. When construction began, Tozzoli effectively became the general contractor, "coordinating the efforts of 256 construction trades and saving millions of dollars by handing out the steel fabrication contracts [to] hundreds of smaller companies around the region."

In spring 1962 Tozzoli selected the Detroit firm of Yamasaki and Associates from a dazzling array of internationally acclaimed American architects, including Philip Johnson, Walter Gropius, and I. M. Pei. Yamasaki had designed only one high-rise building, the twenty-eight-story Michigan Consolidated Gas tower in Detroit. Tozzoli had been impressed with the architect's Federal

Science Pavilion at the 1962 Seattle World's Fair. Of Yamasaki's design *Time* magazine would write in 1963:

> Probably no building put up in 1962 caused such a world of comment or brought into action so many cameras. Professional critics found dreadful flaws, but to almost everyone else the U.S. Science Pavilion, that pleasure dome of the Space Age at Seattle's Century "21" Exposition, was a modern Xanadu, built for their delight, a declaration of independence from the machine-made monotony of so much of modern architecture.

When he received the unsolicited letter asking if he wanted to participate in the competition for the WTC, with an estimated budget at $280 million, it is said that Yamasaki thought there was a typographical error—perhaps a stray zero had found its way into the figure. Anyway, he won the closed competition. Antonio Brittiochi and Emery Roth and Sons were associate architects and (at Yamasaki's request, who had worked with them before) John Skilling and Leslie Robertson of the firm of Worthington, Skilling, Helle. and Jackson were engaged as engineers. Architectural historian Paul Heyer writes,

> Yamasaki's commission to design the WTC with the New York firm of Emery Roth and Sons . . . house(s) anyone and anything connected world trade. The program presented to Yamasaki . . . : twelve million square feet of floor area on a sixteen acre site, which also had to accommodate new facilities for the Hudson tubes and subway connections—all with a budget of under $500 million. The vast space needs and limited site immediately implied a high-rise development that . . . make(s) the adjacent drama of Manhattan's business tip seem timid in comparison."[6]

Yamasaki continually reworked the massing of the complex, generating no fewer than 105 site models. Finally he decided that two slender towers, between eighty and ninety floors high, "framed by a collection of boxy low-rises, would stand out boldly in a plaza." His clients liked the concept, but the towers that he proposed would provide only 8 million square feet of rentable office space—2 million fewer than they had asked for. They had their way and the final scheme included two 110-story towers—the world's tallest buildings.

When the design was unveiled in 1964, the size of the Twin Towers immediately provoked entrepreneur and lawyer Lawrence Arthur Wien, owner of a large part of the Empire State Building, to become one of the WTC's most strident opponents. He formed the Committee for a Reasonable World Trade Center, claiming, "it seems that without any supervision, without being accountable to anybody in the city of New York, to build the largest buildings in the world with a method of construction which has not been tested and tried and proved appropriate, subjects the city of New York to the possibility of a major physical disaster." Wien appointed Robert Kopple, a 53-year-old

lawyer, to head up the committee. Kopple promised, "We are ready to go to court to try to get this bloated project—these 'Tobin Towers'—brought down to size." The project's major opponents were citywide real estate operators, who demanded that the Port Authority should scale down its plans because the proposed development would be three times larger than necessary and would erode the rental values of Manhattan office space. In 1966 Wien's committee won the support of the new mayor, John V. Lindsay, who had the Planning Commission undertake a new study on the effects of the project. Among the matters raised was the possible interference with television transmissions from the Empire State Building—a problem that some judicious spending quickly solved.

Architecture critics also censured the WTC design as a "supreme example of self-glorifying monumentalism on the part of unaccountable, autonomous public authorities." They variously described it as "graceless"; a "fearful instrument of urbicide"; and (referring to Yamasaki's Neo-Gothic referencese) "General Motors Gothic." Its scale also was said to be threatening. At the end on May 1966 the influential critic Ada Louise Huxtable wrote in *The New York Times*, "Who's afraid of the big, bad buildings? Everyone, because there are so many things about gigantism that we just don't know. The gamble of triumph or tragedy at this scale—and ultimately it is a gamble—demands an extraordinary payoff. The trade-center towers could be the start of a new skyscraper age or the biggest tombstones in the world."

Indeed, most of the antagonism was focused on the twin towers. But the complex had other parts: a twenty-two story, 818-room hotel (Three WTC); two nine-story office buildings (Four and Five WTC); an eight-story Customs House (Six WTC); and, although built later, another forty-seven story office building (Seven WTC). They were grouped around the 5-acre landscaped plaza named for Austin J. Tobin. Beneath the plaza was The Mall, housing about sixty specialty shops, banks, restaurants, and function spaces and PATH subway stations. About five hundred international businesses, employing a total of fifty thousand people, were located in the Center. In March 1999 a panel of U.S. construction executives would include the complex among the top-ten construction achievements of the twentieth century. The combined seven hundred contracts needed to achieve it were coordinated by the Titman Realty and Construction Co.

Groundbreaking took place on August 5, 1966. The foundation excavation was made difficult by the need to protect two adjacent subway tubes without interrupting busy downtown services but a six-level basement was built in the 70-foot deep hole and the one million tons of spoil produced 23 acres of landfill, the site of Battery Park City.

The Twin Towers, each 208 feet square in plan, began to rise in March 1969. Derived from his twenty-story I.B.M. Building in Seattle, Washington, completed in 1963, Yamasaki's "row upon row of precise, narrowly spaced vertical columns" were not for mere aesthetic effect. Using the same structural

principles as those in the one-hundred-story John Hancock Center in Chicago (Graham and Kahn, completed 1969), Skilling and Robertson designed the load-bearing external walls as a rigid "hollow tube," with 18-inch wide aluminum-clad perimeter box columns at 40-inch centers. Spandrels welded to them at each floor effectively made them into huge trusses and dramatically reduced the weight of the structure. The façades became steel lattices, providing efficient wind bracing; less than a third of each tower's surface area was glass, with vertical slot-like windows. The restrictions of the urban site presented difficulties for the assembling of two hundred thousand modular components, prefabricated in Seattle, Washington, St. Louis, Missouri, and Los Angeles, California. Delivery and fixing was managed by a computer-programmed control system; eight "kangaroo" cranes were used to hoist the elements into place.

Elevators and service shafts, restrooms, stairwells, and other support spaces were located in the towers' 87 by 135 foot rectangular cores. Each core contained forty-seven steel columns running from the bedrock to the top of the tower. The column-free space between each building's perimeter and its core was bridged by 33-inch deep prefabricated steel trusses carrying 4-inch thick lightweight concrete slabs. The floors supported their own weight as well as imposed loads, while providing lateral stability to the external walls, and distributing wind loads. The structural system yielded about 40,000 square feet of rentable office space per floor—about 75 percent of the gross area, at a time when the average for high-rise buildings in the United States was around 50 percent.

Efficiency of vertical movement through the towers was enhanced by a "sky lobby" transportation system—a combination of express and local elevator banks—that called for fewer elevator shafts. Developed by Otis Elevators, it had been first employed in the John Hancock Center. In the case of the WTC, each tower had three vertical zones; express elevators served sky lobbies at the forty-first and seventy-fourth floors; from these, and from the plaza level, four banks of local elevators carried passengers to each of the three zones.

Four two-floor sections of each tower's 110 stories, equally spaced up the building, were reserved for mechanical services. The remaining levels were dedicated to open-plan offices; in all, the seven-building complex provided 11.2 million square feet of area that allowed for very flexible subdivision. As noted, at peak usage in the 1990s about five hundred tenants, including the Port Authority itself, were accommodated in the complex. The top floor of One WTC (North Tower) housed transmission equipment for commercial and public service radio and television; its roof bristled with transmission antennas. There was a restaurant, "Windows on the World," on the 107th floor. Two WTC (South Tower) had an indoor public observation space, "Top of the World," at a height of 1,310 feet. In good weather visitors could proceed to a 1,377-foot *outdoor* platform that provided an unequalled view.

The first occupants moved into the lower floors of One WTC December 16, 1970, although the upper stories were not completed until 1972. Tenants first

took up space in Two WTC in January 1972, and the building was finished in 1973. The ribbon-cutting ceremony was held on April 4, 1973, before four thousand people, mostly Port Authority employees and construction workers. Although the WTC buildings were intended to be a complex dedicated to organizations and businesses with a direct role in "world trade," at first it proved difficult to fill the space. During the early years, various government bodies, including the State of New York, were the major occupants; and it was not until the 1980s that an increasing number of private companies—mostly financial firms—took up tenancies.

Minoru Yamasaki said of his building "World trade means world peace and consequently the World Trade Center buildings in New York . . . had a bigger purpose than just to provide room for tenants." Regarding it as "a living symbol of man's dedication to world peace . . . , beyond the compelling need to make this a monument to world peace," he believed that the World Trade Center should, because of its importance, become "a representation of man's belief in humanity, his need for individual dignity, his beliefs in the cooperation of men, and through cooperation, his ability to find greatness."[7]

As noted, the original budget had been $280 million, but Yamasaki's own early estimates inflated that by 25 percent. It has proven difficult to find a reliable, consistent figure for the final cost—sources cite anything from $400 million to $1.5 billion. Brian Anderson of the conservative *City Journal* observed only weeks before the destruction of the Twin Towers that "virtually every important consideration in developing the World Trade Center had nothing to do with business and everything to do with politics, accusing, 'The final cost of the twin towers . . . swelled far beyond initial estimates. Supporters of the development had low-balled those estimates to win public support. Since the WTC originated as government's idea of what lower Manhattan needed, rather than as what the market really called for, it's no surprise that it misfired commercially.' "[8]

A "DAY THAT WILL LIVE IN INFAMY."

The destruction of the WTC was part of a coordinated attack upon the United States by an international extremist Islamic alliance. The plot was conceived and carried out by six core organizers and thirteen other members of a terrorist organization, *al-Qaeda* (The Base). In 1979 the U.S. government had assisted Saudi-Arabian Osama bin Laden to resist the Soviet occupation of Afghanistan; 10 years later he established *al-Qaeda* "as a 'rapid reaction force' in jihad against governments across the Muslim world." In 1996 he announced his objections to U.S. foreign policy regarding Israel and to America's political intrusion in the Middle East, calling for "American soldiers to get out of Saudi Arabia." Two years later he "directed his followers to kill Americans anywhere."

On the morning of September 11, 2001, four teams of terrorists, each including at least one trained pilot, hijacked four commercial passenger jets en route to California from Dulles International, Logan International, and Newark airports. One plane, American Airlines Flight 77, a Boeing 757-200, targeted the Pentagon in Virginia. The passengers and crew in a second plane, United Airlines Flight 93, tried to overcome the hijackers, but it crashed in a field near the town of Shanksville, Pennsylvania; *al-Qaeda* leader Khalid Shaikh Mohammed later confirmed that Flight 93's target was the U.S. Capitol.

And other hijackers deliberately crashed an aircraft into each of the Twin Towers of the WTC, "causing massive initial damage and triggering uncontrollable infernos."

Terrorists had attacked the WTC before. In February 1993 a 1,200-pound truck bomb had exploded in the parking garage, blasting a 150-foot diameter hole. Six people died, and over 1,000 more were injured. Although three levels of floors were shattered below the detonation point, the building's structural integrity—because of the "tube" construction—was hardly affected. But a stationary 1,200-pound truck bomb can hardly be compared with a 150-ton aircraft, carrying 12,000 gallons of aviation fuel and moving at over 400 mph.

At 8:46 A.M. Eastern Time American Airlines Flight 11, a Boeing 767-200, was flown into the 94–98th floors of north façade of One WTC (North Tower). Having just taken off, the aircraft was fully loaded with fuel for a trans-continental flight. Seventeen minutes later another 767-200, United Airlines Flight 175, crashed into the 78–84th floors of Two WTC (South Tower). That event was thoroughly covered by commercial television broadcasters and transmitted to stunned audiences around the world. Followed a half hour later by its twin, the South Tower underwent a spectacular and complete structural collapse at about 10:00 A.M.

WTC 7, a forty-seven-story office block that had been added to the Center in 1987, having been damaged by the collapsing North Tower, caught fire toward evening and also collapsed. Many other buildings were destroyed or significantly damaged, including all buildings of the WTC complex: WTC 6, the U.S Customs House to the north; WTC 3, the twenty-two-story Marriott hotel west of Tower Two; and the Plaza Buildings to the east, WTC 4 and 5. The Deutsche Bank Building was later condemned due to the toxic conditions inside it. The Borough of Manhattan Community College's Fiterman Hall at 30 West Broadway was also condemned due to extensive damage. Other neighboring structures, including the Verizon Building and 90 West Street suffered major damage but were later restored. World Financial Center buildings, the fifty-four-story One Liberty Plaza, the Millennium Hilton, and 90 Church Street underwent moderate harm. Radio, television, and two-way radio antenna towers were destroyed beyond repair.

The debris smoldered for ninety-nine days. The New York City Fire Department (FDNY) sent half its units to the disaster site; off-duty firefighters also

rushed to help, together with New York City Police Department (NYPD), Emergency Service Units (ESU), and Emergency Medical Technicians (EMTs). But "search and rescue" tasks soon turned into "search and recovery." Thousands labored around the clock to recover bodies and remove 1.8 million tons of debris. For a time the tragedy unified New Yorkers and the rest of the American people. Many police and rescue workers from elsewhere in the country traveled to New York City to offer their help.

By May 30, 2002, when the site-clearing process officially concluded, 1,796 people remained unaccounted for. Five years later, 2,750 death certificates had been filed, about 60 percent of the victims having been identified from forensic remains. The FDNY lost 341 firefighters and two paramedics, while twenty-three NYPD, thirty-seven Port Authority Police Department officers, and eight private ambulance personnel were killed during the rescue and recovery operations. Altogether about twenty-eight hundred people—in New York City, 2,603 in the towers and on the ground—died as an immediate result of the four attacks. The frequently quoted report of the National Commission on Terrorist Attacks Upon the United States (9/11 Commission) said:

> 1,366 people died who were at or above the floors of impact [in One WTC]. Hundreds were killed instantly . . . by the impact while the rest were trapped and died after the tower collapsed. As many as 600 were killed instantly or were trapped at or above the floors of impact in Two WTC. Only about 18 managed to escape in time from above the impact zone and out of the South Tower before it collapsed. At least 200 people jumped to their deaths from the burning towers, landing . . . hundreds of feet below. Some of the occupants of each tower above its point of impact made their way upward toward the roof in hope of helicopter rescue, but no rescue plan existed for such an eventuality. The roof access doors were locked and thick smoke and intense heat would have prevented rescue helicopters from landing. . . . Approximately 16,000 people were below the impact zones in the WTC complex at the time of the attacks. A large majority of those . . . survived, evacuating before the towers collapsed.

It was later reported that there were twenty-five hundred contaminants in the piles of toxic debris resulting from the collapse of the Twin Towers. Also, the fires produced extremely high levels of dioxin and other toxins from the fires; many of the substances were carcinogenic, and others could cause various medical problems. In the few years since the disaster, exposure to them has generated "debilitating illnesses among rescue and recovery workers [and] to some residents, students, and office workers of Lower Manhattan and nearby Chinatown." Immediately following the crashes, funds were established to provide financial assistance to the survivors and to the victims' families. Throughout the world memorial services and vigils were held, and temporary monuments were erected at the three crash sites, with permanent memorials in the planning stages, or under construction. In New York, 6 months after the event the *Tribute in Light,* an installation of eighty-eight

searchlights at the bases of the Twin Towers projected two vertical columns of light; on each anniversary of the tragedy the ceremony has been repeated.

CONTROVERSIES, CONSPIRACIES, AND CRACKPOTS

As always, the conspiracy theorists could be relied upon to rise to the surface following "9/11." The view most aired among them is that "somehow the Bush administration, with the collusion of the Pentagon, was either behind the attacks or simply allowed them to happen in order to institute a quasi-police state"; it was followed closely by another crackpot and dangerous "revelation" about the involvement of the Israeli government "and, by natural extension the perennial and ever-useful 'international Jewish conspiracy.' "

There have been many variations on these basic themes: *Vanity Fair* contributing editor, Nancy Jo Sales writes, "Nine-eleven conspiracy theories have been circulating for years, producing millions of Web links [an exaggeration; there are only 356,000 on *Google*], scores of books, and a nationwide collection of doubters known as the '9/11 Truth' movement."

> . . . according to a May 2006 Zogby poll, 42 percent of Americans [believed] that the U.S. government and the 9/11 Commission "concealed or refused to investigate critical evidence that contradicts their official explanation of the September 11th attacks," and that "there has been a cover-up." . . . For those who can't find information about the alleged cover-up on the nightly news, there is *Loose Change*, a documentary about 9/11 conspiracy theories. . . . Since it appeared on the Web in April 2005, the 80-minute film has been climbing up and down Google Video's "Top 100," rising to No. 1 this May [2006], with at least 10 million viewings.[9]

WHAT *DID* HAPPEN TO THE TWIN TOWERS?

The ten-member independent, bipartisan 9/11 Commission was created by Congress in late 2002. Its report, published on July 22, 2004, concluded that the impact of the planes blew off the fireproofing of the Twin Towers' structural frames, exposing the steel. Although the fire would not have been hot enough to actually melt the steel, the metal's strength was dramatically reduced by prolonged exposure to it, increasing deflections. The conflagrations—perhaps 1,500 to 2,000 degrees Fahrenheit—weakened the under-floor trusses, which sagged, causing the external steel columns to buckle inward; because the core columns had failed in the heat, the exterior columns, unable to carry the building loads by themselves, collapsed. A simplistic analysis.

A more urgent structural investigation had already been published. The *WTC Building Performance Study: Data Collection, Preliminary Observations and Recommendations* was produced jointly by the Federal Emergency

Management Agency (FEMA), the American Society of Civil Engineers (ASCE), and other organizations in May 2002. Its authors attributed the delayed collapse of the towers to a sequence of three separate "loading events." The first was the aircraft hitting the building at speed, slicing through the structural skin, and creating a fireball that immediately ignited some of the jet fuel. The structural system had a high enough factor of safety to prevent even this major damage from causing collapse. But continuing fire, fed by aviation fuel and combustible building contents, "weakened the structural systems, adding stress to the damaged structure." The sprinkler systems, "compromised by the impacts, were not operating as designed." Finally, as soon as one story collapsed all floors above it would have started to fall. The huge falling mass would gain momentum, crushing the intact floors below, ending in the failure of the entire structure.

These explanations have been challenged by some. Questions remain, and the complete story may never be known.

THE WTC IN POPULAR CULTURE

The Twin Towers dominated the Manhattan skyline for about 30 years, so it was virtually impossible for moviemakers to exclude them from any long-distance shot of the city. One compulsive-obsessive website lists no fewer than 472 movies (as at 2006) in which the buildings have appeared; as if it mattered, the compiler even provides a detailed gloss—for example, "Opening credits (twice, as airplanes fly over Manhattan, close to the towers), 1 hour 42 minutes, 1 hour 57 minutes." The towers, still under construction, appeared first in William Friedkin's Oscar-winning 1971 thriller, *The French Connection*. But they were only in the background.

Because of their superlative height and clarity of form they were bound to capture the popular imagination and before long, as well as being employed for "establishing shots" by filmmakers, they began to be used as locations, making it but a short step to their integration into movie plots. In Sydney Pollack's *Three Days of the Condor* (1975), the CIA is based in One WTC. And most spectacularly of all, in Dino De Laurentiis' 1976 remake of *King Kong*, the final confrontation between ape and aircraft took place atop the WTC, instead of the Empire State Building, as in the original 1933 film—a change that recognized that the Twin Towers had won the title (at least temporarily) of the world's tallest buildings. In 2005 Peter Jackson's nostalgic version Kong was back on the Empire State, whose fenestration would have made it easier to climb, anyway. Other films—too many to discuss here—used the WTC, inside and out, for location filming.

The Twin Towers have appeared in some way or other in many popular television series, as well as to give interest to the bland nonmusic videos of bland nonmusical performers. They have been featured in many video and

computer games, animated cartoons, and even comic books. Without listing the tedious minutiae, the obvious point can be made that such a plethora of populist expression demonstrates how the WTC—in its birth and its death—has loomed and still looms large as a populist icon. Its resurrected role awaits later assessment: will the structures that replace it be "icons of the future?"

On the eve of the first anniversary of 9/11, the controversial independent filmmaker Lloyd Kaufman published on his website *The Unsung Hero of 911*, a blistering polemic on the mainstream media's opportunism and greed. He noted that in the days immediately following 9/11, "we have been graced by all sorts of heroes who have preserved America's optimism: cops and firemen who selflessly lost their lives by attempting to rescue people from the Towers, EMS lifesavers, teachers who assuaged the worries of our young ones, psychologists who have counseled the victims, etc." Then he bitterly added,

> While all of these magnificent, glorious people should certainly be memorialized . . . the American Mainstream Media (AMM) needs to be honored. Yes, for the past year, AMM has been brave enough to stand by our side every minute of every day, pumping a positive and patriotic blood into our veins via television, newspapers, magazines, and soon movies!

He gave examples of media exploitation: for instance, how the FOX-TV network repeatedly broadcast the "burning Towers spitting out live people again and again and again and again," ostensibly as a public service and how the networks, realizing that continually replayed footage "might have become boring without an ominous musical score [they invented a catchy title . . . 'America fights back' was now instantly superimposed over the never-ending re-broadcasts of the now musically scored scenes of World Trade Center oblivion."[10]

The terrorist attacks changed the popular perception of the WTC from triumph to tragedy. A few weeks after 9/11, critic Kevin Pack observed, "To me, things seem so contradictory in this 'new' world we live in. Since the horrific day . . . everyone either seems to act is if they were born again and celebrate and appreciate life, or have become consumed and driven by hate."

> Radio stations have [long] lists of songs that can't be played . . . because it could be seen as "offensive" and more depressed than we already are. Just a minute ago, everyone was on ecstasy, [now we are] all suffering from the most extreme case of depression. . . . The public can't hear songs like "New York, New York" by Old Blue Eyes, and movies are having their release dates pushed back because we need to edit out every . . . shot of the World Trade Center. People don't want any reminders of the devastating events that have happened and can't be bogged down with thoughts, feelings, sights, or sounds that could push them over the edge. *Sidewalks of New York* had its release date pushed back . . . because scenes of the WTC had to be edited out . . . The WTC may be rubble

now, but when the film was shot it was a tall monument that was a symbol of America and a hallmark of one of the best cities in the world, NYC. So, instead of celebrating what once was, we have to walk on tip toes and edit it from, well, I guess everything.[11]

Washington Post journalist Rita Kempley warned, "If we erase the towers from our art, we erase it [*sic*] from our memories. It's right out of *Forrest Gump* and *Zelig*. We're destroying our own history, never a wise idea." She might have said, "It's right out of *1984*." In George Orwell's 1949 novel, the Ministry of Truth dealt with news, entertainment, education and the fine arts, expunging from records—it was called "rectifying"—anything that was distasteful to politicians; in short, "destroying history." That's how the film and television industry, assuming the role of arbiter of taste, dealt with the Twin Towers issue: for months after the attack, nearly all made-in-New-York movies and TV shows (even re-releases), either by editing out the footage or digital removal, disposed of the buildings. Kaufman complained, "AMM seemed to be against the idea of the pre-September 11th towers appearing. After all, seeing the [them] crumble one hundred times a day on CNN was much healthier for . . . children than seeing [them] stand tall and proud on a fictional program."

One Internet source lists a dozen or so movies and television series from which the towers were removed. Here a few typical examples will suffice. A battle at the end of *Men in Black II*, originally shot on the roof of the WTC, was refilmed at the Chrysler Building; but the original finale could be seen as the "alternate ending." in the 2005 DVD release. In the comedy *Zoolander*, released on September 28, 2001, the towers were digitally removed from one scene and obscured in another. And as noted, all this sensitivity was retroactive: early in Touchstone Pictures' sci-fi disaster movie *Armageddon* (1998), a meteorite shower rains on New York City. One hits the top of Two WTC, partially destroying it and starting a fire; another punches a hole in One WTC. When ABC aired *Armageddon* on TV in April 2002, the scene was cut.

But, according to Kaufman, "Soon, [an annoyed] American public began to disapprove of the AMM monopolies erasing the Twin Towers. They felt that removing [them] was like destroying them all over again. . . . The television media elites decided that they had to safeguard America's feelings as well as their station's ratings [and] therefore they stopped editing the Towers out of television programs."

The events of 9/11 have been portrayed in over fifty documentaries and about ten acted movies, including two major films, both released in 2006. Paul Greengrass' *United 93* is, of course, about the aircraft that crashed in Pennsylvania. Oliver Stone's *World Trade Center* is the first feature-length film specifically about the attacks on the Twin Towers.

INEVITABLY: KITSCH

A year—almost to the day—after the disaster, Jessica McBride reported in the *Milwaukee Journal Sentinel* that Ground Zero was a hotbed of kitsch peddlers, selling Osama bin Laden toilet paper (in regular and "commemorative" editions—at which the mind boggles), Ground Zero and New York Police Department baseball caps, soft pretzels, New York Fire Department Beanie Babies, WTC paperweight snow globes and key chains. She described the district as having "the heartbreaking solemnity of a Holocaust museum—a sea of tattered family pictures staring out from the past—combined with Graceland-style kitsch." In the first 6 months of 2002 a million people visited the site, after which the city stopped keeping count. By 2004 about 8.2 million tourists, many "with a morbid fascination for Ground Zero," were visiting Lower Manhattan. In March the New York State Legislature, wanting to maintain the sanctity of Ground Zero, passed a law limiting the number of legal street vendors. The Port Authority posted signs asking tourists, "Please help us maintain this site as a very special place. Please do not purchase any items or services here, or donate money to people soliciting here, so that this place can be fully appreciated by all visitors." Despite all efforts and enactments, according to one report trade in souvenirs, many tasteless, prevails. As late as November 2007, the area was an open-air bazaar for everything from Rolex knockoffs and 9/11 figurines to photo books printed in India, showing the devastation of the WTC. Lee Ielpi, who lost his firefighter son in the attack and later established the nonprofit Tribute Visitor Center, whose earnings support educational programs, complains about the souvenir sharks: "To think that these people are coming here using this horrible disaster that our country suffered, to profit off it totally for themselves, is tasteless. . . . It should not be a place where people come and make money on the dead."

The WTC site has special significance, not just for New Yorkers, but for the American people. It has no "light side." Souvenirs become a question of propriety that lies with the tourists, whether foreign or home-grown. Many agree that it is inappropriate and "not very tasteful" to have merchandise commemorating the attacks, and ask "How can you profit from something like this?" But what entrepreneur could resist such opportunity?

THE IMPERATIVES OF COMMERCE

The Australian art critic Robert Hughes, who considered the original WTC ugly boxes, is reported as saying that its loss "did no architectural damage to New York." He believed it to be "a large, scaleless lump, which completely dominated that end of Manhattan" and which "only became iconic when it was knocked over by a bunch of Arabs." He callously added that there was no need for a monument to mark the tragedy, "though you can't say that to

the relatives of those who died. What I'd prefer is for an empty space to be left or perhaps some smaller memorial. . . . " It's good that nobody listened to him. Besides, given the value of real estate in Lower Manhattan, it was impractical and imprudent to leave Ground Zero empty.

In purely economic terms, the attack on the Twin Towers ultimately cost the City of New York 13 million square feet of office space; it cost eighty-three thousand people their jobs. The repercussions were far wider: the United Nations estimates that the attacks on America put twenty-four million people around the world out of work, and drove fifteen million more into deeper poverty.

Proposals for rebuilding the area, incorporating a memorial, commercial/ retail space and a transportation node were invited on April 30, 2002. Of course there was wide and intense public interest in the project. The Municipal Art Society of New York conducted about 230 public workshops and collated no fewer than eighteen thousand suggestions for the site. Around mid-July the Lower Manhattan Development Corporation (LMDC; the agency responsible for coordinating reconstruction) released six concept plans. The proposals included Memorial Plaza, by Cooper Robertson and Partners for Brookfield Properties; Memorial Square and Memorial Triangle, both by Beyer Blinder Belle; Memorial Garden by SOM for the developer Larry Silverstein, who controlled the lease of the site; and Memorial Park and Memorial Promenade by Peterson/Littenberg Architecture and Urban Design, both for the LMDC. It was expected that a winner would be chosen by December 1. Not so.

A *New York Times* editorial described the schemes as "dreary, leaden proposals that fall far short of what New York City—and the world—expect to see rise at Ground Zero." It continued, "The public will never be satisfied with any redevelopment that contains as much commercial space as the site did before September 11. . . . Despite all the talk about a downtown that would be alive 24 hours a day with cultural institutions, entertainment and residential developments, these features, which make an urban area live and breathe, are missing." The newspaper's architecture critic, Herbert Muschamp, agreed: "the plans have little to recommend them. Thus far, . . . [the LMDC] has demonstrated little besides a breathtaking determination to think small. Don't come looking for ideas that reflect the historic magnitude of last year's catastrophe."

Although the designers defended their proposals, blaming the constraints of the architectural program, as early as mid-August 2002, "in reaction to widespread negative criticism, planning officials for the site indicated that they would [make revisions to space requirements] and invite more architects to submit designs." Consequently, in summer 2002 the LMDC launched an international search for "visionary designs." More than four hundred submissions were received from around the globe. Nine designs were shortlisted in mid-December, and following extensive deliberations, public hearings and

community consultation, on February 4, 2003, the LMDC and Port Author-
ity announced that two conceptual proposals "were under final consider-
ation": the Memory Foundations design by Studio Daniel Libeskind of Berlin,
Germany, and the World Cultural Center design by THINK, a team led by
Shigeru Ban, Frederic Schwartz, Ken Smith, and Rafael Viñoly. The Libeskind
design was judged to be "best overall based on twelve criteria including price,
public response, vision, connectivity, public space, and how the victims of the
September 11th attacks would be memorialized"; its focus and tallest struc-
ture was a 1,776-foot office tower and spire, whose height reflected the year
of American independence.

A PARENTHESIS

In April the LMDC announced the WTC Site Memorial Competition. Com-
mittees that included survivors, first responders, victims' family members,
residents, community leaders, and design professionals developed the mission
statement and program for a single memorial that "should clearly show the
'footprints' of the fallen towers, designate a resting place for unidentified vic-
tims and acknowledge everyone who was killed at the site as well as those
killed in an earlier terrorist attack on the towers February 26, 1993." The first
stage called for an anonymous single-sheet conceptual design. A thirteen-person
jury represented a cross-section of the community: the widow of a 9/11 vic-
tim; art administrators; New York City politicians and bureaucrats; artists,
architects, and designers; representatives of philanthropic organizations; a
museum curator; and academics. The open competition attracted more than
13,500 international registrants, resulting in fifty-two hundred entries from
sixty-three countries. From those, a jury chose eight finalists and financed
them to further develop their designs. None was a well-known designer or
architect.

The winner, "Reflecting Absence" by Israeli architect Michael Arad and
(following the recommendation of the jury) landscape architect Peter Walker,
was announced on January 13, 2004. The jury statement said in part that the
design

> fulfills most eloquently the daunting—but absolutely necessary—demands of
> this memorial. In its powerful, yet simple articulation of the footprints of the
> Twin Towers, "Reflecting Absence" has made the voids left by the destruction
> the primary symbols of our loss. By allowing absence to speak for itself, the
> designers have made the power of these empty footprints the memorial. . . .
>
> In our descent to the level below the street, down into the outlines left by the
> lost towers, we find that absence is made palpable in the sight and sound of thin
> sheets of water falling into reflecting pools, each with a further void at its center.
> We view the sky, now sharply outlined by the perimeter of the voids, through
> this veil of falling water. At bedrock of the north tower's footprint, loved ones

will be able to mourn privately, in a chamber with a large stone vessel containing unidentified remains of victims that will rest at the base of the void, directly beneath an opening to the sky above.

While the footprints remain empty, however, the surrounding plaza's design has evolved to include beautiful groves of trees, traditional affirmations of life and rebirth. These trees, like memory itself, demand the care and nurturing of those who visit and tend them. . . . "Reflecting Absence" has evolved through months of conversation between the jury and its creators.[12]

A couple of critics, both writing for *The New York Times*, were unkind to all eight short-listed proposals, Herbert Muschamp asserting that "none of them deserve to be built in their present form." Although Arad's scheme (he wrote) had the "signal virtue of focusing the viewer's attention where we want it to be focused: on the symbolic pair of shapes that have come to represent the simultaneity of public and private loss, the design has problems, too." The rest of his diatribe shows that he didn't really grasp that design. Published a few days later, the *Times* chief art critic Michael Kimmelman's condemnation was much more peremptory: "Now that everyone agrees that the Ground Zero memorial finalists are a disappointment, there's only one thing to do. Throw them all out."

In December 2004, allegedly in response to security and economic constraints, the memorial design was revised. The new plan included a Memorial Hall between the reflecting pools to mark the footprints of the former WTC. It also included a grove of oak trees with a clearing for memorial services, and public access to the stumps of the columns that once held the Twin Towers aloft. Among other changes, the names of the dead were to be raised above ground, waterfalls would cascade into underground pools, and most of the underground galleries were to be eliminated—considered by Arad as the most significant and unwarranted revision. Commentator Haim Handwerker writes, "If [Arad] had thought, somewhat naively, that his plans would be implemented in the format he envisioned, he was quickly disillusioned . . . a young architect who seemed steeped in euphoria and quite astounded by his win, he became caught up in an imbroglio of politicians, architects, public officials and interest groups."

Arad's project drew considerable criticism, in part for its high price—estimated at almost $1 billion. His response was that the figure was inflated by including the estimated cost of the surrounding structure. In the inevitable political manipulations, the project was effectively taken out of Arad's hands, and its realization given to New York architectural firm Davis Brody Bond—inexplicably, not to Handel Architects, in which Arad is a partner. *The New York Times* editorialized, "what Arad had designed quickly turned into something else, a site being planned by a committee: almost everyone has a hand in it, and sometimes there are conflicts. What is happening here is a recipe for chaos." The memorial project was due to be completed in 2009, but most likely will not be done until 2010.

MEANWHILE, BACK AT FREEDOM TOWER . . .

Libeskind's rebuilding scheme may have won the competition, but by July he seems to have been "relegated to becoming the site's 'planner.'" The developer Larry Silverstein, who controlled the lease on the site, commissioned David Childs of SOM, who was responsible for the World-Wide Plaza on Eighth Avenue (1989) and the reflective-glass towers of the AOL-Time Warner Center (begun 2000), to design what became known as the "Freedom Tower." The so-called collaboration between Libeskind and Childs threatened to end in disaster as they "became exceedingly testy and appeared headed on a crash course." Leaked press reports described Childs' design as a "torqued" tube crowned with a trellice [*sic*] inside of which would be windmills—an idea far removed from what Libeskind had proposed. The hybrid scheme was made public on December 19, and the next day architecture critic Justin Davidson, noting that "design by politics and committee is almost always compromised," wrote a cautious, balanced review in *Newsday*, noting that "the weakest elements of the design are those at the borders where Childs' method and Libeskind's literary ideas meet" and "the tower's three levels—solid base, airy torso and slender needle—are well articulated but need to be better glued together. For now the top third of the building looks a bit like a nutcracker soldier's tall hat adorned with a wispy feather that is practically begging to be knocked off."

> Childs has been heretofore a good practitioner of classy but basically conventional high-rise office towers. Despite the hoop-la and controversies over their collaboration, the two architects have somehow forged an interesting new design that is likely to become popular because of its asymmetry and its height . . . this design is a much better start than most of us anticipated in this very tortured design process, but it's still a bit early to give a final verdict.

"A bit early" was right. Of course there were further bureaucracy-driven compromises, and a redesigned Freedom Tower was unveiled in June 2005. Over the intervening 18 months voices were raised against the wisdom of the project. In the *New Yorker*, critic Paul Goldberger called the Freedom Tower "an unnecessary building," and with 9/11 fresh in the city's memory, *New York Times* columnist Frank Rich demanded, "What sane person would want to work in a skyscraper destined to be the most tempting target for aerial assault in the Western World?" And just as Childs' revised design was made public, *New York Observer* columnist Ron Rosenbaum extravagantly accused that it was "dreadfully apparent that the entire project—and the lives of its potential inhabitants—[was] in the hands of a group of egotists, idiots, political opportunists and incompetents."

The new scheme bore little relation to Libeskind's original proposed tower, his master plan, "nor to any of the many previously submitted designs." Only the height of the antenna remained unchanged. The new design

included moving the base of the tower 40 feet to the east, in the northeast corner of the 16-acre former WTC site, for "security reasons." Rising from a 186-foot, nineteen-floor podium with 3-foot thick concrete walls, the Freedom Tower's sixty-nine floors, reached via an 80-foot high lobby, provided 2.6 million square feet of rentable office space and twenty more floors for other uses. In June 2006 it was decided that the podium, criticized for being "too brutalist," would be covered by a screen of glass prisms.

Nicolai Ouroussoff of *The New York Times* confessed that "the temptation is to dismiss it as a joke . . . [an effort that] fails on almost every level." That view contradicted the paper's editors, who wrote, "In almost every respect, the new design for the so-called Freedom Tower . . . is better than the one it replaces." But perhaps that was damning it with faint praise.

New York's Governor George Pataki wanted the structural frame to be completed by September 11, 2006—a vain hope—and the skyscraper finished by 2008. The debate between the Port Authority and developer Silverstein "over who will build on Ground Zero, how much rent will be paid, and how to divide money paid to Mr Silverstein" continued until March 2005 when the Authority withdrew from negotiations. But discussions soon resumed, and a tentative deal being agreed, construction work began late in April. By then, site works had been in progress on the WTC Memorial and Museum for about a month.

An agreement provided that Silverstein would cede rights to develop the Freedom Tower and Tower Five in exchange for financing with Liberty Bonds for Tower Two, Three, and Four. On June 22 the Port Authority announced that J.P. Morgan Chase would build the forty-two-story Tower Five on the site occupied by the Deutsche Bank Building; the architect, named a few weeks later, was Kohn Pedersen Fox. The final designs for Towers Two (architect, Sir Norman Foster), Three (architect, Richard Rogers), and Four (architect, Fumihiko Maki) were unveiled on September 7. The Freedom Tower was slated for completion in 2012.

The piecemeal approach to the rehabilitation of the Ground Zero site has been costly in every way. When the design process had scarcely begun, Critic Carter B. Horsley made an observation that held true throughout the project: "Overhanging the [memorial] competition is the messy and still unresolved design for the rebuilding of the WTC. What has been particularly disturbing is the public announcement of a selection and then its subsequent redesign to something substantially different."

> Such a process is a charade and smacks of poor planning and, worse, influence peddling. Both competitions are not for some suburban mall, but for one of the world's most famous sites. In their zeal to involve the public, the sponsors . . . have emphasized the need to honor those lost in the terrorist attacks and not surprisingly the families of the victims have become very, very vocal. Their concerns are important, but the project is more important than the individual victims.

It needs to be a community-wide, city-wide and national response and monument. Indeed, it needs to be an internationally meaningful design. Such a solution . . . would be difficult to achieve on a barren battlefield, let alone at the center of a [very] large mixed-use development that is integral to the future of Lower Manhattan, which for several decades in the early 20th Century was the world's most glorious, important and influential skyline.[13]

Minoru Yamasaki

Minoru Yamasaki, a second-generation Japanese American, was born in the Yesler Hill neighborhood of Seattle, Washington, on December 1, 1912. His father John Tsunejiro, who had emigrated to the United States in 1908, was a struggling purchasing agent; his mother Hana was a pianist. In 1926, when Minoru was in his second year at James A. Garfield High School, his mother's brother, Koken Ito, an architecture graduate from the University of California at Berkeley, came for a short stay with the family. The more his uncle talked about architecture, the more Minoru wanted to become an architect. He paid his way through the University of Washington by working at Alaskan salmon canneries in his summer breaks.

In September 1934, partly because of racial discrimination, upon graduating he moved to New York and arrived with $40 to his name. It was hard to find work in the Depression, and many architects had no commissions. So Yamasaki spent his first year in Manhattan wrapping china for an import firm. Attending night classes, he gained a master's degree from New York University, and in summer 1935 he found work in the office of Githens and Keally. He next moved to Shreve, Lamb, and Harmon (1937–1943), who had designed the Empire State Building, then to the office of the Rockefellers' architect, Harrison, Fouilhoux, and Abramovitz (1943–1944), and finally to industrial designer Raymond Loewy (ca.1944–1946). He taught for 2 years at Columbia University before in 1945 accepting the position of head designer in the six-hundred-strong Detroit practice of Smith, Hinchman, and Grylls.

In 1951 he established three separate practices with former colleagues from that firm: Yamasaki and Associates in Troy, Michigan; Yamasaki, Leinweber, and Associates in Detroit, Michigan; and Yamasaki and Hellmuth in St.Louis, Missouri. From 1951 to 1956 he built the Lambert-St. Louis Municipal Air Terminal; his design, with three pairs of intersecting copper-sheathed concrete barrel vaults, won the American Institute of Architects (AIA) First Honor Award. The stress of managing the project—"arguments and compromises with engineers and client, the insufferable commuting between St. Louis and Detroit"—caused his health to fail at the end of 1953, and after radical surgery and 2 months in hospital he limited his professional activity to the Detroit firm, that became Yamasaki and Associates in July 1955.

What has been called his "breakthrough commission" came in 1954: a building for the U.S. Consulate General in Kobe, Japan. During a month-long visit to Japan, he was charmed by the garden settings of traditional architecture that influenced his subsequent work. He later confessed, "I was overwhelmed by the serenity that can be achieved by enhancing nature. It was here that I decided that serenity could be an important contribution to our environment, because our cities are so chaotic and full of turmoil."

Soon after returning from Japan, Yamasaki undertook an extensive tour of Asia, the Middle East, and Europe. The delight that he discovered in the forms of historical architecture emphasized a major deficiency of ornament, decoration and texture in European Modernism—what had by then become the so-called International Style. According to a January 1963 article in *Time* magazine, "Back in the U.S., Yamasaki told his professional colleagues what he had learned: 'he paid handsome tribute to the glass box of the great Mies van der Rohe,'" but observed that "the glass box, except in the hands of a few highly talented men, had deteriorated into a cliché." He denounced "the dogma of rectangles" and the module system of building—"as monotonous as the Arabian desert."

His acquired ideas were demonstrated in his award-winning design for the McGregor Memorial Community Conference Center at Detroit's Wayne State University (1955–1958). In other buildings, he continued to temper the International Style with allusions to the architecture of other cultures. He was particularly influenced by Islamic arches, a motif that he employed in the bases of the Twin Towers and Gothic elements (which were derived from Islamic models anyway), as seen in Seattle's U.S. Science Pavilion (1962) and the Music Conservatory at Oberlin College, Ohio (1966).

But according to his biographer Sharon Mizota, though his multicultural style appealed to many, "it also elicited scathing critiques, mostly from the architectural critics of the day."

> In trying to push architecture beyond the ascetic confines of modernism, his work was derided as excessively ornamental. On the other hand, his designs for the World Trade Center were criticized for being too brutally minimalist. Caught between the end of high modernism and the birth of eclectic postmodernism, Yamasaki was a pioneer in the development of today's [2004] dominant architectural style, a contribution for which he has never been fully recognized.

Yamasaki's oeuvre is far too extensive to discuss, or even list here. Suffice it to say that throughout the United States between 1951 and 1979 he designed university buildings (and entire campuses), urban development schemes, commercial buildings and banks, hotels, synagogues, and airport

terminals. Abroad, "oil-rich Saudis and auto-rich Japanese continued to hire him, not only as a reflection of their wealth and power, but out of satisfaction with [his] tributes to their cultural heritage." He designed the Dahran Air Terminal (1961), the Monetary Agency Head Office in Riyadh (1973–1982), and the Eastern Province International Airport (1985), all in Saudi Arabia. He also produced the U.S. Pavilion, World Agricultural Fair, New Delhi, India (1959), the Founder's Hall, Shinji Shumeikai (1982) in Shiga Prefecture, Japan, and the Torre Picasso, Madrid, Spain (1982–1988).

To balance the scale of these successes, Yamasaki's disastrous Pruitt-Igoe Public Housing project of 1956—"his first and only foray into low- and middle-income housing"—must be mentioned *en passant.* Alexander von Hoffman of Harvard's Joint Center for Housing Studies calls it "arguably the most infamous public housing project ever built in the United States." In 1972, after futilely spending over $5 million on remedies the St. Louis Housing Authority demolished three of the high-rise buildings. A year later the remaining buildings followed. Von Hoffman comments, "Pruitt-Igoe has lived on symbolically as an icon of failure. Liberals perceive it as exemplifying the government's appalling treatment of the poor. Architectural critics cite it as proof of the failure of high-rise public housing for families with children. One critic even asserted that its destruction signaled the end of the modern style of architecture."

Yamasaki regretted that some of his influential peers believed that each building should be a powerful monument to "the virility of our society," and as a consequence they disparaged "attempts to build a friendly, more gentle kind of building." Minoru Yamasaki died of cancer on February 7, 1986, aged 73.

NOTES

1. "The Road to Xanadu." *Time* (January 18, 1963).

2. Cohen, Roger, "Casting Giant Shadows: The Politics of Building the World Trade Center." *Portfolio* (Winter 1990-1991). www.greatbuildings.com/ buildings/World_Trade_Center_History.html

3. Mizota, Sharon, "Minoru Yamasaki: Architect of the American Dream," *Nikkei Heritage* (Spring 2004). http://sharonmizota.com/writing/art/yama saki.html

4. Cohen.

5. Cohen.

6. Heyer, Paul, *Architects on Architecture: New Directions in America.* New York: Van Nostrand Reinhold, 1993, 194–195. www.greatbuildings.com/ buildings/World_Trade_Center.html

7. Yamasaki, Minoro. www.greatbuildings.com/buildings/World_Trade_Center .html

8. Anderson, Brian C., "The Twin Towers Project: A Cautionary Tale," *City Journal* (Autumn 2001).

9. Sales, Nancy Jo, "Click Here for Conspiracy," *Vanity Fair* (August 2006).

10. Kaufman, Lloyd (2002). www.lloydkaufman.com/roids/2002/09/11/unsung-hero-911/

11. Pack, Kevin, "Hollywood Patriotism, 2001." www.publicitywhore.com/pwblast16/Articles/hollywood1.html

12. WTC Memorial jury statement for winning design. www.wtcsitememorial.org/about_jury_txt.html

13. www.thecityreview.com/memwtc.html

FURTHER READING

Dal Co, Francesco. "Ground Zero: The Facts and the History." *Casabella*, 71(October 2007), 3–29; 113–117.

Darton, Eric. *Divided We Stand: A Biography of New York City's WTC*. New York: Basic Books, 1999.

Doumato, Lamia. *Minoru Yamasaki*. Monticello, IL: Vance Bibliographies, 1986. See also Robert B. Harmon, *Serenity and Delight in the New Architecture as Exemplified in the Work of Minoru Yamasaki: A Selected Bibliography*. Monticello, IL: Vance, 1981.

Friend, David. *Watching the World Change: The Stories Behind the Images of 9/11*. New York: Farrar, Straus and Giroux, 2006.

Glanz, James and Eric Lipton. *City in the Sky: The Rise and Fall of the World Trade Center*. New York: Holt, 2003.

Huxtable, Ada Louise. "Minoru Yamasaki's Recent Buildings." *Art in America*, 50(Winter 1962), 48–55.

Keegan, William, Jr., with Bart Davis. *Closure: The Untold Story of the Ground Zero Recovery Mission*. New York: Simon & Schuster, 2007.

Lubell, Sam, et al. "Redesigned Freedom Tower Will be Sleeker, Safer; Architects: Skidmore Owings & Merrill." *Architectural Record*, 193(August 2005), 23–26.

"Minoru Yamasaki." *Architectural Record*, 135(September 1964), 169–184.

Mizota, Sharon, "Minoru Yamasaki: Architect of the American Dream." *Nikkei Heritage* (Spring 2004).

Pledge, Robert, ed. *Eleven: Witnessing the World Trade Center, 1974–2001*. New York: Universe, 2002.

Rybczynski, Witold. "Less Is Less; Architect: Michael Arad, with Landscape Architect: Peter Walker." *Landscape Architecture*, 94(March 2004), 20–24.

Salomon, David L. "Divided Responsibilities: Minoru Yamasaki, Architectural Authorship, and the World Trade Center." *Grey Room* (Spring 2002), 86–95.

Skidmore Owings & Merrill. "Freedom Tower, New York, USA, 2003-." *Architecture and Urbanism* (June 2004), 6–11.

Smith, Dennis. *Report from Ground Zero*. New York: Plume, 2003.

Snoonian, Deborah, et al. "World Trade Center, 1973–2001; Architects: Minoru Yamasaki & Associates."

Stout, Glenn, Charles Vitchers and Robert Gray. *Nine Months at Ground Zero: The Story of the Brotherhood of Workers Who Took on a Job Like No Other*. New York: Scribner, 2006.

Woods, Lebbeus. *The Storm and the Fall*. New York: Princeton Architectural Press, 2004.

Yamasaki, Minoru. "A Humanist Architecture; the Annual Marley Lecture Sponsored by the Yerbury Foundation, given by Minoru Yamasaki at the R.I.B.A. . . ." *Architect and Building News* (November 23, 1960), 665–666.

Yamasaki, Minoru. *A Life in Architecture*. New York; Tokyo: Weatherhill, 1979.

Glossary

abutment. (In bridge construction) the landward approach to the bridge; the part of a structure that supports the end of a span or accepts the thrust of an arch; sometimes supports and retains the approach embankment. (In dam construction) the part of the canyon or valley side against which the dam is constructed.

adobe. Sun-dried brick of clay, water, and sometimes a bonding material (e.g., straw).

aggregate. Broken stone, gravel (coarse aggregate), and sand (fine aggregate) that is mixed with portland cement (or lime) and water to form concrete.

aisle. (In churches) the part of the building running parallel to the nave and separated from it by an arcade or row of piers.

anchorage. (In suspension bridges) the part located at the outermost end to which the main cables are attached.

apse. (In churches), the termination (usually semicircular in plan) at the east end that often houses the altar.

arcade. A series of arches supported by columns, piers, or pillars, either free-standing or attached to a wall to form a gallery.

architecture parlante. (lit. "speaking architecture") A late-eighteenth-century architectural philosophy (initially French) that "sought to mold form and ornament to express a building's purpose and thereby inspire social reform."

Art Deco. A popular movement (mid-1920s until World War II) in architecture, interior design and industrial design, and the applied arts, inspired by The *Exposition Internationale des Arts Décoratifs et Industriels Modernes* (International Exposition of Modern Industrial and Decorative Arts), Paris, 1925.

arts and crafts. A late-nineteenth-century artistic movement, a reaction to industrialization, based on the ideas of John Ruskin and William Morris, which

promoted traditional forms of design and the use of traditional materials, restrained vernacular decoration, and handcraft construction.

ashlar. Squared blocks of smooth stone laid in courses.

attic story. (In Neo-Classical architecture) a low story above the main order of a façade.

Baroque. An architectural style that developed from the late Renaissance in the seventeenth and eighteenth centuries, "characterized by exuberant decoration overlaid on classical architectural details."

barrel vault. The simplest form of vault, consisting of a series of semicircular arches extended prismatically; also known as a tunnel vault.

bascule bridge. An opening bridge in which a hinged counterweight at one end of a span falls, causing the deck to rise.

bas-relief. Low-relief sculpture or carving, often applied as architectural decoration.

battered wall. A wall whose face inclines inwards toward the top.

bedrock. The solid rock underlying unconsolidated sediment or soil.

bevel. A right-angled corner cut off asymmetrically (i.e., at other than 45 degrees).

breastworks. (In defenses) a barricade, usually about breast high, that shields defenders from enemy fire.

breccia. A sedimentary rock composed of angular rock fragments cemented together.

brise-soleil. A sun protection deviceused to prevent façades with a large areas of glass from overheating during summer.

built-up roofing. A continuous, semiflexible membrane consisting of saturated felts, coated felts, fabrics, or mats with alternate layers of bitumen and surfaced with mineral aggregate, bituminous material, or a granule surfaced sheet.

buttress. A masonry support built against an exterior wall (usually) of a building to absorb lateral thrusts from roof vaults; local thickening of a wall.

caisson. A watertight chamber used in underwater construction work or as a foundation.

cantilever. A horizontal projection from a building (e.g., a balcony, beam, or canopy) that is without external bracing and that appears to be self-supporting.

capital. The head of a column.

cast iron. A brittle and nonmalleable alloy of iron, carbon and silicon cast in a mold.

cast stone. Concrete with a fine aggregate or mortar made to resemble natural building stone, cast into blocks or slabs.

catenary. The shape of a hanging flexible chain or cable when supported at its ends and acted upon by a uniform gravitational force (its self-weight).

centering. The temporary formwork, usually timber, used to support elements of arches or domes until the keystone is placed, and they are self-supporting.

clerestory. The upper part of any wall whose windows allow light into the center of a space. (Also clearstory or overstory).

coffering. Decorative pattern on the underside of a ceiling, dome, or vault, consisting of sunken square or polygonal ornamental panels. It reduces the weight of the ceiling without structurally weakening it.

colonnade. A row of columns supporting an entablature or arches. See Arcade.

compressive strength. The ability of a structural material (e.g., stone, brick, or concrete) to withstand a load when being crushed.

coping. A course of stones or other material protecting the top of a wall from water penetration.

corbel. A projecting block of stone built into a wall, usually to support horizontal construction or the springing of a roof frame.

Corinthian. The latest, most ornate of the three Greek orders of architecture, (Doric, Ionic, Corinthian). It comprises a molded base, a fluted shaft, a bell-shaped capital decorated with Acanthus leaves, and an entablature with a continuous frieze.

crossing. (In churches) the space at the intersection of the nave and the transepts.

cupola. A dome, especially a small dome, on a circular or polygonal base, crowning a roof or turret.

curtain wall. In modern architecture, the outer skin of a building that has no load-bearing function but serves as an environmental filter.

dado. The lower part of an interior wall, usually specially decorated or faced with a different material from the rest of the wall.

dead load. The self-weight of a structure itself, independent of traffic, or the environment.

deformation. The change in shape that occurs in a structural member when loads are applied.

Doric. The order of Greek architecture that originated on the Greek mainland around the 6th century BC. It comprises a baseless column with a cushion capital and a modular entablature.

dormer. A gable extension of a sloping roof to accommodate a vertical window.

double-hung (window). A window in which the upper and lower sliding sashes move up and down against counterweights.

downpipe. A pipe that conveys rainwater to the ground from the upper parts of buildings.

dressings. Masonry moldings around openings and at the corners of buildings, usually of better quality than the other facing work.

drystone. Walls built without mortar, in which the horizontal joints slope outward, to allow water run-off.

entablature. (In Neo-Classical architecture), the part of an architectural order between the tops of the columns and the roof, comprising an architrave (the lower horizontal section that connects the columns), a frieze, and a cornice that projects to support the edge of the roof.

escutcheon. Armorial bearings displayed on a shield.

fanlight. A semicircular window above a door, of the same width as the door.

fasces. A bundle of rods containing an axe with the blade protruding; in ancient Rome it was a symbol of a magistrate's power.

flitch. A piece of timber with a cross section exceeding 4 by 12 inches.

formwork. A set of temporary framing placed to hold wet concrete until it sets; also known as shuttering.

fresco. (fr. the Italian "affresco" meaning fresh) "Buon fresco" is painted on wet plaster, "a secco" on set plaster.

frieze. (In Classical architecture) the part of an entablature between the architrave and the cornice.

gable roof. A roof consisting of two sloping planes meeting at a ridge, and supported at their ends by triangular extensions of the walls (gables).

Georgian. Architectural style current in Britain and her colonies between about 1720 and 1840, named after the British monarchs George I, II, III, and IV.

Gothic Revival. An eighteenth- and nineteenth-century architecture style based on those of northern and western Europe from the middle of the twelfth century to the early sixteenth century. Also "Neo-Gothic" and "Gothick."

grout. A mixture of Portland cement, aggregates, and water, which can be poured or pumped into cavities in concrete or masonry to fill joints/voids.

Guastavino tiles. The "Tile Arch System" patented in the United States in 1885 by architect/builder Rafael Guastavino (1842–1908) to build self-supporting arches and vaults using interlocking terracotta tiles.

hipped roof. A roof with slopes on all four sides. The "hips" are the joints formed when the slopes meet at the corners.

in situ concrete. Concrete poured in forms in location (as opposed to prefabricated concrete).

Ionic. The order of Greek Classical architecture that originated in Asia Minor in the mid-sixth century B.C. It comprises a molded base, a fluted shaft, a cushion-shaped capital with volutes, and an entablature with a continuous frieze.

lantern. A small open-sided structure crowning a dome or roof, to admit light and/or air into the space below.

latin cross. (In churches) a plan form in which one arm (the nave) is longer than the other three (the transepts and chancel).

lintel. A beam that supports the weight above an opening in a wall.

live load. The load carried by structural members other than their self-weight; that is, arising from the occupancy, wind, seismic, and snow loads.

loggia. A roofed open gallery overlooking an open courtyard.

lunette. A crescent-shaped or semicircular opening in a wall.

maquette. (In sculpture) a preliminary model of a larger work.

monolithic. An architectural element made of a single block of stone.

mullion. A vertical member dividing components of a window or opening.

nave. (In churches) the central principal space, extending from the narthex (entrance) to the chancel (sanctuary).

obelisk. A tall, tapering shaft of stone, usually monolithic, square, or rectangular in section, crowned with a pyramid.

oculus. A circular or oval (eye-shaped) window, or an opening at the top of a dome.

off-form concrete. Concrete left unfinished except for the impress of the formwork on its surface.

Palladian. A style of Classical architecture widely spread in Britain and her colonies inspired by the work of Italian, Andrea Palladio (1518–1580).

parterre (de broderie). A geometrical ornamental garden with paths between beds of low planting.

pediment. (In Neo-Classical architecture) a triangular or arched gable over a portico, often used on a smaller scale over doors and windows

pendentive. A concave, triangular-shaped structure which supports a circular dome over a square compartment.

piazza. An open square (Italian). The English and French equivalent is "place"; Spanish, "plaza"; and German, "platz."

pilaster. An attached rectangular column (not necessarily structural) projecting slightly from a wall surface.

pile. A timber, steel, or reinforced concrete column driven into the ground to carry structural loads through weak soil to the stratum capable of supporting them.

piloti. A structural stilt that raises a building, allowing the ground level (undercroft) to be left open.

polychromy. (In architecture) a term used to describe styles that employ multiple colors.

portico. A roofed area, open on one or more sides, typically supported on one side by the façade of a building and on the others by columns or arches.

Queen Anne style. A late-nineteenth-century style of (usually) domestic architecture incorporating an asymmetrical plan, a variety of roof types, porches, and bay windows.

quoin. The contrasting treatment defining the corners of masonry buildings.

refectory. A dining hall in a monastery, college, or other institution.

repoussé. A technique for producing a relief design by pressing or hammering the inside or backside of a metal surface into a "negative" mold.

reveal. The inner surface of a door or window opening, between the edge of the frame and the outer surface of the wall at right angles to it.

rubble. (In masonry) rough, irregular stone fragments used in wall construction; may be laid in courses or not (random or uncoursed rubble); often used as infill between ashlar faces.

rusticated. (In masonry) stonework comprising regular or irregular blocks with roughly dressed faces, separated by wide, recessed joints

sacristy. (In churches) a room where sacred vessels and vestments are kept or meetings are held.

sally port. (In defenses) a gate through which soldiers could "sally forth" to counterattack.

sanctuary. (In churches) the space at the extreme east end, where the altar is located.

soapstone. A soft, easy-to-carve stone with a soap, aka steatite.

spandrel. (In Historical architecture) an irregular, triangular wall segment adjacent to an arched opening. (In Modern architecture) a panel between the

top of one window and the sill of another window on the story directly above it, that masks the underfloor spaces.

(Spanish) mission. A style of (generally) domestic architecture incorporating elements of Spanish architecture (e.g., terracotta roof tiles, rendered walls, and arched openings).

stainless steel. A rust- and corrosion-resistant steel alloy containing chromium, and sometimes nickel or molybdenum.

stringer, string course. A projecting course of bricks or some other material forming a narrow horizontal strip across the wall of a building.

stucco. A material consisting of cement, sand. and lime, applied as a hard covering to exterior walls.

suspension bridge. A bridge in which the main structural cables are draped from towers and restrained by anchorages on either end; the bridge deck is suspended from the cables by vertical connections.

swag. (In Neo-Classical architecture) a sculpted garland of flowers or fruit hanging in a curve between two points.

tensile strength. The ability of a structural material (e.g., steel) to withstand a load when being pulled apart.

terrazzo. A flooring finish of marble chips mixed with cement mortar, the surface is ground and highly polished.

tessera. Small pieces (usually cuboids) of marble, glass, or metal used in mosaic work.

tracery. (In Neo-Gothic architecture) ornamental stone window framing.

transept. (In churches) the transverse arm of cruciform plan church, intersecting the nave and chancel at a right angle.

triglyph. An ornamental module of a Doric frieze, consisting of a rectangular slab with two complete grooves in the center and a half-groove at either side.

truss. A triangulated assemblage of structural members forming a rigid framework for a column, beam, or roof framing.

Tuscan. A relatively plain architectural order developed in the Italian Renaissance, aka Roman Doric.

vara. A Spanish/Portuguese unit of linear measure, varying from 32 to 43 inches. Also a square vara, as a unit of area.

vault. An arched masonry structure of various types forming a ceiling or roof.

vernacular. In architecture, relating to the common building style of a culture (literally, "home-grown").

voussoir. A wedge-shaped brick or stone, a component of an arch or vault.

wainscot. Timber paneling applied to the lower portion of a internal wall.

widow's walk. A railed rooftop platform, typically on a coastal house, originally designed to observe vessels at sea; (aka roof walk).

wind load. A transverse load on a building resulting from wind pressure and/or suction.

wrought iron. A tough, malleable, relatively soft form of iron, suitable for blacksmithing.

ziggurat. A type of step-pyramid temple first built by the Sumerians.

Selected Bibliography

Bergeron, Louis, and Maria Teresa Maiullari-Pontois. *Industry, Architecture, and Engineering: American Ingenuity, 1750–1950*. New York: Abrams, 2000.

Blumenson, John J. G. *Identifying American Architecture: A Pictorial Guide to Styles and Terms, 1600–1945*. Nashville, TN: American Association for State and Local History; New York: Norton, 1981.

Conn, Steven, and Max Page, eds. *Building the Nation: Americans Write about Their Architecture, Their Cities, and Their Landscape*. Philadelphia: University of Pennsylvania Press, 2003.

De Long, David G., Helen Searing, and Robert A.M. Stern, eds. *American Architecture: Innovation and Tradition*. New York: Rizzoli, 1986.

Faherty, Duncan. *Remodeling the Nation: The Architecture of American Identity, 1776–1858*. Durham, N.H.: University of New Hampshire Press; Hanover, N.H.: University Press of New England, 2007.

Fitch, James Marston. *The Architecture of the American People*. New York: Oxford University Press, 2000.

Gelernter, Mark. *A History of American Architecture: Buildings in Their Cultural and Technological Context*. Hanover, N.H.: University Press of New England, 1999.

Hafertepe, Kenneth, and James F. O'Gorman. *American Architects and Their Books to 1848*. Amherst: University of Massachusetts Press, 2001.

Harris, Cyril M. *American Architecture: An Illustrated Encyclopedia*. New York: W.W. Norton, 1998.

Heyer, Paul. *Architects on Architecture: New Directions in America*. New York: Van Nostrand Reinhold, 1993.

Howard, Hugh. *Dr. Kimball and Mr. Jefferson: Rediscovering the Founding Fathers of American Architecture*. New York: Bloomsbury, 2006.

Kennedy, Roger G. *Architecture, Men, Women and Money in America, 1600–1860*. New York: Random House, 1985.

Packard, Robert T., and Balthazar Korab. *Encyclopedia of American Architecture*. New York: McGraw-Hill, 1994.

Poppeliers, John C., and S. Allen Chambers. *What Style Is It?: A Guide to American Architecture*. Hoboken, N.J.: John Wiley, 2003.

Roth, Leland M. *America Builds: Source Documents in American Architecture and Planning.* New York: Harper & Row, 1983.

Roth, Leland M. *American Architecture: A History.* Boulder, CO: Icon Editions/Westview Press, 2001.

Scully, Vincent Joseph. *American Architecture and Urbanism.* New York: H. Holt, 1988.

Twombly, Robert C. *Power and Style: A Critique of Twentieth-Century Architecture in the United States.* New York: Hill and Wang, 1996.

Upton, Dell. *Architecture in the United States.* Oxford; New York: Oxford University Press, 1998.

Whiffen, Marcus. *American Architecture Since 1780: A Guide to the Styles.* Cambridge, MA: MIT Press, 1992.

Wilson, Richard Guy, and Sidney K. Robinson, eds. *Modern Architecture in America: Visions and Revisions.* Ames: Iowa State University Press, 1991.

Wiseman, Carter. *Twentieth-century American Architecture: The Buildings and Their Makers.* New York: Norton, 2000.

Index

About the Author

DONALD LANGMEAD is an adjunct professor at Louis Laybourne Smith School of Design, University of South Australia. Now retired, his primary training is as an architect, although he has spent most of his professional life in academia. He holds postgraduate qualifications in city planning and the history of architecture. Langmead has published nine books in the field (four as joint author) in Australia and the United States, as well as many articles in Australian and overseas journals.